D1084907

Art Course
Step-By-Step

An Instructional Guide to
Drawing, Pastels, Watercolor, and Oils

Art Course Step-By-Step

An Instructional Guide to
Drawing, Pastels, Watercolor, and Oils

IAN SIDAWAY

This edition produced 2003 by
PRC Publishing Ltd,
64 Brewery Road, London N7 9NT
A member of **Chrysalis** Books plc

Published by Greenwich Editions
64 Brewery Road, London, N7 9NT
A member of **Chrysalis** Books plc

© 1996 PRC Publishing Ltd.

All rights reserved. No part of this publication may
be reproduced, stored in a retrieval system, or transmitted
in any form or by any means, electronic, mechanical,
photocopying, recording, or otherwise, without the prior
written permission of the Publisher and copyright holders.

ISBN 0 86288 552 3

Printed and bound in China

CONTENTS

INTRODUCTION

IF YOU'VE EVER WANTED to learn how to draw or to use pastels, watercolors, or oil paints, this book is an ideal introduction to some of the basic techniques that are in common use today. Each of the four sections includes information on equipment and materials, as well as techniques to practice before starting on one of the projects. Using and becoming familiar with the techniques in isolation, without concentrating on making a picture, helps give you confidence in handling the materials. Once a certain amount of confidence is gained you can start on one of the projects. These are relatively straightforward to begin with, and when you want more of a challenge, gain in complexity. You will also be shown several alternative paintings and drawings that deal with and solve similar problems to those dealt with in the project paintings.

Leon Battista Alberti, a 15th-century aesthetic and scholar, said: "Begin with the bones then add the muscle." He was referring to the correct way of representing the human figure; however, the laying of a strong foundation is central to all art, and the ability to draw well lays that foundation. The process is twofold: first, we need to relearn the way we look at things; and second, we need to learn about technique—the marks that it is possible to make with our chosen materials, and how to go about making them.

You can learn all about drawing in the first section, where the projects combine a range of basic techniques with specific picture-making principles. You will be shown different ways of looking at your chosen subject; how to compose the picture; how to deal with perspective and proportions; and how to use light, shade, and line to create the illusion of mass, shape, and form. For each project you will also be shown several alternative ways of approaching and handling the subject matter.

Drawing is an intuitive and instinctive activity. However, to do it well it does require focus and thought. Drawing skills are acquired, and subsequently developed, by practice and repetition, in much the same way as the art of writing. Even in the age of the silicone chip, most of us still practice the art of writing daily, be it only in scribbling a shopping list or simple route directions for someone to follow. The opposite is true of drawing: it is an activity that, because of lack of practice, most of us forget how to do once we have left childhood behind.

All children draw—it is their natural inclination to reach for the pot of wax crayons and cheap paper we all diligently supply for them, long before they can talk, and as a race, humans have always drawn, as the prehistoric rock paintings found throughout the world so graphically show. Some of these drawings were made some 25,000 years ago, yet they are surprisingly sophisticated and pure representations. The people who created these remarkable paintings were not trained in any way to be artists: the concept of the artist did not exist. Instinctively, they simply drew and interpreted what they saw, and it is in this spirit that we still begin as children to express ourselves by drawing.

Young children produce drawings and artworks intuitively, for their own sake, completely without inhibition and early on in their development, without any sense or feeling of failure. With age comes an increased awareness and knowledge of how things really look, and in the search for exactitude we try to imitate correctly what we see, using increasingly difficult techniques. It is at this point, usually around the awkward years of early adolescence, that, embarrassed and frustrated with failure, we cease to draw, believing that we cannot.

Yet in spite of this the basic desire to draw stays with us; few of us can resist scribbling and doodling in the margins of telephone directories or on the backs of envelopes, and we do so almost without thinking. To fulfil the desire to draw we need to learn again and develop those forgotten skills, and, like learning anything, this requires time, effort and practice. It is by drawing that we learn to draw.

Forget about failure; even professional artists experience that. The work we admire, so immaculately framed and bathed in ideal light on the gallery wall, is more than likely the result of several less successful attempts consigned to the plan-chest drawer. To the artist, these unseen drawings or paintings are of no less importance than the work on show: they are a necessary and crucial part of the artist's creative development.

It would be foolish to suppose that drawing is not difficult. There are no shortcuts or easy answers here, but learn the principles and techniques, become familiar with the materials, and, above all, practice, and you will soon see promising results. Each time you put pencil to paper the task will become just that bit easier, and the satisfaction just that little bit greater.

When you have mastered the techniques of drawing you may want to try a different medium. The next section serves as an introduction to some of the many basic pastel techniques as well as a few that are not such common practice.

There is no right or wrong way of using pastel, it is a versatile and seductive medium that can be adapted and used in a surprisingly wide variety of ways. Only dry pigment pastels are dealt with here and not wax or oil pastels that, while similar, do require a slightly different approach. You will be shown how to prepare supports and how to work on different surfaces. How to build up paintings in layers, how to use different types of pastel, and how to use fixative creatively.

Pastel is a relatively modern medium: black and red crayons were made in stone age times while hard chalks and crayons in the limited palette of white, black, and red were developed and have been in use since the late fifteenth century. However, pastels as we know and use them today, in a limited (by today's standards) but relatively comprehensive range of colors, only came into use around 250 years ago.

Despite pastel's fragility, it rapidly gained in popularity, its potential being exploited and explored by artists such as Rosalba Carriera (1675–1757), Quinten de La Tour (1704–1788), and Chardin (1699–1779). Pastels popularity waned during the first half of the nineteenth century along with the demand for portraits, but the medium was seized on and its strengths immediately recognized by the Impressionists. Edgar Degas (1834–1917) developed techniques that were far removed from the delicate portrait and landscape work that the medium had been used for previously.

Degas and the other Impressionists were quick to see how the purity of color and the immediacy of the pastel technique made it a medium that suited their ideas concerning color and light. New techniques were utilized and invented that did away with the subtle blending that had been used in the past. Artists began using confident strokes of bright color which were laid next to each other and allowed to interact visually and mix optically or they used broad flat areas of color contained by fluid, flowing line work.

Pastel is unique; it is a dry painting medium that needs neither the addition of water nor turpentine. Pastel color is color in its purest form—unadulterated by additives or diluted with liquid media. The effect of working with a pastel is immediate as the color seems to flow from the very fingertips and the colors, far from being pale and insipid, are invariably surprisingly strong and bright.

Perhaps the one thing that really sets pastels apart from other media, and which requires from the artist some confidence and perhaps a certain degree of recklessness, is the fact that pastels cannot be mixed on a palette prior to being applied to the support compounding the immediate nature of the medium.

Pastel has lots of attractions and potential, but for one reason or another, has unfairly been saddled as a medium used predominantly by rather amateur artists. Perhaps given today's concerns with finance, value for money, and longevity the fragile pastel is seen as a risky thing for the artist to invest his or her valuable time in. But then given the current rebirth and interest in good figurative painting, pastel as a traditional medium may yet begin to find its way back into more artists' studios.

Water-based mediums, unlike pastel which is relatively modern, have been in use for over 20,000 years. In the watercolor section, you will be shown how to lay and combine washes, how to mask out areas to prevent them being covered in paint, how to use the white of the paper, and how to create a range of textural effects, to name but a few.

Primitive watercolors, using paint made from ground pigments suspended in water and bound with animal fats, still survive in remarkable condition preserved on the walls of deep caves throughout Europe, protected as they are from changes in the atmosphere and the harsh light of day. A tradition had begun that would gain artistic strength throughout the three thousand years of the great Egyptian dynasties and increase in momentum with the creation of illuminated biblical text and manuscripts, which played such an important part in the birth of Christianity and the spread of the gospels throughout Europe during the Middle Ages.

Far across the world in China the watercolor tradition had developed independently into an essential skill. It was considered to be a spiritually uplifting and meditative pastime practiced by all learned folk, and it is perhaps here that the true beginnings of watercolor, as we know and use the medium today,

began. The Chinese artists exploited the white of the paper, which they invented around one hundred years before the birth of Christ, and they made use of transparent washes of color and tone. Both of these techniques are still central to the traditional method of watercolor painting.

In Europe throughout the 15th, 16th, and 17th centuries watercolor was used by relatively few artists, and it was not until the end of the eighteenth century that the potential of this medium began to be fully explored and exploited by a group of English landscape painters. It was the Age of Enlightenment and the obligatory European Grand Tour, and there was a steady demand for books and prints that included paintings or engravings of archaeological, historical, and topographical scenes. The landscape as subject, as the Chinese so readily acknowledged centuries before, is well suited to the watercolor treatment, and the artists of the time, professional and amateur, experimented hard, looking for and developing satisfactory techniques to convincingly depict the ever changing light and effects of the weather. In doing so, watercolor finally came of age.

There is little doubt that watercolor holds a very special appeal and fascination. Perhaps it is that so much can be accomplished with so little or perhaps it is because many watercolors look deceptively simple, spontaneous and effective, and the results so achievable and quick to accomplish. In reality, successful results come quickly only occasionally. More often than not the painting has taken a great deal of planning and forethought, and there lies the key to success.

Watercolor is unpredictable, which for many is part of its attraction, but by thinking logically, working methodically, and with a little perseverance and practice, success will surely follow. It is also important to remain flexible and to be ready to make the most of those chance effects that are an inherent part of the medium. Do not be dissuaded by the first inevitable failures. Try a new tack, a different paper or brush and things will begin to click; suddenly a wash will go down flat and colors begin to run together in just the right way. But be warned; watercolor is a seductive medium and you may, given time, find yourself becoming involved in a serious love affair.

Despite the versatility of oil paint, it is still seen by many to be a difficult medium, but in truth it is much easier to work with than watercolor. The final section of this book illustrates just some of the ways you can use oil paints. You will be shown how to work wet into wet and wet on dry, how to glaze, when to use a mask, and how to paint with a knife, to name but a few.

It is the unmatched depth, intensity, and richness of color that is one of the reasons oil paint is so desirable to use. The wide range of colors that are available and their strength and purity can make color mixing more straightforward and therefore easier to match those colors seen in the natural world. But perhaps it is the way that oil paint can be adapted to suit the style and approach of an individual that is its biggest strength.

Paint can be applied with brush, knife, fingers, rag, or roller, or you can, if you wish, throw it at the support. Paintings can be large and expressive or intimate and small, the paintwork flat and smooth or thick and textured. You can work wet paint over dry paint or wet paint over wet and you can remove and obliterate what you have done by scraping it off with a knife or simply by painting over it.

The use of pigments, ground and suspended in oil, has been common since the Middle Ages if not earlier, but it was not until the early 15th century that the real potential of the medium began to be recognized, explored, and exploited, primarily by the Dutch painter Jan Van Eyck; up until then tempera painting in various forms was used exclusively. The tempera technique imposed certain restrictions on the artist: for a start there was only a limited range of colors and these were difficult to blend; the technique called for a slow building up of form and color, which made it difficult to achieve any degree of naturalism.

Van Eyck dried his varnished tempera paintings done on wooden panels in the sun, as was common practice. When one of these panels split with the heat Van Eyck began to look for a varnish that would dry in the shade. After experimenting he found that linseed and nut oil did just that and soon began to mix his pigments directly into these oils, which he worked in glazes; this gave a brilliance and intensity to his colors that had hitherto not been seen.

After a visit to Flanders, Antonello da Messina took Van Eyck's methods back to Venice. At first the Italians were slow in

picking up the baton and continued to underpaint in tempera; however, gradually, in the hands of artists such as Giovanni Bellini and Etian, the true strengths and possibilities of oil paint began to be realized. It was also around this time that in Northern Italy—and particularly in Venice—canvas supports began to be used rather than wooden panels.

Today the legacy of these artists along with countless others can be seen hanging on gallery walls throughout the world; more oil paintings hang there than work done in any other medium and in their diversity of technique and style show just how enormously adaptable, versatile, and expressive the medium really is.

This book covers all the basic techniques that an artist would use and will enable you to explore and develop your own creative talents in a diverse range of media. All you need to remember is that making pictures is a subjective process. While there are certain principles that need to be acknowledged, these are always open to wide and varied interpretation, and it is this very interpretation that makes for artistic individuality. Indeed many of the best works stretch these principles to the limit.

MATERIALS AND EQUIPMENT

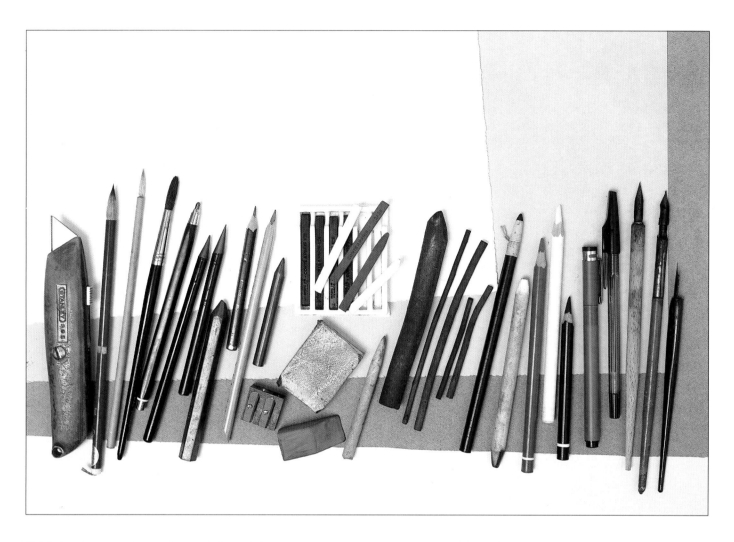

THE QUALITY AND SURFACE of the support you choose to work on are of primary importance, and can make the difference between success and failure. Therefore, the first material you should consider purchasing is the support for your work.

Drawing papers and boards

Given the bewildering range of paper and boards available it is little wonder that beginners find it difficult to decide which papers to use. Papers can be expensive, and making the wrong decision not only leaves a hole in the wallet, it can also make the drawing process more difficult than necessary. Common sense should match the paper with the medium. Charcoal tends to work best on a surface that has some texture, while it is preferable to do a drawing with pen and ink on a smoother paper. By experimenting with a variety of papers you will discover the ones that are best suited to your way of working, subject, and chosen medium.

Papers and boards come in a wide range of sizes, textures and weights, and most papers used by artists are finished with glue, or "sized," to give an acceptable and receptive surface on which to work. In addition, papers are either handmade or machine-made. The handmade papers tend to be more expensive and are sized on one side only, this being the correct side on which to work. They are usually watermarked or embossed with the manufacturer's name, and have a ragged, or "deckle," edge. Machine-made papers come with three types of surface: Hot Pressed paper, which is smooth, with little or no surface texture; Not or CP (Cold Pressed) paper, which is not hot pressed and has a definite tooth or texture; and Rough, which has a very pronounced texture. All three surfaces can be used, but Not and Hot Pressed present the best surface for drawing.

A paper's thickness is indicated by its weight: the heavier the weight the thicker the paper. Two systems

exist for measuring weight: the first is in pounds and refers to the weight of a ream (500 sheets) of that particular paper, for example, 140 lb, 260 lb; the second is in grams, and refers to the grams per square meter of a single sheet, for example, 300 gsm, 356 gsm.

Thick papers can withstand vigorous, heavy overworking and multiple erasures when using a dry medium; when using a wet medium they stay flat and resist cockling, so they do not need stretching. For most drawing you will find that a medium-weight 90 lb or 140 lb cartridge paper is more than adequate. White or off-white papers are traditionally used for drawing, but colored papers offer some exciting possibilities. There is a large range of colored papers available; most are used for pastel, chalk or charcoal work and usually carry a fine to medium tooth. Boards are available with Not and Fine surfaces, and are ideal when drawing with fine technical pens.

Sketchbooks come in a multitude of shapes and sizes containing a wide variety of paper weights, surface types, and color. Choose your sketchbooks with as much care as you would paper, giving thought to what you want to draw and the materials you intend to use. Over time you should amass quite a few, for it is within the pages of the sketch book that you can not only practice drawing, but also experiment with marks and effects, so building up a reference of possibilities.

Pencil and graphite

The pencil is arguably the most widely used and versatile of all drawing implements. It is possible to achieve a vast range of marks—from light, delicate, almost imperceptible lines to broad, dark, strong areas of heavily scribbled tone and textural effects—with just one, carefully chosen pencil. There are 20 grades of pencil: they range from 9H, the hardest, to H, F, HB, and B in the middle; then they get progressively softer, to 9B. The harder grades make lighter and finer lines. They can be sharpened to a fine point, which makes them more suitable for precise technical drawing where a consistent line thickness is important. For freehand work it is better to choose a softer grade: as the point becomes worn and blunt—which with the very soft grades happens surprisingly fast—it is possible to vary the quality of the line, giving interest and expression to the drawing.

In reality, rarely is one pencil used when making a drawing: more often, two or three of varying degrees of

hardness are used. The HB pencil is generally thought of as being the ideal all-round drawing pencil, with greatest flexibility, capable of rendering a broad range of tone and line. I prefer the F; the line quality tends to be crisper but the tonal range that can be achieved is just as wide.

The pencil shaft tends to be either hexagonal or round. Hexagonal shafts give a firmer grip while round shafts enable the pencil to be rolled easily in the finger, making it possible to present a different profile of the graphite strip to the paper, without having to pause in your work.

Studio or sketching pencils are rectangular and flat, like carpenters' pencils, and come in soft, medium, and hard grades. When used with the graphite strip flat, they are ideal for quickly blocking in large areas of tone, but when turned on their side they give a line varying in thickness. They may feel a little unwieldy and awkward at first, but with experimentation are capable of producing a wide range of marks, and are good when working large.

I find graphite sticks the most useful and easy to use of all the drawing instruments. They come in grades of softness from HB to 9B, and in a variety of thicknesses. They are the perfect tool for making marks. These solid sticks of graphite are either coated on the outside to keep the hand clean or, as in the case of the thicker hexagonal sticks, uncoated. Given the large area of exposed graphite it is possible to make the transition from fine lines to broad, dense areas of tone in one stroke. Care should be taken with the thinner, soft pencils, as they can break easily if held high up the shaft and pressed hard, or if dropped on to a hard floor.

Graphite can be obtained in the form of powder; when rubbed on to the paper with a rag or a finger it will produce a beautiful area of tone that can be worked on with a pencil or graphite stick, and lightened by drawing into it with an eraser.

Charcoal, conté, and chalk

The best charcoal is charred wood from the willow, the beech, and the vine. This is the oldest-known drawing material, made in much the same way for centuries. Charcoal is a very expressive and direct medium; the boldness and clarity of the marks encourage the artist to work larger than one might with pencil. This can be very helpful when learning to draw, as it forces the artist to look at the subject as a whole rather than

concentrate on detail. Charcoal is available in varying degrees of hardness and thickness. The thinner sticks are bought by the box but the thicker sticks, often referred to as scene-painters' charcoal, are sold individually. The thin sticks are best used for line work and can be sharpened to a point with fine sandpaper. The thicker sticks, while also suitable for line work, are used to block in large areas of tone, either by using the end or by turning the stick on to its side. Thicker sticks are best sharpened with a craft knife. Drawing with charcoal can be a messy business. If this becomes a problem, it can be minimized by wrapping silver foil around the stick, which will keep the fingers clean, by using a clean sheet of paper to rest the drawing hand on to prevent rubbing the drawn surface, and by periodically fixing the drawing (see page 15). Marks made with charcoal can easily be removed before fixing by flicking over the surface with a clean rag or using a large soft brush. A ghost of a mark will remain which can be removed with a putty eraser or left to serve as a guide for any redrawing. The marks left when redrawing in this way are known as *pentimenti*. Blending can be done with the fingers, cotton wool buds, rag, brush, or tissues. However the ideal tool is the torchon, or paper blender, a tightly rolled paper stump—usually pointed a both ends—which enables the artist to blend and push the charcoal dust around the drawing.

Compressed charcoal sticks are made from charcoal powder and a binder. They are harder than traditional charcoal, making the marks harder to erase and blending more difficult, but they are cleaner to use. Compressed charcoal can also be bought as pencils encased in paper or wood. They vary in degrees of softness so are suited to finer work. Their one disadvantage is that, unlike pure charcoal, they cannot be used on their side.

Conté sticks, or pastels, are harder than charcoal and come in a range of colors, tones and hardness. Traditionally, black, red (known as sanguine), dark brown (or bistre), and white were used for drawing, often together, to produce beautiful works of great depth and intensity. The conté stick is best used on tinted paper with a slight tooth to provide a mid tone and a key for the chalk. It can be used to build up subtle areas of tone and shading by using the end (which can be sharpened with a knife) for hatching and line work, or by blocking in areas of tone using the stick on its side.

Like charcoal, conté sticks can be blended, but unlike charcoal are not as easy to erase. It is advisable to give the drawings a coat of fixative when they are finished.

All the colors are available as pencils, with the same advantages and disadvantages found with the charcoal pencils. Treat charcoal and pastel pencils gently; if dropped the strip can crack inside the wood, making it impossible to sharpen them without pieces breaking off.

Pen and ink

Pen and ink has been a favored drawing medium of the artist for centuries. The pen, or quill, as the word pen originally meant, has been an instrument for writing since early Christian times. The quill pen is made by shaping the end of a suitable feather with a penknife and is capable of making the most beautiful of lines. A variety of feathers can be used, but it is said that the point fashioned from a crow's quill is the best for drawing. With time the point wears down and becomes soft, so it needs to be reshaped.

Quills are available at art shops, as are cane or reed pens. These produce a jerky, coarser line, and are suitable for working on drawings that are done on a larger scale.

The dip pen is perhaps the most versatile for the artist. It consists of a holder made from wood or plastic into which a vast range of nibs of different shapes and sizes can be inserted. Nibs range from the extremely fine to the very broad; it is even possible to buy nibs that produce several parallel lines at once, which makes them useful for drawings that are heavily hatched. Sometimes a new nib has trouble accepting ink, in which case a little saliva rubbed on to the nib will solve the problem.

Ink is either waterproof or non-waterproof and both types are available in a wide range of colors. Waterproof ink can be overlaid with washes; it dries with a slightly glossy surface and sits on the paper surface rather than soaking into it. Washes can be overlaid without fear of dissolving the previous layer. Non-waterproof ink perhaps offers greater flexibility. Overworking with washes will dissolve dry ink—indeed, many of the techniques are similar to those used in watercolor. If ink is thick in the bottle it can be diluted by adding a little distilled water.

Ink can be spattered, brushed, sponged, and dabbed on to the support using a variety of implements. Liquid

concentrated watercolor and liquid acrylic can also be used for drawing, extending the possibilities for making marks still further.

Always work on a fairly smooth surface. A heavy cartridge paper is ideal, as the nib runs across the surface without catching. By varying pressure on the nib and altering the angle of the pen you can alter the thickness of the line. Ink used straight from the bottle gives a consistent tone, so unless a shading technique is used the only way to suggest variations of tone within a line drawing is through the thickness and quality of the line.

While it is possible to make corrections to a pen drawing, they are often unsatisfactory; in many cases it is the correction that ruins the drawing rather than the mistake. Ink can be removed by blotting, then dabbing with damp paper. Non-waterproof inks can be diluted with clean water then blotted away, and dry ink can be scraped away with a sharp blade. It pays to plan: a simple, light, soft pencil drawing can be used as a guide for the pen drawing, and the pencil erased when the drawing is finished. To avoid smudging your drawing allow it to dry for several hours before attempting to correct the mistake with an eraser.

A better result will be achieved if you use the pencil drawing as a rough sketch only, redrawing and reinventing in ink; trying to follow the pencil line exactly will make for a dull drawing with stilted, dead, labored line. To clean your nib, rinse it in water. This will stop it clogging with ink and will prolong its life.

Although fountain or reservoir pens are only available with a limited range of nibs, they do offer the advantage of not having to be dipped constantly in ink. They can also be carried in the pocket, which makes them ideal for sketching. To prevent clogging, only fill them with non-waterproof ink.

Any brush can be used with ink. Sable or synthetic watercolor brushes are well suited as are Chinese and Japanese brushes, which are capable of producing extremely fine, delicate lines.

Other drawing media

There are countless technical pens, markers, and felt tips on the market that contain both waterproof and non-waterproof inks. Technical pens are essentially linear tools; tone is achieved by dots or hatching. As each pen puts out a consistent thickness of line, so several pens with nibs of a different thickness are needed for drawings with varying line widths. They can produce drawings with a complete tonal range of great depth. As your pens run out of ink they give an inconsistent, broken line. Don't throw these pens away, as they can be put to good use on those areas that require a minimum of work, bringing yet another quality to the drawing.

Technical pens are best used on a smoother surface such as cartridge paper or card. The same principles apply to ballpoint pens, from which the ink flows easily, making them good for sketching. As they are difficult to erase you are forced, for fear of making mistakes, to look closely at the subject and be incisive with any marks that you make.

Markers, felt, and fiber-tipped pens come by the thousand, varying in size and color. A few are water soluble: most are not. The latter can be blended, removed, and softened by using correction markers that contain a solvent. Correction markers can also be obtained that contain white paint, thus pushing the possibilities still further.

Markers tend to bleed through the paper, so when using cartridge paper make sure you cannot harm the surface on which it is resting. Alternatively you can work on bleed-proof paper, which is fairly thin and transparent. It is common practice to produce a rough drawing first, place it beneath a sheet of bleed-proof paper and use the rough drawing as a guide.

You can draw with anything that will make a mark; each implement will bring with it is own distinct qualities and characteristics. Some will be easier to use than others, and there are many that do not need to be expensive art shop purchases. Indeed you can make a drawing with a match stick dipped in ink. All drawing media can be used in conjunction with one another. Try a marriage of ink and charcoal or graphite and chalk; the results can be both unexpected and exciting. Experiment with your materials, but above all enjoy using them.

Erasers

Erasers should not be thought of simply as the means of getting rid of mistakes; they have a far more important roll to play as a drawing aid that is capable of making its own range of marks. Used with a little care and thought the eraser can add interest and surface quality to areas that have been overworked. They can be used to pull out lighter tones from dark areas, crisply pick out

highlights and negative shapes, make patterns, and soften hard edges.

Erasers tend to be inexpensive so try a few to see their possible effects. You can even cut them to retain sharp or pointed edges or to remove a dirty profile.

The putty eraser is, as its name suggests, soft and malleable. It can be used for cleaning up large areas or molded to a point to put in highlights. Because it is soft it is kind to the surface of the paper, but it can get dirty very quickly when used with charcoal or on heavy dark pencil work. It is, therefore, a good idea to keep one eraser to hand for really dirty jobs and another for cleaner, more detailed work. Alternatively, you can buy the larger size and cut off pieces to use for messy work.

The plastic and India-rubber erasers are harder than the soft kneadable type and are more suited for work on smaller areas or for putting crisp, sharp, light lines into areas of tone. The Artgum eraser is best used to clean up unwanted marks on white paper. Erasers can be used in conjunction with an eraser shield—a small flat sheet of metal with a variety of shapes punched out of the metal. When placed over a drawing it is then possible to erase very small areas without disturbing the surrounding drawing.

Knives and sharpeners

Pencils and thick charcoal are best sharpened with a sharp craft knife or blade. When the blades themselves are sharp they are easy to control and will sharpen all shapes of pencil—unlike the pencil sharpener, which will only sharpen the strip of standard shaped pencils into a very uniform point. A pencil sharpened with a knife keeps its point longer, as the act of sharpening tends to reveal more of the strip. Sandpaper blocks are available to help shape the point, but if a pencil is sharpened correctly these should not be necessary. Sandpaper is best used to sharpen a stick of charcoal. Pencil sharpeners are used to keep a point on graphite sticks, which should be sharpened frequently. If they are allowed to become blunt and round a great deal of sharpening will be needed to restore the point.

The thicker graphite sticks can be kept sharp by using a sandpaper block, or by scribbling the edge of the pencil very hard on concrete or stone, turning the stick all the time until it has a satisfactory point. Conté and chalk can be sharpened using either a knife or sandpaper.

Fixative

Drawings in pencil, charcoal, chalk, and other soft materials that lie on the surface of the support, rather than permeate it, will smudge if rubbed against, so it is prudent to give the drawing a coat of fixative to bind the drawing material to the surface. When working with very soft material such as charcoal you may find it a good idea to fix the drawing periodically as you work; the layer of fixative does change the feel of the paper surface, so use it sparingly. You may also fix that part of the drawing that you are happy with or feel is complete. Once fixed the drawing cannot be modified by erasing, so think ahead.

Aerosol cans are easily used by holding the can 12 in. (30 cm) away from the drawing and spraying steadily while moving the can across the drawing. Test the spray before you use it on the drawing as occasionally the fixative fails to atomize, and a jet, rather than a spray, is discharged, which could spoil your work.

Sundry equipment

A good drawing board is essential. Choose a size that is large enough to accommodate the largest sheet of paper you intend using. Few things are as irksome as trying to work on a sheet of paper that is too large for the drawing board. You may find that it makes good sense to have two boards: a smaller, lighter board for working outside; and a larger, heavier board for working inside. Easels can make the drawing process easier but should not be thought of as a necessity.

A drawing board can usually be rested on or against something, be it a pile of books in the home or a convenient gate or fence post outside. Some artists secure a length of canvas webbing to the middle of each short side of a drawing board; the webbing can then be passed over the head and worn around the neck, supporting the board against the body. Professional artists often have more than one easel, as different easels fulfil very different needs and functions, and it may take time to assess exactly what your own personal needs are. A good easel is a large investment but one that should last a lifetime.

All artists tend to be magpies, picking up more implements and equipment than they need, and the range of materials available is vast. That said, try only to buy what you need; bear in mind that all art shops are notoriously seductive places and that art materials are not cheap.

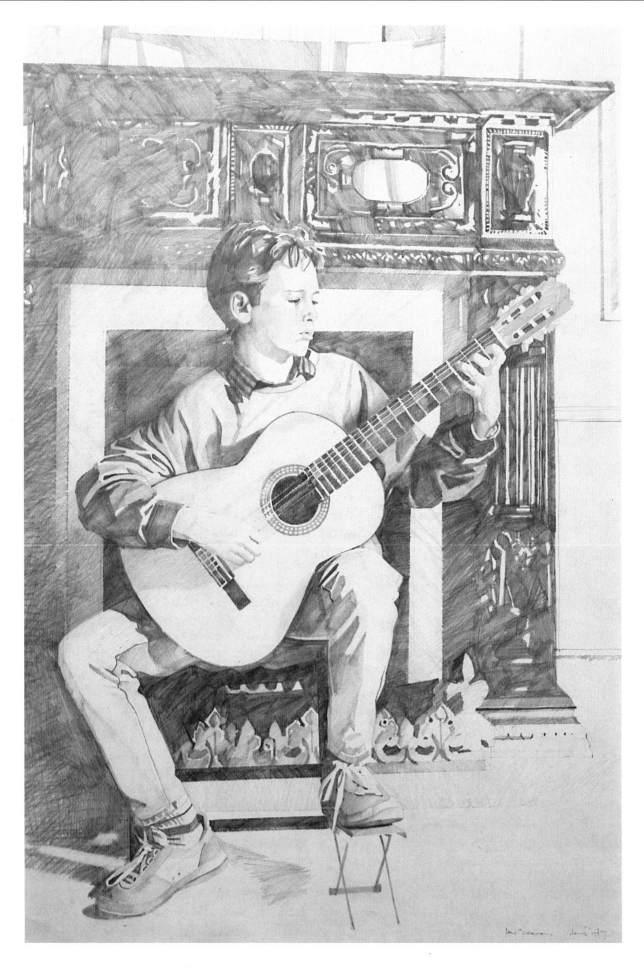

TECHNIQUES

TECHNIQUES ARE THOSE marks and effects that can be achieved with a chosen medium. Working without some knowledge of the effects that are possible and how to achieve them is really like trying to write a book without having any knowledge of grammar. Think of techniques as a visual vocabulary; being able to call on and be familiar with a repertoire of techniques frees the artist to concentrate on the content of the picture.

Many drawing techniques are remarkably simple, but to use them successfully you need to execute them effortlessly and smoothly. All the best drawings, regardless of style, seem to have been executed with a fluid, easy economy of line, or a combination of marks that seem just right for conveying successfully the artist's vision. While it is true that great or even good art cannot be born of technique alone, a familiarity with materials and the marks that are possible with those materials will certainly bring that vision closer to realization.

I believe that any time spend handling, experimenting, doodling, and scribbling with materials and media will help you acquire the technical skills drawing requires. It is not obligatory or even desirable to have an image in mind. Working abstractly in this way means that you can put more thought and concentration into making the marks. Unconscious control of the drawing media enables us to concentrate on form, perspective, composition, color, and other fundamental underlying principles that are central to good drawing.

Learning about technique is cumulative; as you will see, many of the same techniques are used with several different media. Using and becoming familiar with one technique in one medium will help you when using the same or a similar technique with another.

The techniques that follow are but a selection of the great many that are possible with the range of materials we are using. As you experiment you will discover other drawing materials and ways of making marks for yourself—some by accident. The possibilities are endless. Try working and practicing the techniques in a sketch book, or, if the work is done on pieces of scrap paper, paste the results into the sketch book, in this way a very useful visual reference library of possibilities can be built up, to which you can easily refer.

The Techniques

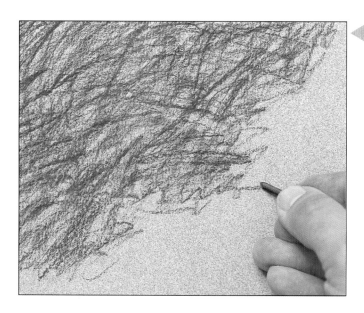

Scribbling with charcoal creates subtle areas of tone of varying density and strength. Large, uniform areas of tone can look flat and uninteresting, whereas scribbled areas varying in density look fresher. They can be built up by covering an area several times over—using the charcoal with more or less the same pressure—or by applying heavier pressure to achieve a thick dark mark. Hold the charcoal nearer the end when using heavier pressure, or the stick will shatter. Holding the stick higher forces you to apply less pressure and so make lighter marks.

Once an area, or patch, of scribbled tone has been laid it can be blended to a smoother finish by using tissue, a soft cloth, torchon or finger. If using a finger

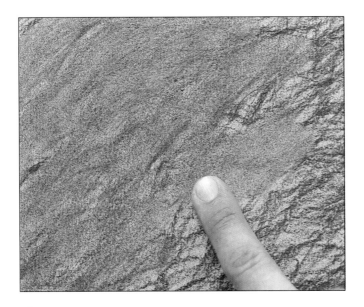

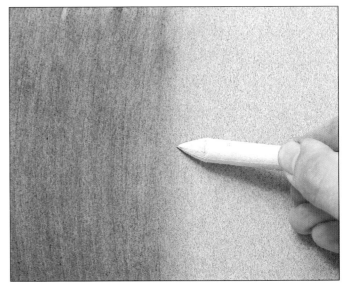

make sure it is dry and rub lightly, blending the marks; repeating the process of scribbling and blending will give a darker tone. If you intend to blend an area in this way do not press too hard with the charcoal, as once embedded in the paper it will become increasingly difficult to blend successfully. To build a dark enough tone it may be necessary to apply some fixative between layers.

To achieve a subtle and gradual change in tone the charcoal is applied loosely and then blended with a torchon. Charcoal is not applied to the lightest area, but the charcoal powder is pulled with the torchon across the surface of the paper into the light areas. A finger, tissues, clean rags or cottonwool buds can be used, but the torchon, because of its shape, is ideal for the purpose, making it possible to blend in very small confined areas as well as over more open, larger expanses of drawing. It is also possible to draw with the torchon simply by picking up charcoal dust on the end and rubbing it on to the paper.

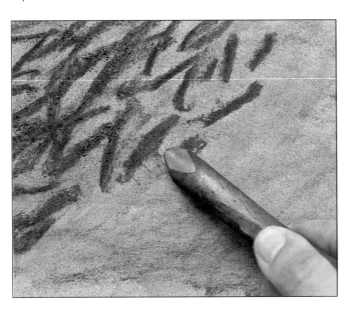

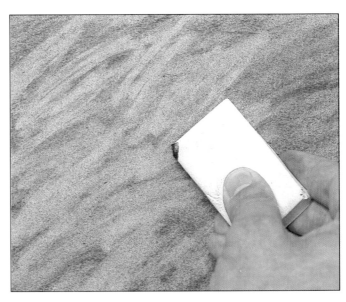

You can work over a light area of charcoal with a variety of marks made with more charcoal (or chalk). As the thickness of charcoal dust builds on the paper surface a point will be reached when the drawing will need to be fixed before it will accept any more charcoal; otherwise the stick will slide over and remove some of what is already there.

The eraser plays an important role when drawing. Not only if it a means of correcting mistakes, it is also used to draw into areas of laid charcoal, pencil, conté or any other soft medium. Large areas of flat tone can be lightened or given texture, and lines can be drawn or

redefined and highlights flicked in. The kneadable putty erasers are well suited to charcoal: the harder plastic erasers tend to push the charcoal deep into the paper. Try a selection with different media. The eraser will get dirty quickly and once covered in thick charcoal will not work as well. Use a sharp knife to cut away the dirty portion, revealing the clean eraser beneath. Harder erasers can be sliced at an angle to keep a sharp edge; soft erasers can also be shaped to a point either by pulling or by cutting with a sharp knife. When lifting out small highlights do not rub with the eraser—just press down hard and lift the charcoal from the surface.

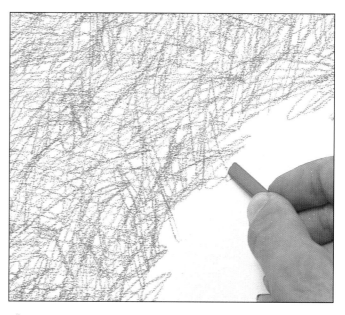

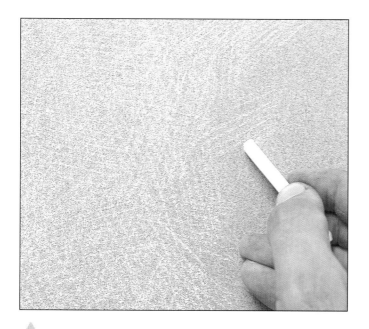

With the softer materials tone is easily built up by blending: with the harder materials this becomes more difficult, so line is used. By cross-hatching lines of varying density or thickness it is possible to achieve a complete tonal range. The technique is used with soft materials too but the effect is less satisfactory than when it is done with those drawing materials capable of making crisper marks; here, white conté is used. Cross-hatching is a very controllable way to render light and shade; it can be slow and considered or fast and loose. The lines do not have to be straight but can curve into the contours of your image, helping to suggest the form.

Scribbling with conté, like charcoal, enables you to build tone gradually over large areas white keeping an interesting surface. The areas of support that are left showing between the marks—in this case white paper—are as important as the marks themselves; it is

the balance between the marks and the paper that gives the desired density. Varying the direction of the strokes, as with hatching, ensures that the observer's eye is led in more than one direction.

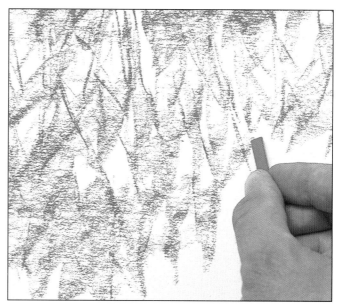

With drawing materials such as charcoal or conté sticks that have a large marking surface, it is possible to utilize the whole stick. Here the sharp, long edge of a conté stick is pulled up and down in an inverted "V," while at the same time it is moved sideways.

By working in layers you can achieve effects that would otherwise be impossible. The surface of an area of sanguine conté—blocked in by using the stick on its side—is fixed, then given added interest by lightly

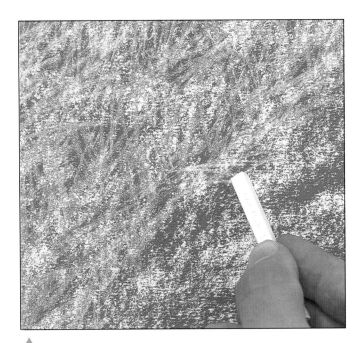

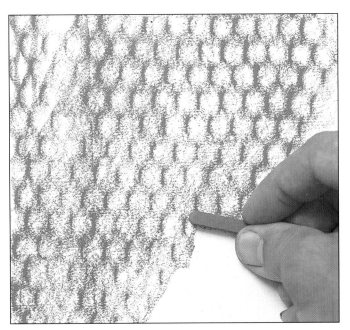

▲

scribbling over the surface with the end of a stick of white conté.

implement is rubbed over the paper surface, an image of texture will show through. This is known as *frottage*, which can be a useful technique to have in the repertoire. While it is not necessarily used on its own to make a drawing, it can be used in conjunction with other techniques to give variety and relief to an image.

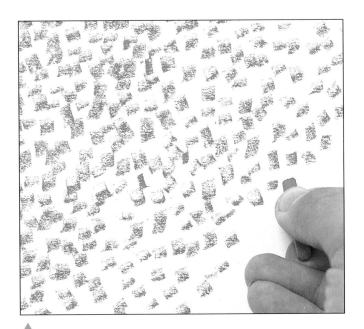

▲

Building areas of texture and tone by dotting or stippling can take time. However it is a useful technique that can be used in conjunction with others to give added interest. The blunt, square end of a conté stick can be used to make short or long marks. The suggestion of tone is made by varying the density of the dots and therefore the amount of white paper showing around them.

If a sheet of paper is placed over a firm textured surface, such as floorboards or a metal grill, and a soft drawing

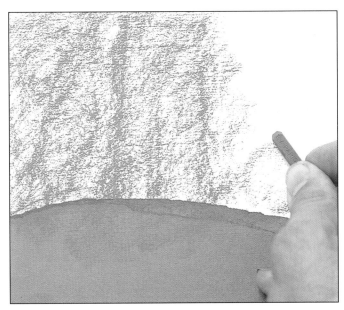

▲

To work up to an edge with an area of tone and give that edge a distinct quality, a piece of paper torn or cut to shape can be placed on the drawing to act as a mask. Holding the mask carefully so that it does not slip, the drawing medium—in this case a sanguine conté stick—is worked over the desired area and the edge of the mask.

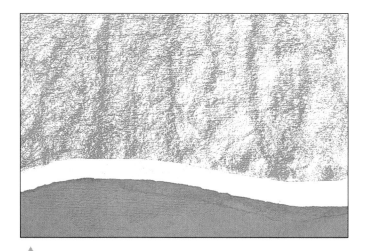

When the mask is removed you will be left with a line that is difficult to achieve by other means.

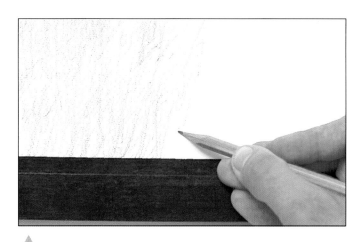

With harder drawing materials such as pencils and graphite sticks that tend to have a point, a similar result can be achieved by using a thicker material, such as a piece of card or a ruler, as a mask.

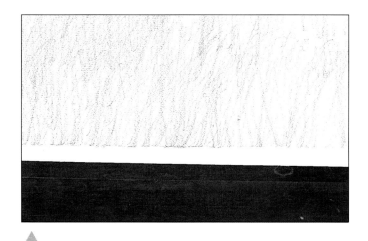

The mask needs to be thick because the point tends to catch on thinner materials, pulling them up or even tearing them.

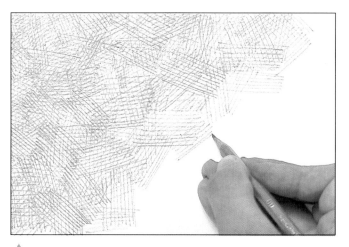

A sharp pencil hatches and cross-hatches beautifully; a mix of hard and soft grades produces a full range of tones from an almost imperceptible light gray to deep black. While it is possible to get a range of tone with a single pencil by pressing harder, do not try to get a dark tone with the hard pencil—you will only succeed in making deep indentations. If you require a darker tone choose a softer grade pencil.

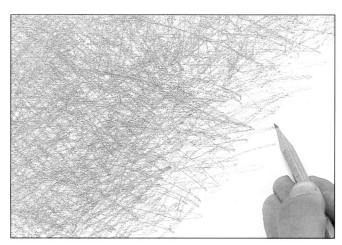

Scribbling with a pencil is a quick way of laying down an area of tone or texture. As with charcoal you will find that holding the pencil higher up the shaft will enable you to achieve a lighter, uniform tone, while holding the pencil further down—closer to the point—will enable you to apply greater pressure and so make darker marks. Remember to vary the direction of your strokes.

Graphite powder is sprinkled on to the surface sparingly and then blended and rubbed into the surface with a finger or soft cloth. Any excess powder can be tipped back into the jar. The depth of tone achievable is limited, and the powder, once spread, does have a

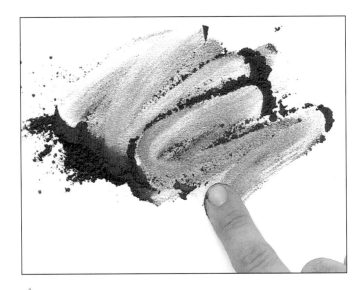

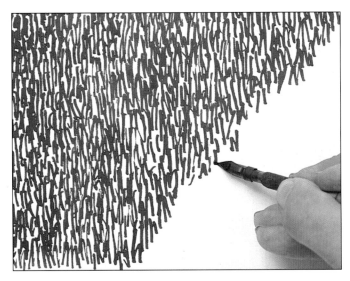

tendency to look flat. To achieve darker tones you will have to fix one layer and then overlay another; detail can be drawn with a torchon dipped into the powder. The secret is to work loosely and use the technique in conjunction with others. Keep the surface alive with soft-pencil work and work into it with the eraser; this will have to be done before the work is fixed. Fix well once the powder has been used, as, like charcoal, it will smudge off on to anything that rubs against it.

Calligraphy nibs give a greater range of thickness to line than standard dip pen nibs. Drawings can be made using a single nib that, because of its shape, is able to produce a single line of varying thickness. This is accomplished not by pressure but by altering the angle of the nib to the paper. While not as versatile as the standard nib, a calligraphy nib could be put to good use in conjunction with a standard nib to give a drawing a greater range of line quality.

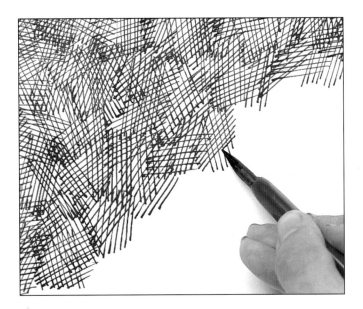

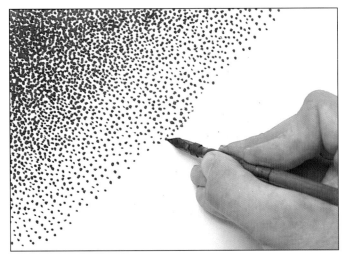

The dip pen is essentially a tool for making lines; cross-hatching in ink is crisp, and when handled well can be very effective. A single nib can produce hatching with lines of a regular thickness, tone being suggested by their density; by applying more pressure the lines can be made to vary in thickness. Alternatively you can change to a thicker or thinner nib to give the line produced greater variety.

Uniform black dots placed close together appear darker than those placed further apart: the principle is the same as cross-hatching. The process is slow and can look mechanical but is capable of achieving very gradual gradations across the tonal scale. Be careful not to make a blot as this will spoil the subtle effect. Any nib can be used: here the particular shape of a calligraphy nib gives a precise dot. Technical pens and fine liners are an ideal choice for dot drawings. These are available in a range of nib sizes and deliver a steady flow of ink that will not blob.

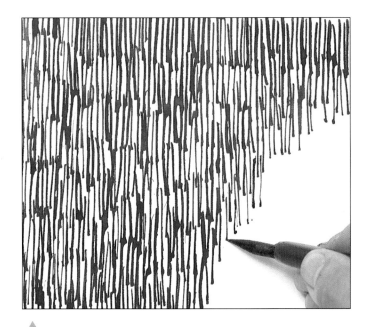

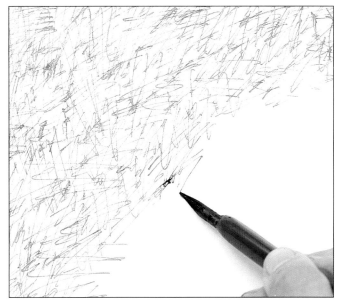

Hatching with a dip pen can be done in any direction to describe form texture and tone. As with other dip pen techniques line variety is brought about by pressure, line density and thickness suggesting tone. The technique is quick to do but requires care and thought, as a drawing produced with lines hatched in one direction only can look lop-sided, as the eye is drawn in the direction that the hatched lines are running.

Scribbling with a dip pen can take some getting used to. Tone can be built up in the same way as cross-hatching; although the principle is the same, the finished effect has a more spontaneous and lively look. The ink can be diluted with water to give a gray rather than a black line, as shown here. Diluting the ink alters its viscosity, making it thinner and more prone to run from the nib, so add the dilute ink to the nib with a brush, a little at a time.

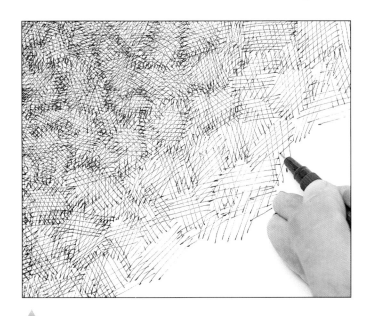

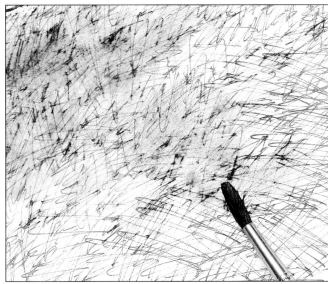

Cross-hatching with a fine liner or technical pen gives a uniform line thickness and can look mechanical and flat; however, because the nib is thin and the flow of ink steady, the results can be very subtle. You cannot change the thickness of the line by pressure, so if you require variety in the thickness of your line you will need a range of pens with nibs of varying sizes.

If non-waterproof ink has been used, brushing over the work with clean water when it is dry will dissolve the ink, making it possible to lighten pen work, soften lines and modify tones. The drawing can be overworked again with pen and the process repeated. Make sure the drawing is completely dry before working in layers, or the pen will stick into and pull at

the fibers of the paper. Interesting and useful effects can be achieved by using a mixture of waterproof and non-waterproof inks in layers. When water, dilute ink, or watercolor is brushed on, the dry waterproof ink will stay stable and any lines crisp.

pencil. Using the pencil on its side enables large expanses of tone to be blocked in very quickly. They are the ideal sketching tool when speed is needed to capture the moment.

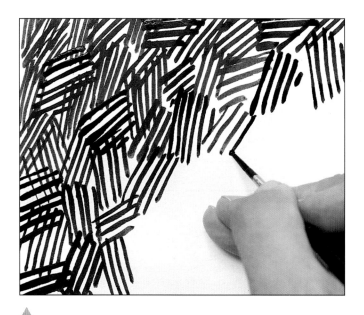

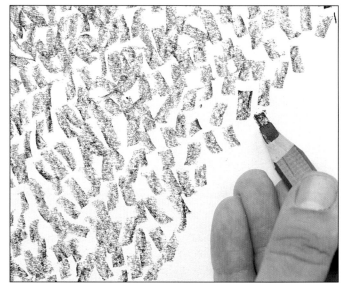

Lines can be drawn with a brush of any thickness; soft watercolor brushes are ideal but you can also try larger bristle brushes—the trick is to work confidently. Hesitant work will show in the quality of the marks. Take care not to smudge your drawing: the ink, when applied thickly from a brush, can take hours to dry. You can dilute the ink with water to give a lighter, more subtle line.

Studio pencils and graphite sticks can lay in areas of tone faster than the standard pencil because of the flattened strip. Here short, broad marks using the full width of the pencil are made. However, by turning the pencil on its side (so that the narrowest part of the point is in contact with the paper), you alter the angle at which the graphite strip comes into contact with the paper, thus varying the width of the mark.

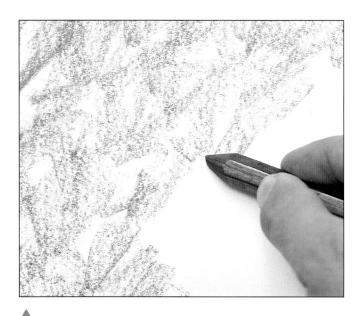

The shape of a graphite pencil allows for a wider range of marks to be made than is possible with an ordinary

A HOUSEPLANT

Pencil

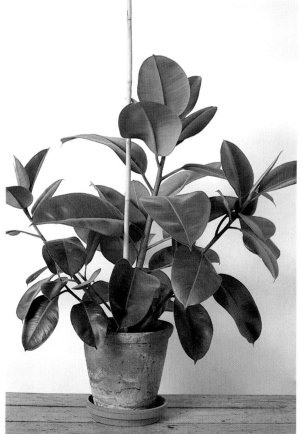

REGARDLESS OF THE size at which you choose to work, and regardless of the medium you choose, the ability to draw accurately relies on being able to assess proportion, position and structure correctly. By using a combination of measurement and vertical and horizontal plumb lines, and by reading negative space correctly, the position and structure of your subject can be transferred to your drawing. The details can be addressed later—the correct shape of objects and their relationship to each other must come first.

The distance between two points can be measured by holding a pencil at arm's length, closing one eye and sighting along the outstretched arm, past the pencil and on to the subject. The top, or end, of the pencil is visually positioned against one point on the subject (for example, the top of the plant pot); the thumb is then moved up the shaft of the pencil to mark the other point (for example the base of the plant pot), thus giving a unit of measurement. Then, keeping the thumb in the same position, the pencil is held against

the paper and the measurement marked off.

These measured points are usually placed where a line changes direction or is intersected by another line. By taking just a few preliminary measurements in this way you can plot and position your drawing on the paper and check for accuracy as it develops. If you decide to work on a smaller or larger scale then the unit of measurement indicated on the drawing is adjusted accordingly: by doubling the unit the drawn image will be twice the size; by halving the unit of measurement the drawing will be half the size. The important thing is to keep your measurements, calculations and position they are taken from consistent. Plumb lines dropped vertically and lines run across the drawing horizontally, when used together with measuring, help position objects and elements relative to one another.

Negative spaces are those spaces or shapes that surround the positive forms or objects that you are drawing. Logic will tell you that getting the negative shapes right means the positive shapes are also right; the way they relate is critical and a good means of judging the accuracy of your drawing. Negatives also play an important role in composition, acting as a balance to the positive, more obvious shapes.

A rubber plant is the perfect subject to practice measuring and accuracy. The leaves are large and relatively simple in shape, giving good negative spaces around and between. Work with a HB or softer pencil on a sheet of medium weight A2 cartridge paper secured to a drawing board and held vertically on an easel or propped up on a chair. Position the easel so you only need to turn slightly to face your subject.

MATERIALS AND EQUIPMENT

Sheet of paper
Craft knife
HB pencil
Putty eraser

The Drawing

1 To find a convenient unit of measurement, hold your pencil upright at arm's length, close one eye and look past the pencil to the plant. In this case the measurement used is the distance between the first and second notches on the bamboo stake. Applying this unit of measurement, it is calculated that from the first notch on the stake to the bottom of the flower pot is four-and-a-half units, and that from the outer leaf on one side across the plant to the other side is three-and-a-half units.

2 Conveniently, the bamboo stake is more or less vertical, so a line representing the position of the stake is dropped down the sheet of paper slightly off-center. Against this, beginning a little away from the top edge of the paper, the four-and-a-half units giving the height of the plant and pot are marked. Half way down the vertical line a horizontal line is drawn; against this the three-and-a-half units of measurement are marked— one-and-a-half units on one side of the vertical and two units on the other side of the vertical, giving the width of the plant and indicating that the major part of the plant falls on the side that measures two units.

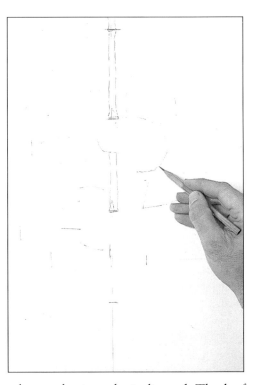

3 With the overall proportions plotted, and in the knowledge that all of the plant will fit on to the paper, the top of the bamboo stake is drawn disappearing off the top of the sheet of paper, and the position of the leaves relative to the stake can begin to be indicated. The leaf positions are measured and plotted in the same way as the overall position of the plant, by using the pencil to measure distances and transferring those measurements on to the drawing. Mark the measurements lightly if you do not want them to show when the drawing is complete; however, these marks can add interest to a drawing, showing, as they do, how it was constructed.

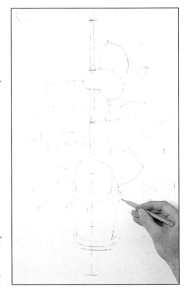

4 As the drawing progresses, the job does become relatively easier, as there is more of a drawn image to which you can relate your new measurements. Where a line runs at an angle the position of the line is calculated by taking horizontal and vertical measurements that mark the position of each end of the line. The two marks are then joined, giving the correct angle.

5 When a framework of relative positions is established the drawing process becomes freer; the position of lines and the point at which they intersect other lines can be calculated visually without the need to take measurements. An awareness of the negative shapes between and around the leaves will enable you to check the drawing for accuracy.

6 The shape of the plant has been described so far in line only: we have concentrated on getting the proportion and position right. The angles and internal contours are now hinted at by working into the leaves with line, indicating the veins and ridges. These help us read the direction and way the leaves hang from the main stem. These internal contour lines combine with the outline drawing to give the plant form.

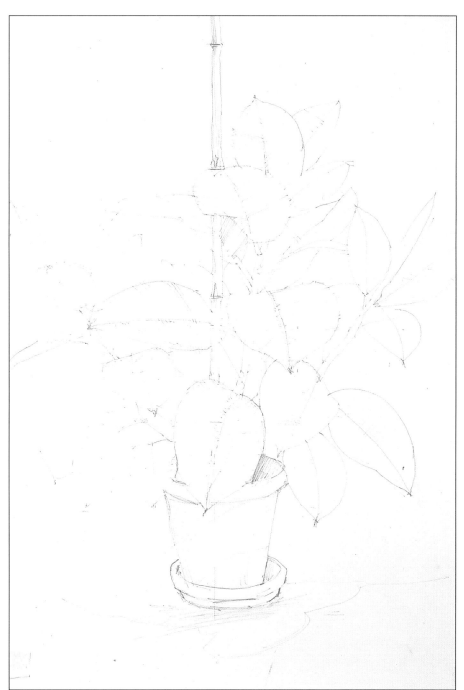

7 The simple drawing is completed with a little loose dark shading on the inside of the flower pot, which helps to push forward the large leaf that is hanging in front, and hints at the pot's roundness. A few lines run down one side of the cane serves the same purpose, helping the viewer read it as a round, three-dimensional, shape rather than as a flat, two-dimensional shape.

Alternative Approaches

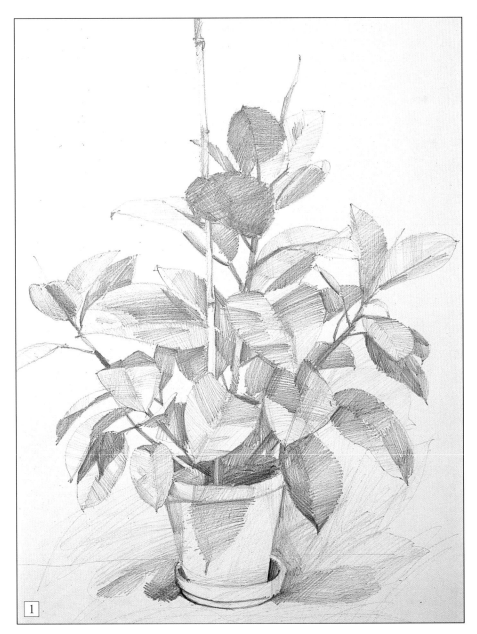

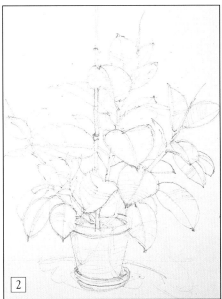

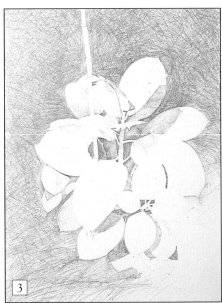

1 Once the structure and shape of the plant were established in light pencil, tone was hatched and scribbled, giving the plant form and dimension. The shading is simple, lively and directional, following the planes of the leaves and suggesting their angle and position relative to each other.

2 In this drawing a soft graphite pencil was used to explore and search out the shape and contours of the plant. Once a few guidelines had been indicated to keep the drawing on track the pencil was kept moving over the surface of the paper, defining and redefining the shapes, working in and around them. This approach gives the drawing a fluid, lyrical quality.

3 By changing the viewpoint and looking down on the plant the pot disappears and the leaves become larger, flatter shapes. By concentrating on the dark, negative spaces between and around the leaves they are made to stand out from the background, reaching up and out to the viewer. The scribbled tone over the background, while being a fairly uniform large area, is broken and multi-directional, creating an interesting texture.

FRUIT AND VEGETABLES

Pencil

PROJECT TWO

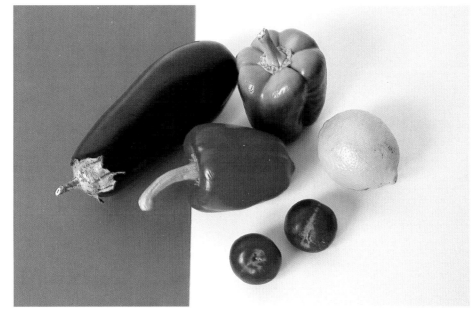

IT IS THE light that falls on to an object that enables us to see that object as a form in three dimensions. That side of an object facing the light source will be the lightest, while the side farthest away or hidden from the light source will be the darkest. To draw an object so that it appears to be three dimensional we need to show these light and dark areas.

This graduation from light to dark is known as a tonal or achromatic scale. The scale runs from white through all the possible shades of gray to black. The principle is simple: putting it into practice can be a little more difficult, as the following exercise illustrates.

With a pencil, draw a circle on a sheet of paper. The circle is all that you see, but if you then work from one side of the circle to the other, scribbling on tone that gets progressively darker as you move across the circle, it will begin to look like a ball or a sphere.

The scribbled shading or tone has suggested the form.

Tone is also used to suggest color. Draw a pair of circles side-by-side on a sheet of paper. Imagine one is a bright yellow ball and the other a dark blue ball. The overall tone you need to use to suggest the color of the blue ball will be much darker than the overall tone needed for the yellow ball.

Assessing and separating tonal values can be difficult because they are affected and influenced by color, pattern, texture, and the changing intensity or direction of the light source. Looking at your subject through half-closed eyes can help, as this visually simplifies and exaggerates the play of light and shade on the subject—so simplifying and reducing the range of perceived tones.

It is not always necessary or even advisable to try and represent the complete range of tones: an object can be made to look three-dimensional by using only a very dark, a mid and a very light gray tone.

For this project a selection of different shaped colored fruit and vegetables are used to explore the effects of light on color and form. The small still life is set up on a sheet of white paper, with a second sheet of red paper positioned about one-third of the way across. The colored paper serves as an aid to composition, breaking up and adding interest behind the group. Work on an A3 sheet of medium-weight cartridge paper using a 2B pencil. You will need a putty eraser for highlighting and for correcting tone that you consider to be too dark.

MATERIALS AND EQUIPMENT

Sheet of medium-
weight paper
Craft knife
2B pencil
Putty eraser
Ruler

The Drawing

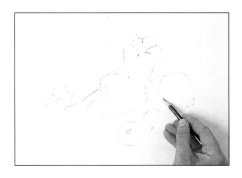

1 Using a 2B pencil establish the position of the eggplant and the two bell peppers. The position of the red sheet of paper is indicated where it intersects the top of the eggplant. A little tone is scribbled loosely to indicate the edge of the pepper against the dark eggplant. This has the immediate effect of placing the bell pepper at the front of the group.

2 The line representing the edge of the dark sheet of paper is continued down from the front pepper. The two plums are positioned at the front of the group before lightly sketching in the lemon on the right.

3 Check that everything is positioned correctly and make any adjustments. Scribble on a mid tone to indicate which part of the object is darkest and begin to give some hint of its overall color. Simple, directional shading helps suggest the planes or surface direction of the objects.

4 The tone representing the color of the dark red sheet of paper begins to be built up with multidirectional scribbling. Work around the eggplant and bell pepper, allowing the scribbled tone to redefine their edge.

5 The drawing is now blocked in with tone so that the objects are beginning to appear three-dimensional, but the tones are all in the mid range. The tonal values need to be stretched and beefed up. Remember, it is always easier to darken a tone by working over it with pencil than it is to lighten one by using the eraser. To prevent the drawing from smudging as you work, and the side of your hand from becoming marked with graphite, rest your hand on a sheet of clean paper placed over the drawing.

6 The dark, almost black, tone of the eggplant is scribbled in. all other tones will be made relative to this. Marks on the drawing board can sometimes show through when working hard and dark in this way, but you can avoid this by placing an extra sheet or two of paper beneath the sheet on which you are working.

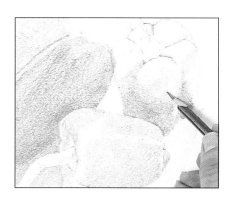

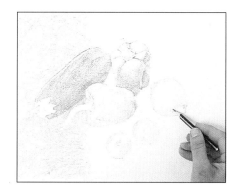

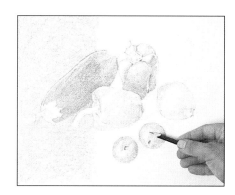

7 Work over the bell peppers, darkening and modifying the complex tones and balancing their depth and intensity against that of the eggplant. Notice how the shadow on the green pepper at the back is as dark in tone as the purple eggplant.

8 The lemon on the right is the lightest object in the group, but it is still considerably darker than the white surface on which it is sitting. The lines outlining the lemon are made to disappear by working the tone right up to them.

9 The plums are worked on next. Work the tone around the surface, allowing the white paper to show through in order to suggest the reflected highlight.

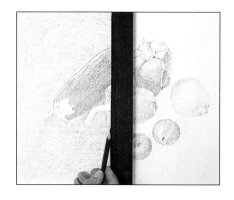

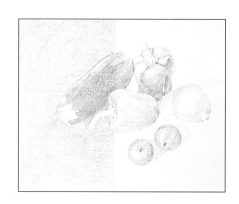

10 The dark red paper needs to be darker and the edge crisper. This is done by placing a ruler on the drawing so it can be used as a mask, and scribbling right up to it with the pencil.

11 The highlights are lightened and the background around the shadows cleaned using the putty eraser.

12 The scribbled shading successfully shows the form, mass, and volume of the objects, hints at the differences in their color, and also describes the smoothness of the eggplant and bell peppers and the subtle, pitted texture of the lemon. The dark sheet of paper placed behind the eggplant balances the large area of white on which the rest of the group is placed.

Alternative Approaches

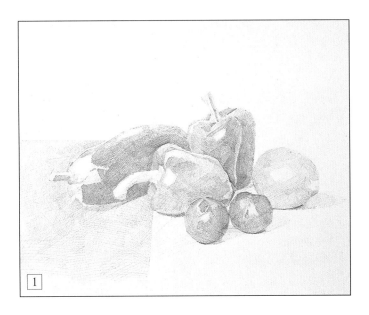

1 The viewpoint has been changed but the composition and the position of the group remain the same. Using controlled cross-hatching made with a single sharp HB pencil, the tones are gradually built up until their values work in relation to each other. The lightest areas are covered with almost imperceptible light hatching, while the darkest areas are layered with heavier, denser cross-hatching.

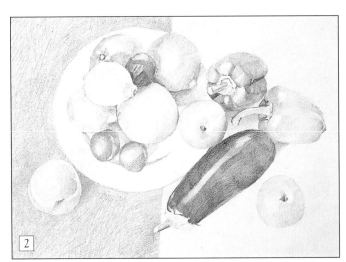

2 The still life is elaborated with more fruit, which is piled on to a white plate. The sheet of red paper is used again, but this time it is positioned so that it dissects the composition almost in half. Because the dark paper runs underneath the plate it defines the plate's white shape and throws it forward. The composition works because the dark mass of the paper is balanced by the dark of the eggplant and bell peppers on the right. The unusual viewpoint serves to give the drawing an almost abstract quality.

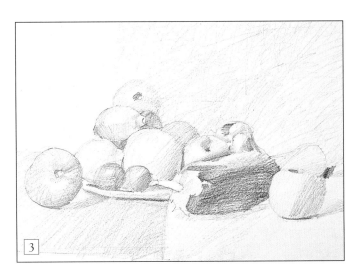

3 A composition similar to the above is given a much looser and faster treatment using a very soft 6B graphite stick. The forms, this time viewed from the side, are treated simply with scribbled tone helping them to read as round, solid objects. An area of tone has been added partway across the background, acting as a compositional device to add interest and balance to the top half of the drawing.

MONT ST MICHEL

Graphite

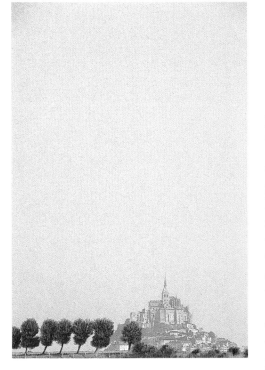

COMBINING A NUMBER OF different techniques in a single drawing opens up exciting possibilities. Drawings that are executed using one technique alone, while often being competent drawings, can look tired. These flat or weary-looking pictures can be perked up by introducing new or different marks, or by working over and into the drawing with a different medium, but the simplest answer is not to allow your drawings to become dull and jaded in the first place.

Some media are better suited than others for making a wide and varied range of marks. The humble pencil is one of these, as is its close but more versatile and flexible cousin the graphite stick. When used with graphite powder the graphite stick can produce stimulating, rich drawings containing a wealth of exciting marks and techniques.

Graphite is a quick medium. Its nature and characteristics seem to encourage the artist to work with some urgency, which, if working from the landscape, or *en plein air*, is no bad thing, given the often capricious nature of the weather. The landscape—and the weather, which has an immediate effect on it—are infinitely variable, providing the artist with an ideal opportunity to

practice with the mark-making capabilities of a medium.

A well-chosen position from which to work can make the difference between a successful and a less successful drawing. Bear in mind that a very small shift in viewpoint can considerably alter the scene in front of you. When choosing a place to work, always try to look for the unusual.

Clever use of composition and the illusion of depth through the utilization of atmospheric or aerial perspective are two important considerations. Composition is about visually balancing all the elements within your picture. Color, space, scale, form and texture all play a part and can be used to compose and structure your drawing.

Various formulae exist for composition, based on precise mathematical calculations that divide the picture area up into an idea, underlying grid on which to work. Perhaps the best known of these is the golden section. A simple, yet alternative, method of balancing your drawing is to divide the picture area approximately into thirds. First draw a rectangle on a sheet of paper, then divide the rectangle horizontally and vertically into thirds by drawing lines across the rectangle to mark the position of the divisions. This will give you a basic grid. The theory is that by positioning important elements or focal points on or about these dividing lines, or at the four points where the lines intersect each other, gives a satisfying arrangement.

The rule works, but rules, as we know, are made to be broken. A useful aid to composition can be made by taking a smallish rectangular sheet of card and cutting a slightly smaller rectangle from the center. Stretch four elastic bands over the card, two across the horizontal and two across the vertical, thus dividing the rectangular hole you cut into thirds. The grid that is formed can be held up as a viewfinder, and will assist you in making decisions on composition and format.

MATERIALS AND EQUIPMENT

Sheet of medium-weight
Graphite powder
Stanley knife or craft knife
4B pencil
Putty eraser, plastic or rubber eraser

The use of aerial perspective helps solve the problems that can occur when trying to give depth to a drawing. As a rule, because of the effects of atmosphere, tone, and color will become lighter the farther away they are from the onlooker. Distant objects also appear smaller and less well-defined than those which are close to; close objects therefore appear to be in sharper focus, darker in color and tone and larger. The view of Mont St Michel in Brittany illustrates these two principles of composition and perspective. The subject is a simple one, with—on first sight—little with which to work.

For your drawing, use an A2 sheet of medium-weight cartridge paper with a 4B graphite stick and graphite powder. Various erasers are needed to draw into the powder, and fixative to prevent smudging.

The Drawing

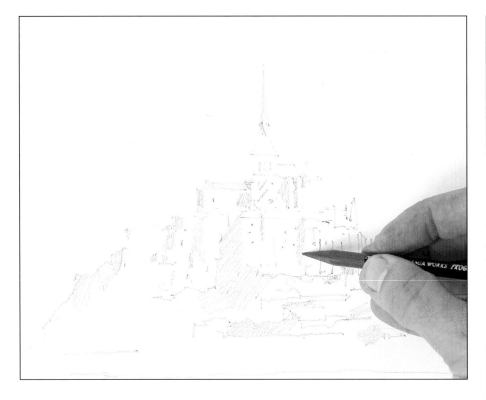

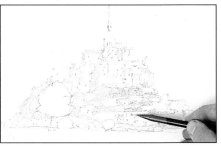

1 Using the 4B graphite pencil the subject is positioned on the sheet of paper about a third of the way in from the right-hand side, and just below the halfway point from the bottom. The buildings are drawn in lightly: being in the distance they are indistinct and pale in tone. The graphite pencil can make a dense black, so work carefully, with just enough pressure to make a mark. This will be easier if you hold the pencil loosely and not too near the point.

2 The buildings and trees on the mount are elaborated. A few windows and other details are indicated. Below, but in front of the mount in the middle distance, the row of trees and bushes running off to the left-hand side of the drawing are sketched in.

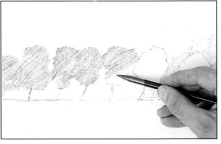

3 The foliage on the trees is loosely scribbled in. As you draw, turn the pencil between the fingers to retain the point. The trees must be darker than the buildings and the mount in the distance. This makes them appear to sit in front of the distant abbey, occupying their correct position in the middle distance.

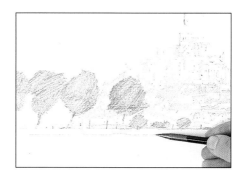

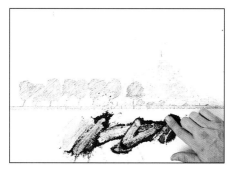

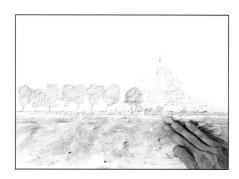

4 The bank of grass below the trees is drawn next and blocked in with scribbled tone. Broken fence posts and a few bushes are indicated.

5 With the drawing lying flat, a little graphite powder is tipped on to the lower part of the drawing. Be careful not to pour out too much: you may find it easier to control if you remove powder from the jar with a spoon or palette knife. Spread the powder out across the area to be covered by using a finger, or, if you prefer, a piece of tissue or torchon. Any excess powder can be poured back into the jar.

6 Make sure your hands and fingers are dry, and without pressing too hard, rub the powder into the paper. Don't worry if the result looks a little uneven.

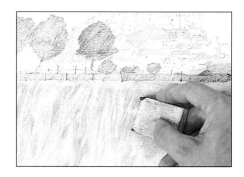

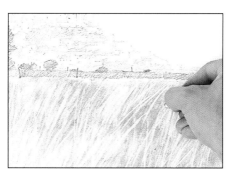

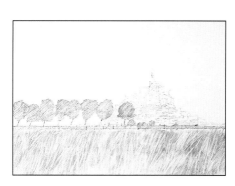

7 With the putty eraser, work into the powder, pulling it off in lines to represent an overgrown field of grass or a crop of cereal. The eraser will get dirty very quickly and will then start to smear the graphite rather than remove it. Cut off a slice of the eraser with a sharp knife to get a new clean edge.

8 Finer, thinner marks can be made by slicing a harder plastic or rubber eraser at a sharp angle. Again, once the eraser is covered with graphite it will cease to work and will need recutting.

9 The finished drawing is a balanced composition, alive with a variety of marks. The foreground could easily be worked into further with soft graphite sticks or, once the drawing has been fixed, worked over with more powder. As it was a clear day the sky has been left as white paper, but powder could be used there too, gradually lightening it as the horizon or distance is approached. An alternative is to work with the eraser, cutting out dramatic cloud formations.

Alternative Approaches

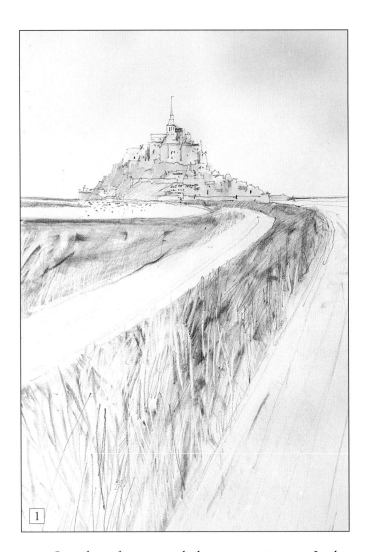

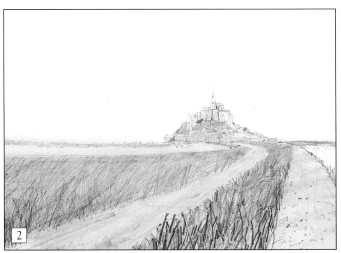

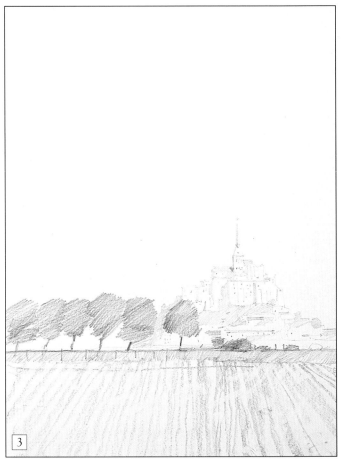

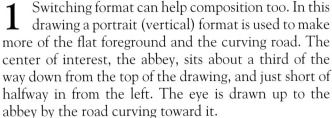

1 Switching format can help composition too. In this drawing a portrait (vertical) format is used to make more of the flat foreground and the curving road. The center of interest, the abbey, sits about a third of the way down from the top of the drawing, and just short of halfway in from the left. The eye is drawn up to the abbey by the road curving toward it.

2 Breaking rules when drawing and painting is all part of the fun. Here the line of the horizon runs straight across the middle of the drawing. The mount sits on the horizon just off center jutting up into the sky. Balance is achieved with tone and texture. The foreground is heavily worked, while the sky is plain white paper. The on-looker's eye is taken to the lower half of the drawing by the depth of tone and the texture, but then, again, is immediately taken back to the abbey by the road curving toward it.

3 Here a vast expanse of featureless sky balances the buildings, trees and field at the bottom. The abbey spire lures the eye up to the heavens, but it falls back to earth, pulled by the interest below. Again, the attention is focused on the row of trees and the abbey, all sitting on a line a third of the way up the drawing.

A YOUNG GIRL

Charcoal

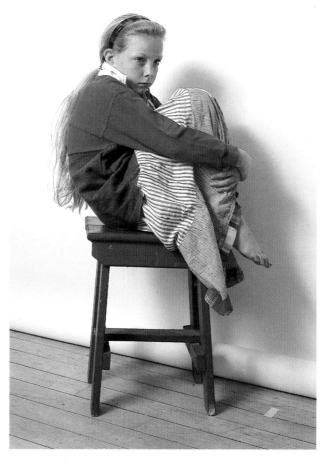

WHILE IT IS PERFECTLY possible to work at any scale with any medium, and in any style, with certain media more than others there does seem to be an optimum size. Charcoal is a case in point. At best, working small can be difficult, and you will find yourself unable to use to the full the many qualities and characteristics of the media.

Charcoal has long been favored as a medium for teaching drawing, as its very nature forces a broader approach that precludes becoming too involved in details. Laying down tone in charcoal is fast and easy, and it is happily married with a host of other media. However, the real beauty of charcoal comes from its ability to create a dark, sensual line that is quick to produce, one that can easily be varied in thickness and intensity. Any unfixed marks can simply be dusted off, making corrections and erasing an easy matter. Charcoal will smudge if brushed against, so drawing should be done with the hand kept free of the paper surface, and only the charcoal coming into contact with it. This gives looser, flowing stokes that result from using the whole arm rather than just the wrist.

Lines in the wrong place or of the wrong thickness are inevitable. A flick of a soft rag and all that is left is a ghost of an image, which remains as a useful guide for making your correction.

Work with a sheet of paper secured to a drawing board held vertically on an easel or propped against a chair. Standing makes moving easier and so the marks made with the charcoal will appear less restrained and more fluid.

This project demonstrates that matching the subject to the medium can pay dividends. The girl was dressed specifically for the type of drawings that were planned: the shirt and dress are full of linear patterns that give a clue to the form beneath; this, together with long hair falling down her back, presents a perfect subject for the graceful, confident lines that can be made with a stick of charcoal. A thick and a thin stick of medium charcoal were used on a sheet of 140 lb Not surface watercolor paper.

MATERIALS AND EQUIPMENT

28 x 21 in. (71 x 53 cm) sheet of 140 lb Not watercolor paper Medium sticks of charcoal, thick and thin

The Drawing

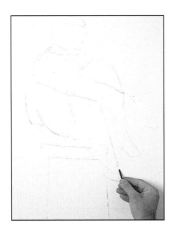

1 A few preliminary measurements were made and the overall shapes of the figure and stool sketched in lightly. The shapes suggest a triangle sitting on an upright rectangle. Draw in the approximate directions of the arm, the fall of the hair and the curve of the head. Hold the charcoal high up to encourage a light line.

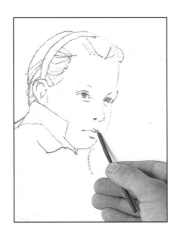

2 Working without too much pressure, draw in the shape of the head and the features. Pay particular attention to the angle of the eyes, nose, and mouth relative to the angle of the head.

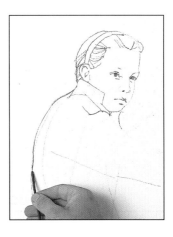

3 Working in fluid lines of varying thickness, sketch in the hair using the light construction lines as a guide.

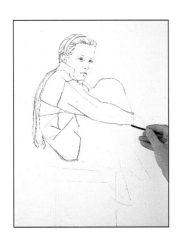

4 Work around the torso, describing the contours of the shirt. Use the seams, the change in pattern and the lines created by the folds of the cloth to help describe the form. Describe the arc of the dress lying taut across the knees, and the upper and lower edge of the sleeve. Indicate the fall of the skirt down the front of the leg.

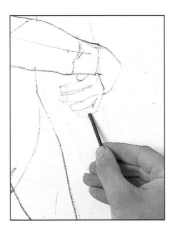

5 The fingers of the hand are drawn lightly, curving around and holding on to the leg. Try to vary the line thickness to give a suggestion of light and shade. Notice how the line describing the uppermost hand is thicker and darker where it rests across the other hand.

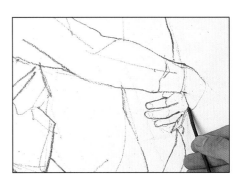

6 Once the hand is drawn correctly in light charcoal it can be redrawn using more pressure to produce a darker line.

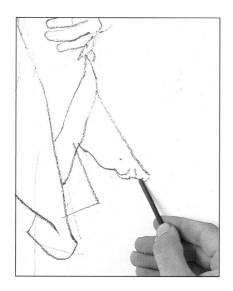

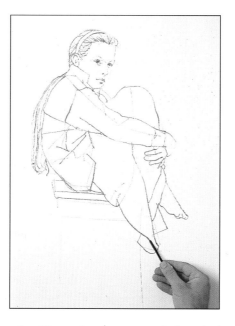

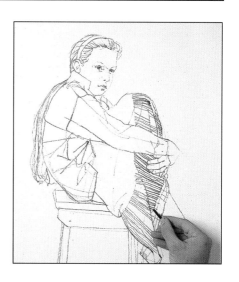

7 Feet are notoriously difficult to draw convincingly; the simpler the treatment the better. Try describing them with as few lines as possible. Here the top of the foot is almost straight with a slight bump at the end. The bottom of the foot curls around into the little toe. The position of the other toes are merely hinted at.

8 Draw in the seat of the chair and finish the flowing line of the dress. Indicating the line of a few creases helps the dress to hang from the body.

9 The legs of the chair are drawn and the hair falling down the child's back is reworked, drawing a few long, light lines. Lines of shadow and folds of material are redefined on the shirt, and the lines of the pattern are stroked in on the skirt using more pressure to make a darker mark.

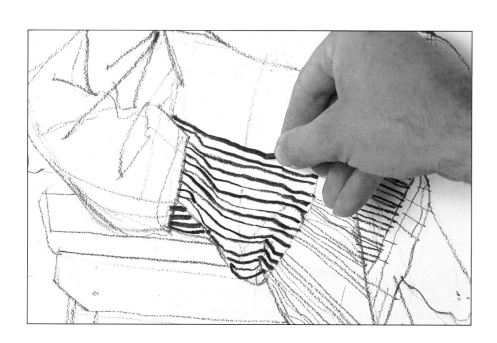

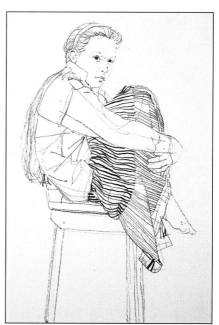

10 With a thicker piece of charcoal held close to the end, draw the rest of the pattern lines, following and using the contours and folds of the dress as a guide. Draw with a dark line; if the pressure shatters the stick of charcoal, simply break the end square and carry on.

11 Complete the pattern on the dress and make adjustments to the hair and skirt folds. The finished drawing shows how variety in the quality of line can successfully describe pattern, direction, light and shade, and thus form.

Alternative Approaches

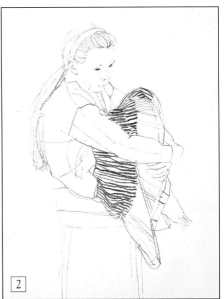

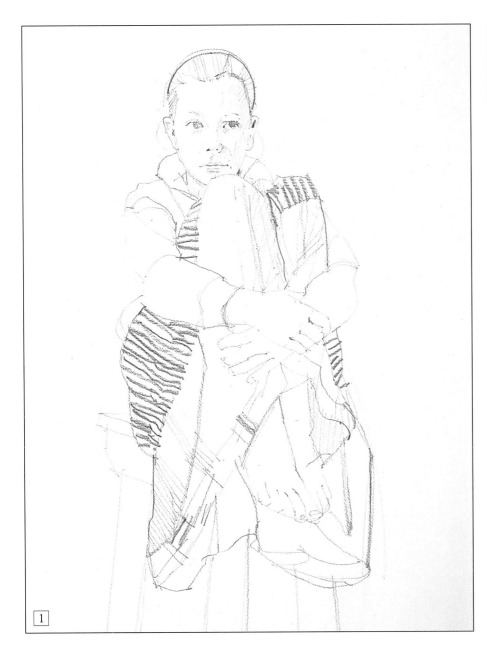

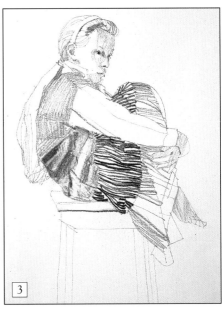

1 This drawing has been done with a sharpened stick of black conté. The quality of the line is lighter and more subtle than the charcoal. Conté sticks can be difficult to erase so by working lightly mistakes can simply be corrected and redrawn and will not be too glaringly obvious in the finished work. Once the drawing looks right it can be redrawn using a darker line. The pattern on the skirt was drawn using the blunt square end of the stick.

2 Changing the viewpoint gives the drawing a little more depth. This is because the top of the head,

the curve of the shoulder, the skirt stretched over the knees, the top of the foot, and the seat of the stool are all visible. These planes or perspectives take us into the drawing.

3 Mixing media is always fun and the results sometimes surprising. Here the figure has been drawn with a mixture of black and sanguine conté, charcoal, and white chalk. The sanguine was used for the skin and the hair, and gave color to the shirt and the pattern on the skirt. The heavy dark of the charcoal completes the pattern and the bottom of the shirt.

HAT, COAT, AND BAG

Charcoal and White Chalk

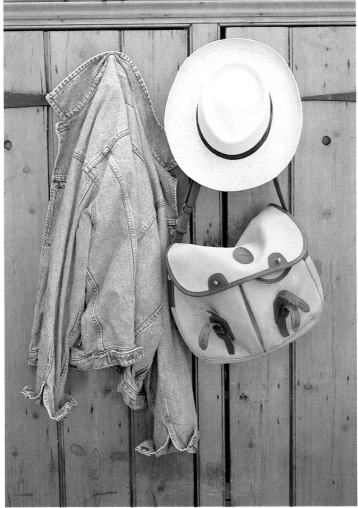

THE QUALITIES that are to be found in many monochromatic (single color) drawings can be extended further by working on toned or tinted paper. Charcoal, because of its density and strength, is the perfect medium for this traditional technique, because when working tonally on a white ground it can be difficult to judge the strength of the tones against the white of the support. Draw a line of charcoal on a sheet of white paper and another line—using equal pressure—on a sheet of tinted paper, and you will notice how much darker the mark reads on the white sheet.

Another traditional way of working is to establish the mid tones first, then judge the density of the lights and darks against them. By choosing a mid-tone paper the charcoal is used to give the mid to dark tones and white chalk or conté is used to pull out the lighter tones. The paper will show through your drawing, giving an overall sense of harmony. You can work on paper of any color, but a more satisfactory result will be achieved if the tones and colors used are chosen from the many neutral greys, browns, and ochers available from the various manufacturers.

Deciding what to draw is often a real problem for the beginner, yet the fact is, everything can be seen as a subject. However what inspires and excites one person to reach for their drawing materials will do nothing for another.

Suitable subjects are all around and we don't need to look far to find one. Here a straw hat, denim jacket, and canvas bag made ideal subjects for a few hours' drawing. The drawing was made on a sheet of Ingres paper using thin willow charcoal, a thick stick of charcoal, white conté, a torchon, and a putty eraser.

MATERIALS AND EQUIPMENT

25 x 20 in.
(63.5 x 51 cm)
sheet of mid-gray
Ingres paper
Sticks of charcoal,
one thin willow
charcoal stick and
one stick of thick
charcoal
Two sticks of
white conté grades
HB and 2B
Torchon
Putty eraser

41

The Drawing

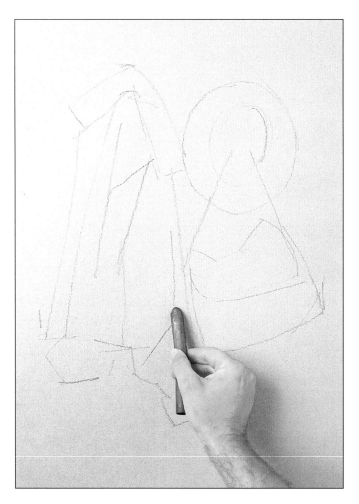

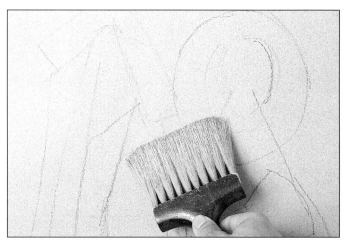

2 If the lines are a little dark lighten them by brushing over the drawing with a soft brush or by flicking a soft rag over the surface. Leave just the ghost of an image to act as a guide.

1 Position the hat, coat, and bag centrally in the paper. Work lightly with as few strokes as possible, keeping the shapes basic. Pay particular attention to the angles of the jacket collar and the slant of the bag. If you do make mistake, then simply reposition and redraw the line.

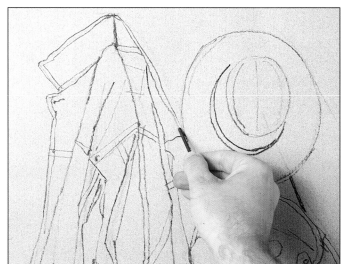

3 Once the subject has been positioned correctly you can begin to redraw with a thin stick of charcoal. Using the light drawing beneath as a guide, search out the folds and contours of the coat and bag. Pay particular attention to the oval shape of the hat and try to give the coat weight, so that it looks as if it is really hanging from a hook. The same applies to the bag; the dent in the top of the flap seems to suggest the bag has some weight. Once the drawing seems correct in line, it can be given a coat of fixative to prevent accidental smudges.

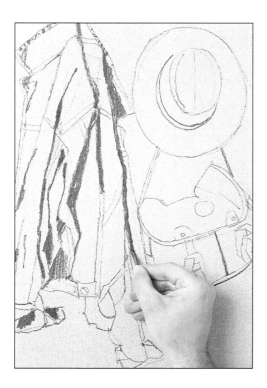

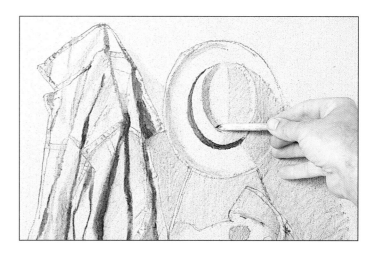

6 With the torchon, work over the drawing, blending and softening the dark charcoal. Pull and push tone over the paper surface. Pick up the charcoal dust on the torchon and use it to describe the detail in the seams of the jacket. Soften the shadows on the hat and smooth out the charcoal scribble on the wall.

4 With a thin stick of charcoal, loosely and boldly lay in the dark shadows that are found in the creases of the jacket.

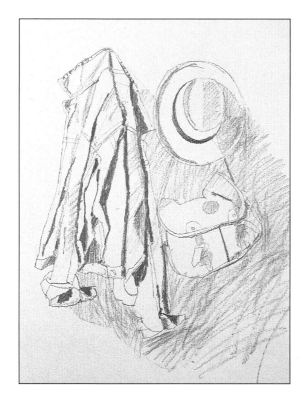

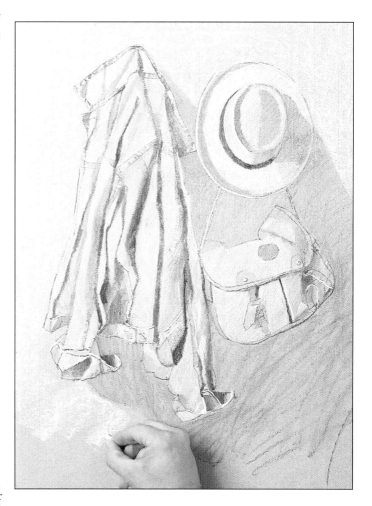

5 The dark of the hat band is laid on in the same way, and a dark definite shadow indicates the edge of the bag flap. The thicker stick of charcoal is then used to scribble loosely over the darker areas of the coat, the wall, the hat, and around the buckles of the bag.

7 The putty eraser is used to cut back into the charcoal, making corrections, lightening tone and redrawing the way the folds in the cloth fall.

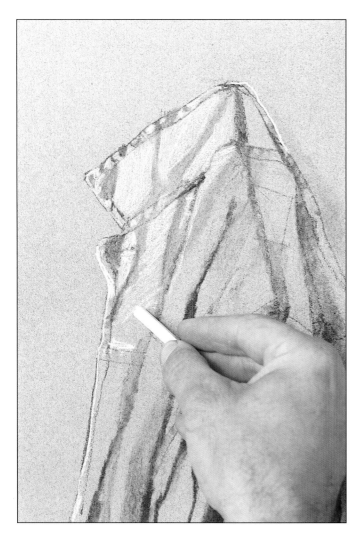

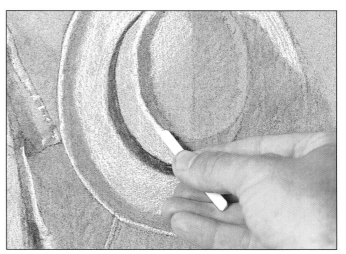

9 Move on to the hat. Lay in a flat, light, uniform tone around the brim and on the side toward the light. Holding the chalk close to the end press hard and draw a crisp line around the edge of the brim and around the top. Run a few light lines of chalk around the brim to suggest the weave of the straw.

8 With the HB stick of conté chalk hatch in the lighter tones on the jacket. Work around the darker tones, molding the material into folds and creases by highlighting with the chalk. Keep the hatching loose but controlled. The tight but visible lines of the hatching contrast with the softer blended areas of charcoal. They also suggest the weave of the material. Turn the chalk to get a sharp edge and run crisp light lines around the seams.

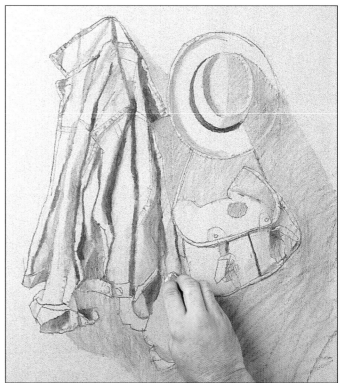

10 Light areas of tone are cross-hatched on to the top and front of the bag and crisp lines are drawn where the light catches the straps. Changing to the softer 2B crayon the background is laid in using the stick on its side to give a broad, flat stroke. Work carefully around the hat and jacket and cut in to define the shape of the shadow.

11 The torchon is used to blend the white chalk to give a uniform light tone across the background. For the flat open areas use your fingers or a clean rag. The edges of the jacket and hat are made sharper by working the chalk up close to make a clean line.

12 The drawing works tonally but looks a little flat, and could benefit from increasing the contrast between the lights and darks. The thick charcoal stick is used to darken in and around a few of the deeper folds on the jacket, and in the darkest area of shadow between the hat, coat, and bag.

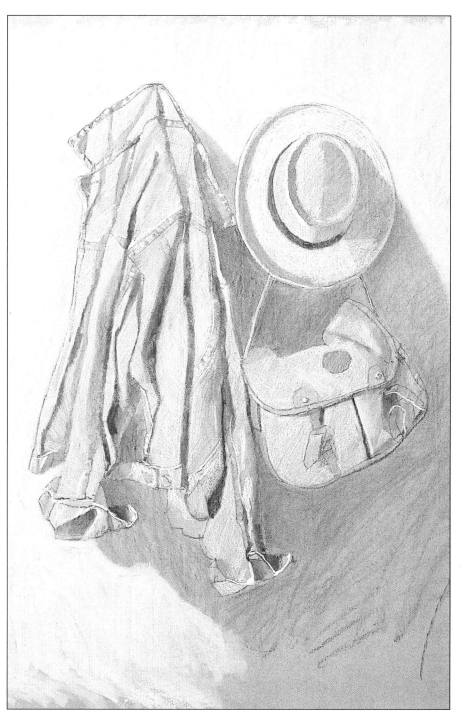

13 The finished drawing shows how the charcoal, chalk, and tinted paper work together, creating a wide range of tones that describe the forms, creating depth in the shadows and height on the top of the hat. The shadow anchors the subjects to the wall while the light hatching and the sharp white lines jump forward toward the viewer.

Alternative Approaches

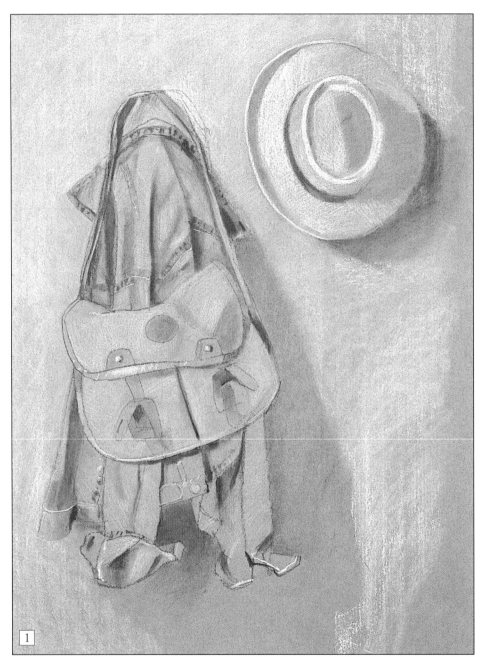

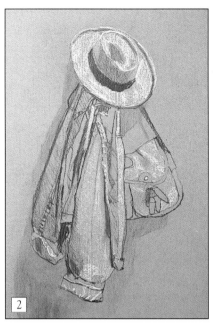

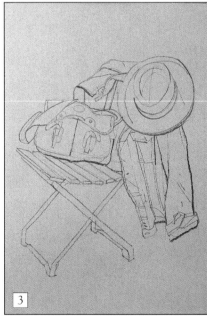

1 The composition has been changed so that the bag hangs on top of the jacket and the hat is off to one side by itself. This positioning suggests that, spatially, the bag sitting on top of the jacket is nearer the viewer than the hat, and we read it this way although the hat is lighter in tone and seems to be more prominent.

2 This drawing is much looser. It was done very quickly—in just a few minutes—while trying to decide on a pleasing arrangement, and was the first of the session. The range of tone is limited, with the white dominating, showing the direction of the light source. It is sometimes a good idea to do a so-called warm-up drawing; the fingers loosen up and the marks seem to flow easier after a few minutes scribbling.

3 Adding a fourth element, the chair, increases the possible compositions, and inspires a carefully constructed, more considered drawing in line only.

PORTRAIT

Conté Pencil

PROJECT SIX

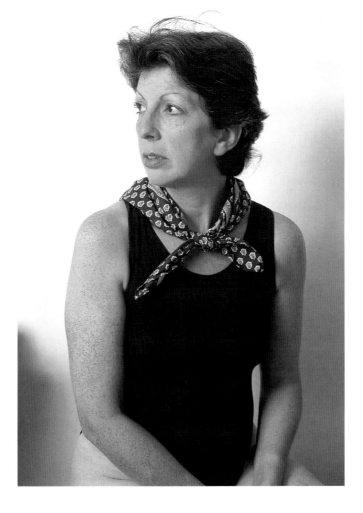

THE PORTRAIT HAS always been considered the most difficult subject for the artist—along with hands and feet, and closely followed by the human figure. When we objectively draw or paint most other things a certain degree of latitude seems to be acceptable. What does it matter if two or three trees are left out of a wooded landscape, or five instead of six oranges are drawn in a still life? In fact this visual editing of what we see and choose to put on paper should and does happen all the time, as artists use license to improve on composition and design. But draw a portrait wrong and the world and his wife seem to notice.

It was the American portrait painter John Singer Sargent who referred to portraits as "a likeness in which there is something wrong about the mouth." Approach portraits as you would any other subject: get the basic proportions right; plan and position the features relative to each other correctly; make them look as if they are sitting convincingly on a firm structure—and a likeness will inevitably follow.

A useful formula for estimating proportion for portraits is the rule of halves. Put simply, the eyes tend to sit on a line about halfway between the top of the head and the chin; the bottom of the nose on a line halfway between the eyes; and the base of the lower lip on a line halfway between the nose and the chin. Obviously this should act as a guide only: proportions differ from person to person, but it will help to establish the approximate position of the sitter's features.

Le trois crayon, the three crayons, is a traditional drawing technique seldom used today but capable of producing seductive drawings of great depth and beauty. The technique is a useful exercise in controlling tone. Working on a light- to mid-toned paper a black crayon supplies the dark areas, a red or sanguine the mid tones, and the white the highlights.

MATERIALS AND EQUIPMENT

20 x 14 in. (51 x 35.5 cm) sheet of cream-colored Ingres paper
Craft knife
Conté pencils, black, white, and sanguine or terracotta

47

The Drawing

1 With a sanguine pencil, and using light marks, establish the position and axis of the head. Work out the height and width by making a few preliminary measurements, paying particular attention to the way the head is turned. This is indicated by marking the apparent position of the center of the face—the imaginary line that, if the face is

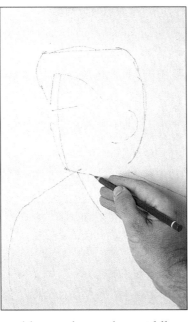

viewed from the front, would run down the middle between the eyes and the center of the nose. On this line indicate the position of the nose and mouth, and the angle of the eyes. Measure back across the head and position of the ear. As a rule you will find that the top of the ear lines up with the eyes and the bottom with the mouth.

3 The black conté pencil is then used to darken the eyes and lashes; the shape and fall of the hair is redrawn and redefined, and the dark area inside the slightly open mouth is pencilled in. With loose, flowing lines draw in the scarf and top. Take care to make the clothes appear as if they fit on and around the figure by curving the pencil lines into and over the underlying form.

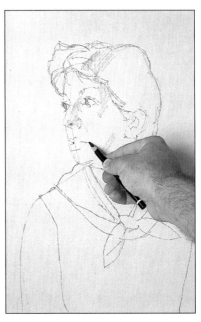

2 Making use of these few construction lines, which act as a guide, begin to draw the features in lightly. The light marks made with soft conté crayon, unlike those made with conté chalks, can be corrected easily by using a soft putty eraser. Loosely hatch on a little tone to indicate the side of the nose that is in shadow, and so

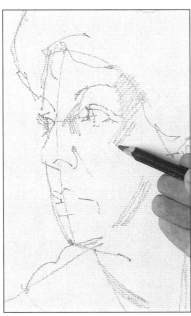

indicate the direction of the light. At this point the drawing already begins to have depth as we look across the face into the drawing.

4 Take up the sanguine pencil and hatch in the areas of shade down the right-hand side of the face and neck, under the eye and down to the side of the mouth. With the black pencil darken the eyebrow, hatch in the hair, the scarf, and the top. Do not make the hatching too dark; while it is easy to darken these areas by working over them again it is

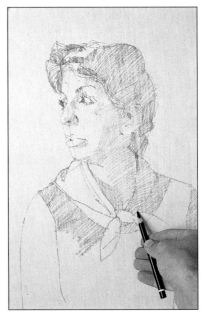

a more awkward task to lighten them. These loose areas of tone have the immediate effect of giving solidity to the form.

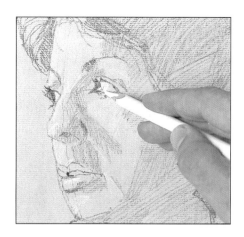

5 With the white conté pencil hatch in the light areas, paying particular attention to the white of the eye and the highlight on the lower lip.

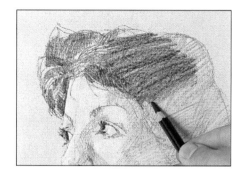

6 Rework the hair with the black conté, paying attention to the shape and suggesting here and there the detail of a few individual hairs. With the sanguine pencil shade in the top lip.

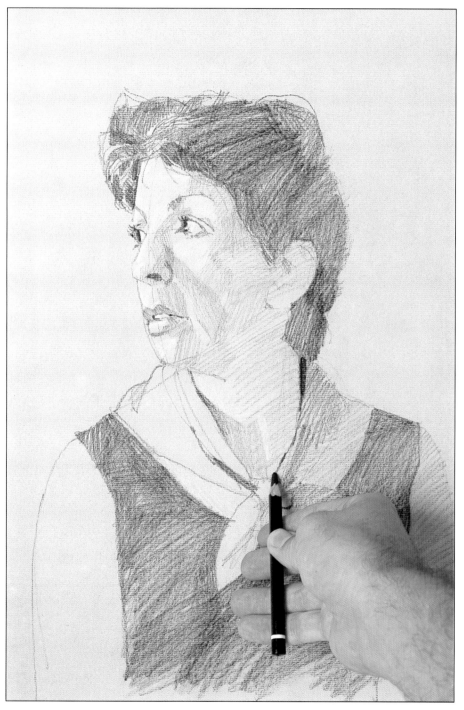

7 Darken the shadows on the scarf where it sits against the neck and rework the black top.

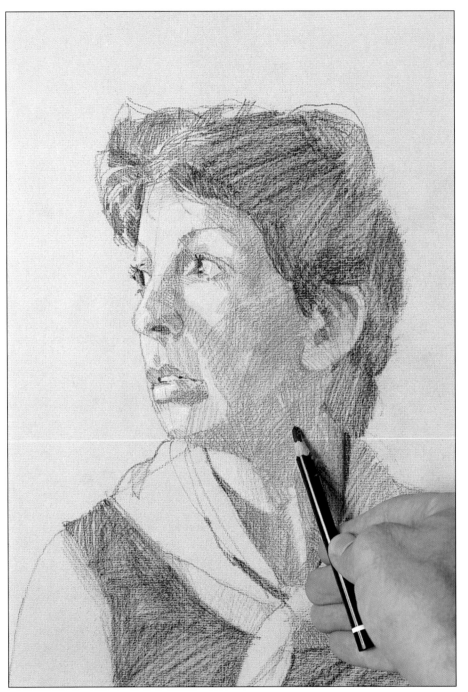

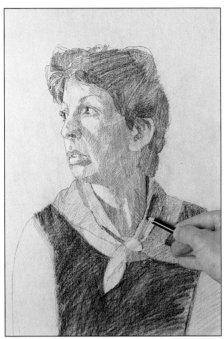

9 The neck scarf and top are darkened again. A light tone is loosely hatched over the lighter side of the scarf to separate it tonally from the background and help position the scarf on and around the neck.

8 With the sanguine and the black conté pencils methodically work across the face, adjusting the tones by cross-hatching and gradually building up the contours. The task will be easier and more precise if you keep your pencils sharpened to a point.

10 With a sharp white conté pencil press the highlights into the eyes.

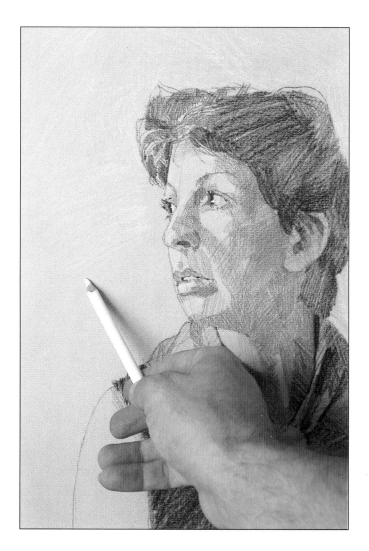

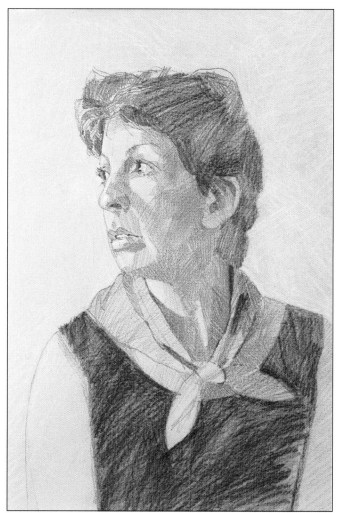

11 The background is lightened by scribbling over it with the white pencil, varying the direction of the strokes. This has the effect of lifting the head and visibly pushing it forward, out and away from the background.

12 The drawing receives a few adjustments and is finished. The three conté pencils and the cream-colored paper have worked together to produce a deceptively colorful drawing.

Alternative Approaches

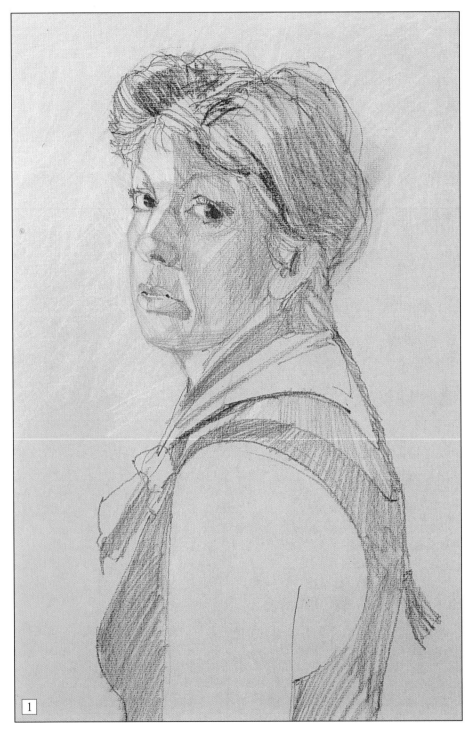

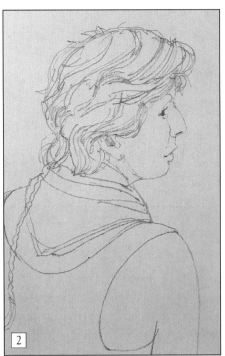

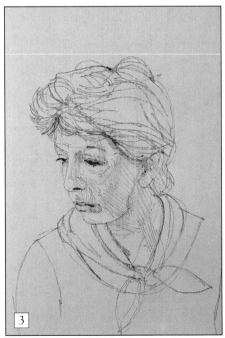

1 The technique of using the three crayons remains the same but the drawing is looser, relying more on line to suggest the fall of the hair.

2 Dark brown, rather than black, was used to give a dense line that was not too overpowering.

3 A sharpened square black conté crayon gave a looser and more subtle line, with just a suggestion of hatching on the planes of the face, which gives just a hint of form.

LOBSTER AND LEMONS

Pen and Ink

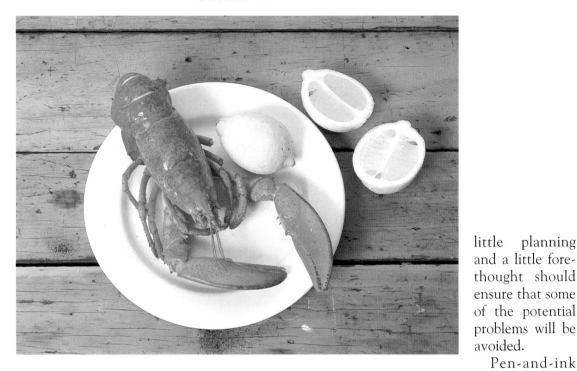

PEN-AND-INK techniques, much favored today by illustrators for their clarity in reproduction, are well tried and have a fine tradition—they were a favored medium of so many great artists of the past. Today, however, ink as a medium is often viewed with some trepidation by beginners—perhaps because it is seen as an unforgiving medium. While there is some truth in this attitude, a little planning and a little forethought should ensure that some of the potential problems will be avoided.

Pen-and-ink drawings are essentially about line, when used on a dip pen straight from the bottle the ink delivers a black line of uniform density. It is the variation in line quality, the alternating combination of thick and thin, broken and continuous, hesitant and incisive, that give the medium its special quality.

The range of marks possible from a single nib are many, and it is perfectly possible to produce a drawing full of line, and with a variety of marks, using one nib only. The versatility of ink expands even further when you consider that, unlike all other drawing media, it is a liquid capable of being diluted, spattered, blotted, brushed, stippled and dribbled.

The lobster, along with other crustaceans, seems to have been created as the model for pen-and-ink drawings. Its contoured, segmented body, its long arms and legs covered in spines and nodes, demand the use of a wide repertoire of marks.

MATERIALS AND EQUIPMENT

Sheet of 200 lb Not watercolor paper
Two pen holders
One thin nib and one thicker nib
Waterproof Indian ink
2B pencil
Putty eraser

The Drawing

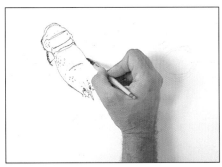

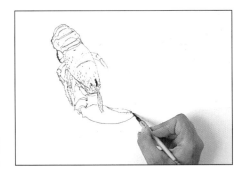

1 Lightly sketch in the lobster, plate and lemons with a soft pencil. There is no need to go into great detail, but include enough to act as a guide for the ink drawing. The pencil will be erased when the drawing is finished and the ink is dry. Don't press too hard or you will make indentations in the paper.

2 Begin to draw in the body of the lobster, working away from the drawn area so you don't smudge the wet ink. Use the pencil drawing as a guide but do redraw, referring constantly to the subject, rather than just following the pencil lines.

3 Work around the edge of the lobster. Press harder on the pen and splay the nib to get a thicker line: turn the nib on its side to obtain a very fine line. A line varying in thickness is central to pen-line drawing: the thicker lines suggest an edge that is in shadow, while a fine line suggests one that is brightly lit. Return periodically to indicate texture and pattern on the lobster's shell.

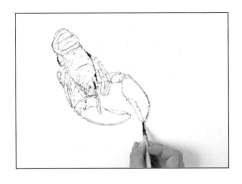

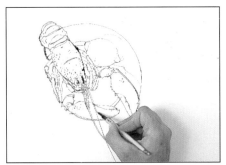

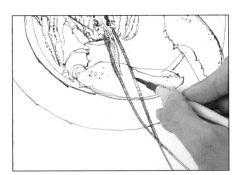

4 Long fluid lines indicate the shape of the claws. The light preliminary pencil drawing is especially useful for guiding these descriptive lines, which otherwise can be difficult to judge.

5 Draw in the lemon with a thin line that complements its delicate color, indicate the far, curving edge of the plate, and the long antennae. The very observant will notice that my lobster had lost his antennae, so I indulged in a little artistic license.

6 Finish drawing in the thin segment ridges that would make up the antennae, and finish the line of the plate. Note how a thicker line denotes the shadow on the inside edge.

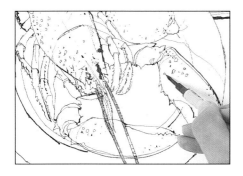

7 Dots and circles indicate the patterns and the textures on the lobster's shell.

8 Draw in the two lemons on the table and the grain of the wood. Use plenty of ink on the nib and alternate long, light, fluid strokes—with the pen held well back from the nib—with short, heavier ones. The pen may catch on the paper, giving the line a jagged, broken look. Use the thicker pen nib for the thick, heavy lines.

9 Touch the back of the nib with a finger or thumb and create texture on the shell by using your fingertip or tip of your thumb.

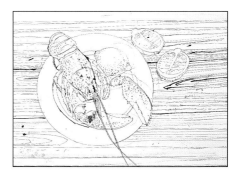

10 Dragging an inky finger over the surface of the paper creates a wood-grain-like smear.

12 When the drawing is complete, allow it to dry overnight before attempting to erase any of the pencil drawing lying underneath, or you run the risk of smudging the ink.

11 Dilute the ink with water for a subtle tone. Add the dilute ink to the nib with a brush (do not overload the nib as the thinned ink is prone to blob) and work back over the shell, creating more pattern and texture. Alternate between the thick and thin pen nibs in order to vary the marks.

Alternative Approaches

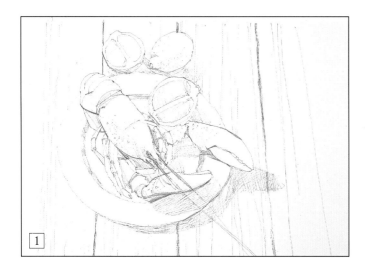

1 An inexpensive, disposable, black biro was used for this drawing. While it is impossible to vary the thickness of line noticeably, it is possible to make the line lighter or darker by varying the pressure and the speed at which it moves across the surface of the paper.

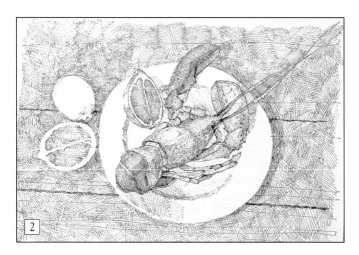

2 This cross-hatched drawing was built up steadily using a fine technical pen. The same result could be achieved by using a fine liner or fine fiber-tipped pen. Notice how the density of the hatching gives the tone density. The lightest tone on the plate was made by using a pen that had almost run out of ink, and was only capable of making a light line.

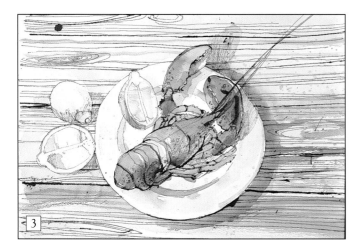

3 Mixing waterproof and non-waterproof inks, and using watercolor—applied with brush and pen—pushes the possibilities further. The sharp pen line works well with the softer layers of tone and color brushed loosely over the finished drawing.

SUNLIT FIGURE

Pen and Wash

DILUTING INK WITH water immediately creates a more versatile medium. Tone can now be achieved with washes—rather than having to rely on the constraints that are inevitably found when depicting tone by stippling, hatching, cross-hatching, and other techniques using line only. The two methods of working are often used together: the tones, light and shade, are created with a combination of wash and line; or by using the washes to show tone and color while using line to describe the texture, the outline and detail.

Whether you are using waterproof or non-waterproof inks, the wash techniques are very similar to those used when painting in water-color. Watercolor is worked from light to dark, the darkest tones and colors usually being applied last. Ink washes are worked in the same way, as it is impossible to lighten a wash once it has been applied and is dry. This means that, as with watercolor, a little forethought and preliminary planning are required before beginning work.

Look at the subject and try to simplify what you see, grouping tones together, increasing the contrast between the lightest and the darkest. As we have mentioned before, looking at the subject through half-closed eyes will help, as this cuts down on detail and seems to reduce the perceived range of tone.

For this project, if you are not entirely confident you can make a very light preliminary pencil drawing as a guide. However, unlike the preliminary sketch that helped in the drawing of the lobster, it will not be possible to erase this one because the dry washes of ink will cover up the pencil marks. With the darker washes the tone of the wash will hide any pencil marks, but in those areas where the washes are very light the pencil marks may show through. Remember that once a wash is dry it will not be possible to lighten it—only to make it darker.

MATERIALS AND EQUIPMENT

One sheet of 22 x 15 in. (56 x 38 cm) 300 lb Not surface watercolor paper
Black waterproof Indian ink diluted with water
One nib of medium thickness
One no 9 sable watercolor brush
One medium-size Chinese brush

The Drawing

1 Mix a light to mid tone of ink and water. Working over a light HB-pencil drawing done as a guide, and beginning at the top of the paper, establish all the mid tone areas and the dark areas as one flat wash, using the no 9 sable brush. Be careful not to cover any light areas; if you do, you can quickly brush clean water on top and blot the resulting ink wash off with clean paper towel before the ink dries.

3 Allow the wash to dry. Mix a darker tone and, using the Chinese brush—which because of its shape gives a more expressive line—redefine the shape of the urn, the fall of the hair, and the line of dark shadow at the front of the dress. Begin to put a little detail into the face by pulling the wash around to make the dark shadow beneath the chin. Darken the eye socket and the area below the nose.

2 Continue to work down the drawing in the same way and indicate the lines of the stone floor tiles, the shadows across the legs, and the cast shadow running over the couch. Working with the board at a slight angle means that the wet ink wash will puddle at the bottom of the drawing. Any excess ink can be removed by touching the puddle with a large dry brush or a piece of paper towel.

4 Block in the rest of the dress. Leave the areas where light catches the bodice and work carefully around the shape of the arm, indicating the shadow beneath the hand resting on the knee and the shadow of the dress draped across the other knee. While this is painted in one tone, if you allow the ink to "puddle" in areas—for example on the hair, around the ear and the bottom of the dress—these areas will dry to a darker tone. Before a wash dries it is also possible to flood water into it, making it lighter.

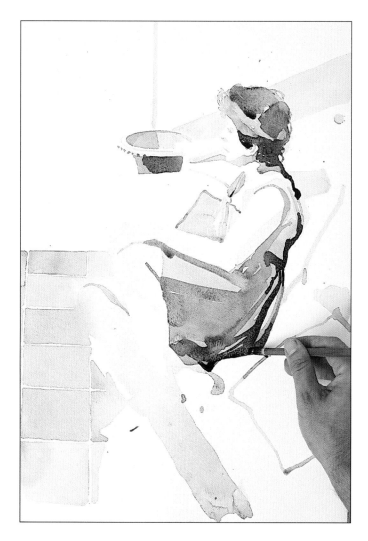

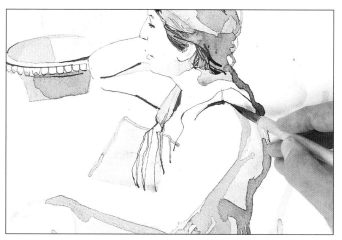

6 Once the washes are thoroughly dry the drawing is worked on in line, using the pen and undiluted Indian ink. Begin with the face, sharpening the features and the fall of the hair. Thin lines show the ruched material on the front of the dress, while lines that alter in thickness, indicating shadow, describe the arm and the shoulder. Note: Using the hair dryer will hasten the drying process, but do be careful not to blow dilute ink on to areas where it is not wanted.

5 A little more ink is added to the previous mix to make it darker. Paint in the shadows on the urn, the darker tone found in the hair, the shadows in the creases and folds of the dress, and the shadow beneath the arm resting on the knee. Allow the wash to dry slightly, then, working on to the still-damp paper, rework the back of the dress and some of the shadows, making them darker.

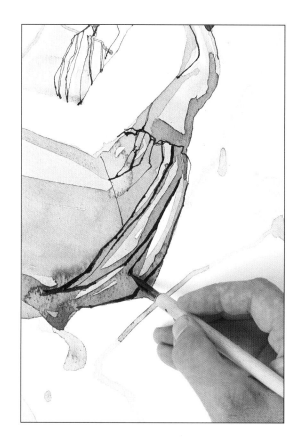

7 The back of the dress receives the same treatment as the front. By holding the pen near the nib you can apply the pressure necessary to make the lines thicker.

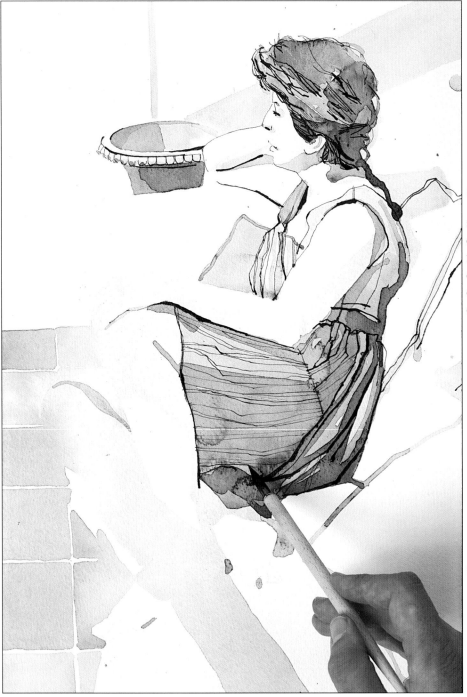

9 Dilute ink is used to draw the hands. The underlying drawing and the tone help position the lines correctly, while diluting the ink makes the line lighter and more delicate. Draw in the line of tassels on the edge of the kilim (throw) covering the couch.

10 The feet receive the same treatment as the hands, again using dilute ink

8 Holding the pen higher creates lighter lines, as less pressure is applied to the nib, restricting the amount of ink that flows on to the paper.

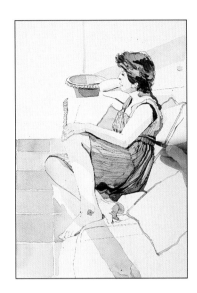

11 A light tone is used to modify the shadows on the hand and feet; a darker mix strengthens the hair and the deep shadows in the creases at the back of the dress.

12 With varying tones of dilute ink the material of the dress is loosened up and the pattern on the kilim painted. Work loosely, but carefully follow the contours and folds, allowing the pattern to indicate the form of the couch.

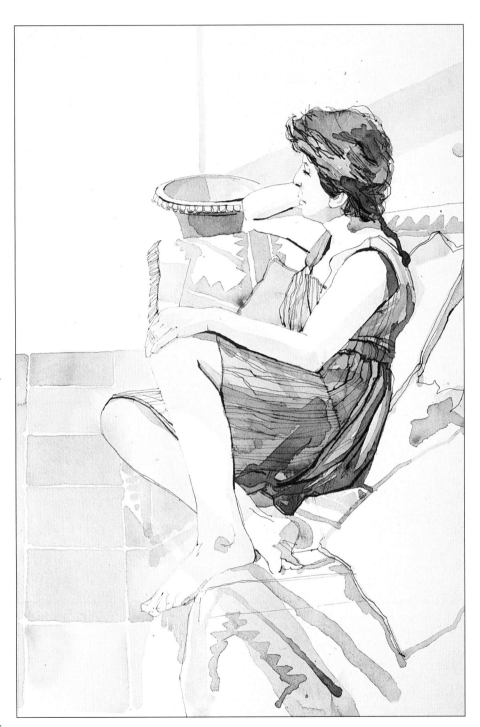

13 The finished drawing shows how the combination of line and bold washes work together, complementing each other and creating a strong image that nevertheless contains subtle variations in light and shade. The loose brush work on the dress and in the pattern of the kilim hints at the softness and texture of the material.

Alternative Approaches

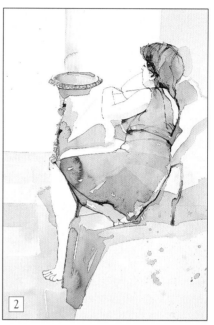

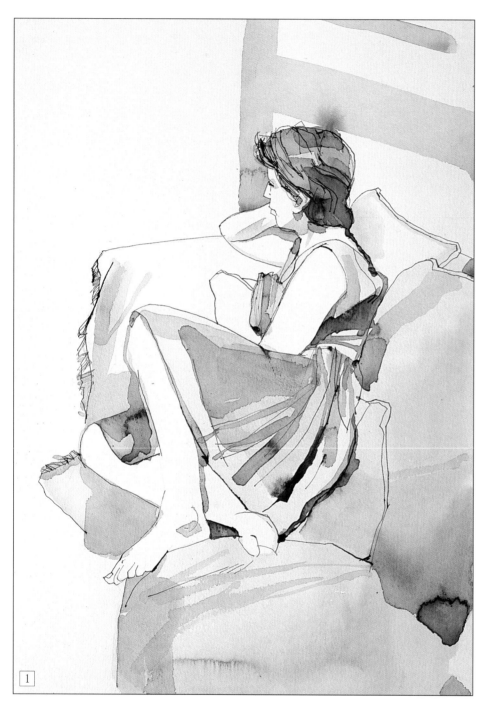

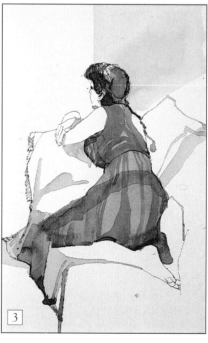

1 The same techniques of wash and line have been used in this composition, but with fewer and looser washes. The image was drawn in pen using waterproof ink. Later, when the ink was dry, washes were worked over the pen drawing. The image is simplified by leaving out the pattern on the couch and omitting the urn, thus putting greater emphasis on the shadows thrown across the wall behind the subject.

2 Loose, simple washes worked wet into wet are contained with just a few lines.

3 After the initial laying-in of light and shade a thin mix of dark red watercolor was used for the dress. The drawing was finished in line using waterproof ink. When the ink on the dress was dry this area was reworked using more of the same watercolor mix.

THE VILLAGE CHURCH
Pen, Wash, and Gouache

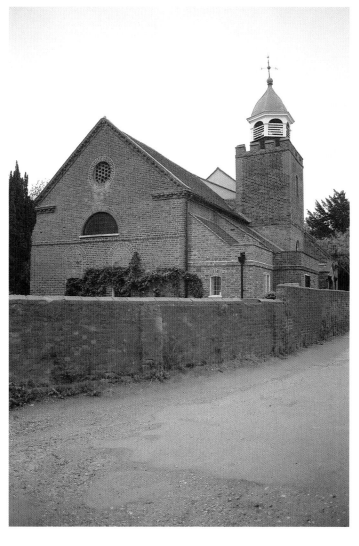

THE SUBJECT OF THIS project demonstrates how a number of different drawing media can be used to create new and exciting possibilities. Although certain combinations, such as charcoal and gouache, ink and watercolor, have long been favored, there are no written rules to say what should and should not be used together.

Using a variety of artistic treatments in one drawing is particularly suitable for architectural subjects. The materials from which buildings are constructed often have marvelous texture and color, and the shapes of the buildings, together with their surroundings, provide the artist with a wealth of suitable subject matter. The buildings themselves can also be particularly inspiring.

Old buildings, new buildings, small and large, all have something to offer. Churches especially seem to be a subject that artists return to again and again, and many of the older churches are situated where it is particularly pleasant for the artist to work on the spot.

In order for a building to stand, its construction must conform to certain geometric criteria. Linear perspective echoes these criteria, but this is a complex and involved subject—to deal with it in any depth is beyond the scope of this book. Put simply, the principle dictates that all receding parallel lines meet at a mutual point in space, a point known as the vanishing point. This point lies on the so-called horizon line, an imaginary line that runs horizontally and lies at eye-level, regardless of your position.

The drawing of a small village church on the outskirts of London offered the opportunity to use just a few different techniques and media in one drawing. Countless other, equally agreeable, combinations will be found simply by experimenting.

MATERIALS AND EQUIPMENT

One sheet of 15 x 22 in. (38 x 56 cm) light-beige, 160 gsm Ingres paper
Indian ink
Gouache in the colors: sap green, pthalo blue, yellow ocher, and titanium white
One pen with a medium nib
Two sable watercolor brushes, one no 12 and one no 4

The Drawing

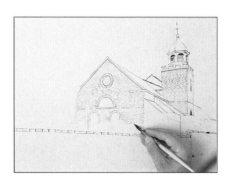

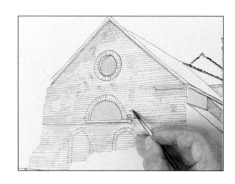

1 Using a soft pencil carefully sketch in and position the church on your sheet of paper. It is important to make certain that the angle of the building and the perspective look correct at this early stage, as this will help you with your drawing later on.

2 Dilute some black Indian ink and, working over the pencil drawing with the pen, carefully line in the shape of the louvered cupola, the tower and the main body of the church. Use neat black ink to darken and define the end of the tiled roofs and the louvers on the cupola. Darken the tower windows and draw in the line of the wall and its top row of stones. Use dilute ink to draw the brickwork and window surrounds of the church; add texture to the brickwork by wetting a finger with ink and using it to print across the walls.

3 Take the smaller brush and, using the dilute ink, block in the dark areas of the windows. Now begin to add detail to some of the brickwork.

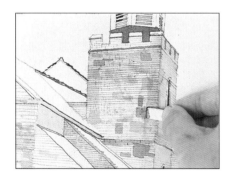

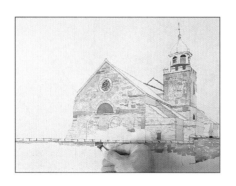

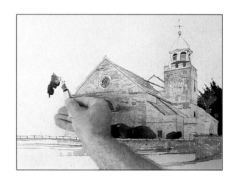

4 A different quality can be added by cutting a small piece of card, dipping the end in ink and using it to make brick and stone-shaped marks across the church walls.

5 Use the same technique to indicate the brickwork along the wall in front of the church; varying the strength of the diluted ink gives a variety of tone. Indicate the dark areas on the round window by dabbing ink on with a small brush. Using the brush, draw in the tiled roof.

6 Using a dark green mix of ink, gouache, and water, apply the same technique to draw in the ancient yews and bushes in the churchyard, and the line of grass at the base of the wall. As the piece of cardboard you are working with becomes softened by the ink you will need to recut the end, or replace it with a new piece of card.

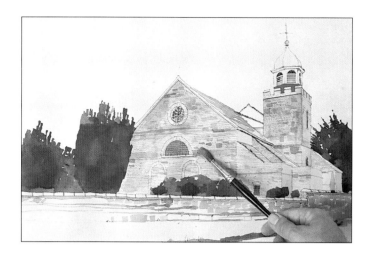

7 A light wash of ocher gouache is brushed over the stonework wall of the building with the larger sable brush. This serves to set the building apart from the stone wall in the foreground.

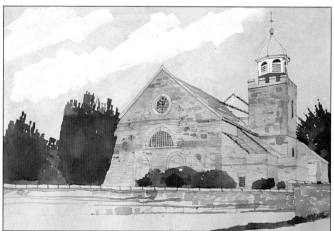

9 Clouds are painted using neat white gouache. As the gouache dries the intensity of the white diminishes; a second coat will help to lighten them.

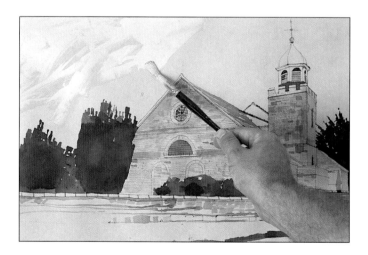

8 The same brush is then used to wash on a layer of light blue, mixed from white and pthalo blue gouache. Work loosely up to the trees and the church. Allow this to dry before brushing over the white. Do not be too concerned about bringing the sky right up to the building and the trees.

10 The painting is completed by lightening the cupola with white and, with the smaller brush, indicating the grill across the window. Finally, a few dark thumb and finger prints liven up the brickwork on the church.

Alternative Approaches

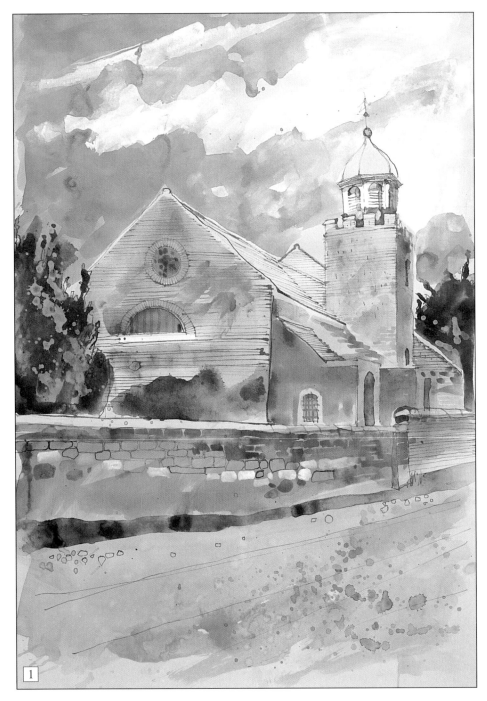

1 Bright acrylic inks give color to this lively and decorative rendition, drawn from a similar view.

2 By drawing the church end-on the linear perspective is almost non-existent, except for very top of the cupola and the stone wall on the extreme right. Distance is shown by the dark yew in the foreground, which visually pushes forward, and the lighter row of trees in the background receding. This is achieved by painting the trees in the distance with a more dilute mix of ink and water.

3 In this drawing no attempt has been made to fill in any areas of tone. The dark, almost black yew trees are shown as white shapes, the clumps of foliage in outline only.

MATERIALS AND EQUIPMENT

Types of paper and board

The quality, texture or tooth, tone, and color of the support you choose to work on can make the difference between success and failure, so the choice should be given careful consideration. The range of paper and board available is wide and varied and paper is expensive—so making the wrong choice not only makes the drawing process more difficult it can also leave a hole in the wallet. Beginners are often bewildered by what is on offer and find it difficult to decide which paper or board it is best to use. When choosing paper for pastel work the three most important considerations that need to be matched to your subject and style of working are the tooth, which is the texture of the paper; the color, is it warm, cool or neutral, and the right choice for the subject; and finally the tone, or how light or dark the color is.

Pastel takes best on paper that has at least some tooth or texture: on very smooth paper pastel tends to slide over the surface and the pigment dust is spread evenly and clogs up what little texture the surface has very quickly, resulting in a thick, impasto layer of pigment making it difficult to overlay more pastel. The rougher papers shave off more pastel from the stick but the dust builds up more slowly on the coarser textured surface and adheres more firmly, which enables more layers to be overworked before the support surface becomes completely clogged. The pronounced tooth on the rougher papers shows through the work giving a sparkling, broken color effect and is one of the reasons why careful thought should be given to the color and tone of your support.

Mi-Teintes and Ingres are types of pastel paper that are available in a wide range of tones and colours from several different manufacturers. The better known ones being Canson, Fabriano, Sennelier, Tumba, and Daler-Rowney. The Mi-Teintes papers have a more pronounced tooth, not unlike fine canvas, while the Ingres paper can be recognized by the hundreds of feint parallel lines that run across its surface. Either side of the paper can be used, one side you will find is slightly rougher than the other, the choice is yours. Pastel papers are usually of medium weight falling between 90 gsm and 160 gsm, lighter weight papers suitable for

pastel are available but these can cockle when fixative is applied so they are best used for sketches or, if used for more important work, it may be advisable to stretch them beforehand in the same way that you would stretch watercolor paper. Pastel, when used on thinner papers, can also show up any imperfections or marks in the drawing board so place few extra sheets of paper beneath the one you are working on to act as padding and prevent this from happening.

Pastel boards are available but in a limited range of colors, the board are simply made by mounting pastel paper on to a cardboard backing. It is a relatively easy process to make your own. Cut a piece of cardboard to the size you want the painting to be, cut a piece of pastel paper a little larger than the cardboard, with a large flat brush apply a water-based glue evenly and thinly over both the board and the paper, then align the paper along one edge of the board and lay it on to the board smoothing it level as you go. Once the paper is down, smooth it flat and remove any air bubbles by rubbing over the surface with a soft cloth working from the middle outward. Once the paper is firmly in position the edges can be trimmed with a sharp knife.

Several other papers and boards also give ideal surfaces on which to work, a range of pastel boards and papers are available manufactured by Schmincke, known as Sansfix they have a very fine, granular, sand-like surface that is very pleasant to work on. A similar pastel board is available from Frisk. Velour, or flocked, papers are like velvet and take pastel very easily but are difficult to fix as the velvety surface comes away from the backing paper if wet, so drawings are prone to damage unless stored very carefully or framed immediately. Very fine sandpaper, sometimes known as flour paper, can be purchased at some hardware shops, this makes a wonderful surface on which to work but unlike artist's papers is not acid free so your drawings may deteriorate with time. "Not" and "Rough" surface watercolor paper can also be used and although these are white, which is not a desirable color to work on in pastel, they can be stretched and toned with watercolor or thin acrylic paint to any color that you wish.

Canvas and fine muslin can also be used, these can either be glued to hardboard or a thin sheet of medium density fiber board (MDF) or alternatively, for canvas, stretched as for oil painting but with a sheet of

cardboard at the back between the canvas and the stretchers. One advantage of using canvas is that, should you wish to, pastel works of a substantial size can be produced. Do not use an oil-based primer but a water-based acrylic one. The desired ground color can be added to the primer using acrylic paint or added as a separate coat once the primer is totally dry. The grade or texture of the canvas you choose will very much depend on the desired result, but for most work a fine linen or 10 oz. (28 g) cotton duck should suffice.

One of the most satisfying surfaces to work on are marble-dust boards, these are not commercially available but are very easy to make—the process is described later in the book.

The color and tone of the paper is important for several reasons, pastel rarely completely covers the support and if you use a white paper you will find that you are desperately trying to obliterate every bit of white with pigment—unless you are painting a snow scene, and even then you may find that a blue paper works better. Choosing a paper color that contrasts with your subject will often enrich and intensify the colors that you use, while choosing a paper that harmonizes with your subject can cut down on work, making it easier to assess and match colors and tonal values. Strong, strident colored papers are more difficult to use as they easily overpower the softer, more subtle pastel colors. It is perhaps best to stick with the more muted, neutral browns, ochers, greens, and grays which more closely echo those colors seen in nature.

The tonal value of a color is judged to be correct by comparing it against the tonal value of the colors that surround it, that is why working on to a light or white support can be difficult. Working on a mid-tone paper allows you to judge both the lighter and darker tones more accurately. Dark tone papers can emphasize the lighter tones while a light paper will work in the opposite way and make the darker tones and colors appear stronger.

Pastels

Three distinct types of pastel are available, these are soft pastels, hard pastels, and pastel pencils, all three can be used freely, one with the other, as can different makes. Pastels are made by mixing dry, raw pigment with a binder and preservative, only enough binder is used to hold the particles of pigment together which is why pastel colors appear to be so strong. Different types

of pigments require different types and amounts of binder, these include gum tragacanth, various resins, starch, and milk. Some old recipes for making pastels even advise on using stale beer.

Because pastel is a dry medium and the colors cannot be mixed prior to being applied, manufacturers offer a wide range of color, tints, and tones. Talens, Schmincke, Sennelier, Daler-Rowney, Faber-Castell, Grumbacher, Unison, Conte, Caren, D'arche, Carb-Othello, to name but a few, all offer ranges of soft, hard, and pastel pencils that together give a choice of over 600 different colors and tints, Sennelier, one of the main pastel manufacturers offers an assortment of 525.

Soft pastels offer the artist the largest range of colors; these are round and fragile and arrive wrapped in paper. Whenever possible, unless you need to use the pastel on its side, remove only enough paper to enable the pastel to make its mark, as the paper not only helps prevent the stick from crumbling it also keeps it clean. Very little binder is used in the manufacture of soft pastels, which is why they are soft. However, soft is a relative term, as you will notice that the degree of softness varies from one brand to another, as it does with different colors.

Soft pastel colors are graded as to their tonal value, unfortunately this grading system differs from brand to brand, with some ranges carrying as many as ten shades of certain colors. Put simply, each color can be found in its purest, strongest form together with different shades and tints of the same color. The darker shades mix pure pigment with black, while the lighter shades are mixed by adding white chalk.

Soft pastels, like paints, are graded for permanence, however, most offer good resistance to the effects of light and fading.

Hard pastels are square, they have a higher binder content than the round soft pastels making them firmer. They can be sharpened to a point using a sharp craft knife or razor blade, which makes them ideal for drawing and work where sharp, fine lines are needed. They can be used by themselves or with soft pastels to tighten up and pull slightly fuzzy areas into sharp focus or they can be broken into small pieces and used on their side to block in areas of flat color. Because hard pastels, when used, shed considerably less pigment than soft pastels they can be used to establish a composition without fear of clogging up the tooth of the support which could make further applications of softer pastels

difficult. Hard pastels are not available in as wide a range of shades and tints as soft pastels but the colors that available are carefully chosen.

Hard pastels can be blended on the support with fingers or torchon, they can be optically mixed by hatching or other means, and glazing colors lightly one on top of the other is easy and straightforward.

Pastel pencils are, as the name suggests, thin strips of hard pastel encased in wood, because of this they are clean to work with. The range of colors echo those found for hard pastels and like them they can be sharpened to a point and are an excellent choice for fine linear work and cross-hatching. Be gentle with pastel pencils, if they are dropped the pastel strip will break making them impossible to sharpen.

Pastels are sold in sets or can be purchased individually. Sets are available consisting of anything from 12 basic colors up to the full range. A basic set while providing a useful introduction to the medium may not provide the best selection for your chosen subjects. You may find it better to buy an empty box, these are available to accommodate various numbers of pastels, and fill it with your own carefully chosen range of colors. A useful tip is, no matter what spectrum of colors you select, try to purchase at least three tones, a light, medium, and dark in each one.

Pastels do not stay in the same clean, pristine condition they are bought in for very long, they wear down, sometimes at an alarming rate, and pieces become broken off. As you replace used pastels you will find that you are collecting a lot of bits, these are all usable and useful so should never be thrown away. Artists who use pastels a great deal collect hundreds of broken and partly used sticks so keep them in separate boxes according to individual colors or color groups (ultramarines, cadmium reds, grays, and so on) such a systematic approach not only stops the pastels becoming dirty with other colors, it also makes for ease of use and helps you keep track of colors and whether or not any need replacing.

Pastels do become dirty, an easy way to clean them is to three quarter fill a glass jar with ground rice or, if unavailable, ordinary white rice, and place in any dirty pastels, shake the jar for a while and the slight abrasive action of the rice with remove the dirty outer layer of the pastels leaving them nice and clean.

As you work, selecting pastels from your box or boxes, put the pastels you are using to one side and do

not replace them until you have finished work as it can be both exasperating and time consuming to keep refinding specific colors and shades when absorbed in an inspired flurry of creativity.

Erasures

Pastel, prior to fixing, can easily be erased in a number of ways. A soft brush or rag flicked over a surface will remove a large amount of pastel dust and lighten an image considerably. Traditionally a bird's wing was used and while difficult, if not impossible, to find in an art shop today you can easily obtain your own by buying an unprepared duck or game bird from your local butcher. White bread rubbed gently over the paper also cleans and erases pastel from large areas remarkably well. Fine, hard bristle brushes can be used in confined and precise areas as can cottonwool buds or a clean torchon. A sharp knife held at right angles to the support and pulled across the surface will also successfully remove excess pastel and can be used to remove heavy build-ups prior to erasing proper.

Some conventional erasers need to be used with care, plastic and India rubber erasers should be avoided as they become clogged with pigment very quickly and can push the pigment deep into the tooth making it very difficult, sometimes impossible, to remove. The putty rubber is, as its name suggests, soft and malleable. It can be used for cleaning up large areas or molded to a point for erasing small precise areas. As it becomes dirty a fresh clean profile can be found simply by cutting away the dirty side with a sharp knife.

Erasing, however, should not be thought of as simply a way of getting rid of mistakes but as a means of making marks that can add interest and surface quality to overworked areas or as a means to lighten tones, make patterns and soften, or blend, crisp edges.

Knives and sharpeners

Soft pastels can be sharpened very carefully with a sharp knife but the point disappears more or less immediately the pastel is used. Hard pastels and pastel pencils sharpen better using a knife or a conventional pencil sharpener, a point can also be given to hard pastels by rubbing them on to fine sandpaper.

Fixative

Pastel paintings are very fragile and unless fixed, smudge very easily, so they need to be stored with great care or framed immediately. Fixative is a varnish that, as it dries hardens, fixing the pigment to the support. The use of fixative, whether to use it or not, is an ongoing debate among pastel artists. Many consider that is does the work no favors at all, destroying tonal values, darkening the color and removing the sparkle and brilliance that is characteristic of traditional pastel painting. I use fixative freely as the painting progresses both to fix areas of work that I intend to repaint with more layers of pastel and to intentionally darken areas of color so as to enable me to extend the tonal range of the colors I have at my disposal.

Fixative affects certain colors more than others and the difference between an area that has been fixed and an area that remains unfixed is especially noticeable where lighter colors have been used and, with heavy fixing, white can almost disappear completely. These problems can be overcome by fixing the painting just before it is completed, then finishing with layers of unfixed color that will retain their brilliance and freshness. A painting does not have to be fixed all over, by cutting or tearing paper masks it is possible to fix selected areas leaving those areas of color that seem prone to more dramatic changes untouched. Furthermore, erasing sometimes flattens and smooths out the tooth of the support, making it reluctant to accept further pastel, here a light spray of fixative prior to any reworking can solve the problem.

Fixative is available in aerosol cans or as bottles of liquid for which you will need a diffuser. To spray a painting first tap the support to dislodge any loose dust then secure the painting to a drawing board and prop it vertically on the easel or up against a wall. Test the spray before you use it on the painting as occasionally they fail to atomize and a jet, rather than a spray, is discharged which could spoil your work. Hold the can at least 12 in. (30 cm) away from the work and steadily direct the spray back and forth across the painting. Using fixative liquid and a diffuser is a little more difficult as regulating the flow of air and so the amount of fixative dispersed, takes a little practice, but the principle remains the same.

An alternative method is to spray fixative on to the back or reverse side of the paper, if sufficient is used it should soak through and wet the pastel dust holding it in place as it dries. I have never found this method to be particularly satisfactory but I know of people who swear by it.

Drawing boards, easels, and sundry equipment
A good drawing board is essential, choose one that is large enough to accommodate the largest size sheet of paper that you are likely to use, few things are as irksome as trying to work on a sheet of paper that is too large for the drawing board. But remember that as you grow in experience so may the size of your paintings. It may make good sense to have two boards, a smaller, lighter board for working on location and a larger, heavier board for more ambitious drawings done in the home or studio. Drawing boards can be bought from an art suppliers or made cheaply from medium density fiber-board. Several boards can be cut from a standard size sheet of MDF in sizes that match the paper sizes that you use most frequently.

Pastels are best done with the support vertical as this allows excess pastel dust to fall harmlessly to the floor, rather than lie on the support surface where the artist tends to blow it away, dispersing it into the air. While strict manufacturing regulations keep harmful, toxic pigments to a bare minimum, breathing pastel dust is best avoided, as is breathing any other kind of dust. An easel allows the work to be kept vertical and can be adjusted to height allowing the artist to work either standing up or sitting down. The easel must be stable as

pastel work calls for a fair degree of pressure to be applied so the easel must keep the drawing board and the support in place. You will also need a table, or trolley, to hold your pastels and any additional equipment. This needs to be positioned close to the easel and if it has wheels making it easy to move, so much the better.

A mahl stick has a long handle with a soft, usually chamois covered pad at one end. It is used by holding the handle in one hand and resting the pad on the edge of the drawing board or part of the easel. The other hand, holding the pastel, can then be rested on the long handle and steadied while being kept clear of the picture surface, so preventing it from becoming smudged or smeared.

Torchons or tortillons are soft paper rolls that are used to blend colors together; you will find it makes good sense to have a few and keep one for blues, one for reds, and so on, as you can very easily contaminate a color by using a torchon that has been used to blend a different color. Torchons are good for small areas but for the most part fingers are better. Paper is best attached to your board with heavy clips, one at each corner. Drawing or push-pins can be used but avoid using tape as it can tear the surface of the paper.

TECHNIQUES

TECHNIQUES ARE THOSE MARKS and effects that can be achieved using a chosen medium. By having a broad knowledge and working repertoire of such techniques the artist is liberated to concentrate on the content of his, or her, work.

Many techniques are remarkably simple, but in order to achieve them and use them successfully they need to be executed in a seemingly effortless and smooth manner. This requires practice and it is my belief that any time spent handling and experimenting with your materials will help you to become familiar with the technical skills that pastel painting requires.

Learning about techniques is cumulative, one method often leads the way to another—and many are but simple variations on each other. It is not obligatory or even desirable to have an image in mind, just to use and experiment with the materials themselves. Working abstractly in this way channels more thought and concentration into the mark making process. This unconscious control of the medium enables the artist to turn attention to color, form, perspective, composition, and other fundamental principles that are central to good pastel work.

Pastel is a unique medium as it sits astride a fence that has drawing on one side and painting on the other: it leans toward and owes much to both disciplines, and in doing so it borrows and combines techniques from both.

Pastels require focus as the medium is not an easy one and can easily get the better of you. This is not to say it is as dependent for success on technique as is watercolor, nevertheless like watercolor it does require a certain amount of planning and forethought. This coupled with the right techniques make pastels surprisingly versatile and capable of precise photographic realism, colorful impressionistic work, or large color field abstracts—in other words, whatever takes your fancy.

The Techniques

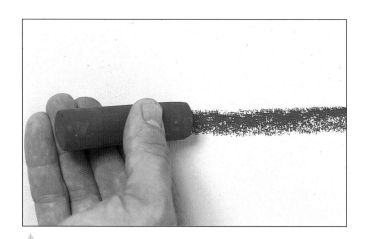

Presenting the pastel end on to the support will give a mark—the thickness and density of which can be varied by turning the stick as it wears and by varying the pressure with which it is applied.

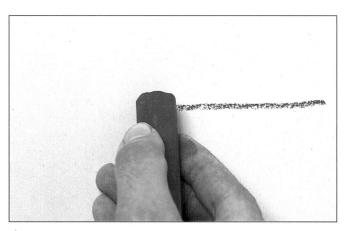

Holding the stick in the same way but pulling it sideways across the support will present less of the pastel to the support, so making a thin linear mark that, as before, can be lightened or darkened simply by applying more or less pressure.

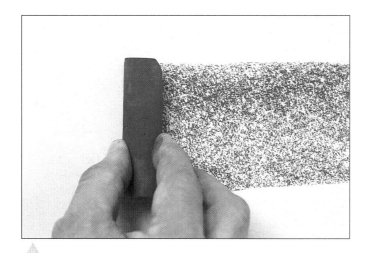

Drawing the pastel sideways across the support leaves a broad band of even color; the density of pigment can be altered by varying the pressure and the speed with which the pastel is applied. By using this technique very large areas of color can be blocked in remarkably quickly.

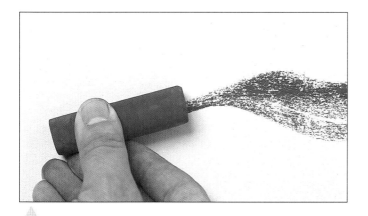

Turning the pastel on its axis as it is pulled across the support gives a fluid flowing band of color that will vary in thickness.

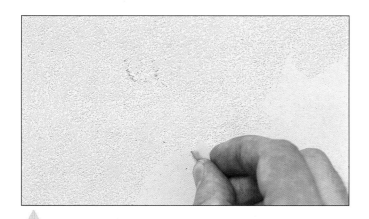

Large areas of flat color are built up by using the pastel on its side. The required density is better achieved by

working several thin layers one on top of the other: the first layer is applied using broad parallel strokes using the full length of the pastel, the second layer is then applied at right angles to the first.

Alternatively in order to achieve a more random effect, work the pastel in all and every direction with each layer. If you wish, each layer can be given a spray of fixative to bind it to the support.

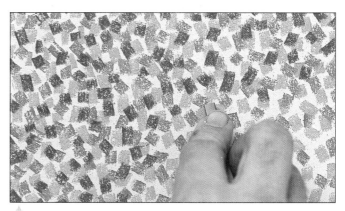

By using short heavy strokes, small blobs or blocks of pure color are placed next to each other that, when viewed from a suitable distance, optically fuse to create an overall tone or color that is a mixture of the colors used. This optical mixing was the principle that was used by the Pointillists. It was known by the artist who practiced it as Divisionism and is a technique perfectly suited to pastel work as all color mixing takes place on the support. Entire paintings can be executed using the technique or it can be used in tandem with other techniques. Turning the pastel—altering the angle that makes the mark and varying the spacing—makes irregularities in the dot pattern, so preventing them from looking too mechanical.

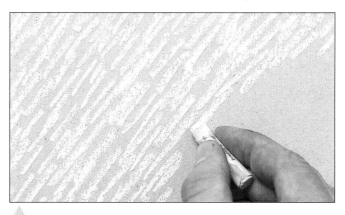

Hatching uses a series of parallel lines to give an impression of an overall tone or color. Hatching is essentially a linear technique, the colors used are left

unblended. By altering the distance between the lines, the depth of color used, and the thickness of the lines, the tone can be made lighter or darker and the color more or less saturated. By steadily widening the distance between the lines, tones and colors can be made to fade light to dark. Hatched lines can be short or long, thick or thin, sharp or vague, they can also be curved so they are seen to flow around the form following the direction of its surfaces.

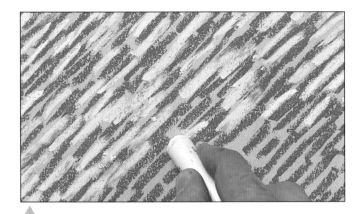

Two or more colors can be hatched together creating color that will mix together optically when viewed from a distance. Hatching large areas in one direction only, needs to be done with care, the painting can easily look lopsided as the eye tends to be drawn off in the direction that the hatched lines are running. Hatched areas offer a lively contrast and can look considerably more vibrant and interesting than flat, uniform areas of color.

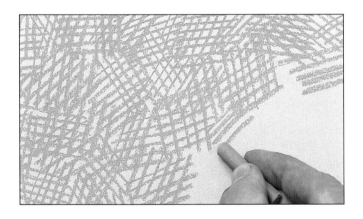

Cross-hatching is also a way of building an area of tone or color which, like hatching, is a linear technique. With cross-hatching the tone and color is built up by overlaying hatched lines, each layer hatched at a different angle to the previous one. Hatching is an easily controlled technique and it is possible to achieve

extremely subtle and intricate variations of tone and color intensity simply by varying the density of line.

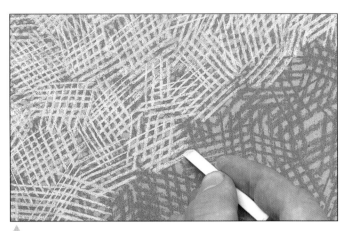

Colored cross-hatching is carried out in the same way—however for each layer a different color is used. As with hatching these layers of different color mix optically when viewed from a distance. Cross-hatching can be done straight on to the support or over previously worked surfaces. Both hatching techniques are extremely useful for reviving tired, flat areas of color and adding vigor to the work.

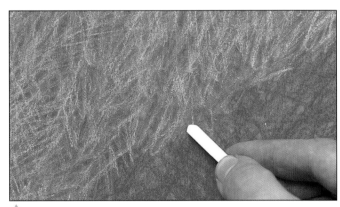

Scribbling is a simple and quick way of laying down a tone or texture. It enables the creation of subtle areas of color and tone of varying density and strength to be established quickly. Large uniform areas of tone can look flat and uninteresting, whereas scribbled areas look fresh and alive. You can build an area up by covering it several times over using more or less the same light pressure, or by applying more pressure cover the area in one dark layer. If you apply heavy pressure to a pastel it will wear down very quickly and make a very distinct, unsubtle mark. Hold the pastel near the lower end when using heavy pressure or it will break. Holding the pastel higher forces you to apply less pressure and so make lighter marks.

An area of color that has been fixed can be scribbled over with an ordinary pencil, graphite stick or charcoal—this will have the effect of knocking back the color or tone making it less strident or darker.

When scribbling tone or color always vary the direction of the strokes by altering the angle of the drawing implement or, if you are working flat, by turning the paper or board.

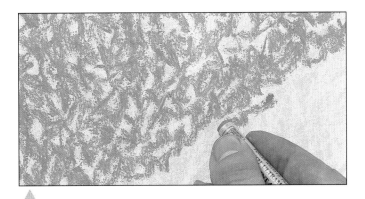

Scumbling is achieved by working lightly with a blunt tip or broken piece of pastel in a loose, haphazard, roughly circular motion over another color. The pastel is applied in such a way as to leave gaps that will allow the previous layer of color to show through. Here a dark color is scumbled over a lighter color.

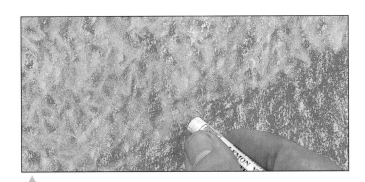

Here a light color is scumbled over a darker color, layer upon layer can be applied in the same way. If you

fix between layers the colors will stay separate, otherwise as each layer is applied it will pick up and move the pigment that is left by previous layers, blending slightly with them. The effect will be less crisp than if fixative had been used. By choosing colors or tones that are close to one another they will mix optically giving a subtle shimmering surface that would be impossible to achieve by overlaying flat colors.

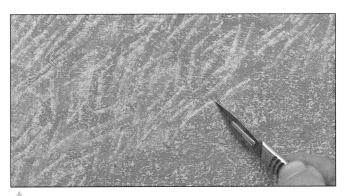

Sgraffito is a method whereby a layer of pastel is scratched or scraped into using a sharp implement, so exposing what is beneath, this could be the support or another layer of pastel. The word Sgraffito comes from the Italian word *graffiare* which means to scratch. The underlayer must be consolidated either by fixing or by being well rubbed into the tooth of the support. Alternatively, the lower layers could be a colored ground of acrylic paint or gouache. The over layer should be applied thickly using soft pastel and must not be fixed or rubbed into the support but should remain untouched. Any sharp instrument can be used to scratch through to the lower layer, as can your fingernails or even sandpaper. If you are working on paper take care not to tear or cut right through it.

To achieve a broken color effect, short strokes of color are applied so that they sit unmixed, next to each other. When viewed from a suitable distance the colors

optically fuse and blend, while seen close to, the surface stays lively and fresh. The technique is not unlike that used by the Pointillists, the achieved effect is similar but the pastel marks are more fluid and irregular, often following along in the direction of the contours of your subject.

A large, flat, soft bristle brush is useful for blending and softening large areas of paste. Use the brush gently to spread and remove excess dry pigment, or used more vigorously and with more pressure it will push the color deep into the texture of the support making it an ideal technique for consolidating a colored ground. Smaller, bristle oil painting brushes can be utilized in the same way to blend smaller, more intricate or highly detailed areas.

Blending together two colors to give a subtle gradation one to the other can be achieved by using the finger and it is easy to vary and regulate the pressure needed to accomplish the task.

Take care to wash your hands well before working with pastel to avoid getting any grease on the support which will make the pastel difficult to adhere. However, when working with pastels the hands do become dusty and dry very quickly, which will at least dry up any perspiration or greasiness.

The finger is again used, this time to quickly rough

blend broad strokes of light pastel applied over a darker color. Again using just the right pressure is important, the intention is not to flatten out the color but to vary the pressure, softening and blending the color—in some places more than in others. This gives a subtle, undulating effect to the color that is more interesting than the same color rendered featureless and flat.

The torchon or tortillon is also used to blend or consolidate color by pushing it deep into the tooth or textured surface of the support. Tortillons are available with fine points that make them useful for blending intricate detail and working in small areas that are too big for the finger or a brush. Torchons very quickly become contaminated with color and cannot be washed clean like fingers. To clean torchons and tortillons either peel away the dirty paper or rub the dirty end against fine sandpaper.

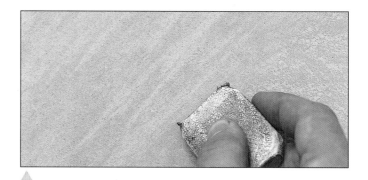

The putty or kneadable eraser can be used to remove

thin layers of pastel but thicker layers will clog the eraser very quickly. Thick pastel should be removed by scraping it from the support with a single edged razorblade or a sharp scalpel blade.

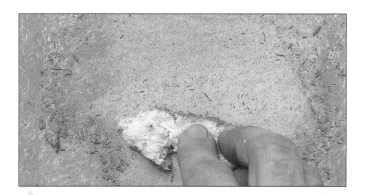

A far more efficient means of erasing larger areas of color, (as long as the pastel has not been applied too densely or thickly), is to use soft, white bread. The bread collects the pigment dust as it is rubbed over the surface, the crumbs are then blown away leaving the surface remarkably clean.

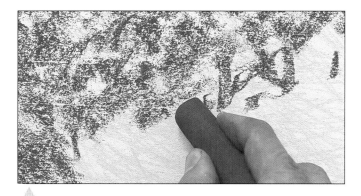

Hard pastel is best used underneath soft pastel. Used over the top the rather softer, thicker layer of pigment prevents the harder pastel from leaving much of a mark. Hard pastels deposit less pigment dust, so do not clog the tooth and texture of the support as quickly as soft pastels; when used with light pressure they also leave lighter marks. When the intention is to work in several layers this can be of great benefit, establishing the composition and blocking in approximate colors and tones with the less comprehensive range of hard pastels, then reworking and finishing the work with the wider range of softer pastels.

Glazing is a traditional oil painting technique where thin layers of transparent color are laid one on top of the other, each layer modifying and altering the one

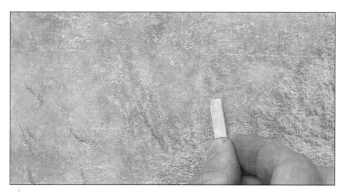

beneath. The technique can be used just as successfully with pastels, although hard pastels are best. Used on their side and with a light pressure they deposit a thin layer of color that allows the previous layer, or layers, to be seen. Here a yellow pastel is glazed over a darker red to achieve a light orange, had the red been glazed over the yellow the resulting orange would have been darker, or more red, as the top color will always read the stronger.

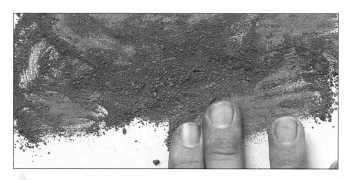

Small pieces of pastel that are too small to be held should be saved as they can be ground into dust and used for toning grounds. The pastels can be pounded into dust by placing the pieces in a mortar and pestle or by hitting them gently with a hammer. Use either pastels that are all of one color to give an overall uniform color or mix pastels of different colors to give an interesting multicolored effect. Sprinkle the dust on to the support then distribute it thinly and evenly over the surface, rub it deep into the tooth and remove any excess dust with a brush or by tapping the back of the support and then fix.

By placing your paper support over a textured surface such as bark, rough grained wood, wicker, or stone and rubbing a pastel over the paper, an image of the texture below is transformed on to the paper. This technique is known as "frottage." The technique can be used literally, for instance to create the texture and pattern of a real piece of wood on to a painting of a

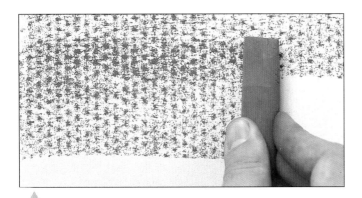

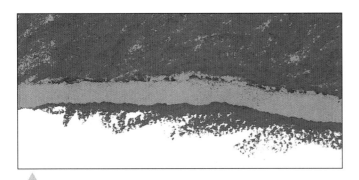

still life standing on a wooden table, the wood grain representing the wood grain of the table. Or it can be used more abstractly, simply to create textures that are then used as part of the representation or other, unrelated subjects.

In order to work up to an edge with an area of tone or color and give that edge a distinct quality, a piece of paper can be torn or cut to shape and placed on the drawing to act as a mask. Hold the mask carefully so that it does not slip, the pastel is worked over the desired area as well as over the edge of the mask. When the mask is removed you will be left with an edge that is difficult to achieve by other means.

A crisp straight edge can be achieved by using a ruler, card or paper as a mask, working up to it in the same way as before. When using thin materials like paper, care should be taken not to work too energetically as hard pastels and pastel pencils that have been sharpened to a

point can catch on the mask edge pulling it up or tearing it, which can spoil the desired effect.

Pastels are soluble in water and white spirit or turpentine. The pigments darken noticeably when water is applied but dry to their original color. When turpentine or white spirit is used the color becomes darker and richer staying that way once dry. When using washes work either on stretched paper, card or prepared marble-boards. Do not use any kind of liquid on velour paper, sandpaper or prepared pastel boards as the surface textures will be dissolved and the support ruined. The technique can be used to lay a colored ground or to blend and consolidate the underpainting either in its entirety or selectively, leaving some areas untouched.

Soft pastels are best sharpened with a sharp knife or razorblade, however the effect is short-lived as the point will wear down almost immediately. Hard pastels sharpen better and retain their point much longer; they can be sharpened with a scalpel, razorblade, pencil sharpener, or simply by rubbing the pastel on sandpaper. Pastel pencils sharpen easily, using any of the ordinary sharpening techniques. Because the pastel strip is relatively soft treat pastel pencils with care, don't drop them or the strip will shatter inside the wooden case making it impossible to sharpen them without pieces persistently breaking off.

PREPARING A MARBLE-DUST BOARD

PASTELS WORK BEST on a surface that has a slight tooth or texture and one of the most satisfying surfaces to work on is a rigid board that has been prepared using marble dust. The beauty of this kind of surface is it can be tailor-made to suit your needs, size, shape, color, and degree of tooth can all be varied and adjusted accordingly.

The dust can be applied to the board in one of several ways, either mixing it into a tint made with water and acrylic paint, or by simply sprinkling the dust onto the board and spraying the surface with fixative, more tooth is added simply by sprinkling more dust onto the board and refixing. Alternatively the dust can be mixed with gesso and paint, which is the method I use.

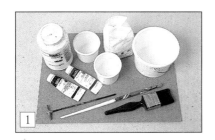

You will need a sheet of hardboard or thin MDF (medium density fiber board) that has been cut to size and the edges sanded smooth, acrylic paint for the desired ground color, acrylic gesso, marble dust, and water.

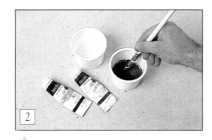

Use acrylic paint color for the ground and mix it up in a container straight from the tube without any water, this will ensure that you get no lumps of unmixed color. Add a little water and mix again, keep mixing and adding water a little at a time, until you think that you have enough. Keep the color strong as it will lighten enormously when added to the white gesso mix.

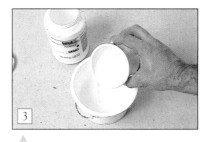

Pour sufficient acrylic gesso into a container and while stirring add water until is reaches a thin creamy consistency.

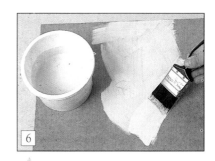

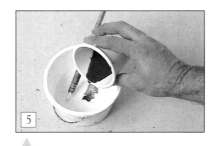

Sprinkle in and stir-well a dessertspoonful of marble dust, the exact amount you need depends on how much gesso you have mixed and how rough you want the surface to be. By testing the mixture periodically on a piece of board you should be able to gauge whether or not you need to add any more dust.

Pour in and stir the mixed acrylic paint well. Notice how much the white gesso lightens up the paint, you can mix up and add more color to the mix to darken it further or alternatively if you desire a very dark tint for the ground, wait until the coats of gesso are dry and apply a wash of dilute color.

Use a clean flat decorating brush and apply the mixture to the board using random brush strokes to get a flat finish. Once this is completely dry give the board a second and if necessary a third coat. Allow the board to dry well before starting work. Any mixture that is left over can be stored until needed again, in an air-tight container. You may find it makes sense to prepare several boards at once rather than one at a time.

COLOR

UNLIKE OIL, WATERCOLOR or other painting materials which require a liquid medium or vehicle to suspend the pigment in, pastel is dry. Wet media can be mixed, modified, and altered on a palette prior to being applied to the support—pastel colors can only be mixed on the support. For this reason pastel manufacturers try to remove the need for excessive mixing by supplying the artist with a large range of colors.

With over 600 pastel colors to choose from this gives the artist a wide choice. Mixing takes place on the actual support by glazing colors one over the other, blending, optical mixing, cross-hatching, and other techniques. But the intention should always be to keep mixing to a minimum, so preserving the purity of pastel color. This may infer that in order to work successfully with pastel the artist needs a complete range of colors—in reality this is far from the case. With time and practice it becomes possible to achieve a great deal with relatively few colors.

Artists also tend to specialize in one particular area, this means someone whose work is predominantly concerned with the landscape may amass a large collection of greens, blues, and browns but very few pinks and reds, alternatively a portraitist would not need too many blues or greens. However, a basic understanding of color theory can still be of great help, as the same color principals apply.

Red, yellow, and blue and the primary colors, they cannot be mixed from other colors, hence their collective name. Red and yellow make orange, yellow and blue make green, and blue and red make purple or violet; these mixed colors are known as secondaries.

But as a glance at a paint color chart will show there are many different tones within the various reds, yellows, and blues and the secondary colors obtained will depend very much on which of these primaries are used. The same is true of the tertiary colors, these are those colors that fall between the primaries and the secondaries. They are made by mixing an equal amount of a primary color with an equal amount of the secondary next to it to obtain a red-orange, orange-yellow, yellow-green, green-blue, blue-violet, and violet-red.

All colors are considered to be either warm or cool: the warm colors are red, orange, and yellow, the cool colors are green, blue, and violet. However, the terms "warm" and "cool" are relative as all colors have a warm and cool variant, there are warm reds, such as cadmium which have a yellow bias, and cool reds, like alizarin crimson, which have a blue bias. To confuse the issue further a color that is seen as warm in isolation can appear cool when seen next to a warmer variant of a similar color. This warm-cool color relationship is very important and can be put to good use, especially when painting the landscape, as warm colors seem to visually advance and cool colors appear to recede.

Complementary colors are those colors that fall opposite one another on the color wheel. One color will always have a warm bias while the other will have a cool bias. Hence red is the complementary of green and orange is the complementary of blue, these color opposites are known as "complementary pairs" and have a very special relationship. When placed next to each other complementary pairs have the effect of enhancing or intensifying each other.

The color wheel shows the primary, secondary and tertiary colors, the "cool" colors are violet, blue and green, the "warm" colors are yellow, orange and red.

Fixing noticeably darkens color and can be used to good advantage by extending a colors' tonal range.

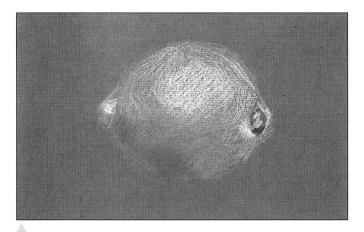

Here the pastels are scribbled delicately over each other.

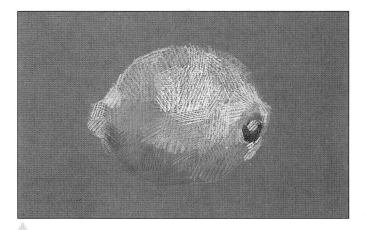

Color is applied and mixed by building up cross-hatching.

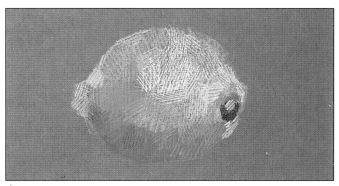

Here the color is mixed by working in flat glazes.

If small dots of pastel are applied next to each other the color will mix optically when viewed from a distance.

The color of the support has a marked effect on the perception of a color.

A NOTE ON COLORS USED THROUGHOUT THE BOOK

The grading of pastel color and tint strength varies according to manufacturer, unfortunately this is not standardized. Rather than complicate the text with a great many different names and numbers I have generalized, calling better known or commonly used colors, by name and approximate tone ie light cadmium red, dark pink, blue gray, and so on.

FIRST SNOW

Support Color, Blocking in, Blending

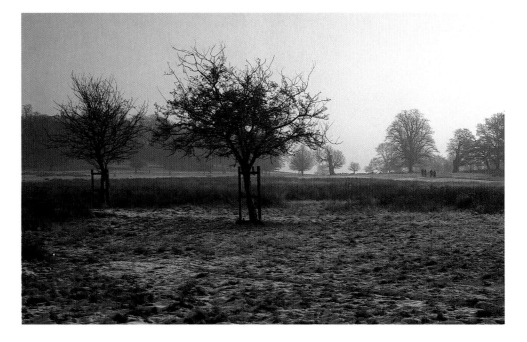

THE SUCCESSFUL PASTEL PAINTING RELIES on the combination of technique and a carefully chosen support color and tone. Unless the pigment is pushed deep into the texture of the paper, (or board) the grainy quality of pastel coupled with the tooth of the support allows the color of the support to show through as thousands of tiny pin-pricks of color. This has a very real and dominating effect on the finished picture, so the support color needs to be chosen with great care and consideration. Choosing correctly can cut down considerably on the amount of work needed to complete the picture and, more importantly, can make the difference between success and failure.

The choice of color and tone can be arrived at in one of, or a combination of several ways. The color could be chosen as closely representing the overall dominant color of the subject, alternatively it could be chosen for being either warm or cool in color so representing the overall color temperature of the subject, or it could be light, medium, or dark in tone—so setting a tonal value from which to work.

Pastels are best worked broad and loosely to begin with, then gradually tightening up and working any detail in the latter final stages. Pigment can be shaved from the pastel by the rough surface of the support at a surprising rate. So use a light touch in the initial stages of the work, putting just enough pigment down to achieve the desired effect and so avoiding a premature build-up and accumulation of pastel dust in the tooth of the support.

Traditionally one of the primary pastel techniques is the blending together of colors. While blending has an important role to play in most pastel works, it can be overdone—resulting in a soft, flat surface without interest and impact and lacking in any sharp definition. You will find that using your pastels with clean, precise strokes and choosing your support and pastel colors with care, can keep any blending to a minimum and help your painting retain its sparkle and brilliance.

Work on a 15 × 22 in. (38 × 56 cm) sheet of cool blue-gray paper, using white, light cobalt blue, mid cobalt blue, light cool gray, mid cool gray, dark cool gray, raw umber, raw sienna, yellow ocher, and black.

MATERIALS AND EQUIPMENT

cool blue-gray paper
15 × 22in (38 × 56cm)
white, light and mid
cobalt blue, light, mid
and dark cool gray, raw
umber, raw sienna,
yellow ocher, black
fixative

The Painting

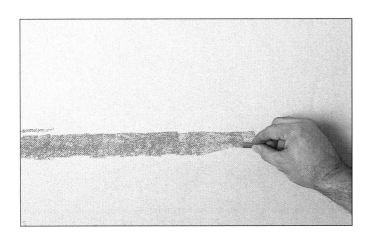

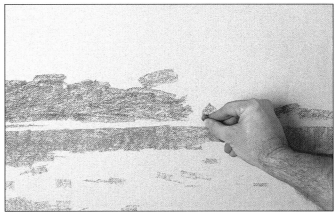

1 Working on a sheet of cool, light blue-gray paper using a raw sienna pastel on its side. Begin by establishing the patch of dry bracken and grass which lies across the center of the landscape in the middle distance. Paint in a few patches of ocher grass that can be seen showing through the snow lying in the foreground. You will find that it is often easier to use smaller pieces of pastel than large whole sticks. If you are using a new set of pastels grit your teeth and break off a piece that is ½–1 in. (1.25–2.5 cm) long.

2 The distant bank of trees standing on the slope of the hills is lightly blocked in with a few strokes of a dark, cool gray pastel, again used on its side. With all initial blocking-in, do resist the temptation to press too hard so clogging the paper tooth with pigment too early on, which would make the application of subsequent layers of pastel very difficult.

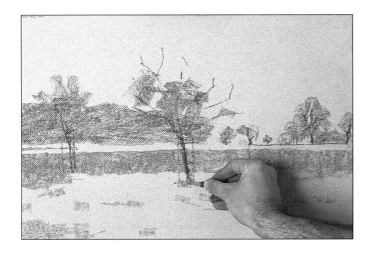

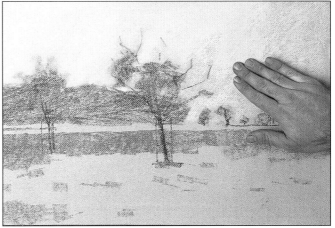

3 With a very dark cool gray, block-in and establish the skeletal shape of the leafless trees in the foreground and draw in the trunks of the few individual trees seen on the sky line.

4 Loosely block in the sky using a light cobalt blue pastel. Again use the pastel on its side to lay down the color in wide strokes. Once the area is covered, smooth and blend the pigment over the area by rubbing with the fingers, working the pigment down into the trees.

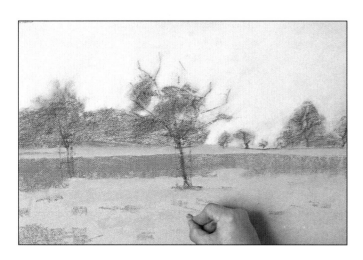

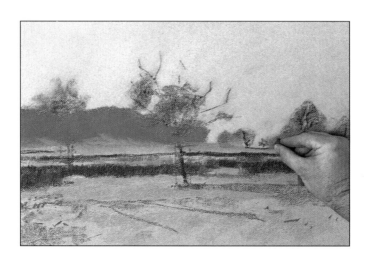

5 With a slightly darker shade of cobalt blue, loosely block in the snow lying across the far middle distance and the foreground. Once done the whole picture can be given a coat of fixative, this will have the effect of darkening the colors.

6 Work over the middle ground bracken and grass darkening the area with raw umber. Pull a little umber across from the base of the central tree to the right hand edge of the support, then rework and lighten those areas catching the light with light yellow ocher. Crisp fine lines are achieved by using the edge and the end of the pastel rather than the side.

7 A dark, cool gray reshapes, darkens and solidifies the stand of trees in the background. With a slightly lighter cool gray pull a little color up the slope of the hill into the trees suggesting the snow that lies in the shadow beneath them. Pull a few lines of varying thickness across the foreground.

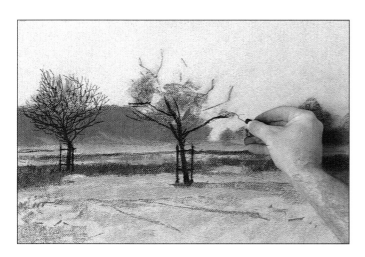

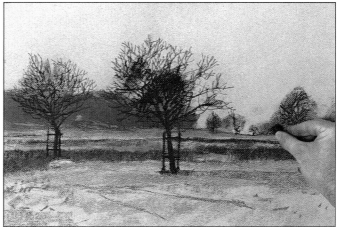

8 The dark branches and twigs are then drawn in using both a hard and soft pastel. The soft pastel easily draws in the thicker branches, whereas the harder pastel can easily be sharpened to a point and will make crisper, finer lines for the thinner branches. Alternatively use a thin piece of hard or medium charcoal for the branches.

9 Rework across the background, darkening the stand of trees on the hill and drawing in a suggestion of a few larger branches. Work the dark gray around and through the branches of the foreground trees, redefining and sharpening their shape.

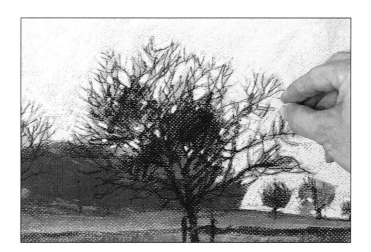

10 With the light cobalt blue pastel rework the sky around and through the tree branches. If possible use a hard pastel for this as it can be sharpened, enabling you to work through and between the branches more easily.

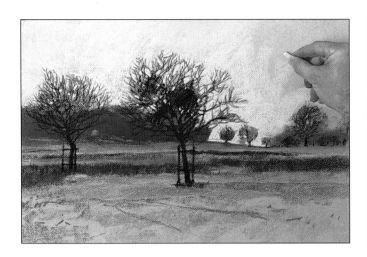
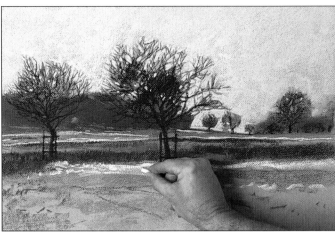

11 With the light blue pastel on its side continue to recover the sky working down into the trees. Do not blend the pastel this time but leave the pigment lying on the tooth of the paper so allowing the previous blue layer, which reads as being slightly darker, showing through in places.

12 Using heavy, varied strokes, start overlaying the white of the snow. You can use both hard and soft pastels if you wish—the soft pastels will allow more pigment to be left on the paper giving the suggestion of deeper snow.

13 In the finished picture the combination of the paper color and the limited palette of colors can be seen to easily and economically represent the cold winter scene.

Alternative Approaches

1 This relatively large painting was blocked-in and the main elements established using large, thick pastels. The details were added with smaller, soft pastels and the painting fixed. Once dry the picture was reworked, again using very loose, scribbled strokes of thick pastel, especially over the foreground. The final pastel work was left unfixed so helping to retain the brightness of the colors.

2 In this tight, academic painting of a skull the initial blocking in of the forms and colors was very loose. The pigment was rubbed deep into the tooth of the paper using a torchon and any surplus pastel dust removed by tapping the back of the support, then the painting was fixed. The process was repeated many times, each time the forms and colors were tightened, modified, and blended, any excess pastel removed and the work fixed.

FRUIT AND VEGETABLES

Hard Pastels and Pastel Board

PROJECT TWO

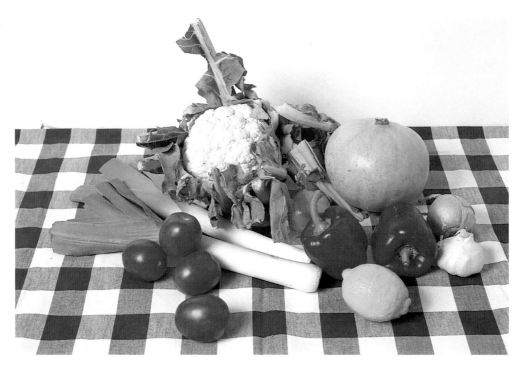

HARD PASTELS ARE IN MANY WAYS EASIER to use than soft pastels, as they shed less pigment and are less prone to crumbling between the fingers. They can be sharpened to a point for detailed line work and are easily used when building up color by cross-hatching. When broken into smaller pieces and used on their side they are perfect for the preliminary roughing out and subsequent blocking in of the composition, as they tend not to clog the texture of the support with pigment, making it possible to overlay more pastel with ease.

The materials used for this painting came from a box of short, square pastels that were extremely good value for money (they cost only a few dollars) which shows just how little outlay you need make to begin working in pastel. The picture was constructed by underpainting using broad simple marks, this was then fixed and glazed over with more pastel, finally details and highlights were flicked in bringing the picture to life.

The choice of color for the support may at first seem puzzling after what was said in the previous project regarding the choice of paper and board color. However, working on a color that is dark in tone but not strong of color will have the effect of seemingly strengthening your pastel colors making them stand out and sparkle, jewel-like, against the dark ground. This can be especially effective with subjects that are brightly colored, such as flowers and fruit. Brightly lit compositions also benefit from this treatment as the tones seem so much brighter when they sing out in contrast against the darker ground.

You will need a 12 × 16 in. (30.5 × 40.5 cm) sheet of blue-gray Frisk pastel board and pastels in the following colors: white, Naples yellow, yellow ocher, dark olive green, leaf green, light leaf green, dark green, dark gray-green, lime green, burnt sienna, dark cadmium red, mid cadmium red, light cadmium red, cadmium yellow, light cadmium orange, dark orange, lemon-yellow, light gray, and black.

MATERIALS AND EQUIPMENT

12 x 16 in.
(30.5 x 40.5 cm) blue-gray
Frisk pastel board
Hard pastels in white,
yellows, greens, burnt
sienna, reds, oranges, light
gray, and black
Fixative

The Painting

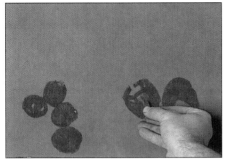

1 Working on a sheet of dark, blue-gray pastel board, three reds, light, medium, and dark, are used to establish the color of the bell peppers and tomatoes. The square pastels are used with hard precise strokes that follow the contours of the subject and the marks are left unblended.

No preparatory drawing is done but if you wish, do a faint sketch with a light pastel to act as a guide.

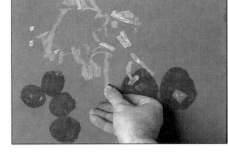

2 A light leaf green and a duller leaf green are used to draw in the shapes and positions of the leaves of the cauliflower and the red pepper stalks. The pastel marks are drawn using the full width of the square end.

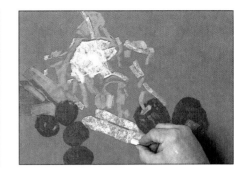

3 The same dull leaf green pastel is used to block in the leek leaves, a darker green establishes the shadow. A few strokes of lime green are placed on the foliage of the cauliflower, then a very light ocher is used for the florets. The whites of the leeks are blocked in with broad strokes using the side of a white pastel.

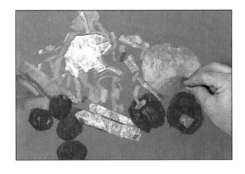

4 Turn your attention to the squash—using the ocher, dark olive green, lime green, and blue-gray fill in its shape, following the contours, but paying close attention to how the colors change on its surface as it reflects some color from the objects that surround it. Use the same dark olive color to paint in the shadow on and around the leeks.

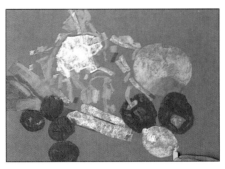

5 For the lemon, use a pale lemon yellow on the upper surface of the peel with cadmium yellow on its underside, a little white gives the highlight.

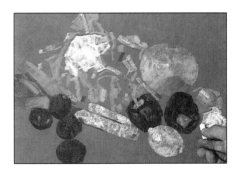

6 With a light burnt sienna glazed over with light red and Naples yellow, establish the form of the onions, then, work carefully in and around the shapes made by the other vegetables. White pastel establishes the bulb of garlic.

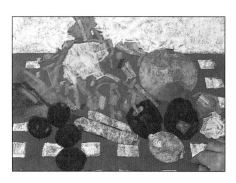

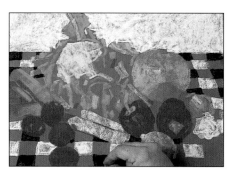

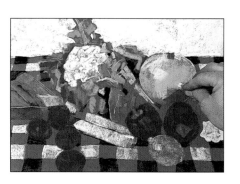

7 With white pastel used on its side, loosely block in the background, cutting around the shape of the cauliflower leaves. Then with simple, clean strokes, using the same pastel, paint in the light squares of the tablecloth.

8 With the black pastel, carefully paint in the black squares. The drawing is then given a coat of spray fixative, this will be alarming as the colors suddenly look so dull. However, spraying with fixative at this stage serves two practical purposes: fixing what is there and darkening all of the colors. The picture is now reworked using the same colors which are now much brighter than the colors on the board, this simply and effectively doubles the range of colors and tones at your disposal.

9 Rework the greens on the cauliflower adding more detail to the leaves. Dark gray-green and black are worked into the shadows and white is glazed over the cauliflower florets while the colors on the squash are strengthened. Glaze white and Naples yellow over the squash following the curve of its contours.

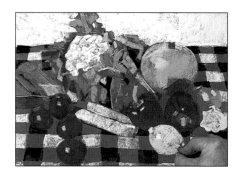

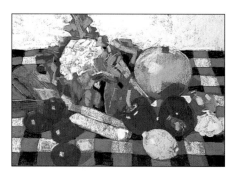

10 Strengthen the form of the red bell peppers and tomatoes: pull a little Naples yellow down the leek roots, use white to press in the highlights with short, sharp strokes and repaint the yellows and oranges of the lemon.

11 The painting is now almost completed: use a cool mid-gray to paint in the gray tablecloth squares. The color of the support is left showing through to act as the shadows that have been cast by the fruit and vegetables. The painting is left unfixed to preserve the brilliance of the colors.

Alternative Approaches

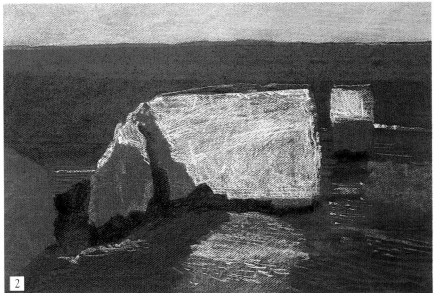

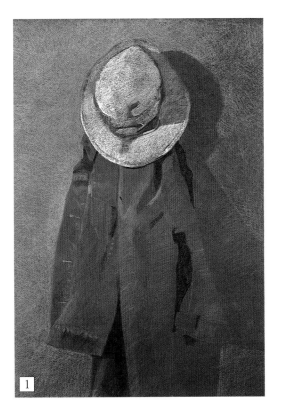

1 In this study of a cream canvas hat and denim jacket the dark warm gray color of the support throws the hat into stark relief, while the bright blues used for the jacket are much more subdued. The dark support helps neutralize the brightness of the hues, making them less strident and more realistic.

2 The dark support color used for this small sketch is made to represent the deep shadows seen on the cliffs and in the sea. A strong bright blue has been pulled across the distant sea using broad flat strokes made with the side of a square pastel, the waves in the foreground are created by using marks made with the same pastel used on edge.

THE LEOPARD SKIN COAT

Drawing and Sketching

ONE OF THE QUALITIES of pastels that makes them stand apart from other media is that they can be considered to be both suitable for painting and for drawing; the difference in definition coming simply from the application, or the way in which they are used. The majority of pastel techniques are the same as many that are used in oil, acrylic, watercolor, gouache, and tempera painting. Colors are built up in solid layers, painterly strokes are used to lay opaque blocks of color next to each other, colors are blended together and built up to form thick layers of impasto pigment, and colors can be delicately glazed over one another.

Drawing on the other hand is all about line, and pastels that are sharpened or used by their tip are well capable of making all of those marks that other traditional drawing media can make. They can produce a line that varies in quality and thickness and they will scribble, hatch and cross-hatch colors.

This wide spread of possible techniques coupled with the lack of any need for water, turpentine or drying oils and the containers to hold them, together with brushes, palettes, knives, and cleaning materials, make lightweight, easy to carry pastel the perfect sketching medium. They also have an added advantage in that this duality of application coupled with the spread of possible techniques makes them very quick to use—which in many sketching situations is a very real advantage.

Working on location outdoors, capturing the fleeting variations of the weather, working at the zoo drawing animals and birds or while traveling on holiday, making color notes for further reference back in the studio, planning out compositions or, as here, making quick drawings from the model, are just a few of the many situations when a small box of pastels and a few sheets of paper, or just a sketch book, are all the equipment you will need.

Work on a 28 × 20 in. (71 × 51 cm) sheet of Not surface white watercolor paper, using white, black, pink, cadmium red, dark burnt sienna, mid burnt sienna, raw umber, cadmium orange, and burnt umber pastels.

MATERIALS AND EQUIPMENT

28 x 20 in. (71 x 51 cm) white Not watercolor paper
Various pastels in white, pink, cadmium red and orange, dark burnt and mid sienna, raw umber, burnt umber
Fixative

The Painting

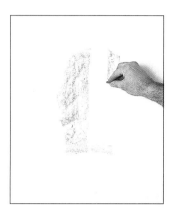

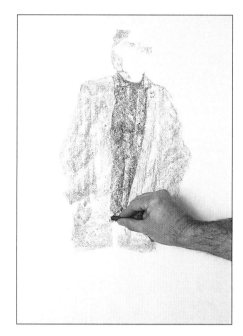

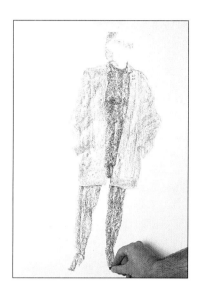

1 Working on a sheet of white Not surface watercolor paper take a few measurements so as to ensure that the proportions and position of the figure are judged correctly: you do not want to half finish the drawing only to find that the feet or head will not fit on your sheet of paper.

Using a light raw sienna pastel on its side loosely establish the shape and approximate color of the coat with broad strokes.

2 With a medium burnt sienna indicate the dark side of the face. A dark gray pastel is then used on its side to block in the dark shape that is made by the pullover beneath the model's coat.

3 A burnt umber is used on its side to establish the shape and color of the legs. Pay particular attention to their angle, note how all of the figure's weight is on the straighter left leg. This leg is also marginally shorter, being slightly farther back and behind the bent right leg.

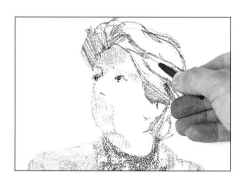

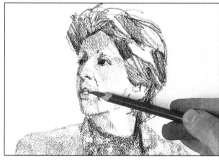

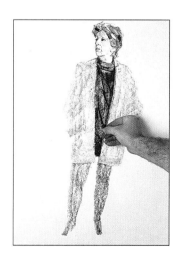

4 With a black hard Conté pastel or crayon which has been sharpened to a point, begin to draw in the hair and features. Work lightly to begin with as the harder Conté crayons are more difficult to erase should you need to correct a mistake. Once the position and shape of the features appear to be correct, the lines can be strengthened.

5 With a sharpened burnt umber and red Conté pastel, or the equivalent color pastel pencil, continue to develop the features, working the shape of the nose and putting color into the lips.

6 A soft black pastel is used on its side to darken the pullover. Turn the pastel on to its long edge, and by applying more pressure— redraw and darken the curve of the neckline and the creases that describe the way the pullover hangs.

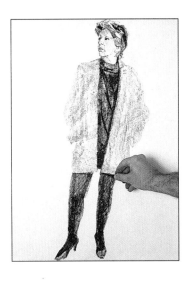

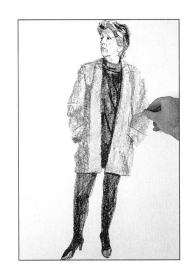

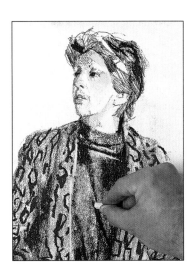

7 Using a combination of pastel pencil and soft black pastel redraw and sharpen the shape of the legs together with the shoes. Shoes can be surprisingly difficult to draw, as a rule keep them simple and, if you have difficulty, merely hint at their shape by using just a few lines or blocks of color.

8 With a combination of a dark burnt sienna, raw sienna, and a bright cadmium orange block in the colored planes that give shape to the coat, use the pastel on its side to obtain the maximum coverage on each stroke. By pulling the pastel sideways while holding it on one of its four edges you will get a crisp, dense line.

9 White and pink pastel give some form to the light side of the face. Then, with a burnt sienna pastel used with some pressure, establish the pattern on the fake fur coat. A few white highlights are then pressed on to the pullover.

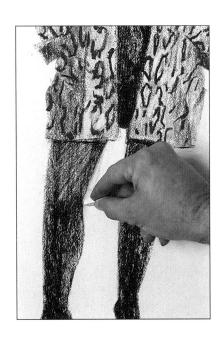

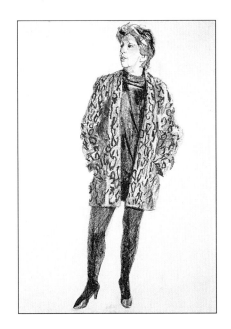

10 Finally a white pastel is used to cut in and around sharpening and correcting the figure's outline.

11 When fixed you will notice how the colors alter very little against the white surface of the support. The entire sketch was completed in less than half an hour, and shows what a fast medium pastel can be.

Alternative Approaches

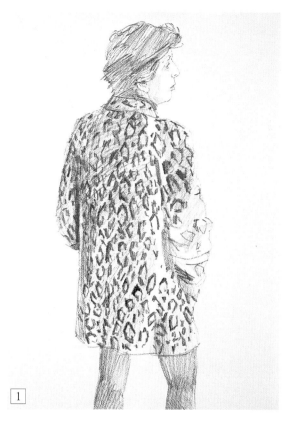

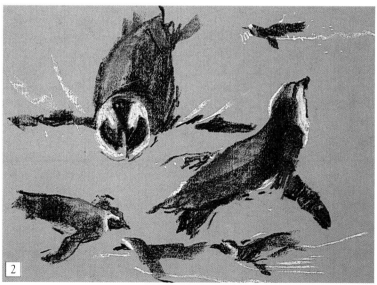

1 In contrast to the project drawing, here the figure was first sketched out in line. A minimum amount of color, detail and pattern were then added to help describe the form.

2 The shape of a broken piece of pastel is perfect for making quick, gestural drawings that capture movement and impression. Birds and animals rarely stay still for long unless asleep, so a quick technique is essential. Here just a few strokes capture the essence of swimming penguins and provide ample information to use as reference at a later date.

GIRAFFES

Velour Paper

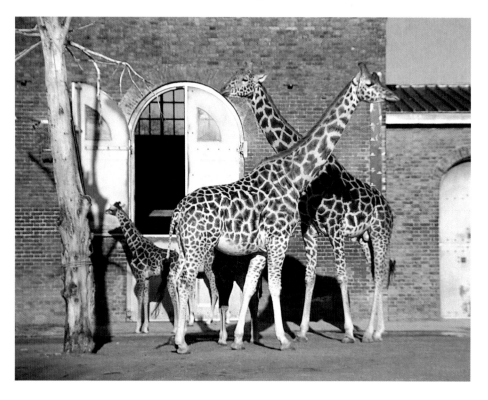

VELOUR PAPER OFFERS A VERY DIFFERENT surface to that offered by Ingres and the other more conventional papers. Velour papers have a soft, velvety nap that takes the pigment from soft and hard pastels very easily. These papers need to be handled and stored with a certain amount of care as they are easily marked or scuffed; the same is true when they are being used, try not to rub your hand across the surface—especially if you are wearing jewelery. Velour papers cannot be wetted and stretched like ordinary papers, neither can fixative be used on them as this dissolves the adhesive that holds the velour surface on to the backing paper. Pastel is easily rubbed off, or smeared, on velour papers

so it you have difficulty keeping your hand off the surface and you are working flat or horizontally, rest the side of your drawing hand on a clean sheet of paper placed over the drawing.

However, when you are working vertically on an easel it is much easier to keep your hand from rubbing over the work, in addition the use of a mahl stick can also help. These can be purchased at most art stores, although they are very easy to make: simply cut a bamboo garden cane so that it is 3 to 4 ft. (around 1m) long, make the cut just above a joint. Roll up a ball of cottonwool and place it over the cut end, take a chamois leather cloth and cut a square from it, about 8 × 8 in., (20 × 20 cm) that is sufficiently large enough to cover the ball of wool, and be gathered neatly and tightly around the top of the cane. To secure the pad bind the chamois where it joins the cane with fine string, once firmly tied any surplus chamois sticking out below the binding can be cut off with a sharp scalpel. The slight bulge of the joint on the cane prevents the pad and binding from slipping off the end.

Work on a 16 × 23 in. (40.5 × 58 cm) sheet of dark ocher velour paper using white, dark ocher, light ocher, Naples yellow, raw sienna, burnt umber, burnt sienna, dark burnt sienna, Prussian blue, cobalt blue, light cobalt blue, dark gray, and black.

MATERIALS AND EQUIPMENT

16 x 23in. (40.5 x 58 cm) dark ocher velour paper • Various pastels in white, dark and light ocher, Naples yellow, raw burnt and dark burnt sienna, burnt umber, blues, gray, black

The Painting

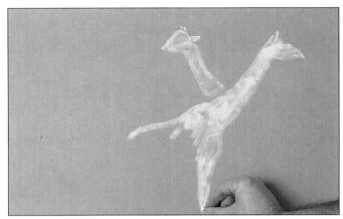

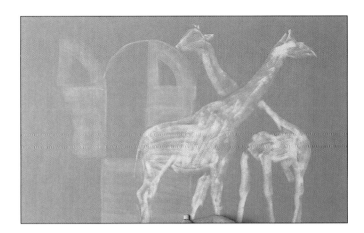

1 On a sheet of dark ocher velour paper use a small piece of soft Naples yellow pastel to block in and establish the shape and position of the two giraffes using fluid, light strokes. Very little pressure is needed as the velour paper takes the pastel easily. Corrections are very difficult on this paper so think very carefully before you commit yourself to making any marks.

2 With a small piece of light cobalt blue pastel lightly indicate the shape of the giraffe house door. Take care not to rub your hand over any pastel work already done as it will easily smudge and smear.

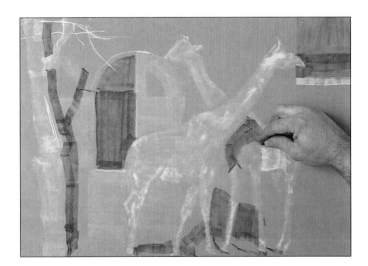

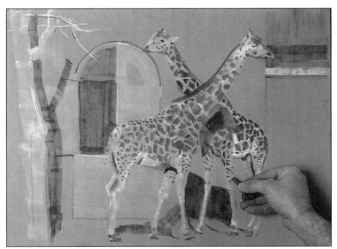

3 A yellow ocher line describes the base of the building and the darker patch of light color on the giraffes' heads. Then Prussian blue is used to block in the sky and a light Naples yellow used to establish the shape of the tree. A dark gray is used to give the dark shadows that can be seen inside the giraffe house, on the roof of the building on the right, behind the tree and on the giraffes, use the same color for the animals hoofs.

4 The giraffes' manes are represented by pulling down a line of burnt sienna. A dark gray line gives the gap around the doors, then a combination of burnt umber and raw sienna is used to carefully draw in the camouflage pattern on both giraffes. Note the way the pattern is distributed over the body actually helping to describe the form.

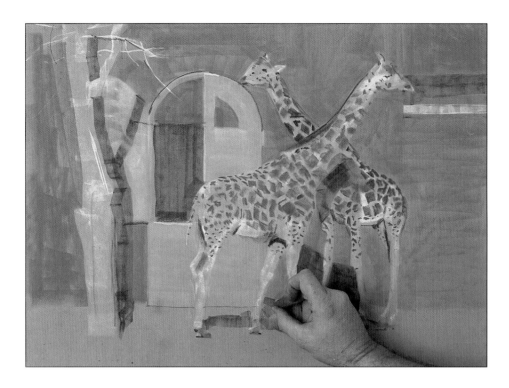

5 With a soft dark ocher pastel used on its side for maximum coverage, block in and darken the giraffe house wall.

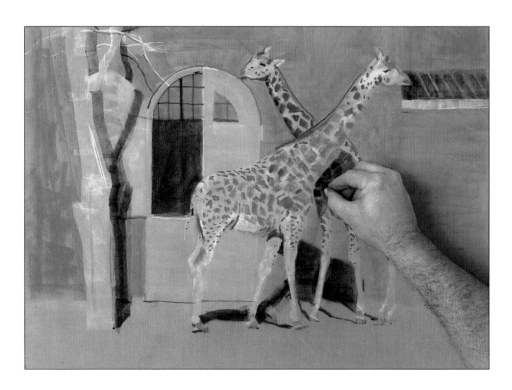

6 With black pastel darken the pattern on the far giraffe's neck together with the pattern in the deep shadow on its front. Intensify and darken the color inside the giraffe house and draw in the shape of the window glazing bars. Also darken the giraffes shadows and the roof on the right-hand side.

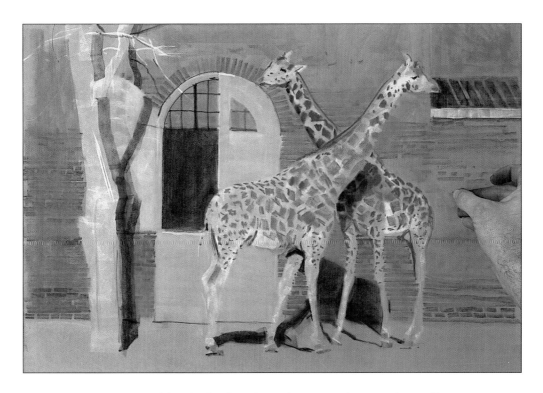

7 Add a little detail to the tree; then with small pieces of square umber and sienna pastels draw in a suggestion of the brickwork.

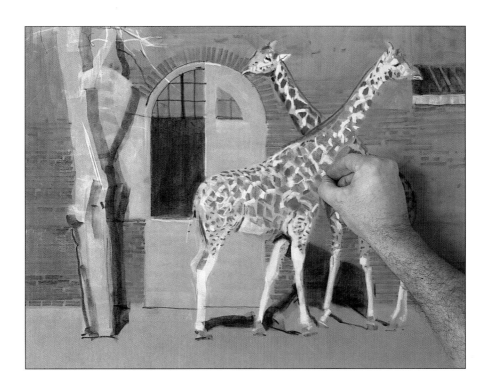

8 Return to the giraffes and rework the light areas between and around the dark pattern with a Naples yellow pastel. Pull some color down to strengthen the color on the spindly legs.

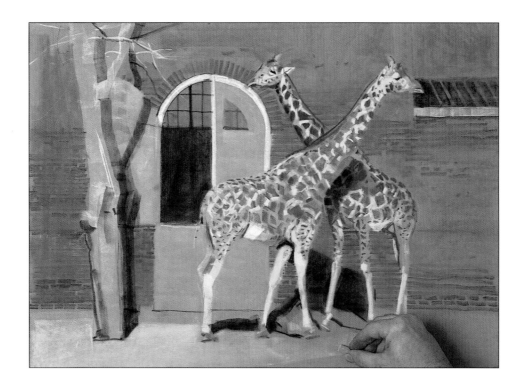

9 Lighten the door surround with white and use it again on the belly of each giraffe. Drag a little light blue across the foreground to give a suggestion of the compound floor.

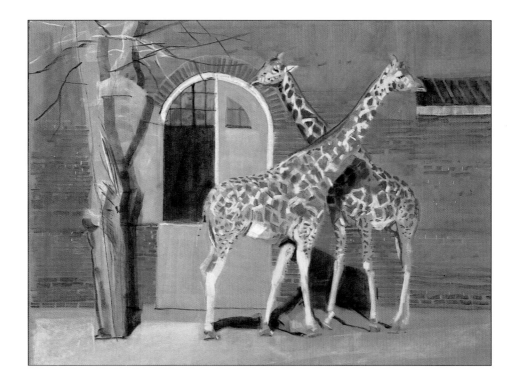

10 The painting is completed by adding Naples yellow details to the brickwork. Burnt umber adds a little bark to the tree and the sky is made lighter with the addition of cobalt blue.

Alternative Approaches

1 Short pieces of square or round pastel used on Mi-Teintes paper make establishing the elephant's shape and color fast and easy. The same pastel used on edge delivers a feint, fine or thick heavy line depending on the pressure. None of the colors are blended—this keeps them crisp and bright.

2 This study of macaws was made with large and fast gestural strokes utilizing the side of the pastel. This can best be seen on the wing and tail feathers where the pastel is used on its side and turned as the stroke is delivered to make a fluid, feather-shaped mark. Animals can be awkward to draw unless the action is frozen by taking a photograph, working from birds and animals in captivity is always good practice as many of their actions tend to be repetitive.

ROUSSILLON

Sandpaper and Impasto

I FIND FINE SANDPAPER to be one of the most ideal surfaces for making pastel paintings on—it is extremely pleasant to work with and its fine, regular tooth easily takes marks made by soft pastels, hard pastels and pastel pencils. It will allow most techniques to be used, including reasonably delicate fine line work, subtle glazing and the build-up of heavy impasto, and gives a look to the finished work that is perhaps most like that achieved when oil paint is used on canvas. Its only major drawbacks are that it cannot be worked on using water or water-based paints as these dissolve and break down the adhesive that keeps the sand in place on the backing paper and the fingers can become sore after heavy blending and rubbing on the gritty surface.

Fine sandpaper is available in various grades, the finest is 00 grade and is known as flour paper, it comes in a neutral buff color and can be found in art shops. Hardware stores also stock sheets of sandpaper in

various grades and colors along with emery paper which is almost black in color and used for polishing the surface of metals and alloys although it can also be used as a surface to work on. The two slight disadvantages that paper bought from hardware stores have, are the size of the sheets available, which are invariably small, 11 × 9 in. (28 ×23 cm) and they are not made from acid-free materials. This means that given time, the color of the pastels may be affected; that said, they are perfect for sketching, experimenting and the working out of ideas—in other words when the longevity of the work is not of primary importance.

The secret of successfully working on this type of support is to build the work gradually, avoiding too heavy a build-up of pastel too early on. Do preliminary work with the harder pastels and pastel pencils, if possible leaving any heavy impasto work with the softer pastels until the final stages. Erasing marks, however, can be a problem—limited success can be achieved by using putty rubbers, blue tack, or even masking tape which if rubbed down over the pastel will remove some of the pigment dust when peeled away. Excess pastel can also be removed by using a stiff bristle brush. By far the easiest solution is simply to work over any mistakes with thick layers of pastel.

Work on a 30 × 22 in. (76 × 56 cm) sheet of 00 grade flour paper using a selection of white, Naples yellow, yellow ocher, dark yellow ocher, terracotta, burnt sienna, burnt umber, raw umber, dark gray, light blue-gray, cerulean blue, cobalt blue, Prussian blue, light green, dark green, light pink, and black.

MATERIALS AND EQUIPMENT

30 x 22 in. (76 x 56 cm) 00 grade flour paper
Soft, hard and pencil pastels in white, yellows, browns, grays, blues, greens, pink, and black

The Painting

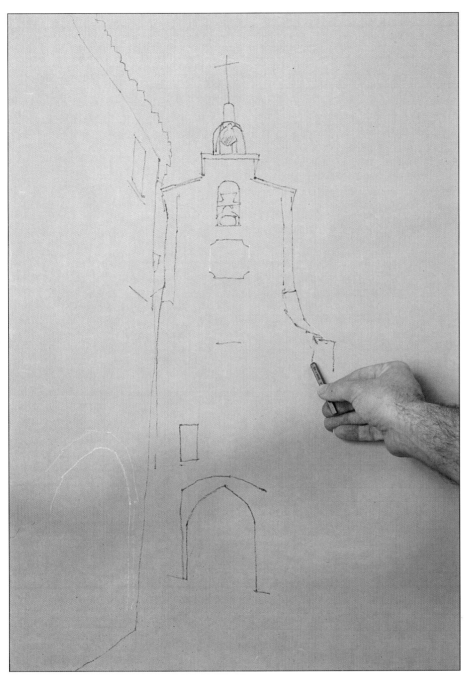

1 Begin by sketching in the tower and buildings with terracotta, Naples yellow, and black pastels. Work lightly so as to avoid an early build-up of pigment dust clogging the tooth of the sandpaper.

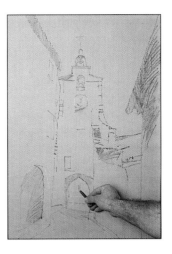

2 Continue to work across the street until all the buildings are established. Use the black pastel to lightly scribble on tone over those areas that are dark and in deep shadow.

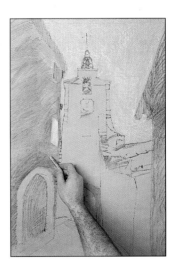

3 With a light cerulean blue pastel used on its side, block in the sky and the blue shutter in the side of the building on the left. Darken the building on the right a little and the dark doorway at the base of the building on the left. Then use burnt sienna, burnt umber, and ocher pastels to establish the overall terracotta color of the same building.

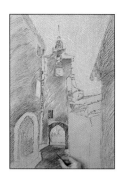

4 The bell tower is blocked in next using a mixture of Naples yellow, raw umber, and dark gray scribbled on and blended together using the fingers, draw in the wooden shutter on the window using dark gray. Establish the position of the bushes seen through the archway with light green. Scribble dark gray over the road and darken the shadow beneath the arch with Prussian blue and more dark gray.

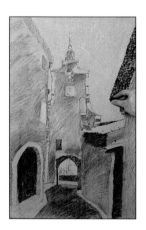

5 Block in the pink door with terracotta and darken the wall of the low building on the right with burnt umber and burnt sienna; the shadow from the roof is darkened with burnt umber. With dark gray color in the doorway on the right and the arched doorway on the left. The color of the wall that can be seen through the archway is established with burnt umber and dark gray, then a small piece of black pastel is used to block in the dark shadows seen beneath the eaves of the building on the right.

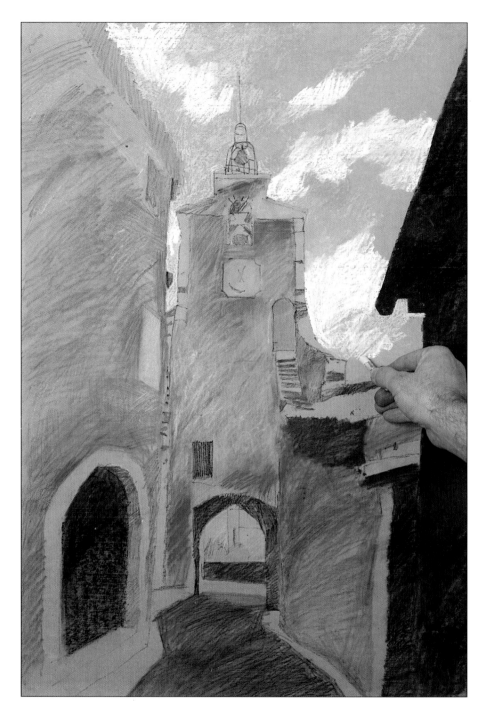

6 Finish blocking in the dark building on the right with burnt sienna and black, then fix the whole drawing. Using white, cerulean, and cobalt blue rework the sky with short hatched strokes of thick impasto color. Begin by painting in the white clouds then work around them with the two light blues.

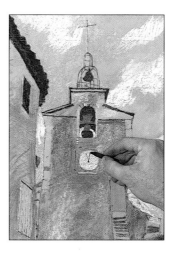

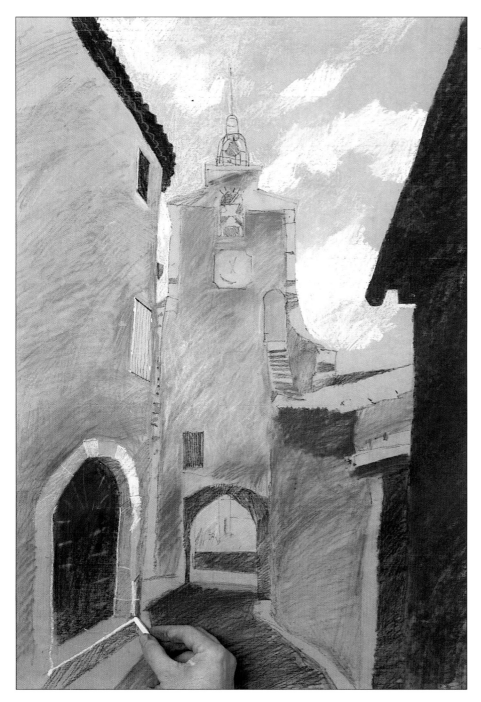

8 Light blue-gray, Naples yellow, and ocher are glazed in layers on to the tower. Naples yellow also adds a few light accents at the top of the tower and around the bell—pull some of the same light color down the top of the wall that runs to the side of the steps that ascend up to the bell tower. Then with a sharpened hard black pastel draw in the details on the tower, bell, and clock.

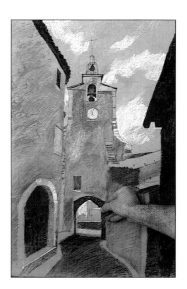

7 With the black pastel darken the roof line and windows on the building to the left. Draw in the line of tiles with burnt sienna and the details on the blue shutter; then with a darkish yellow ocher and burnt sienna pastel dab on some heavy marks across the wall. With the Naples yellow pastel lighten and define the stonework around the dark doorway on the left.

9 With Naples yellow, highlight the sill beneath the shuttered window on the tower. Cerulean blue is used for the light path seen through the arch and a white line describes the sunlit top of the wall. The walls of the buildings are then blocked in again using Naples yellow.

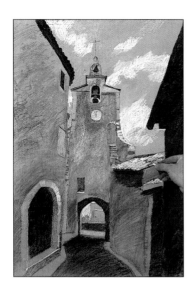

10 With square burnt sienna, Naples yellow, and light pink pastels, used short strokes with the square end of the pastels to describe the shape of the tiles seen on the roof.

11 With thick heavy strokes using a raw umber pastel paint in the stonework on the right-hand building using choppy, short strokes. Work over this with the lighter yellow ocher pastel to indicate where the light hits the stonework.

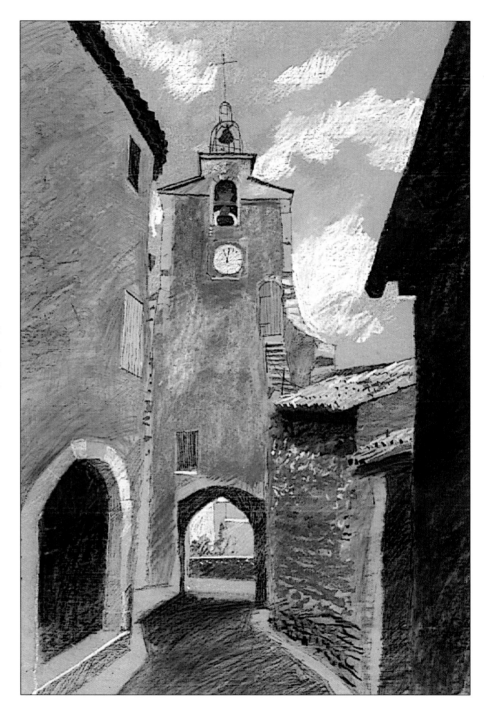

12 The picture is completed by adding some blue-gray stonework to the same wall. Add a few Naples yellow accents to the wall seen through the archway, and finally, indicate the shadows on the shrubs with a little dark green.

Alternative Approaches

1 This painting of Stonehenge utilizes the gray of the paper to represent the local color of the stonework. Thick impasto pastel was built-up in layers for the landscape and sky, and torn paper used as a mask to give the edge between light and dark green grass in the foreground.

2 A watercolor underpainting laid the foundation for this pastel of a beach umbrella and sun loungers—once dry the watercolor was worked over with heavy pastel which takes easily to the rough texture of the watercolor paper.

FLOWERS

Building an Image

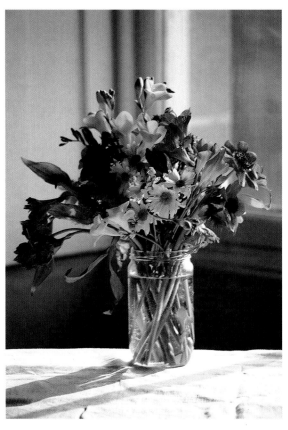

FLOWERS HAVE BEEN A popular subject for the artist since the 16th century, while having been included in many works before that date they had never been thought of as a worthwhile central subject in their own right. Since then most artists, for one reason or another at some point in their working life, turn their attention to flowers—doubtless attracted by the huge variety of forms and colors. Pastels are particularly suited to painting flowers as the purity and brilliance of the vast color range seems to match that of the subject—open a box of pastels and they seem to shout "flowers'. Look at a florists stall and it is if you are looking at a display of pastels in an art supply store.

As with the fruit and vegetables in Project Two, this painting of a bunch of mixed flowers that have been apparently carelessly plonked into a modest glass jelly jar, has been done on a dark paper so as to allow the colors to sing out. The painting was made using a mixture of strokes and techniques and a variety of hard and soft pastels, no blending took place—rather the colors were placed with precise, clean strokes over or next to one another.

In this particular painting the hardness of the pastel was not of any significant importance, each pastel was chosen primarily for its color. The picture was made by slowly building a framework of carefully considered marks relating each to the other until the form of the flowers began to read correctly. The final flower and leaf shapes are drawn and redefined by cutting in and around with the background colors, carefully working the negative shapes.

Work on a dark green 29 x 21 in. (74 x 53 cm) sheet of Canson Mi-Teintes paper using white, dark gray, light gray, dull green, bright green, lime green, bright pink, purple, cobalt blue, cerulean blue, dull orange, bright orange, alizarin crimson, cadmium red, burnt sienna, cadmium yellow, lemon yellow, and Naples yellow.

MATERIALS AND EQUIPMENT

29 x 21 in. (74 x 53 cm) dark green Mi-Teintes paper
Charcoal
Pastels in white, grays, greens, blues, yellows, reds, oranges, browns, bright pink, and purple
Fixative

The Painting

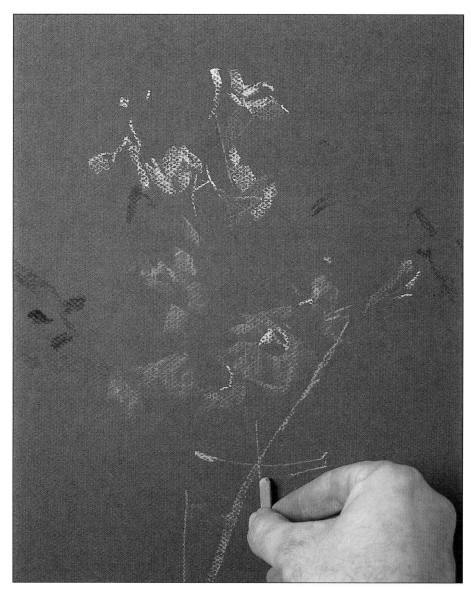

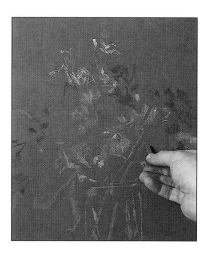

2 Continue to create a framework of shapes and colors using mainly the mid tones, ignoring the highlights and darks for the moment. Gradually the image evolves and comes into focus as the simple blocks of flat color start to relate to one another. Light gray indicates a few reflections in the glass jar and a burnt sienna pastel is used to draw in a flower stem.

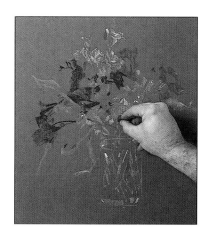

1 Working on a dark green paper begin to establish the shape and position of the flowers using small pieces of pastel that are as close in color to those colors seen on the subject. The positions of the first few marks are very important as everything else is related to them. Do not press too hard at this stage as the intention is to lay in just the ghost of an image that will provide a foundation and guide for further work. A light gray pastel indicates the shape of the glass jar.

3 The process continues, now turning attention to the very dark greens and blacks; these are worked carefully in and around the mid-toned brighter flower colors showing the position of those leaves and flowers that are in deep shadow.

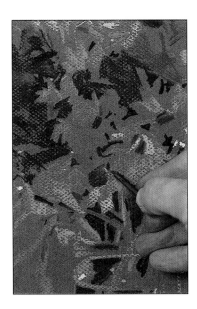

4 Tight intricate areas are picked out using a sharpened charcoal stick to draw around and through the forms—cutting in and redefining their shapes.

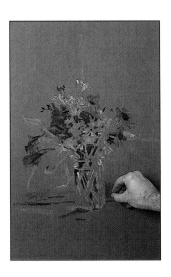

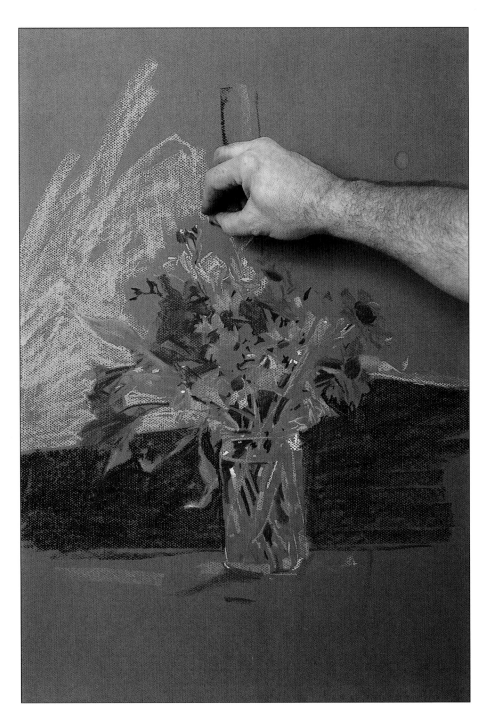

5 As the dark blocking in continues, the flower shapes are seen to emerge from the dark green paper and the image is almost complete. Still using a black pastel, or stick of charcoal, begin to indicate the negative spaces between the flower stems seen through the jar; then using a black pastel on its side, block in the dark wall behind the jar, together with a few of the shadows that can be seen to fall across the cloth.

6 The painting can now be given a coat of fixative. Once the paper is dry a light blue-gray pastel is used on its side for maximum coverage to establish the light wall to the side of the window.

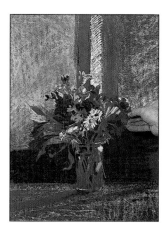

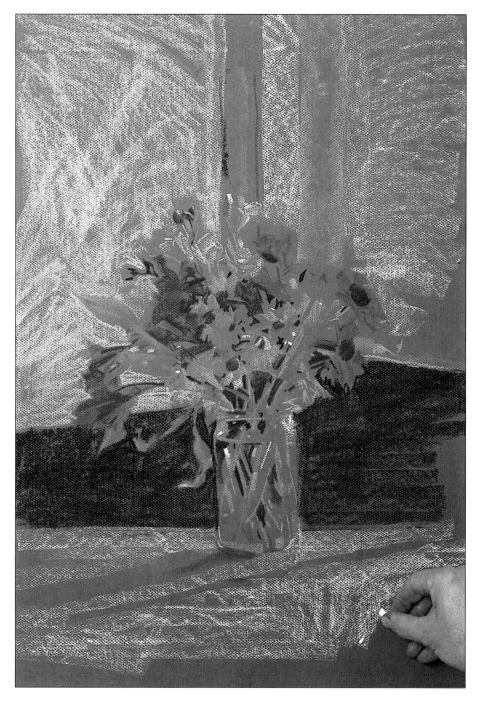

Strengthen the light gray behind the flowers and scribble more Naples yellow into the vertical strip running down the center of the painting. White picks out the shape of the daisies and the other flower colors are strengthened and shapes redefined using clean precise strokes using a range of red, yellow, and purple pastels. Once this process is completed give another coat of fixative.

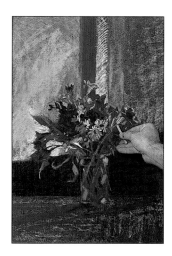

Single strokes of Naples yellow and burnt sienna establish the frame of the window, while cerulean blue loosely blocks in the blue outside. With white, block in the tablecloth leaving the color of the paper to represent any shadows. Once done the painting can be refixed.

The background is reworked and the colors in the picture intensified, some cobalt blue reflections are put on the glass jar. Strengthen the stalks with green and the vertical strip with burnt sienna. The colors become slightly duller each time they are fixed, enabling the same color to be used in layers, each one appears to be a different shade or tone. This is most obvious on the daisies and other flowers.

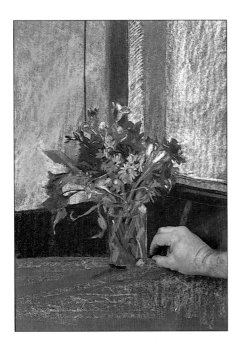

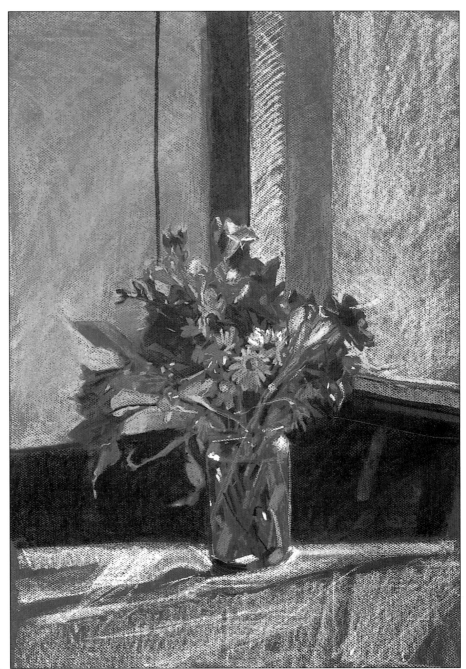

10 A few bright green accents on the foliage and the stems seen through the jar are made with a lime green pastel. The vertical dark line on the wall behind is drawn in with the end of a square black pastel; work also by darkening between the flowers, the stems and through the vase with black pastel and charcoal.

12 The finished painting has a brilliant jewel-like quality with the bright colors working hard against the dark color of the support. Had the painting been done on a paler paper the intensity and brightness of the finished image would have been reduced.

11 Finally paint in the highlights and the tablecloth with heavy but firm strokes.

Alternative Approaches

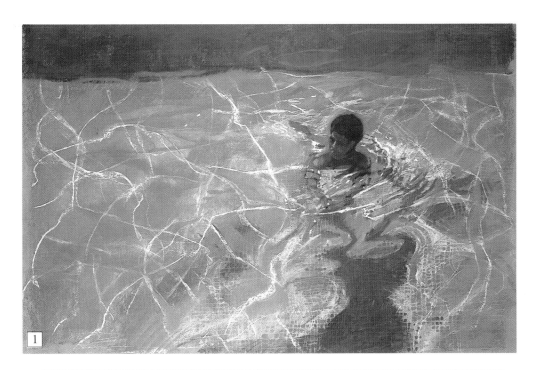

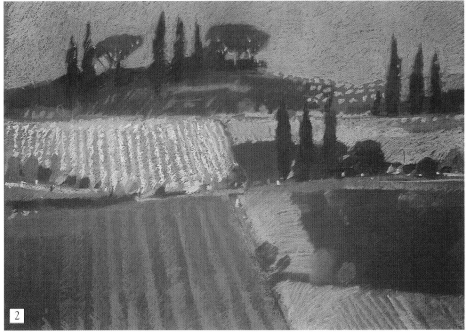

1 Heavy impasto applications of pastel built the foundation for this painting of a swimmer. The painting was well fixed before more pastel was glazed over the surface creating the subtle differences of tone and color seen in the disturbed water. White was finally used to give the pattern of ripples and the mosaic of tiles that can be seen through the water on the base of the pool.

2 This landscape in Tuscany was painted using large thick pastels to scribble on the pigment; fixative was used between layers, not just to fix the work but to "knock back" or deaden the color. This technique enables the same color to be used several times on top of itself, each layer looking like a brighter version.

PENGUIN POOL

Pastel on Marble-dust Board

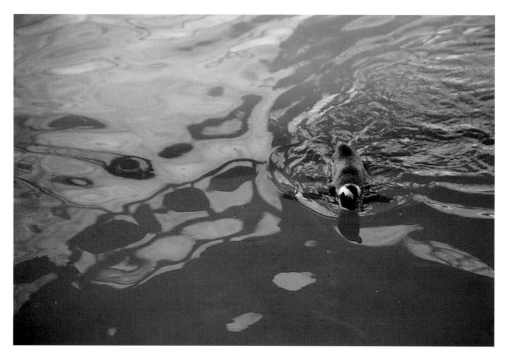

FOR REAL DEPTH OF COLOR AND A surface that allows far more layers of pastel to be applied than is possible on paper, there is no substitute for a board prepared with acrylic gesso and marble dust. Preparing the boards is simplicity itself and their very nature makes the act of working in pastels more closely related to painting than it already is. The rigidity of the board also seems to be reassuring and gives the work a feeling of permanence and stability that can sometimes seem lacking in works that are done on paper.

The boards can be prepared using thick card, hardboard or medium density fiber-board. MDF is available in various thicknesses, is very stable and not prone to warping or bending, the surface is also able to

stand up to quite rough treatment making it possible to scrape out work and make corrections. Any marble dust surface that is also removed in the process can be renewed by sprinkling on more dust and spraying with fixative to bond it on to the surface. Marble dust can also be added as you work in order to increase and vary the tooth in different areas of the painting.

One more advantage of working on board is that it enables the artist to employ the technique, used in this project, of mixing and working into the preliminary layers with a liquid medium, this can be either spirit or water-based. With spirit-based mediums such as turpentine or white spirit the pigment is spread easily but darkens appreciably, this can be no bad thing and once dry gives a stable surface ready for further work.

Water mixes and spreads the pastel just as easily, the colors also become dark when wet but lighten again once dry. I mix a little acrylic matte medium with the water which mixes well with the pastel and dries to give a stable surface that will not smear as it is worked on. Several layers can be built up like this but care must be taken not to add too much acrylic medium or it may clog the tooth of the support.

Work on a piece of MDF that has been prepared using acrylic gesso and marble dust. Use white, light, mid, and dark cerulean blue, cobalt blue, Prussian blue, dark turquoise, black, dark green, pink, light green-gray, and cadmium yellow.

MATERIALS AND EQUIPMENT

MDF board prepared with acrylic gesso and marble dust
Fixative • Torchon
Pastels in white, blues, greens, turquoise, yellow, black, and pink

The Painting

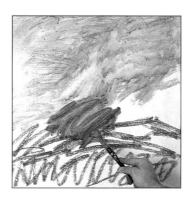

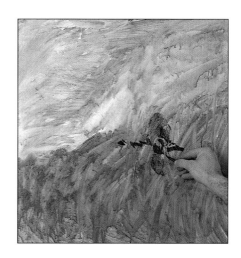

1 Work over the marble board with three blues: cerulean, light cobalt, and Prussian. Use the side of the pastel for maximum coverage and speed, there's no need to cover the board completely. The three blues, light, medium, and dark are positioned on the board to roughly correspond with the light, medium, and dark areas of water.

2 Mix up a little acrylic matt medium with water and, using a large flat brush, scrub over the surface loosely blending the pastel on to the board. If you're working vertically don't be concerned if the mixture runs, this will be covered by subsequent work. Allow the work to dry before continuing, the process can be speeded up by using a hair dryer.

3 With a sharp, hard black pastel draw in the shape and position of the penguin. Work the pastel heavily over those areas that are very dark and lightly scribble a little pastel on to the lighter area of the penguin's back and the reflection of the head that can be seen in the water.

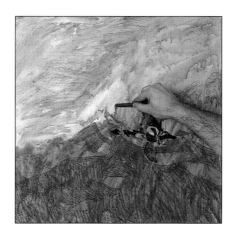

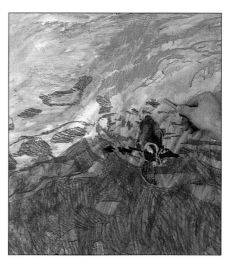

4 A little white is added for the light plumage on the top of the head and around the eyes, some more white is scribbled on to the back and, using a torchon, blended with the black to make a gray. Add a little pink above the eyes and smooth out the white on the head with the torchon and fix.

5 With a dark turquoise pastel work over the dark reflections seen in the foreground and around the penguin. Use a loose open scribbling technique. Do not try to completely cover the board with opaque pastel or the surface will become clogged with pigment, and try not to work too literally as there is no need to paint in every last reflection and ripple.

6 Work the mid blues in the same way using the same open scribbling technique, add a little gray into the ripples that spread out behind the bird.

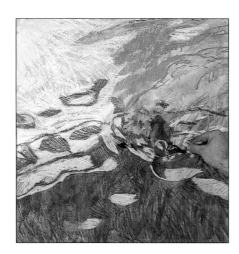

7 With the very pale blue block in those areas of water where the reflections are at their lightest. Already the illusion is beginning to work: the water has depth and the penguin appears to float comfortably on the surface.

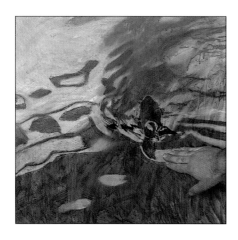

8 Once the blocking in of the water is complete the scribbled colors are roughly blended and smoothed. The fingers are used for the larger areas and a torchon for small, intricate areas around the penguin. When this is done the painting is given another spray of fixative.

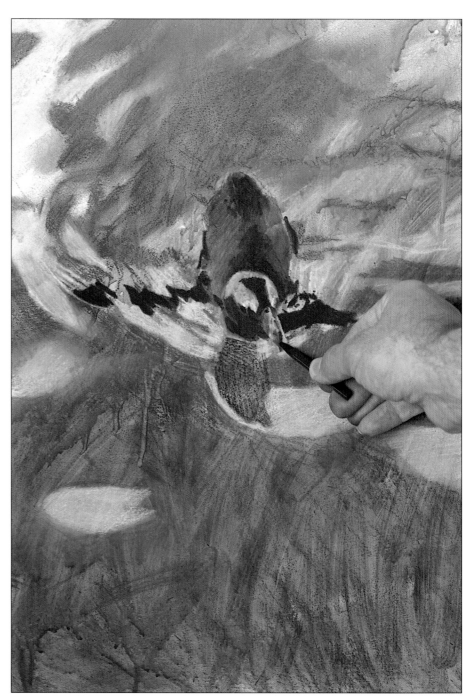

9 Darken, sharpen and redraw the shape of the penguins' wings beneath the water using black and dark blue pastel. Carefully observe how the ripples fragment and distort the part of the bird beneath the water.

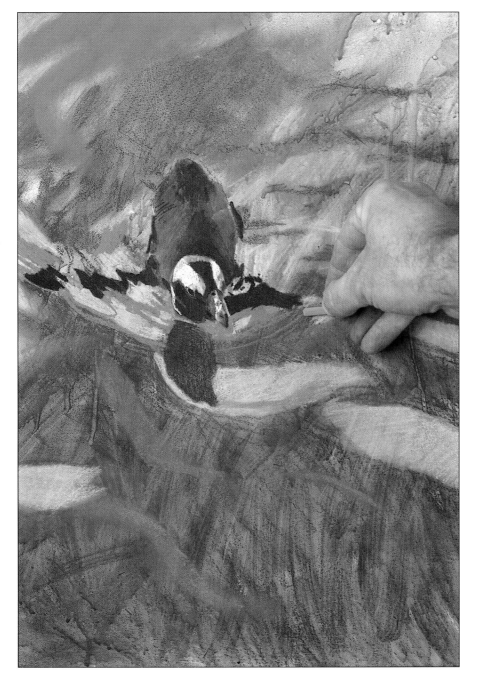

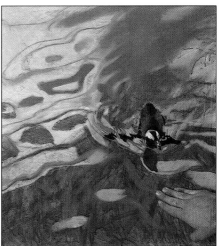

11 The darker cerulean blue is pulled across the painting in fluid wavy lines describing the effects of the light coupled with the movement of the water. Blend with the fingers or the torchon to remove any crisp hard edges and then fix again.

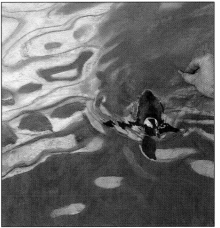

10 Add a patch of white to both sides of the head just above the eyes and a few white accents on the bill. Then, with a dark green, deepen the color seen in the reflection of the head and using a dark cerulean blue carefully paint in more of the ripples around the bird.

12 Rework and darken the deep blue, work in layers smoothing out the pastel as you go until the right depth and density of color is achieved.

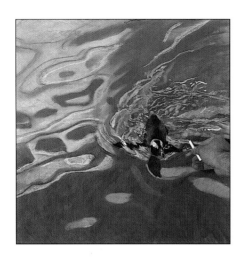

13 Light blue and white pastels are then used for the sparkle and highlights on the water. The light blue is used first to establish the delicate tracery of small ripples, followed by the white which is applied thickly using heavy pressure to leave a lot of pigment.

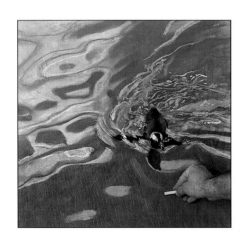

14 The picture is completed by using a hard cadmium yellow pastel for the mosaic of tiny tiles on base of pool: notice how the water distorts, magnifies and curves the straight lines of tiles.

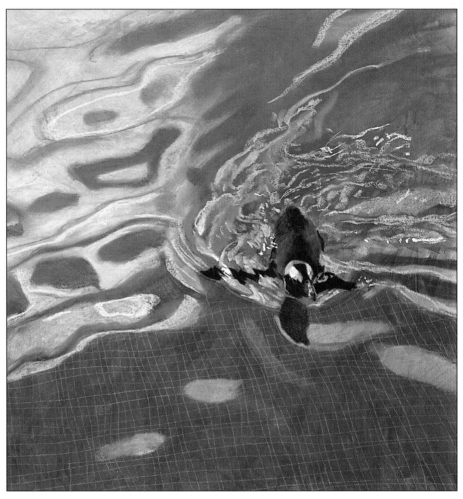

15 In the finished painting it can be seen what a difference the tiles have made—all of the work until the final stage had been about representing what was happening to the surface of the water—with the introduction of the distorted tiles on the pool bottom suddenly there is an illusion of real depth.

Alternative Approaches

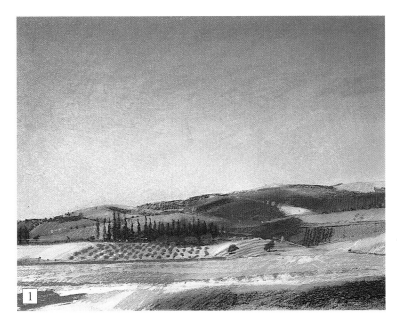

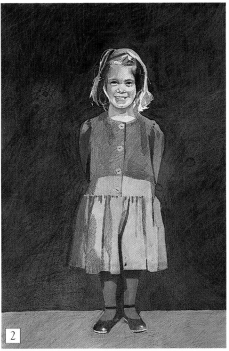

1 Done on a sheet of masonite (hardboard) prepared with marble dust and gesso, this small landscape of a Tuscan hillside was done over another painting which I was unsatisfied with. By adding more marble dust then fixing, and by working in layers of opaque pastel it was possible to work on board without leaving a trace of the previous painting, something which would have been extremely difficult to do on a paper support.

2 This painting of a little girl was done on a sheet of watercolor board prepared with marble dust, the image was established using watercolor before being finished with hard pastels to heighten color and develop the details.

PORTRAIT

Drawing with Pastel Pencil

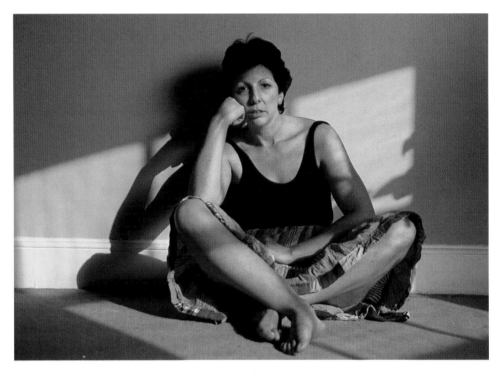

IN ALL OF THE PASTEL WORKS THAT HAVE been reproduced in this section so far, apart from Project Three, line work has been kept to a minimum or is virtually non-existent. The pictures have been completed using solid applications of color, invariably without any preliminary drawing, using glazing and impasto as well as various traditional painting techniques that are more readily associated with oil or other painting media that use either oil or water-based mediums as vehicles to carry and spread the pigment.

As we have mentioned previously, pastels are unique in that they fall between two stools, being both a painting and a drawing material—using techniques taken from both disciplines. Soft pastels are capable of line work but far better results will come from using hard pastels, or pastel pencils, which will allow solid areas of color to be made, but are put to better and more economical use when used for line work.

The ability of pastel pencils to switch from making solid blocks of color to fine intricate line work make them an extremely versatile medium. They can be used on all of the textured surfaces that are used when working with soft pastels, with the added advantage that they are clean to work with. Pastel pencils deposit less pigment on to the support, so while it is possible to blend colors with the finger or torchon, better results will come from using those methods that rely on the density or spacing of the line work as seen in scribbling, hatching and cross-hatching techniques. The openness or linear quality of these techniques also allows for considerable amounts or layers of overworking, as the pigment dust takes far longer to build-up and clog the tooth of the support than it would if solid blocks of heavy color were used.

Work on a 25 × 20 in. (63.5 × 51 cm) sheet of beige or buff-colored paper using white, Naples yellow, pink, cadmium red, burnt sienna, burnt umber, cadmium orange, dull green, cobalt blue, dull cerulean blue, light cerulean blue, bright pink, and black.

MATERIALS AND EQUIPMENT

25 x 20 in. (63.5 x 51 cm) buff paper • Fixative Torchon • Hard and pencil pastels in white, red, yellow, browns, blues, orange, green, pink, and black.

The Painting

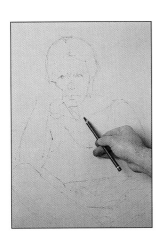

1 Working on cream paper begin by taking a few measurements, making sure the proportions are correct and that the figure sits comfortably in the picture. Lightly map out the position of the figure using black, burnt sienna, and orange pastel pencils, so any lines that are positioned badly can be redrawn without needing to erase.

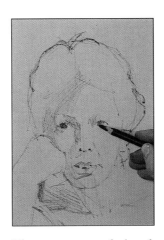

2 The position of the features are redefined and corrected. Tone is scribbled on to the face showing the position of the shadows and a suggestion of form—the lips are drawn using cadmium red and the shape of the hair is redrawn and the eyes darkened with black.

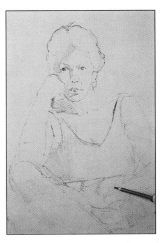

3 With a black pastel, scribble a little color on to the model's top then work over the skirt blocking in the direction and position of the patchwork pattern using an alizarin crimson pencil.

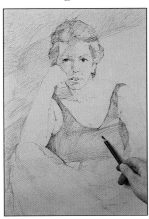

4 Draw the fall of the hair with firm strokes of black and then scribble some of the same color over the background shadow and the hair. Darken the eyes further and draw in the dark area seen inside the slightly open mouth. Lightly scribble a little dark blue into the background shadow, then again using the black, block in the model's top.

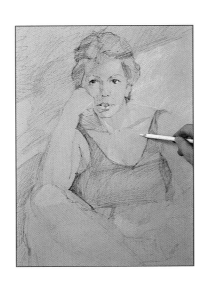

5 With light green, cobalt blue, and cadmium red establish more of the skirt's patchwork pattern, then using Naples yellow, light pink, and white begin to work up the mid to light tones with a series of hatched and scribbled lines. The whole image is now well established and can be fixed.

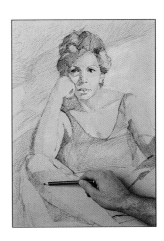

6 Once the fixative is dry return to work—consolidate the dark colors and tones on the face, sharpen the features and darken those areas in deep shadow with hatched and cross-hatched lines using cadmium red and burnt sienna. Establish the shadow that curls over and down the left arm using red, burnt sienna and cobalt blue. Still using cobalt, hatch on to the side of the forehead and nose and over the shadow on the leg.

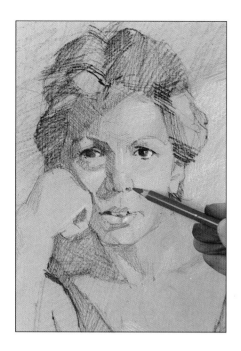

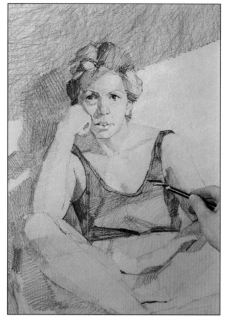

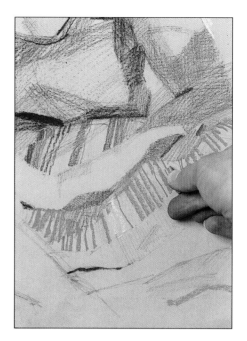

7 Introduce more color into the light and mid flesh tones by cross-hatching more Naples yellow, pink, and white. Then intensify and deepen the color in the deep shadows surrounding the features.

8 With black and cobalt blue darken the shadows on the wall behind the subject, then rework the model's top using varying pressure to indicate the contours of the fabric and the underlying form. Note how the dark line that is drawn across the midriff helps the figure to lean forward.

9 Using a combination of blue, bright pink, sienna, and red hard square pastels and pastel pencils draw in the lines of the pattern that cover the skirt.

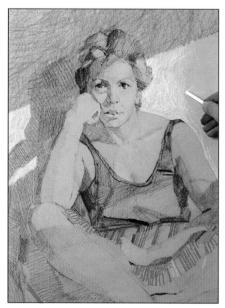

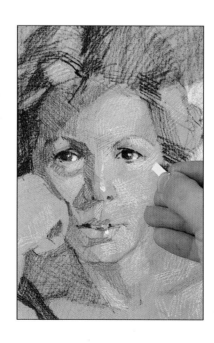

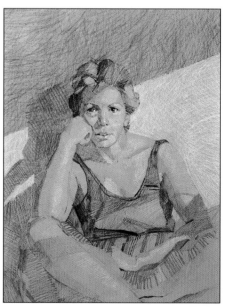

10 With a hard white pastel block in the sunlit wall behind the figure; as with any large area of scribbled color or tone, change direction frequently so that the scribbling does not lead the eye in any one direction.

11 Finally a hard square Naples yellow pastel is used to hatch and cross-hatch highlights on to the face, arms, and hair.

12 In the finished picture the use of scribbling and hatching from the pointed pastel pencils have lent a much more open linear quality that makes the work readily identifiable as a pastel drawing rather than a pastel painting.

Alternative Approaches

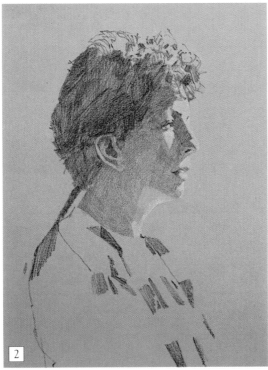

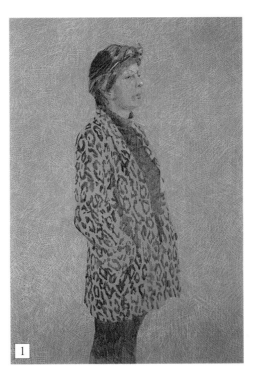

1 Methodical light gray cross-hatching reverses the figure out of its background. In particular note how the leopard skin coat is represented by the color of the support with only the shape of the pattern giving it form.

2 Seen contre-jour, or against the light, this simple study of a woman's profile was done using just five pastel pencils. Again the careful and considered choice of support color has cut down on work.

MATERIALS AND EQUIPMENT

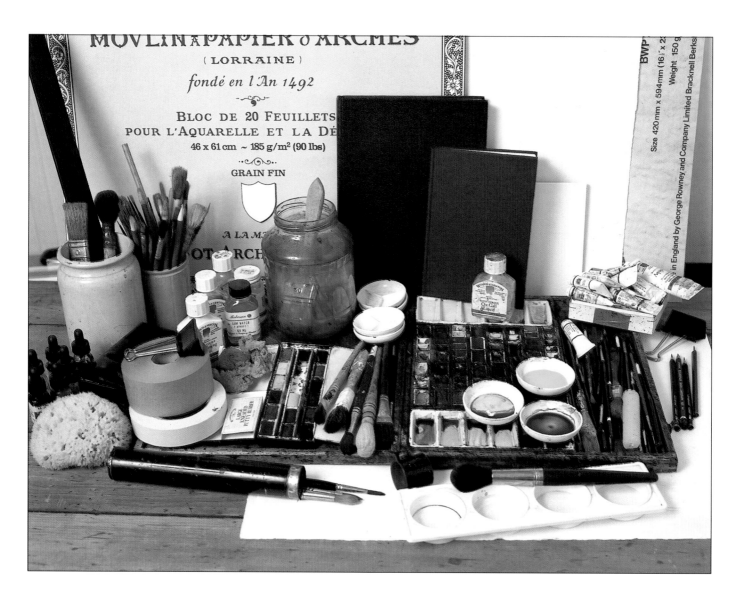

THE TRADITIONAL SUPPORT for watercolor painting is white or pale off-white paper. For the watercolorist the support is of primary importance: it is the brilliance and texture of the paper, combined with the transparent painted washes, that give watercolor paintings their inner light and freshness.

Types of paper and board

The various types of paper have very marked characteristics that make them behave in different ways—some are easy to use and very forgiving, while others can be awkward. With experience artists hit on one or two papers that suit their subject matter and way of working. Finding the right paper can be a matter of trial and error, but hitting on a difficult paper at the start could put the beginner off watercolor painting.

Papers come in a wide range of size, texture, and weight, and most papers are sized with gelatine to give a surface that readily accepts the paint. Size can be added to the paper during manufacture, either at the pulp stage (internal sizing), or applied to the surface of the sheet of paper after it has been made (external sizing). The more size a paper contains the easier it is to remove paint from its surface, which is very beneficial for first-time watercolorists.

Papers are either handmade or machinemade: the best handmade papers are made from pure linen rag processed to remove all the impurities and sized on one side only, this being the correct side on which to work. They are usually watermarked or embossed with the manufacturer's name and have a ragged, or "deckle," edge. Machinemade papers are manufactured from

wood pulp and come with three types of surface: Hot Pressed paper, which is smooth with little or no surface texture; Not or CP (Cold Pressed) paper, which is not hot pressed and has a definite tooth or texture; and Rough, which has a very pronounced tooth.

All three surfaces offer a suitable surface for the watercolorist; however two out of the three have idiosyncrasies that can make them difficult and awkward to use. The smooth Hot Pressed papers are in many ways better suited to drawing, as paint tends to slide over the surface and work can look flat and tired, but flat washes take well and the smooth surface makes it a good choice for fine detail. Rough surface papers can be very rough indeed, making the paint difficult to control, but washes do lie well on the pitted surface, allowing the white of the paper to show through, which gives a satisfying sparkle to the work. Rough surface papers are often favored by landscape artists. Not papers offer the most adaptable and forgiving surfaces on which to work; the slight tooth makes laying washes straightforward and the surface is smooth enough to take detail.

A paper's thickness is indicated by its weight: the heavier the weight the thicker the paper. Two systems exist for measuring weight: the first is in pounds, and refers to the weight of a ream (500 sheets) of that particular paper, for example, 140 lb, 260 lb; the second is in grams, and refers to the grams per square metre (gsm) of one sheet, for example, 300 gsm, 356 gsm.

Thick papers over 300 lb (638 gsm) can withstand heavy work. They stay flat when wet and resist cockling, so do not generally need stretching. Medium and lightweight papers below 300lb benefit from being stretched, although some of the medium-weight papers do stay relatively flat when worked on unstretched.

Paper can be bought in pads, in which the sheets of paper are glued together along all four edges so do not need stretching. When a painting is finished, the sheet can be cut from the rest on the pad, revealing a clean sheet of paper ready for work. Watercolor boards that are stable when wet and require no preparation are also available, but, unfortunately, they are only sold in a very limited range of surfaces.

Paints

The quality of watercolor paints varies greatly, and therefore—perhaps more than any other medium—it pays to buy the best that you can afford.

Watercolors are made from finely ground pigments mixed with distilled water, gum arabic, glycerine, or honey to keep the paint moist and to act as a preservative. The cheaper, or student-quality, paints are often made with pigments that are less pure and have a filler added that extends the pigment, making the colors weaker and slightly chalky. Paints in the professional artists' color range dissolve easily when wet and, for the most part, are permanent, strong and resistant to fading. The color is strong yet transparent and, as already mentioned, it is the paint's tendency to lie on the paper in semitransparent washes—allowing previous layers and the brilliant white of the paper to show through—that is central to successful watercolor painting.

Paint is available in semimoist pans, half pans, tubes of moist color, and bottles of liquid-concentrated color. The liquid color comes in bottles complete with a dropper fitted in the top, so the color can easily be transferred to the palette. These are ideal for working on large formats in the studio where big washes (washes using large amounts of paint) are needed. Unfortunately, liquid colors are not as easy to mix as the pan and tube colors. Liquid colors were originally formulated for illustrators and designers who used them for work intended for reproduction, and they tend not to be as light or as fast as the artist's pan and tube colors.

Tube colors are also useful when working on a large scale, where paints need to be diluted in large amounts. When mixing tube color never squeeze it out of the tube directly into water, as this makes it difficult to mix thoroughly and difficult to gauge the color. Always squeeze some on to a palette and use a brush to transfer small amounts to another palette containing water. In this way the strength of the mixture is built up until the desired color or tone is achieved. Any dried, leftover paint can be reused by wetting in exactly the same way as you would use paint in pans. For this reason it makes sense to squeeze color out on to the same palette or area of palette.

Pan colors are easy to use, and for the novice watercolorist they are the best, as their very nature forces the artist to take color from the pan and mix it with water in a shallow dish or on the palette in relatively small amounts, making the mixing of tones and color a more exact exercise. However, always remember that the color will look duller and darker

once the paint has dried. To this end, it is always a good practice to keep a sheet of paper handy on which to test colors in their wet and dry states before using them.

When exposed to light over a period of time certain pigments are prone to change, with the result that the color becomes lighter and eventually fades. These colors are known as "fugitive." Thankfully, because of improved methods of manufacture and the increasing use of synthetic pigments, there are now only a handful of colors that are considered fugitive: the majority are durable or permanent. Manufacturers' classifications for permanence, which is carried on each tube and pan wrapper, are AA****, extremely permanent; A***, durable considered permanent; B**, moderately durable; and C* Fugitive. Those pigments that are difficult to manufacture or obtain are more expensive than others, so paint is sold either as a series numbered 1, 2, 3, 4, or lettered A, B, C, D, to indicate the price structure; the higher the number or letter the more expensive the paint.

Watercolors are available as separate colors or in boxes containing as many as 24 colors. The range of colors are chosen by the manufacturers and some may not contain the most useful selection, so you may prefer to buy an empty, unfitted box and fill it with your own choice of colors. Whether you choose pans or tubes is really a personal choice, but bear in mind that when, and if, you are working outside all you need to do with pan colors is add the pigment to the water. There is no squeezing out of colors from tubes on to a palette, and pan colors make packing up easy and quick should the weather or the natives turn ugly. A range of plastic or black enameled metal boxes are available. Some even contain a water bottle, water container, and mixing palette, which makes them very portable, tidy and ideal for small paintings done away from the studio.

Brushes

Soft brushes suitable for watercolor painting are available in a wide range of shape, size and quality. They are made from either synthetic fiber, natural animal hair, or a mixture of both. Different brushes serve very different purposes, so it is inevitable that you will find yourself accumulating several; the type and range you choose will depend very much on your subject matter and the manner in which you work. It is perfectly possible, however, to work successfully with as few as three different brushes that have been carefully chosen.

Sable brushes are by far the best: they are also the most expensive, as they are made from the tail hair of the red Siberian mink. The Kolinsky sables fill and hold liquid well, keep their point, shape, and spring, and, if looked after, will last a lifetime, justifying their high initial cost. The larger wash brushes are made from the hair of a variety of animals including ox, pony, goat, and squirrel. These are softer than the sable brushes and lack their springiness. It is also possible to buy a very good brush made from synthetic fibers mixed with natural sable, which will, to a lesser extent, match some of the qualities found in a more expensive brush. For a more moderate price, brushes made entirely from synthetic fibers also do a very good job; many artists use nothing else, but even if they are well looked after they will soon lose their shape and point and need replacing.

The most useful brushes for all-round use come in three main shapes: round, flat, and mop. Because of their shape, "rounds" can successfully cope with a range of jobs from laying down broad, flat washes to fine intricate detail, and are the best brush for all-round use. By varying the pressure and increasingly splaying out the hair, it is possible to achieve a wide range of line thickness. In normal circumstances, working on a modest scale, with just two of these brushes, a no 12 and a no 6, you should be able to deal with most eventualities. "Flats" lay color in a regular, chisel-shaped band according to the width of the brush. With practice you can use them on their side to make a thinner line, but their main strength lies in their capacity to lay even, controlled flat washes. "Mops" are either round or slightly flattened, and, depending on their size, can hold huge quantities of paint, making them ideal for laying in the initial loose, overall washes and for working on a larger scale.

The other shapes of brush that you will inevitably come across serve rather more specific needs and purposes. These go by a variety of names: rigger, fan, hake, and oriental. The rigger consists of long hairs and is designed specifically to hold plenty of paint for making long, straight, or curved fine lines. The fan-shaped brush is a useful addition if you anticipate doing a lot of dry brushwork; it is also used for blending. The hake is a large, flat brush, available in widths up to 6 in. (15 cm) and usually made from goat hair. This brush is

used for washes and the broad, one-stroke application of paint across large areas. The oriental brushes come from China and Japan and are made from a variety of natural hair including wolf, deer, and horse. Held together and glued into a bamboo handle, they can take a little getting used to, as they are not designed for western-style painting. Many of the oriental techniques require the brush to be kept more or less in an upright position; however they do hold paint well, keep their points, and are very versatile.

Brushes come in series and each series contains the same shape brush in different sizes. As a rule round brush sizes begin at 000, the smallest, and increase in size up to 12 or 14, the largest. Flat brush sizes are indicated by the width of the brush, beginning at 0.12in (3mm) and running up to 2in (50mm) or more depending on the series. Mops run 4, 6, 8, 10, 12, and oriental brushes come in the very sensible range of small, medium, and large.

No brush, no matter what its cost, will last long and give of its best if it is not looked after. Follow these few simple rules to keep your brushes in good shape for a long time.

Never leave brushes resting on their points or ends in jars of water.

Always rinse the brush clean of paint after use, paying particular attention to any accumulations around the ferrule (the point at which the hairs join the handle), then shape up the hairs into a point, or, if the brush is flat, make sure the hairs are together with no gaps showing.

Store the brush upright in a jar or suitable container with nothing touching the hair or bristles.

Finally, if the brushes are not going to be used for a long time, make sure they are completely dry and put them into an airtight container to prevent moth grubs from eating them.

Water, other additives, and masking fluid

Some books suggest using only distilled water to dilute the paint, because the pigment particles will then be suspended evenly, as distilled water is free of salts and other impurities. Very hard or very soft water can also affect the colors and the way the paint takes to the surface of the paper. However, as a general rule, this is both unnecessary and impractical, so unless you experience any strange occurrences when you apply your paint, use ordinary clean tap water; never use dirty river water or sea water. Working with clean water which avoids contaminating your mixes, is always good practice. Try to get into the habit of using two jars of water—one for cleaning your brushes in, the other for mixing your colors—and remember to change them frequently.

Some heavily sized papers repel water that has a high surface tension, causing it to sit on the surface in little puddles rather than spreading evenly and soaking into the paper. This is known as cissing. By adding a wetting agent such as oxgall to your water, the surface tension is reduced, enabling the water to flow and lie flat and even on the paper's surface. Glycerine can also be added to your mix. This substance also acts as a wetting agent, and it will extend the drying time of the paint slightly, which can help if the weather or atmosphere is warm and you are working with large amounts of paint (big washes). Alcohol added to the paint has the opposite effect and speeds up the drying time.

Gum arabic and gum water, which is a thinner solution of gum arabic, thicken the paint and make brush marks keep their shape; the effect depends on how much is used. They also increase the brilliancy and transparency of the colors and the solubility of the dry paint, which means that washes laid over areas of paint with gum arabic or gum water added will partly dissolve those areas. For this reason, they are best added to the final stages of a painting rather than the first or initial washes. If too much gum is used the paint surface will be glossy, and with very heavy use the layer of color can crack and peel off. Because watercolors dry lighter and duller, the addition of gum arabic or gum water can help retain the rich glow that is seen in the wet paint.

Watercolor medium—a mixture of gum arabic, acetic acid, and water, which can be bought at art stores—serves a similar function. It also serves as a wetting agent and improves the flow of the paint. Aquapasto is a thick paste which, when added to the watercolor, gives it a thick, buttery consistency that holds the shape of any marks or textures made in it (impasto), making possible a range of effects. Similar results can be achieved by mixing watercolors with any of the water-based acrylic mediums available, but take care not to contaminate your pans of watercolors with any of these, as once dry they are no longer soluble and could therefore spoil your paints, making them unusable.

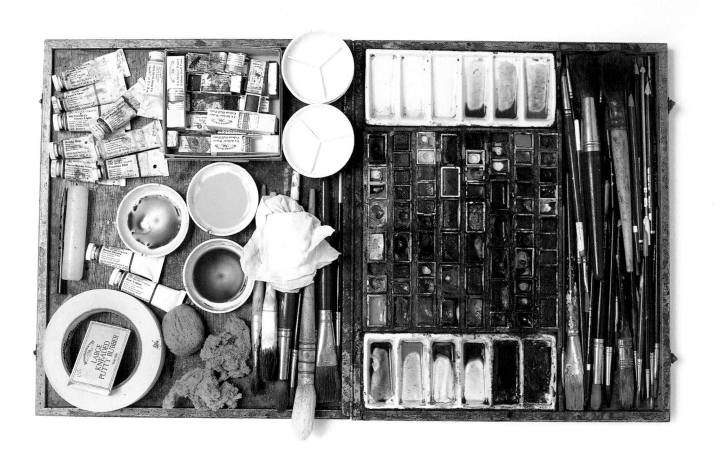

Masking fluid is not a medium or additive, but a liquid rubber solution that is applied by brush or pen directly from the bottle to mask out areas where paint is not required. It dries quickly and can easily be removed once the work is dry by gently rubbing the area with a finger; it is available in white or very pale yellow. Do not allow the fluid to stay on the paper for too long—it will become increasingly difficult to remove—and do not use your best brushes to apply the fluid, as they will very quickly be spoiled. Save an old brush or buy a cheaper one to be used just for the purpose. The fluid, when wet, can be washed from the brush with soap and water, or, if the fluid has dried, the brush can be rubbed with lighter fluid, which will dissolve the rubber.

Easels, palettes, and sundry equipment

For watercolor work an easel is perhaps only really necessary if you are going to work outside, in which case you will need one that is not only lightweight and stable, but also enables your drawing board and paper to be positioned horizontally, so that the paint doesn't run and spoil your work. Indoor work can be done on a table with the board propped up at a slight angle with books; alternatively, use a table easel that is capable of being set at different angles. A drawing board or boards on which paper can be stretched can be bought at an art store, but you can very easily make a selection of various sized boards by cutting up a sheet of thick, medium-density fiber board. This will cost a fraction of the price of one proper drawing board and has the added advantage of enabling you to stretch several sheets of paper at one time.

Palettes with separate wells, or recesses, will prevent colors running together. Metal, ceramic, and plastic types of various designs and layouts are readily obtainable. Some of the plastic types have larger wells and are perfect when mixing large quantities of dilute paint. Ceramic palettes tend not to hold quite so much paint, but are very easy to clean; many artists use ordinary dinner plates and saucers to mix their paints on. Never throw away a plastic yogurt or cream pot, as they make perfect containers for mixing big washes in. Both natural and manmade sponges can be put to many a use—applying color, making textures, lifting out color to correct mistakes, or to create highlights—as can cottonwool buds. Finally, a good supply of paper towels is invaluable for mopping up spills, blotting off excess paint and correcting those all too frequent mistakes.

TECHNIQUES

A GOOD AND SOUND knowledge of technique is perhaps more essential when using watercolor than with any other medium. Being able to successfully use and manipulate washes, knowing what will happen when wet paint is introduced on to a damp surface, when to add gum arabic into a mix in order to bump up the intensity of the color, how to remove an area of paint, and how to mask an area out and create a complicated edge are just a few of the many techniques that might need to be brought together at any one time, each playing their own crucial role in making a successful and satisfying painting.

Watercolor can be difficult to master; it is an unpredictable and often infuriating medium that can seem to have a mind of its own, yet taken individually many of the techniques are surprisingly simple and easy to do. But to gain confidence techniques need to be practiced. Your approach needs to be focused and planned, while always remaining flexible and ready to seize upon a chance effect, watermark or run of paint—weaving them into your plan of things. Being able to recognize the potential of these chance happenings is a technique in itself, but one that, unlike the techniques that follow, cannot be taught.

The Techniques

The laying and manipulation of transparent washes is the fundamental watercolor technique. Flat washes, where one consistent tone of color covers a substantial area, are achieved by mixing up sufficient color to complete the wash without running out. Slightly tilt the board on which you have stretched (see page 135) your paper, load a large brush—round or flat—with paint and, beginning at the top, make a steady horizontal stroke across the paper. The tilting of the board causes the excess paint to collect along the bottom edge of the stroke. Load the brush again and make another horizontal stroke slightly overlapping and just below the first. The excess paint now collects at the bottom of this stroke. Continue to overlap strokes working downward until the area is covered. Run a semidry brush along the bottom to collect the

excess paint and leave it to dry at the same angle. Many people find it easier to slightly dampen the paper surface first with a sponge and clean water.

The graded wash is applied in the same way as a flat wash, but with each horizontal stroke either more water or pigment is added to the mix, depending on whether the wash is to become lighter or darker in tone. Be careful not to add too much water or pigment to each stroke, or the tonal jump between each one will be too noticeable. Variegated washes are similar, but rather than using just one color, two or more are used side by side, the different colors blending into each other. The effects, while unpredictable, are good when painting dramatic skies.

When working wet into wet, paint is applied to an area that is already wet with paint or water. The freshly introduced paint bleeds into the wet surface and mixes on the paper, creating very seductive, soft blends of color. The result is to a certain extent unpredictable and depends on how damp the paper surface is and the strength of the color mix that is introduced. If the paper surface is wet, the color blends quickly over a large area and is impossible to control. If, however, the surface is only damp, the bleed is smaller and slower and more easily positioned and manipulated. The resulting image will have no hard edges and will look blurred and amorphous.

Wet over dry is, as its name suggests, working wet washes over a dry surface and is used in tandem with wet-into-wet techniques to sharpen up the image and pull it into focus. Paint that is applied to a dry surface retains its edge, quality, and shape, and stays where it is put; this allows detail to be added and colors modified without fear of them bleeding into one another. To obtain a crisp edge, the paint must be completely dry, and the judicious use of a hair dryer can hurry the process along.

Certain coarse pigments used in watercolors have a habit of separating from each other, or granulating, when mixed with other pigments. As they dry they give a very fine, speckled texture. This can be used to good effect in shadows and when painting clouds and landscapes. Cobalt blue, ultramarine, manganese, and cerulean blue, together with the earth colors yellow ocher, burnt sienna, burnt umber, raw sienna, and raw umber all behave this way to a greater or lesser extent.

Masking serves two purposes. First, it protects areas from being contaminated by unwanted paint and effects—for instance an area of work may be considered complete, but an adjoining area may need some vigorous spattering. By covering the finished portion of the painting no unwanted spots of color will fall on it. The same principle applies if an area of white paper needs to be retained to serve as a highlight or, for example, a whitewashed building; by masking the area the paper will stay clean and free of paint. Second, the masking material serves to introduce a different edge or line quality into the work. Paper makes an ideal mask, as it can be cut to shape, creating a sharp edge, or torn. Paper will tear in a variety of ways depending on how thick it is, but it always gives an interesting edge; medium to heavyweight paper is better than thin paper for this purpose. Thin paper tends to cockle as it gets wet.

Fabrics can be used for masking and the coarser hessians and canvas are especially good, as the fibers along the edge unravel to make a broken line. You will need to work quickly because the paint will bleed under the mask as the fabric becomes wet; work away from the fabric so as not to push the paint under it. Wait until the paint dries before removing the mask carefully, or you run the risk of smearing the paint.

Masking tape comes in a variety of widths. The thinner widths can be used to create straight lines, while the wider tapes can be torn to create lines similar to those made with torn paper. Wider tapes may also be cut into intricate shapes with a scalpel. When applying the tape do not press it too firmly, and take care when peeling the tape off the paper not to pull and tear the surface.

Masking fluid comes in two colors—yellow and white. The yellow is preferable, for the simple reason that it

is easy to see against the white of the paper. It can be applied to the surface with a variety of brushes and dip pens; in fact any brush mark that can be made in paint can be made in masking fluid. When the solution is dry, forming a rubbery film, paint can be applied freely without danger of it coloring the covered area. Once the paint is dry the masking fluid can easily be removed by rubbing it with a finger.

A white wax candle can be used to draw lightly on to the paper. The wax catches on the tooth of the paper, and when the area is painted the wax repels the paint, which then settles in those areas where there is no wax—leaving the white of the paper or, if applied over a painted area, the underlying color showing through. This is ideal for brickwork or tree bark.

In dry brush work the excess paint is removed from the bristles, leaving them damp and containing a minimum of paint. The brush is then applied to the dry painting surface and the paint is pulled from the brush by the tooth of the paper. The paint can be removed from the brush by squeezing the brush between the fingers or touching it on to a piece of blotting paper. Alternatively, to apply the paint to the brush, mix up an amount of paint in a deep palette and soak a piece of screwed-up paper towel in it. The towel will soak up the paint, and if the brush is then pulled across the towel it will pick up just enough to make the mark. Use a flat brush or, if using a round one, splay the bristles between the thumb and finger.

As with the dry brush, paint applied by scumbling is not flooded on to the surface but scrubbed unevenly across the surface, thereby catching the tooth of the paper and allowing the color beneath to show through. Layers of color can be built up in this way, each layer modifying the tone and color of the previous one. On highly textured papers similar effects can be obtained by rolling the brush over the surface. Scumbled paint is applied in a rough, circular, scrubbing motion; this is tough on expensive watercolor brushes, so you may want to use an old or cheaper brush for the job. This technique is used primarily for describing textures, but is also a handy way to put interest into an area of flat color.

The more a paper is sized, the less the paint will soak into and stain the surface. Papers such as blotting paper are not sized at all. On papers that are heavily sized or given a coat of gesso, and on watercolor and illustration boards, it is possible to use paint that is thickened with gum arabic or aquapasto. The paint, when applied, is thick enough to retain the shape of the brush mark and can be worked and scratched into with painting knives, bits of wood, combs, and coarse brushes—in fact anything that will make an impression.

Sgraffito is a method whereby the artist scratches or scrapes into a layer of paint, exposing what is beneath. This could be paper or another layer of paint. The word sgraffito comes from the Italian word *graffiare*, which means to scratch. This technique can be employed to scratch in highlights (by exposing the white paper) or used to create texture. Any sharp instrument can be used, as can your fingernail or a piece of sandpaper. Working into these marks with more paint will create even further effects, as paint dries to a different color on paper surfaces that have been distressed.

There are three methods of spattering a painting, each having a very different and distinct feel and use. The first is to spatter the paint on to a dry surface, where the spattering is then allowed to dry. The spattered marks will have a crisp outline and can be overworked with more spattering if required. In this way a dense, complex area of small blobs of paint can be built-up. The second method is to spatter into a wet or damp surface. As the spattered paint or clean water hits the wet paper it diffuses and softens in much the same way as paint used wet into wet does. The degree of bleed depends on the dampness of the surface. The third method is to spatter clean water on to a dry painted surface that has had plenty of gum arabic added to the mix. Gum arabic has the effect of keeping the dry paint soluble, so that it loosens and dissolves when rewet. These spatters can be left to become dry and lighter in tone, contained by a distinct watermark. Alternatively, once the paint is dissolved, you can blot them with a paper towel, which will leave much paler,

tidier marks. Use a toothbrush or stiff bristle brush to carry the paint for splattering. Once the brush is loaded, pull a finger (a knife blade can be used with the toothbrush) through the bristles, which will then spring back, flicking the paint off on to the surface. As a general rule, the spattering from the toothbrush will be finer and more easily controlled than that thrown from a larger bristle brush.

Sponges can also be used to apply washes and broad areas of color. They also can make a broad range of textures and effects. Both natural and synthetic sponges can be used; the natural ones are softer and the shape can be altered easily, making it possible to work in smaller areas. Mottled patterns can be built-up in layers or the sponge can be twisted and moved over the surface creating a series of marks that seem to pull in and out of focus. When dabbing the sponge to create a mottled effect, turn it constantly to present a different profile to the paper after each dab. This prevents the same shaped marks being made too close together. Wash your sponges well after use, so that color does not harden in them, leading to unwanted smears of color the next time they are used.

An interesting effect can be achieved by using rock salt. The salt crystals are sprinkled on to wet paint, where they soak up the surrounding paint. Once the painting is dry, the coarse salt is brushed from the surface, leaving a mottled effect that looks like the ice crystals that form on windows. The degree of success and definition depends on judging when to sprinkle the salt. Salt sprinkled on to paper that is too wet soaks up paint from some distance away, so the resulting mark tends to be larger, but indistinct. If you sprinkle the salt when the paper is too dry, very little happens.

Blowing into wet paint will move it across the paper surface. This technique is a useful way to suggest the growth of some plants or the framework of branches in a tree. It is difficult to control the direction in which the paint will travel, but by blowing through a straw you will have more control over the spread of the paint, and can usually manipulate it in the general direction you would prefer it to go.

Gum arabic and gum water are the binders used in the manufacture of watercolor. Either one can be added to paint to enrich and intensify the color. Once added the paint dries to a semigloss finish and holds brush marks better, so it should not be used when painting a large flat wash. The paint also remains very soluble when dry, so it can be rewet and removed or moved around. This means you can draw into areas using water, and the paint taken off by blotting or lifting out with a brush. It also means, however, that any area (even those that are meant to be kept) when washed over with water or more paint will soften and blend with the new layer; therefore a little forethought is needed, using the additive only in final stages, unless specific effects are required early on.

Pulling out highlights from areas of paint that has been mixed with gum water or gum arabic is easy. Simply rewet the area and once the paint loosens it can be blotted off with kitchen or blotting paper. If the highlight is small then use a brush. Very fine light lines can be introduced in this way, which makes it a perfect technique for portraits—individual strands of hair can be picked out, as can sparkle in the eyes.

Domestic bleach will also lift paint that is difficult to dissolve. When brushed on it will gradually lighten the color. It also tends to change the color, giving it a slight blue tinge, so it would pay to experiment first on a spare piece of paper. The bleach is hard on brushes, so do not use your most expensive sable.

Sponges are also used to lift out color, and are an invaluable tool for painting skies. A wet sponge can be used to dab into washes, in order to shape clouds and change colors. You will find that when working into damp or wet paint, color will be picked up and removed more easily if the sponge is damp. The sponge can also be used for flooding areas with water to create backwashes.

Backwashes happen when very wet paint or water is introduced on to an area that is not so wet. The difference in wetness means the areas dry at different speeds, resulting in a watermark where the fresh wet paint met and pushed back the older damp paint. These backwashes often happen when instead of leaving a wash alone and allowing it to dry, the artist tries to touch up an area. The backwash, or backrun, far from being a nuisance is actually a valuable and handy technique, helping put life and spontaneity into painted skies and landscape.

Here the shapes and lines have been painted in clean water, then, while still wet, a brush loaded with paint has been touched to the center of the design. The paint flows from the brush into the wet areas, mixing with the water and gradually becoming more dilute and lighter in tone as it gets farther away from the point where it was introduced. This technique can be used when painting complicated edges, allowing the paint to flow into the desired shape, but without bringing the brush too close to areas where paint is not wanted.

STRETCHING PAPER

THE LIGHTER WEIGHT, or thinner papers, and, to a lesser degree, some of the medium-weight papers, have a tendency to buckle, or cockle, when wet paint is applied. This means the paint puddles in the dips, drying unevenly and leaving unsightly watermarks—always where you least want them. The cockled paper also makes the application of flat washes impossible. To prevent this from occuring the watercolor paper is stretched onto a wooden board. There are several ways of doing this, but the simplest, and perhaps most efficient, is to use strips of gummed paper to secure the edges of the paper to the board. The gummed strips prevent the wet paper from moving so that it dries flat after each wash or layer of paint. Once the painting is finished and dry, the edge of the gummed strip is cut with a sharp knife, releasing the paper.

Stretching paper is very easy, but some papers stretch more easily than others. Thin papers can be awkward, so practise with easier, medium-weight papers such as Bockingford or Saunders.

The Techniques

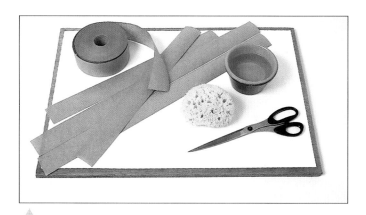

You will need a smooth board that is thick enough to resist warping, such as a drawing board or piece of waterproof, medium-density fiber board, a roll of gummed paper, a clean sponge, water, a pair of scissors and a sheet of watercolor paper. Tear or cut the sheet of paper to the required size and cut four lengths of gummed paper, one for each edge of the paper.

Check that the correct side of the paper is uppermost; if the paper has a watermark this should read the right way round when the paper is held up to the light. Alternatively, look for a slight sheen on the paper's surface, as this indicates the side that is sized and ready to receive paint. Position the sheet of paper centrally on the board and load the sponge well with water. Squeeze the water on to the paper and, using the sponge gently so as not to damage the paper's sur-

face, spread the water evenly over it until it is reasonably damp, but not soaking wet.

Wet a length of gummed paper by simply pulling it across the damp sponge.

Then, using the sponge, smooth the paper strip along one edge of the paper so that about one half to one-third of its width sticks to the paper and the rest sticks to the board. Smoothing the gummed strip around and down the side edges of the board means that the paper cannot be pulled off no matter how taut it becomes.

The paper will begin to cockle, so work quickly and secure the other sides. Wipe off any excess moisture with the sponge and let the board dry. If the paper surface looks uneven and crinkled don't worry—once dry it will be flat and taut. Speed up drying by using a hair dryer, but keep it moving over the paper surface so that the sheet dries at an even rate all over.

COLOR

THE PRIMARY COLORS red, yellow, and blue cannot be mixed from other colors, hence their name. Red and yellow make orange; yellow and blue, green; and blue and red make purple or violet—these are known as secondaries. But, as a casual glance at a paint color chart will show, there are many different reds, yellows, and blues, the secondary colors obtained will depend very much on which of these primaries are used. The same applies to tertiary colors, which are the colors that fall between the primaries and the secondaries. They are made by mixing an equal amount of a primary color with an equal amount of the secondary next to it to obtain a red-orange, orange-yellow, yellow-green, green-blue, blue-violet, or violet-red.

All colors are considered to be either warm or cool—the warm colors are red, orange, and yellow; the cool colors are green, blue, and violet. However, the terms warm and cool are relative, as all colors have a warm and cool variant. There are warm reds such as cadmium, which have a yellow bias, and cool reds such as alizarin crimson, which have a blue bias. To confuse the issue further, a color that is seen as warm in isolation can appear cool when seen next to a warmer variant of a similar color. This warm-cool color relationship is very important and can be put to good use, especially when painting the landscape, as warm colors seem to advance visually and cool colors appear to recede.

When mixing colors it is necessary to remember that a more intense, brighter third color will result if mixed from two colors that have a bias toward each other: for example cadmium red (yellow bias) and cadmium yellow (red bias) create a bright, vivid orange, whereas alizarin crimson (blue bias) and cadmium yellow (red bias) mix to create a more subdued, less intense orange. This happens because alizarin crimson is closer to yellow's complementary color, violet.

Complementary colors are those colors that fall opposite one another on the color wheel; one color will always have a warm bias, the other will have a cool bias. Hence, red is the complementary of green and orange is the complementary of blue. These color opposites are known as complementary pairs and have a very special relationship. When placed next to each other, complementary pairs have the effect of enhancing or intensifying each other. However, if you mix a small amount of a color into its complementary, the color will be subdued or knocked back. Add more of a color's complementary color and you will neutralize it completely, producing a range of neutral grays and browns. It is important to be able to mix and exploit these less vivid,

subdued colors, as they echo many of the colors seen in nature and help bring color harmony to the work.

Tone is measured on a scale that runs from black to white, and all colors can be mixed to obtain a range of tones. Obtaining a lighter tone in watercolor is especially easy, as once a color is mixed all you need to do is add more water until the desired lighter value is achieved. Remember, however, that if you choose to darken the tone of a color by adding black, or another dark color, as well as becoming darker the color will also change.

Color is a complex and intriguing subject and a basic knowledge of the theory is certainly necessary, but the best way to understand what is possible, and why, is to spend time experimenting with your colors. Do remember to make notes, as the combinations using just a few colors are countless and the chances of mixing a color and immediately forgetting how you did it is a real possibility.

Choosing Colors

Watercolors are available in over 80 different colors, but it is neither economically viable, practical or necessary to work with anywhere near that many. Most professional artists work with a limited palette; my own is fairly large and consists of 18 colors, but rarely do I use more than 12 at any one time, and often get by with half that number. The colors that are marked with an asterisk are an ideal choice for a starter palette, which you can add to should you feel the need at a later date.

IVORY BLACK should be used with caution as it can very easily deaden a color, but it is useful when mixed with yellows to create a range of greens.

PAYNE'S GRAY* is used to knock back and modify colors without destroying their vitality.

COBALT BLUE* is a good blue for skies and it is also a useful addition to cool down skin tones.

ULTRAMARINE* is a strong, powerful warm blue, which mixes well with reds to create purples and violets.

ANTWERP BLUE is a pale version of Prussian blue, which is very transparent. It is good for skies and mixing bright greens.

CERULEAN BLUE is an opaque color good for mixing into skies and granulated washes.

VIRIDIAN* is possibly the only green that is really needed. It is a very powerful, transparent green, which mixes well with reds, yellows, and browns to create a vast range of greens.

SAP GREEN is a bright, easily modified green for landscape work.

OXIDE OF CHROMIUM is a very opaque, permanent color, which is good for modifying other colors, especially skin tones. Mixed with reds it creates a range of browns.

NAPLES YELLOW is a semi-opaque color, which is very useful when painting the figure and portraits.

LEMON YELLOW* is a cool yellow, which creates bright greens when mixed with blues.

CADMIUM YELLOW* is a strong, warm yellow, which mixes well with blue to create warm greens, and with reds creating a range of orange.

YELLOW OCHER* is a strong and useful opaque yellow. Some artist prefer to use the similar, but darker and more transparent, raw sienna.

BURNT UMBER is a very warm brown, which mixes well with other colors, especially green. It makes a good black when mixed with Payne's gray.

RAW UMBER is a versatile color, which can be used to tone down other more strident colors.

ALIZARIN CRIMSON* mixes well with Naples yellow and yellow ocher, giving a range of skin tones. It also combines well with the various blues to provide purple and violet.

CADMIUM RED* is a strong red. It makes a good orange and mixes well with green to create a range of browns.

BROWN MADDER ALIZARIN is an extremely useful dull red, which mixes well with the duller yellows, giving good skin tones.

Color Theory—The Basics

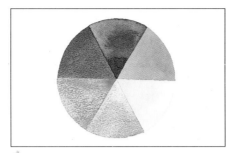

This color wheel is mixed using warm primaries: cadmium red, cadmium yellow, and ultramarine.

Here the secondaries have been mixed using the cool primaries: alizarin crimson, lemon yellow, and cerulean blue.

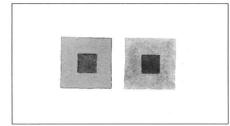

A color is noticeably affected by the color that is next to it. Here the red square seems to be much brighter when surrounded by its complementary green.

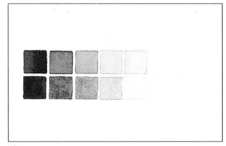

Warm colors will seem to advance and cool colors recede.

All tonal values have an equivalent on a scale that runs from black through to white. The tone of this green has been lightened by adding clean water.

Mixing together complementary colors (as shown here), which will contain elements of all three primaries, will result in a range of neutral grays.

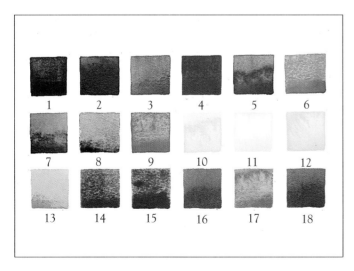

My palette of colors.

1 Ivory Black

2 Payne's Gray

3 Cobalt Blue

4 Ultramarine

5 Antwerp Blue

6 Cerulean Blue

7 Viridian

8 Sap Green

9 Oxide of Chromium

10 Naples Yellow

11 Lemon Yellow

12 Cadmium Yellow

13 Yellow Ocher

14 Burnt Umber

15 Raw Umber

16 Alizarin Crimson

17 Cadmium Red

18 Brown Madder Alizarin

THE SOUTH DOWNS

Using Washes

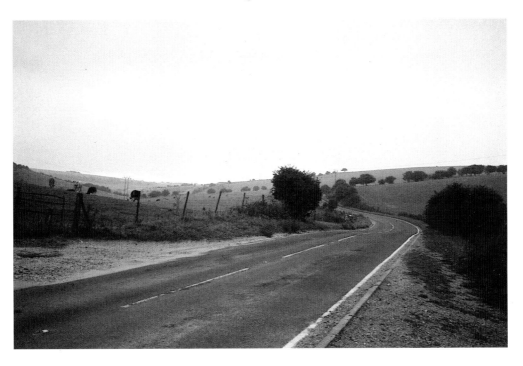

WATERCOLOR IS A TRANSPARENT MEDIUM; the colors and tones are laid, or glazed, in thin washes over one another. To prevent the colors becoming a muddy and meaningless mess, each layer is usually allowed to dry before the next is added. Another wash of the same color can then be applied, which has the effect of strengthening the color or tone, or a wash of a different color can be used—this will modify and alter the color or tone. For this reason watercolors are painted light to dark. The lightest, palest tones and colors are applied first, followed by layer by layer with stronger, darker, often less transparent colors.

Overpaint too much and a watercolor will lose its freshness, so try to achieve the desired effect with a maximum of three or four washes (or layers) of paint. A color is lightened not by adding white paint but by adding water, which makes the color more transparent and thinner, allowing more light to reflect back through the paint from the surface of the white paper. The paper itself supplies the white and any highlights needed, so a little thought and pre-planning are required to make sure that these areas are not accidentally covered with paint.

Landscape, as countless artists have discovered, is rich, diverse, and stimulating and, as a subject, is perfectly suited to the wash techniques of traditional watercolor. This view, looking across the English South Downs on an overcast, misty fall morning, is a relatively straightforward and simple subject with which to work. The dark bush just off-center gives an immediate focal point and the road and fence posts running into the picture and the receding dark clouds give both linear and aerial perspectives. The range of color is limited and the scene is not overfussed with too much detail.

MATERIALS AND EQUIPMENT

15 x 22 in. (38 x 56 cm) sheet of stretched 200 lb (425 gsm) CP Bockingford watercolor paper Medium-size mop or wash brush

Two round brushes no 12 and no 6 HB graphite stick Small natural sponge Gum arabic

Watercolors in the following colors: ivory black, Payne's gray, raw umber, yellow ocher, sap green, and Antwerp blue

The Painting

1 You may find that a light drawing made with an HB pencil gives you confidence in correctly positioning the horizon line and the curve of the road. With the support at a slight angle, begin by painting in the gray overcast sky with a thin mixture of Payne's gray, yellow ocher, and raw umber, using the medium-size mop or wash brush. The paint is loosely washed on to the support and pulled across the sky area, leaving patches of the paper showing through to represent clouds.

2 As the horizon line is approached the mix is lightened by adding more water and the color altered by adding a little more yellow ocher; bring the wash well down below the line of the fields. Already you have introduced perspective into the painting: the darker color at the top suggests that the sky at this point is nearer, more overhead, while the lighter color gives the impression that the sky is receding away in the distance.

3 Once dry rework the sky to intensify the color. Rewet the area with a sponge and clean water and, starting at the top right-hand corner, introduce a wash of Payne's gray and Antwerp blue using the large brush; the paint will naturally run into the wet areas. Pull the wash across the sky, leaving some areas of cloud as white paper, but working lightly over others. The sponge is used to knock back, or lighten, areas that are considered to be too dark and to soften any paint edges around the horizon.

4 Once the sky has been allowed to dry thoroughly, a thin mix made from sap green and yellow ocher, with a little raw umber added to deaden the color, is washed in across the area of fields, taking care not to paint over the position of the road. Use the no 12 round brush; because the sky is no longer wet, the green wash will dry giving a crisp edge at the horizon.

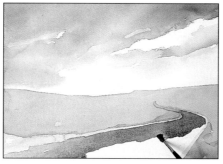

5 Once the fields are dry, use the no 6 round brush to paint the edge of the road with a mix of yellow ocher and a little ivory black. When dry, use the same brush for washing in the road with Payne's gray dulled with a little ivory black.

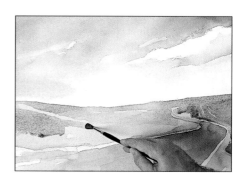

6 When the road has dried, mix sap green, yellow ocher, and Payne's gray to make a light gray-green. Paint in the pattern of the fields, varying the mix by adding more sap green and yellow ocher. At the roadside work into the light green underpainting to suggest tufts of long grass.

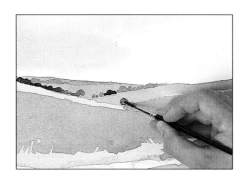

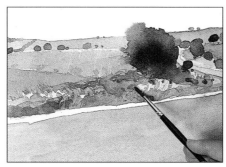

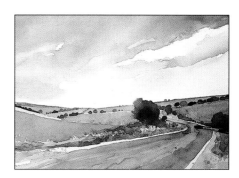

7 Once the fields are dry, use a slightly darker shade of green and work back into them, painting in the lines of crops with the no 6 round brush. Curving the lines slightly gives the impression that the crops are growing up and over the hill. Mix up a few shades of green with the yellow ocher, sap green, Payne's gray, and raw umber and work across the landscape, dotting in trees and hedgerows, varying the colors as you work. Mixing in a little gum arabic will sharpen and intensify the color.

8 The focal point of the picture—the large dark bush— is painted next. The shape is made by dabbing the natural sponge, wet but not sodden, over the area and touching in a dark mix of Payne's gray and sap green with the no 12 round brush. The paint flows from the brush, easily finding its own way into the shape left by the wet sponge. Changing back to the no 6 round brush, paint in the curve of the brambles and flick in tufts of long grass along the road side with dark green.

9 Using the no 6 round brush, the road surface is given interest by washing over it in part with Payne's gray and ivory black. The watermarks are created in the foreground by allowing the paint to dry a little and then brushing on a touch of clean water.

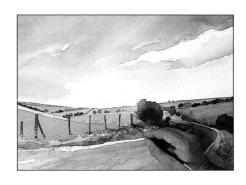

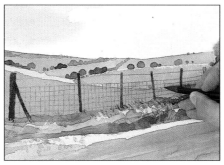

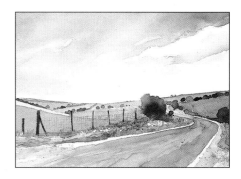

10 Still using the no 6 round brush, paint in the fence posts with a dark mix made from raw umber and ivory black. Paint the bottom of each post as if it disappears behind and into the long grass.

11 The mesh of the wire netting stretched taut between the posts is drawn in with the HB graphite stick.

12 The painting is completed by adding extra interest with more grass at the road side and along the foot of the fence and by painting in the suggestion of crop rows curving over the field on the extreme right.

Alternative Approaches

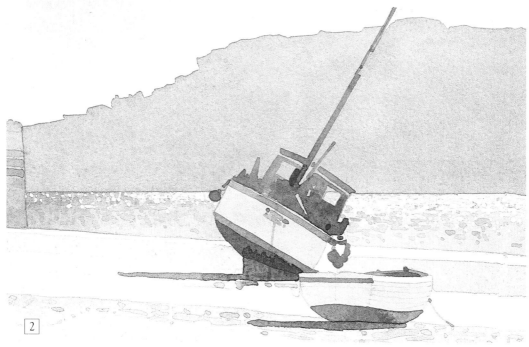

1 The distance is painted in cool, pale blue washes creating the illusion of aerial perspective. The landscape rolling away to the distant sea is covered in a variety of subtle textures, which suggest wooded areas and fields, while the brighter warm colors on the figure bring it firmly to the fore.

2 In this painting of boats on the low-tide beach in St Ives, Cornwall, each wash is worked wet on dry; the tones are carefully considered, helping give an illusion of depth. The sparkle on the water is achieved by using masking fluid to protect the white paper.

VEGETABLES

Combining Techniques

SELDOM, IF EVER, IS A PAINTING COMPLETED using one technique only; more often than not the finished picture is the result of several techniques, each playing its own important part. While it is possible to produce a painting using only wet into wet, that is, working on to damp or wet paper or paint—the painting will look soft and out of focus, with no firm structure or form. The purity of colors will be difficult to control, because they will run and blend together, and, in places where too many different colors had mixed, they would become muddy and unrecognizable. It also becomes difficult to work light to dark because a wet, dark color placed next to or over a wet, light color will run and bleed uncontrollably into it, spoiling the effect.

Painting a picture using only wet on dry techniques, where each layer or area of paint is allowed to dry before another is placed over or adjacent to it, can also have its problems. Each layer or area of paint dries to shape, leaving an edge; working color and tone light to dark in layers does not present any problems, but the colors stay where they are put, so random or controlled running and blending together of color and the use of lost edges becomes difficult.

This painting of vegetables uses a combination of both techniques: the initial laying in of the overall shape, allowing color to blend together, is done wet into wet. The image is then sharpened and pulled into focus by subsequent layers of paint worked wet over dry. This is a classic technique much favored by landscape artists who find the initial wet into wet laying in of color perfect for capturing the effects of atmosphere and weather.

MATERIALS AND EQUIPMENT

15 x 22 in. (38 x 56 cm) sheet of stretched 200lb (425 gsm) CP Bockingford watercolor paper

Three round brushes, no 8, no 5, and no 2
Gum arabic
Watercolors in the following colors: ivory black,

Payne's gray, cadmium yellow, raw umber, yellow ocher, cadmium red, brown madder alizarin, and sap green

The Painting

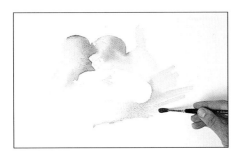

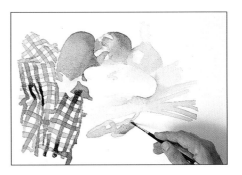

1 A light drawing executed with an HB pencil positions the vegetables and napkin on the table. The main shapes are then blocked in using the no 8 brush and pale mixes using Payne's gray, sap green, and yellow ocher. Note how the lightest tone seen on each vegetable is painted first, and the position of any white highlights are left as white paper. The color of an object is affected and altered by the reflected color from other objects that are placed close by; working the initial light washes wet into wet and allowing the colors to bleed together hints at this and helps to create an overall harmony.

2 A pale mix of Payne's gray and ivory black is used for the pattern on the napkin. Using the no 5 brush, paint this by carefully following the contours of the cloth. Darken the mix slightly and paint in the shadow down the edge of the cloth. Allow the painting to dry.

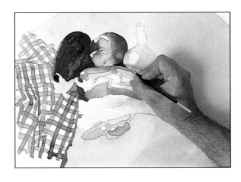

3 Darken the Payne's gray and ivory black mix a little and paint in the cross-over pattern again, taking care to follow the contours of the cloth. With the same mix work over the eggplant, leaving a light edge down the left-hand side and cutting around the green of the stem. Add a little cadmium red to yellow ocher and sharpen up the bulb of the onion, leaving the previous wash showing as a highlight. A very light wash of cadmium red is brushed over the bell peppers. Then sap green and a little Payne's gray intensifies the color on the far pepper and darkens the underside of the small green chillies in the foreground.

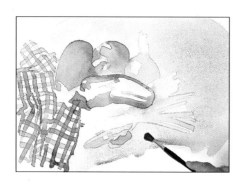

4 Using the no 8 brush and a mix of cadmium red, brown madder alizarin, and a little cadmium yellow, block in the flesh and skin of the red bell peppers, then establish the base color of the table top with a raw umber and ivory black mix. Allow the painting to dry.

5 With the no 5 brush, the color of the eggplant is darkened using Payne's gray mixed with a little brown madder alizarin. Add some of the gum arabic as well to increase the intensity of the color. Let the eggplant dry and brush on water in the position of any highlights—the paint will dissolve and dry to a lighter color. Add ivory black to the mix and paint in the shadows around the bell peppers. This has the effect of crisping up their shape and pushing them forward. Darken the shadow on the far bell pepper with a mix of sap green and Payne's gray, and put a darker wash of ocher and cadmium red over the shadowed side of the onion.

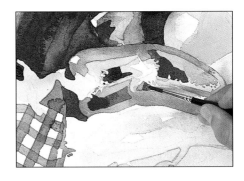

6 With the same brush, use a darkish mix of brown madder alizarin and a little Payne's gray to work the shadows inside the red bell peppers, working carefully and cutting in around the lighter seeds.

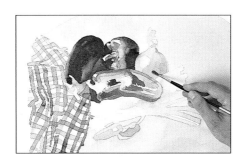

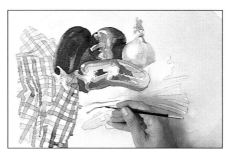

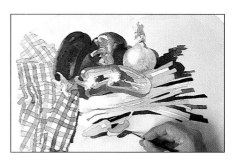

7 Working around the highlight, paint the bright green mid tones on the top of the bell pepper. Adding a little brown madder alizarin gives the warm green found on the underside of the bell pepper stalk, which is picking up some reflected color from the red bell pepper. Use the same range of color on the stalks of the eggplant and the red bell pepper. The crumpled skin of the onion is reworked with a mixture of ocher, cadmium red, and raw umber.

8 Then with a yellow ocher, raw umber, and black mix begin to separate and define the shape of the individual scallions.

9 Still using the no 5 brush, mix sap green with yellow ocher and paint in the green on the spring onion stalks. Next, take Payne's gray, to which you have added a little ivory black, and work carefully around the vegetables, painting in the shadows.

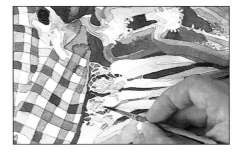

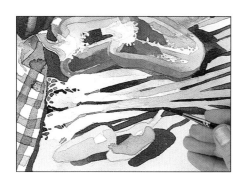

11 Brown madder alizarin adds more texture to the inside of the bell peppers' interiors. Mix raw umber, yellow ocher, and ivory black and, using the no 2 brush, work on the roots of the onions. With a mix of yellow ocher and sap green paint in the ribs of color that run down the scallions' leaves.

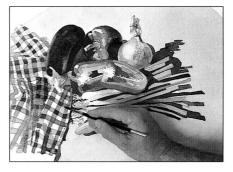

12 Using the no 5 brush, add some detail to the neck of the onion with a mix of raw umber and brown madder alizarin, then add interest to the skin on the bulb by spattering with a little of the same mix. The folds on the napkin are painted next with a medium-strength mix of gray.

10 With the same dark mix begin to paint the dark spaces around and through the scallion roots and the shadows that are cast across them from the red bell pepper. The same mix can then be used to darken the pattern on the napkin where the bands of gray cross each other.

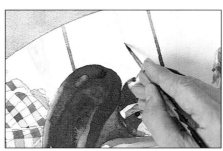

13 Finish by painting the grain on the table. Use a ruler if you wish in order to get the straight lines where the pieces of wood join, then use a combination of thin painted lines, using dilute raw umber and yellow ocher, and lines drawn with the HB graphite stick.

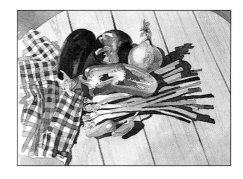

14 The finished picture.

Alternative Approaches

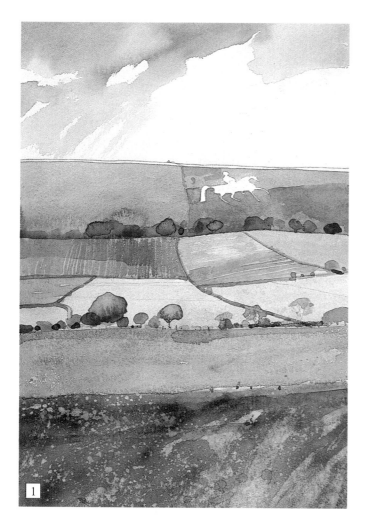

1 A range of techniques have been used to depict this white horse and rider carved into the hillside in Dorset. The area of the limestone figure was masked out with fluid and initial blocking-in worked wet into wet. Once dry, the fields were repainted, working wet on dry with plenty of gum arabic added. A wax candle was repeatedly used between washes as a resist to repel the paint and make interesting textural effects in what would otherwise have been a flat area of color.

2 Prior to applying any paint, a large bristle oil painting brush was used to scrub on masking fluid across the area of water, giving a lively foreground to this painting of San Giorgio Maggiore in Venice.

ANEMONES

Using Gum Arabic

FLOWERS HAVE LONG BEEN A FAVORED subject for the artist, be it as part of a large still life group or as a subject in their own right. They are easily obtained and the range and intensity of color and their complexity of shape offer a very real challenge and endless picture-making possibilities. Flowers are not easy to paint well; a common mistake is to make the subject look too complex and over-arranged, with too wide a variety of color and shape. Stick to simple natural looking groups containing similar colors or species. In order to capture the precise shape and clarity of color these anemones were worked using wet on dry washes: each layer of color was allowed to dry before the next was glazed over the top.

The painting of the actual flowers may, at first sight, look dauntingly complicated, but the effect is achieved by using only three carefully painted layers, or washes, of paint—each layer of paint separates the subject into light, medium and dark tones. If you feel a tone or color is too light or dark it can always be blotted off while still wet with a clean paper towel. Do not rub the mistake or the painted area will be smudged: simply dab the tissue hard on the area and lift off the color.

The preliminary blocking in of the lightest tones was done with paint mixed only with water, but the later paint layers were mixed with gum arabic to increase the transparency of the paint while retaining the strength of color. The addition of the gum arabic also means that the paint remains soluble when it is dry, so hard edges can be softened and color lifted out simply by rewetting it. The simple neutral colors of the plain background, table top and pot help concentrate attention on to the bright colors of the anemones' arrangement.

There are, of course, several ways to approach the subject. An alternative would have been to work in reverse, masking out the colorful flowers with masking fluid, then working the background and table top before removing the masking fluid and working on the flowers.

MATERIALS AND EQUIPMENT

18 x 12 in. (46 x 30 cm) sheet of 300 lb (638 gsm) unstretched CP Waterford paper
Three round brushes, no 12, no 5, and no 2

Gum arabic
Watercolors in the following colors: viridian, sap green, ivory black, Payne's gray, Antwerp blue, alizarin

crimson, cerulean blue, cadmium red, brown madder alizarin, yellow ocher, burnt umber, raw umber, and lemon yellow

The Painting

1 A detailed pencil drawing in a light HB pencil establishes the basic shape of the flowers and the jar, and helps keep the painting on track. Do not press too hard or the pencil line may show through the lighter colors.

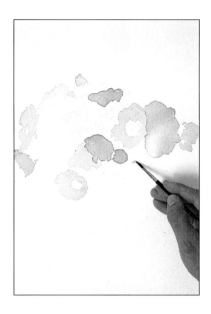

2 Using the no 5 round brush, the lightest tones found on each flower are laid in using a mix of alizarin crimson and Antwerp blue for the purple flowers and mixes of alizarin crimson and cadmium red for the pink and red flowers. Ivory black and a little lemon yellow give the light gray seen on the white flower at the front. To prevent colors running together make sure one color is dry before painting another next to it.

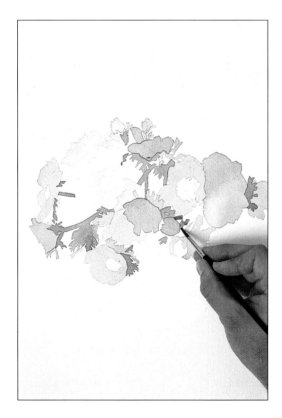

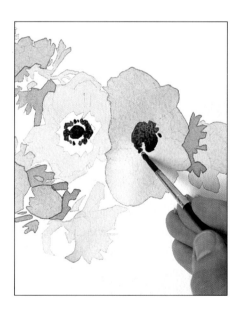

3 Once the flowers have dried, with a pale green—made from viridian and lemon yellow—paint in the palest leaves, darken the color with sap green and a little brown madder alizarin, and complete the rest of the foliage. Follow your drawing carefully and keep the angular shape of the leaves crisp and sharp.

4 Ivory black, Payne's gray, sap green, and alizarin crimson mixes give the range of dark colors that are found in the flower centers.

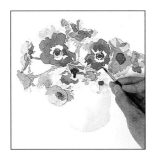

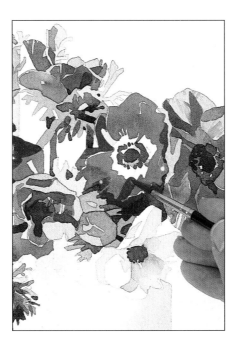

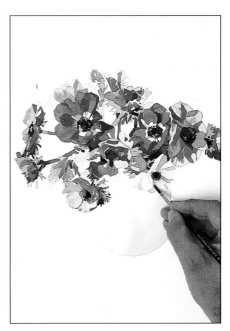

5 A light mix of yellow ocher and burnt umber establishes the color of the pot. For the shadow, this mix is darkened with more umber and worked down the side wet into wet. Then, working slowly and keeping the colors separate, the mid tones on each flower head are painted; add a little gum arabic into each mix to intensify the colors. Antwerp blue and alizarin crimson are used for the purple flowers, cadmium red dulled with brown madder alizarin for the red flowers and alizarin crimson and cerulean blue for the pink flowers. The white flower is wet with clean water and a little red flower mix is touched in to give the slight red tinge seen on the petals.

6 Still using the no 5 round brush, the dark leaves and petals are painted with sap green darkened with brown madder alizarin and Payne's gray.

7 All of the flower mixes are then darkened by strengthening the color and the darkest tones added.

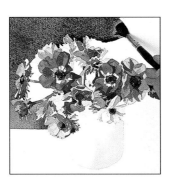

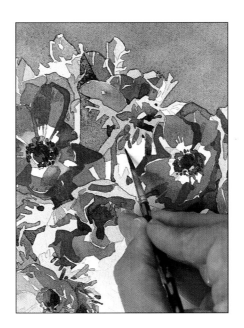

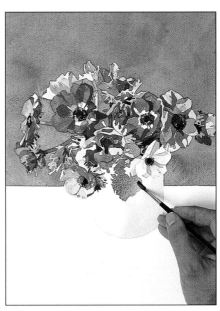

8 The background is painted in one coat with burnt umber darkened with Payne's gray; make sure that you have enough paint mixed to cover the whole area. Using the no 12 round brush, work quickly across the paper painting as close to the flower heads as the large brush will allow. Switch to a smaller brush when working tight up to the intricate shapes made by the flowers.

9 The no 2 round brush is then used to paint the negative shapes that are found in and around the flower heads and leaves.

10 Add a little Antwerp blue and gum arabic to the background color and with the no 5 round brush block in the shadow cast by the flowers on to the pot.

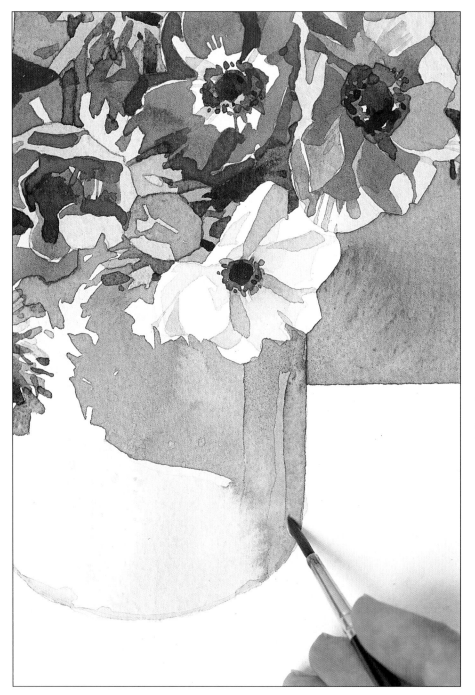

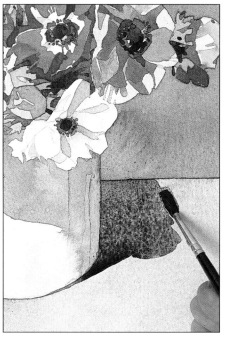

12 Payne's gray with the addition of a little Antwerp blue gives a coolish color for the shadow thrown on to and across the table by the pot.

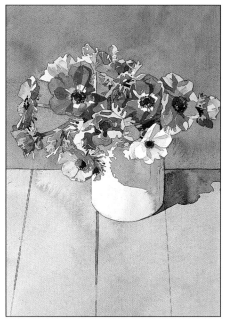

11 Allow this to dry and with clean water brush in two marks that give a suggestion of a reflection in the glaze of the jar. Then establish the color of the table top with a raw umber and Payne's gray mix.

13 A ruler helps with painting in the straight lines of the wood using a gray and umber mix.

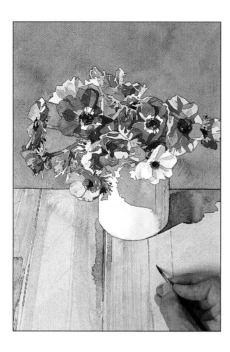

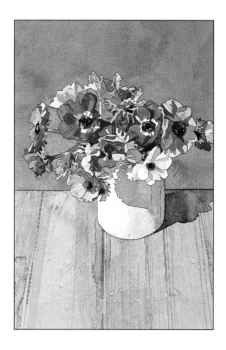

14 The grain of the wood is then painted in freehand with the no 5 round brush.

15 The painting is finished by spattering the table top and jar with clean water; this dries leaving a watermark that gives a weathered look to the table.

Alternative Approaches

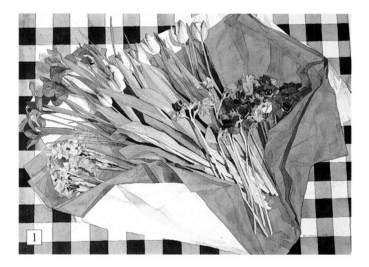

1 Rather than showing flowers as they are more usually seen—arranged in a vase—this painting shows them strewn on to a table top having been just unwrapped. The painting, while being complex, is very structured. Each species of flower lies grouped together and the whole arrangement is kept in order by the mauve tissue paper that runs diagonally, cutting across the vertical and horizontal bands of the table cloth.

2 The painting of parrot tulips (opposite) is painted in a looser style; the shape of the pattern describes the shape of the tulips. The leaves were painted using a combination of wet on dry and wet in wet, so that some of the leaves remain defined while others blend together. The shadow was painted in two washes: the first, describing the shadow of the window frame, was allowed to dry slightly before painting in the darker shadow thrown from the tulips and the stool.

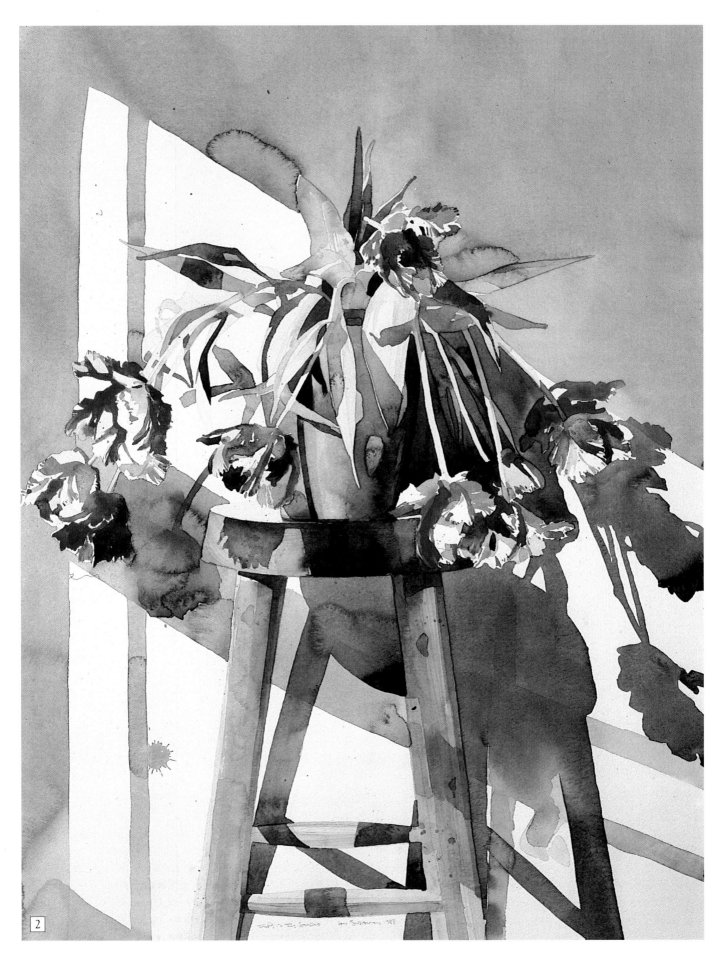

CRAB AND LANGOUSTINE

Creating Texture

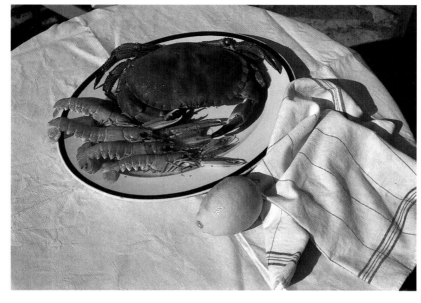

INTRODUCING marks into a painting that would be difficult, if not impossible, to make with a brush can be very liberating, opening up all manner of possibilities. In life the range of textures and patterns that are an intrinsic part of things is vast and varied. Grass, wood, stone, materials and fabrics, water—everywhere we look surfaces shout for special treatment. The problem is usually solved with expressive brushwork: flicks, dabs, blobs, strokes, and dots, all executed with the trusty brush.

While it is true that the range of brush shapes and types are capable of laying down paint in a wide variety of ways, and that experience has shown that they are generally the best tool for the job, they are by their very nature limited, and not necessarily the only tool that can be used. Becoming skilled with a brush takes time, and results that are occasionally better and more convincing—and often very quick to do—can be achieved in a number of alternative ways, none of which compromise the look or feel of an otherwise traditionally painted picture.

Sponges have long been thought of as an essential addition to the watercolor artist's equipment, used as they are for wetting paper prior to stretching, for applying a wash and lifting out color, or for making corrections. They are also capable of solving a range of complex mark-making problems in a very simple and straightforward way. Dipped into paint and stippled over the paper surface, a complex mottled pattern can be achieved. This can be allowed to dry and then worked over using traditional washes or reworked with the sponge, using a similar or different color to build up a multilayered textural effect. The same technique can be employed using clean water and a brush full of paint. The brush then only needs to be touched to the wet surface for the paint to flow into the shape left by the wet sponge. This technique can be used in very small areas and with intricate shapes if a mask is used.

In this painting of seafood, a cut card was also employed to paint in the creases and shadows on the tablecloth, and while a very similar effect could have been achieved with a brush, the paint did lie on the paper in a different way. The effect was also achieved with speed and a certain satisfying economy, which is always an advantage.

MATERIALS AND EQUIPMENT

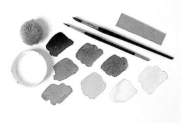

13 x 14 in. (33 x 36 cm) sheet of stretched 200 lb (425 gsm) CP Bockingford watercolor paper Piece of thick chisel-shaped card	Two round brushes, no 8 and no 5 Small natural sponge Masking fluid Watercolors in the colors: Payne's	gray, cobalt blue, cadmium red, brown madder alizarin, cadmium yellow, burnt umber, lemon yellow, and Naples yellow

The Painting

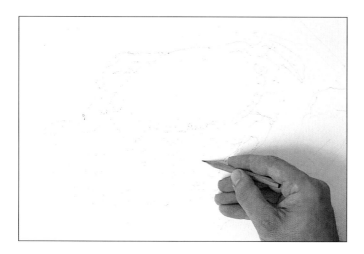

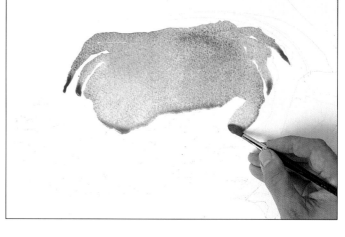

1 A light HB-pencil drawing helps position the crab and langoustine; the format is almost square, with the plate sitting diagonally across the paper. The darkish mass of the seafood at the top of the picture is balanced by the napkin running off the edge and the bright yellow of the lemon next to it.

2 Mix three washes consisting of the following colors: cadmium red, burnt umber, and cadmium yellow; cadmium red, brown madder alizarin, and cadmium yellow; cadmium red and Naples yellow. Using the no 8 round brush, paint in the darkest mix (cadmium red, burnt umber, and cadmium yellow), working around the crab legs and the back of its shell.

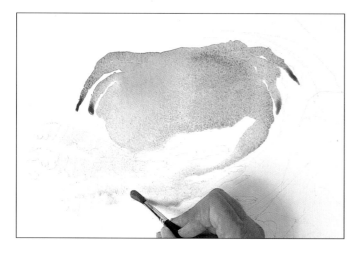

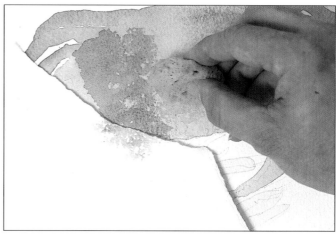

3 Work across the middle of the shell using the slightly lighter mix (cadmium red, brown madder alizarin, and cadmium yellow) and finally establish the overall color of the langoustine using the mix of cadmium red and Naples yellow.

4 Tear a piece of medium-weight watercolor paper to give an edge that has a slight curve. Use this as a mask to prevent paint getting on to those areas where it is not wanted. With the small sponge, or a piece cut from a larger one, dab on some texture over the crab shell to resemble the rough, pitted surface. Next, use the darkest mix from the previous step and, darkened with a little more brown madder alizarin and a little more burnt umber, dab across the surface of the shell to describe the rough, pitted surface.

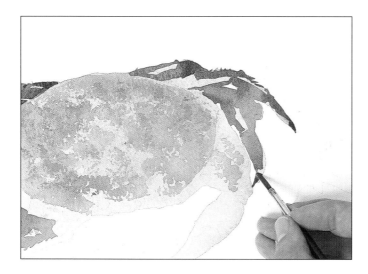

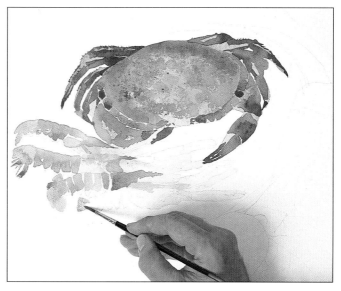

5 Allow the sponged texture to dry and repeat the process to give a layered effect. Using the no 5 round brush and a dark, rich mix of brown madder alizarin, Payne's gray, and cadmium yellow, paint in the dark areas of the legs and claws, cutting in carefully to preserve the distinctive edge of the shell.

6 Add more Payne's gray and burnt umber for the dark color at the end of the claws, then lighten the mixture with water and, looking carefully, describe the segmented langoustine shells. Add a little Naples yellow to the very light shell color and paint in the pinkish shadows that can be seen on the plate.

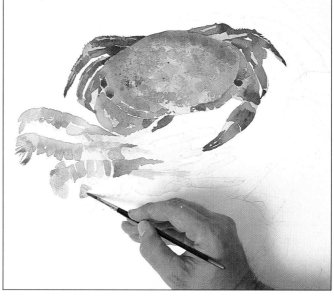

7 The light reflections on the pitted surface of the lemon are reproduced by dotting on a little masking fluid using an old brush.

8 Color some clean water with Payne's gray and cobalt blue and, using the no 8 round brush, wash over the white table cloth, working around the plate. Darken the mix used for the crab shell with burnt umber, brown madder alizarin, and Payne's gray, then wet the shell area by dabbing on water with the sponge and touch in the dark paint around its edges; the mix will run into the wet area finding its own place to rest.

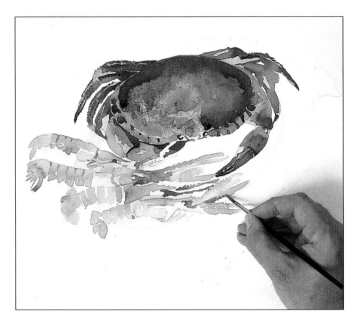

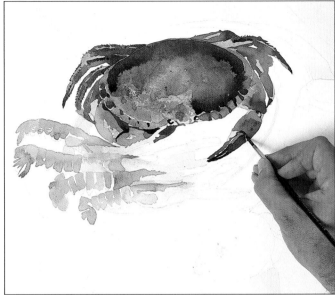

9 Using the same mix and the no 5 round brush, paint the shadows seen in the crevices around the shell edge, the eyes and the spiky fine hairs on the legs. Finally, darken and paint in the detail on the claws by adding a little more Payne's gray into the mix.

10 Lighten these mixes a little with water and, still using the no 5 round brush, sharpen the segments on the langoustine and bring in some detail to their heads and claws.

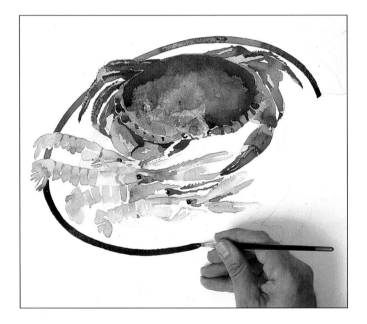

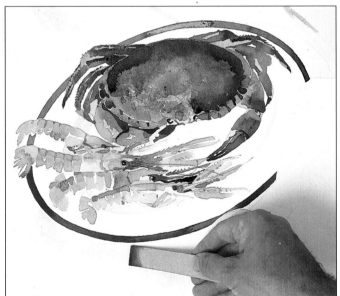

11 Cobalt blue added to Payne's gray gives the color for the blue line around the edge of the plate. This helps define the plate area and separates it from the light tablecloth, visually lifting the seafood. The lemon is blocked in using a cadmium yellow and lemon yellow mix.

12 Payne's gray and cobalt blue also gives a light gray for the shadows and creases found on the white table cloth. Dip the end of the chisel-shaped piece of thick card into the mix and use it to paint on the creases and shadows. By altering the angle of the card the shape of the mark will vary; a very thin line can be obtained by using the card on its edge.

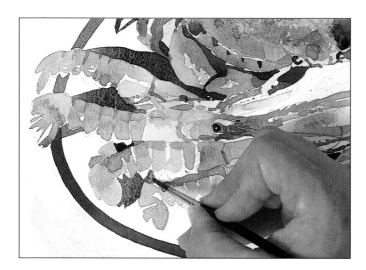

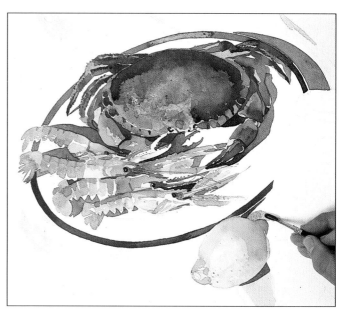

13 Varying mixes of Payne's gray and brown madder alizarin will give the blue-brown colors found in the shadows beneath and around the crab and langoustine.

14 The painting's completed by finishing the lemon with a little cobalt blue mixed with lemon yellow for the green, and a light wash of Payne's gray for the shadow

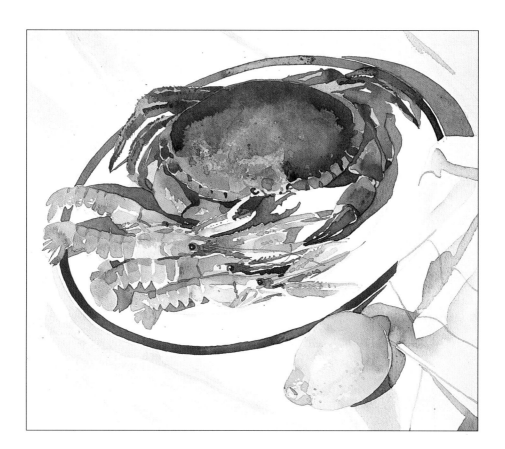

15 Once dry, the masking fluid is rubbed away to reveal the paper highlights. Payne's gray and brown madder alizarin are again used for the dark shadows on the cloth. Finally, the red pattern on the napkin is painted using brown madder alizarin.

Alternative Approaches

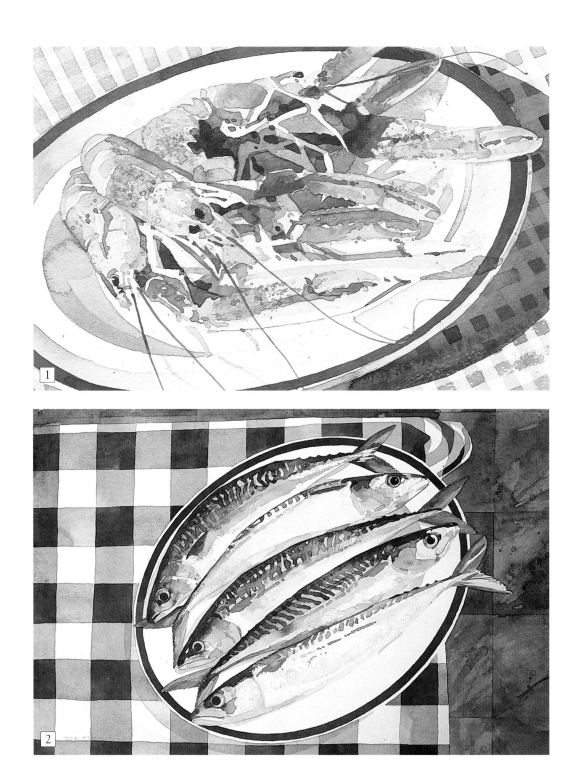

1 This plate of langoustine has been made to fill the picture area. The blue edge of the plate confines the subject and makes a closed composition. The shells have been spattered just enough to suggest some pattern and texture.

2 In this painting the mackerel are made to look silvery and wet by simply drawing the patterns of reflected light seen on the scales with a fine-nibbed drawing pen dipped in masking fluid. Plenty of gum arabic was used in the mixes to keep the paint bright, light and transparent.

BOATS ON A BEACH

Masking and Spattering

WITH CAREFUL and painstaking observation, and with a certain degree of skill, it is possible to recreate the scene before you with complete precision; however, the result can be less than satisfactory. The slow process of representing each and every detail can make the picture look dull and uninspired, regardless of the skill that it took to paint it. The problem may sometimes be one of simply overworking or taking things too far; having successfully accomplished what was intended the artist adds a touch here and a touch there, and before long the spark is lost.

Do remember that a complicated-looking subject can often be painted more convincingly and retain greater visual interest if it is treated with a certain amount of artistic or creative license. Many purists frown on using anything other than traditional brush techniques, but I believe that artists, by definition, are inquisitive and inventive folk, who should use whatever is to hand in order to solve tricky problems of representation.

The seashore is a great place to work, and boats are grand and challenging subjects to paint. They are often very careful or, if not, like our subjects they are beaten and weathered from years of hard work and standing up to the elements. At a glance the view offers little to work with, but by making a few decisions early on about possible treatments the options begin to widen and grow.

The beach and the pile of old nets are a challenge as both are visually highly complex. In the painting, the beach was spattered with paint to give the impression of millions of multicoloured pebbles. By allowing each color to dry before spattering another, the tiny blobs of color dry separately. The illusion is carried further by painting the pebbles larger the nearer they get to the forefront of the painting. Masking the area with torn paper accomplishes two things: it keeps the rest of the painting clean, and the rough, uneven edge gives a distinct quality to the edge of the masked area. The same is true of the tape used to carve out the shape of the pile of nets. These presented their own set of problems, so a loose impression of what was there was considered to be the best solution.

MATERIALS AND EQUIPMENT

15 x 22 in. (38 x 56 cm) sheet of stretched 200 lb (425 gsm) CP Bockingford watercolor paper
Thick piece of card
Bristle oil painting or decorator's brush, 1 in. (2.5 cm) wide
2B graphite stick
Three round brushes, no 12, no 8, and no 5
Drafting tape
Watercolors in the following colors: Payne's gray, cobalt blue, cadmium red, yellow ocher, cerulean blue, burnt umber, cadmium yellow, and raw umber

The Painting

1 The boat, position of the horizon and the nets in the foreground can be established in light pencil if you wish. Using the no 8 round brush and a dilute mix of cobalt blue, apply a flat wash over the sky area down into the sea and across the boat; do not bring the wash down on to the beach. Once dry, darken the mix with Payne's gray and a little yellow ocher and, using the same brush, paint in the sea as a flat wash. Make sure the horizon line runs horizontal and is square to the side edge of the picture.

2 Apply drafting tape to approximate the shape of the piles of discarded fishing net. Do use drafting tape and not masking tape, as the latter is far stickier and may pull the surface off the paper when it is removed.

3 Mix a thin wash consisting of raw umber and yellow ocher. Using the no 12 round brush paint this across the area of beach and over the boats, paying particular attention to the edge that runs against the sky and the sea.

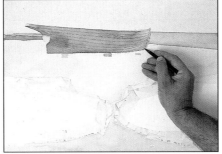

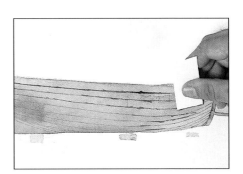

4 With a light mix of raw umber and cobalt blue, and using the same brush, paint in the boats. Allow the wash to dry, then darken the mix with burnt umber and Payne's gray and repaint, cutting out the shapes at the stern of the boat and leaving a pale edge along the top edge.

5 With the 2B graphite stick carefully draw in the shape and direction of the wooden planks on the boat.

6 Using a thin piece of card dipped in a dark raw umber and Payne's gray mix, darken the shadows that run along beneath each plank.

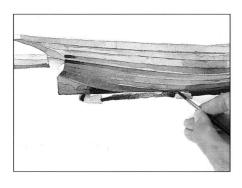

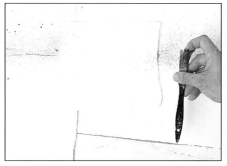

7 Intensify the mixture with a little more burnt umber; using the no 5 round brush, darken those planks that are in shadow around the belly of the boat and the area of shingle that lies directly beneath the boat.

8 A band of shingle is spattered running across the middle of the picture. In order to do this the rest of the painting needs to be covered to prevent splashes of paint falling where they are not wanted. Medium-weight watercolor paper is torn to give an interesting line and secured into place with drafting tape. Different ocher and brown mixes are then spattered across the desired area using the 1-in (2.5 cm) bristle brush. Each mix is allowed to dry before spattering the next.

9 The paper mask is moved down a fraction and a second area is spattered across the bottom of the picture. Once the effect has been achieved the paper mask can be removed along with the drafting tape, leaving the shape of the nets.

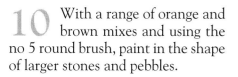

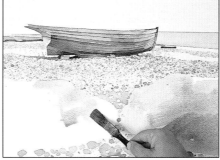

10 With a range of orange and brown mixes and using the no 5 round brush, paint in the shape of larger stones and pebbles.

11 With the 1-in (2.5 cm) bristle brush loosely block in the nets using cerulean blue and a mix of cadmium red and cadmium yellow.

12 Using the piece of thick card and a range of browns and oranges mixed from the colors used previously, paint in the piles of discarded rope and netting, sometimes working the negative shapes. This allows the base color to show through as strands of rope, while in other places the card is used to describe the bright orange of the tangled nylon nets.

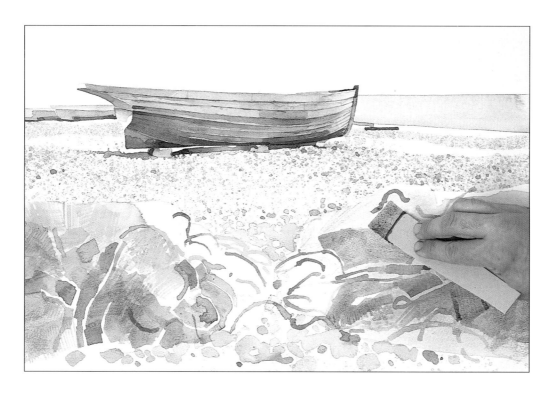

13 The no 5 round brush is used to paint in the finer net lines and the process is repeated with the blue. If and when the end of the card begins to deliver a messy line and becomes over-soggy, simply cut off the wet portion leaving a new crisp edge with which to work.

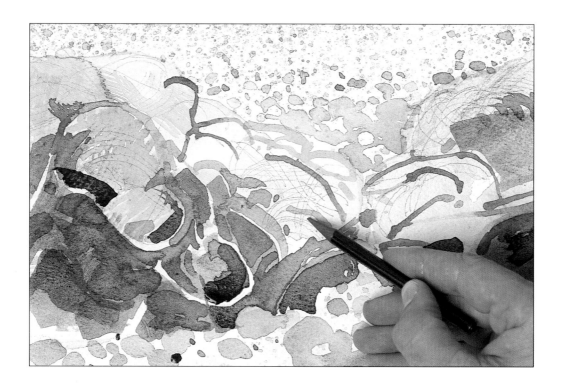

14 Finally, using the 2B graphite stick, work into the netting, scribbling in a little more detail.

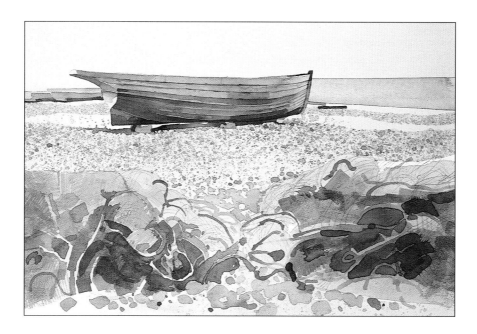

15 The finished picture.

Alternative Approaches

1

1 The effects of aerial perspective can be clearly seen in this painting of the pier at Brighton, on the south coast of England. The pier itself is painted in sharp, bright color, while the color and tone of the distant landscape, glimpsed through the supporting pillars, is muted and cool.

2 A similar effect is achieved, again looking along the beach toward the pier, but from the opposite direction. The muted gray tones of the piers help them to recede into the distance, while the spattering in the foreground, that is suggestive of a pebbled beach, intensifies in color and increases in size as it nears the foreground or bottom edge of the painting.

2

EARLY SNOW

Using White

PROJECT SIX

AS STATED previously the white of the support is of primary importance, affecting as it does the intensity and the tone of the color. A wash with only a little paint added to the water is thinner and allows more light to reflect back from the paper, which in turn makes the color look paler in tone; darken the mix by adding more pigment to the water and less light can reflect back through the paint, making it look darker in tone. In order to paint something that is white without using white paint, you will need to use the white of the paper. This simply means planning well enough ahead in order to keep that area of paper free of paint. It helps to think in terms of white being a color and working, as we are, traditionally, that is light to dark: light colors first, dark colors last, so the white color would come first in the running order.

Once the area that is to be left white has been decided, it can be masked out with paper, tape or masking fluid or carefully avoided and just painted around. How you do this will depend very much on the size and complexity of the white area. If the area consists of thin white lines against a dark background, then it would make sense to use masking fluid for the lines and wash the dark color over the top. If the white area is a larger, simpler shape then painting around it should present no problems—it may be that a combination of techniques is employed, as we have done here.

The shape of the building was easily avoided with paint, but the grass showing through the snow was a different matter and would have been difficult to show by simply painting the grass around the patches of snow. The problem was solved by using candle wax as a resist on the foreground to keep the paint from the paper and allow white to show through in a complex pattern of shapes. Once color is applied the white areas will gradually be transformed into positive areas, which take on their own form and dimension, occupying specific positions in space rather than being white holes surrounded by coloured paint.

MATERIALS AND EQUIPMENT

15 x 22 in. (38 x 56 cm) sheet of stretched 260 lb (365 gsm) CP Waterford watercolor paper White candle

Three round brushes, no 12, no 8, and no 5 Small flat brush Small natural sponge

Watercolors in the following colors: Payne's gray, Antwerp blue, cobalt blue, sap green, and raw umber

The Painting

1 It helps to begin with a light line drawing using an HB pencil.

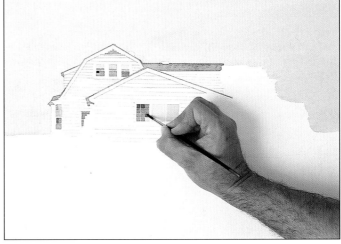

2 Then, using the no 12 round brush, wash in the sky with a light mix consisting of Antwerp and cobalt blue. Allow this to dry.

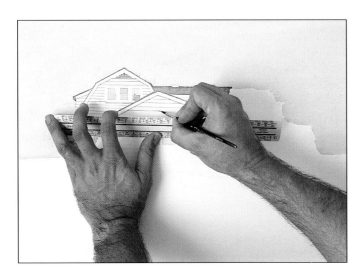

3 With a mix of Payne's gray and raw umber, and using the no 5 round brush, paint in the overall color of the roof and windows. Then, using a ruler as a guide, paint in the shadow that falls beneath each plank on the house.

4 Once dry, repaint the individual panes of glass in the windows using the same mix darkened a little with Payne's gray and cobalt blue and also wash in the trees seen in the distance.

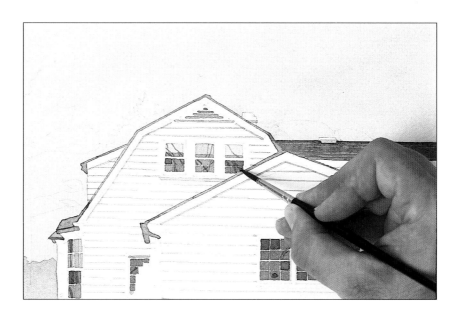

5 Paint in the lines of the roof shingles, darken the mix again with the same colors and paint in the reflection of the tree branches.

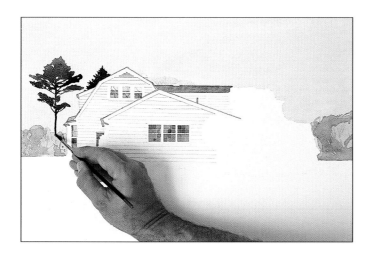

6 Still using the no 5 round brush and with a mix of raw umber and Payne's gray, paint in the branches of the distant trees, which can be seen behind and to the side of the building.

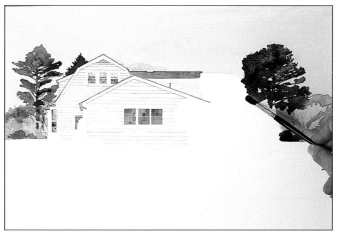

7 Add a little sap green into the previous mix and add more detail to the band of undergrowth that runs across the center of the picture. Allow this to dry, then rework, painting in a suggestion of trees and branches. Add more sap green and paint in a little foliage, then darken the mix considerably with the addition of more sap green, Payne's gray, and raw umber, and using the no 5 and the no 8 round brushes, carefully position the dark trees. Pay particular attention to their shape; do not make them too dense and leave plenty of sky holes.

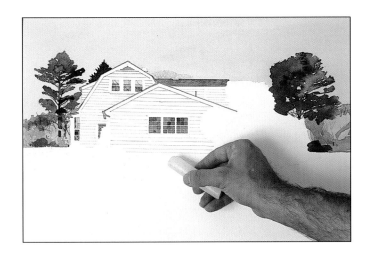

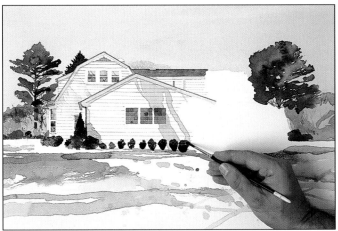

8 Work across the foreground of the painting with the white candle. The wax will act as a resist, repelling the paint and allowing the white of the paper to show through.

9 Mix sap green, a little Payne's gray, and raw umber and, using the no 12 round brush, loosely brush in the grass showing through the light covering of snow.

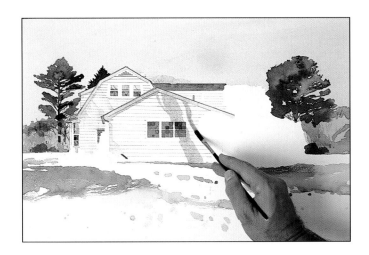

10 Cobalt blue, Antwerp blue, and a little Payne's gray give the blue shadow cast by the trees standing just out of view. Using the small flat round brush the shadows are painted in simple shapes that run down the white-painted timber and across the windows. The same blue mix is also pulled across the snow and grass, indicating the direction of the shadows that fall there.

11 Sap green, Payne's gray and raw umber are mixed to give a dark green. Using the no 5 round brush, establish the small shrub and bushes that are planted around the base of the building.

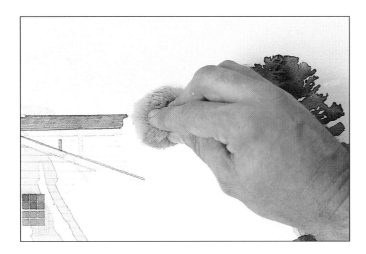

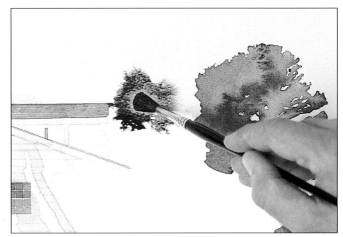

12 The collection of dark shrubs and small trees that stand to one side, but in front of the buildings, are painted next. In order to give the outline a distinct quality the area is first dabbed with a small, wet natural sponge.

13 Then, using the dark green mix and the no 12 round brush, drop the paint into the area. There is no need to brush the paint into the outline, it will find its own way as it flows into the wet shape left by the sponge.

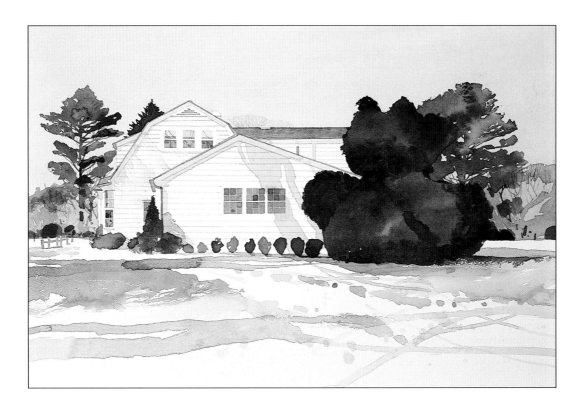

14 The shrubs are darkened a little on the side away from the sun by adding Payne's gray to the dark green mix and the dark shadow cast by a tree that is out of view is painted falling across them with the no 12 round brush and the same mix.

Alternative Approaches

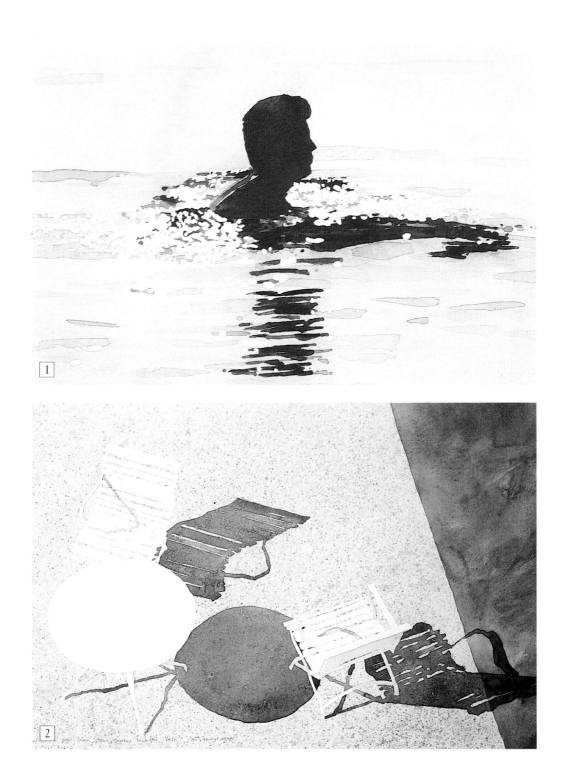

1 In this simple study of a swimmer, only two colors were used. The effect of the sun sparkling on the surface of the water was obtained by dotting on blobs of masking fluid before applying any paint.

2 For this slightly unusual view of a white table and two chairs seen from above, masking fluid was used again to paint the shapes out carefully before commencing work on the loosely painted and spattered background.

ACROSS THE GRAND CANAL

Editing the Scene

PROJECT SEVEN

OCCASIONALLY a scene before you looks so complicated it actually puts you off making any attempt to paint it. The answer is not to give up, but to visually edit the scene, leaving out anything that you feel is not needed, simplifying and distilling the view until it appears manageable. One technique that can be helpful is to half-close your eyes and look carefully at the scene. This technique has the effect of reducing the apparent tonal range of the colors and increasing the contrast. It also has the effect of reducing the amount of detail and texture, which is inevitably contributing to the confusion.

This scene across the grand canal in Venice, looking toward Santa Maria della Salute, is a riot of shapes, colors, and textures, all screaming for attention. However, it could quite easily be broken down into half a dozen different compositions. Choosing what format and composition to go with are usually two of the early decisions to be made. A number of different compositions and formats can be considered before starting work by using a view finder. You can make one from a small piece of card by cutting a rectangle in the middle. Hold this up in front of you and look through it toward the subject.

Certain elements, as long as they are not too important, can always be left out and others added, as we have done here. It was thought that an extra wooden stake should be added to fill the gap in the lower right-hand corner, helping to balance the composition. It may be interesting to note that the well-known 18th century Venetian artist Canaletto sometimes moved entire buildings if they did not suit the scheme of his famous compositions.

The process was further simplified by splitting the picture up into specific areas and methodically working over each in turn; this gives you about as much control as it is possible to have when using watercolors. Most of the colors have been split into just three tones: light, medium, and dark. These are worked light first, dark last, and each is allowed to dry before applying the next. But despite this you will see that the tonal range in the painting appears to be much greater.

MATERIALS AND EQUIPMENT

20 x 14 in. (51 x 35.5 cm) sheet of stretched 200 lb (425 gsm) CP Bockingford watercolor paper	Two round brushes, no 12 and no 5 Watercolors in the following colors: Antwerp blue, cobalt blue, Payne's	gray, sap green, ivory black, brown madder alizarin, yellow ocher, and raw umber

The Painting

1 With such a complex scene, which requires color washes to be kept well under control, a light pencil drawing, using an HB pencil, will act as an invaluable guide.

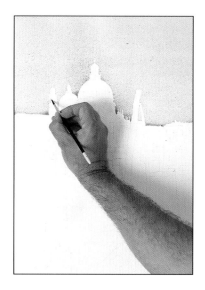

2 Mix up a wash of Antwerp and cobalt blue and, using the no 12 round brush, paint in the sky as a flat wash. Position the board at a slight angle and work quickly, painting as close to the buildings as you can with the large brush. Switch to the smaller no 5 round brush to paint in and around any complicated edges.

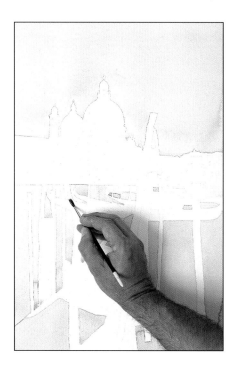

3 Using the same mix, block in the blue canvas covers on the boats and the water, working carefully around the boats and the palina, or wooden stakes, that are used for mooring.

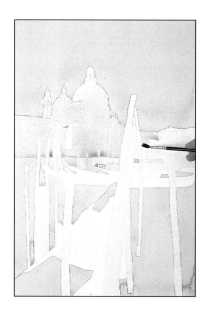

4 Once the blue has thoroughly dried, paint a very pale wash made with yellow ocher and ivory black across the buildings and the wooden stakes. Allow this to dry, then darken and intensify the mix by adding more ocher and black, and apply a second tone across the buildings, this time leaving any light areas and the stakes unpainted. Allow the painting to dry.

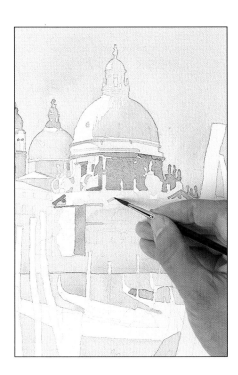

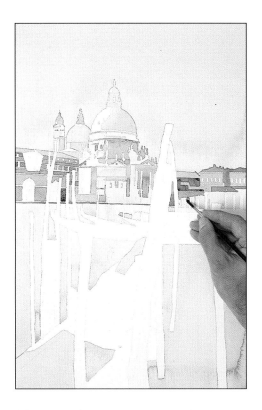

5 Darken the mix once more with ocher and black and carefully and selectively begin to paint in the darker tones, details, and shadows seen on the church.

6 Add burnt umber to the mix, making it richer and browner, and in the same way work the buildings either side of the church. Paint in the dark line that runs across the scene at the waters edge.

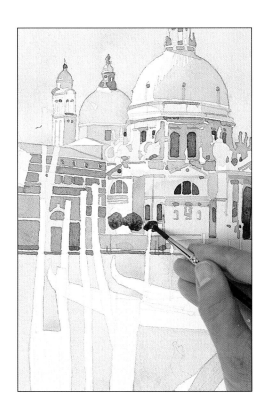

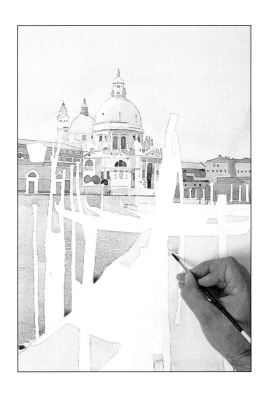

7 Using a still darker mix of raw umber and ivory black, paint the details and shadows seen on the church and the other buildings, paying particular attention to windows and doors. With a sap green and raw umber mix establish the few small trees that stand at the base of the church.

8 Still using the no 5 round brush, mix Antwerp blue, sap green, and a little Payne's gray to deaden the color work across the water, leaving the shape of ripples and small waves showing in places.

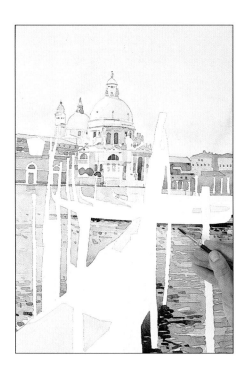

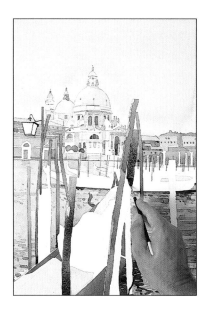

9 Once this is dry, darken the mix with a little Payne's gray and repaint the water, working the shapes seen in the rippled surface. Darken the mix further by adding Payne's gray and paint in the dark shadows and reflections seen beneath the gondolas. Note that by making the ripples larger they appear closer, which helps give the illusion of depth.

10 Turn your attention to the wooden stakes and block them in with a mixture of raw umber and burnt umber. Leave a little bark texture showing where it catches the light and lighten the mix a little by adding water for those stakes that are situated in the middle distance.

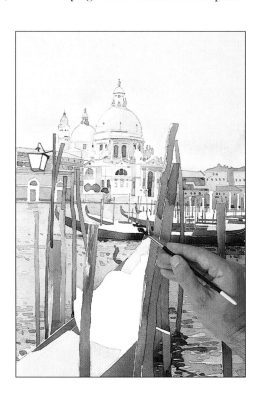

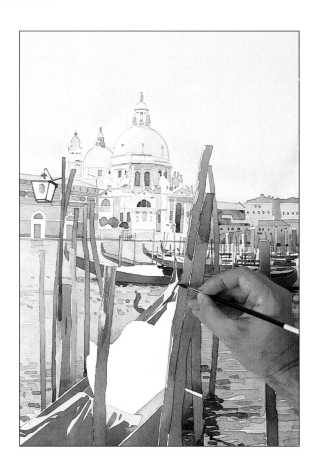

11 Adding ivory black into the mix gives the color for the gondolas; work carefully around the stakes.

12 With a dark blue mixed from Payne's gray and Antwerp blue, paint in the shadows seen on the blue canvas covers.

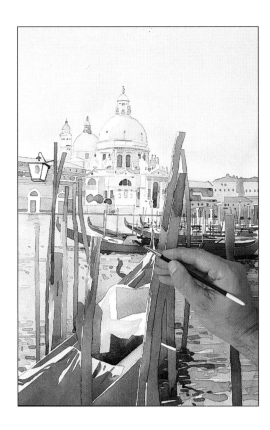

13 Payne's gray and ivory black give a light gray for the shadow on the cover in the nearest boat, while brown madder alizarin and raw umber give a dull, washed out red for the other covers and blankets.

14 Finally, add more brown madder alizarin to redden the mix and paint in the pattern seen on the blankets and the dark red surround on the seat cover of the nearest boat.

Alternative Approaches

1 This large painting looking up Seventh Avenue in New York is painted with very few colors. Varying mixes, using Payne's gray and ivory black, are enlivened by a little color on the buildings to the left, and the red touches seen in the brake and traffic lights.

2 In this painting, looking out of a window in the Louvre, Paris, the tonal contrasts are pushed to the extreme, with the cool building opposite painted in cool, light tones giving a sense of distance and the window frame and tree painted very dark, almost black.

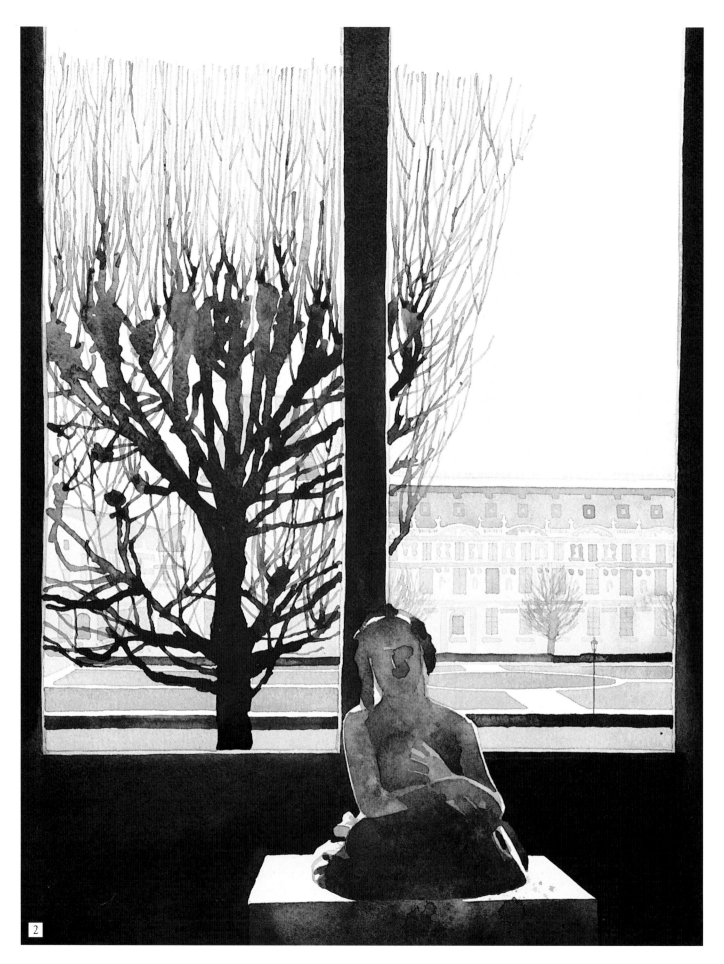

2

ALICE

Controlling Washes and Making Corrections

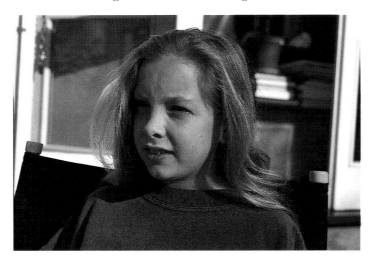

MANY WILL AGREE, I am sure, that portraits are perhaps the most difficult thing to paint convincingly. It is quite enough having to juggle with the complexities of proportion, form, color, and tone, not to mention composition, without the added challenge of trying to capture something of the sitter's character and personality. Children can be particularly demanding, as their attention span is short and they have great difficulty in sitting still for any period of time. Working from photographs is an obvious solution, relieving the tension that both the artist and young model would have inevitably felt, and enabling the artist to take a longer, more considered approach. Photographic reference can be unhelpful though—the main problem lies in the camera's monocular viewpoint of seeing things, as it does, from only one point in space. The binocular vision that humans possess gives a three-dimensional viewpoint; even a very small movement of the head will alter the angle at which the subject is seen, making it possible to assess form, shape and color more easily. However, that said, these problems can be overcome if the photographic reference is used correctly and with a little thought.

With opaque mediums such as oil or acrylic paint alterations and corrections are easily effected simply by painting over and obliterating what was there beneath a new layer of paint. As we have already seen, there is no such luxury with watercolor, so working on a portrait, with its subtle variations in skin tone and color, will test your mixing, as well as your light to dark wash techniques, to the full. Always remember it is easier to darken an area or wash than it is to lighten one; a great deal of gum arabic was used in the middle and later stages of this portrait painting for precisely that reason. It enabled paint to be rewet and lifted, and hard edges softened; it also kept the color bright and transparent.

Obtaining a likeness is often simply a matter of widening the mouth, lengthening the nose or altering the curve of the cheek, and you will find that the gum arabic will give you some latitude to enable you to make this kind of alteration. It may seem an odd thing to say, but keep in touch with the progress of the painting from the outset and try to recognize when, and if, things are not right immediately.

While it may be somewhat awkward correcting mistakes when a wash is wet, it is impossible when the paint is dry and covered with other washes. Pay particular attention to the intensity of your color mixes and bear in mind that the color will look considerably darker when it has dried. To this end, get into the habit of dabbing a little of your mix on to a piece of scrap paper of the same make you are using, and let the color dry before reassessing its strength.

MATERIALS AND EQUIPMENT

12 x 10 in. (30 x 25 cm) sheet of unstretched 250 lb (535 gsm) Bockingford watercolor paper	Two round brushes, no 9 and no 5 Gum arabic Watercolors in the following colors: Payne's gray, ultramarine,	cadmium red, cobalt blue, brown madder alizarin, Naples yellow, yellow ocher, cadmium yellow, raw umber, and burnt umber

The Painting

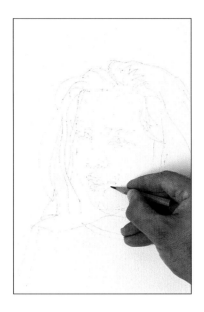

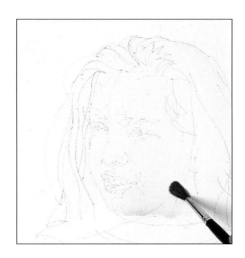

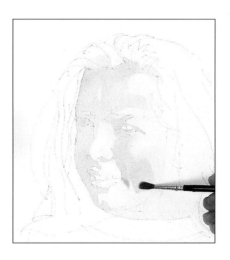

1 Using an HB pencil make a careful line drawing of the subject. Keep the lines light, as they will show through the paint if they are too dark.

2 Using the no 9 round brush wash in the pale blond hair with a mix of cadmium and Naples yellow. With the same brush, wash in the palest skin tone using a mix of cadmium red and Naples yellow, taking care to work around the white teeth.

3 Darken the skin mix by adding brown madder alizarin; use the no 5 round brush to work over the face, establishing the mid tone. To avoid getting a hard line, soften the edge of the color where it ends on the cheek and the forehead by blotting with a paper towel or a barely damp, clean sponge.

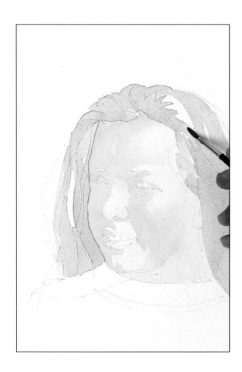

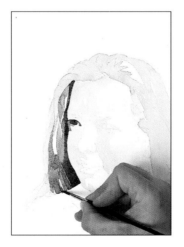

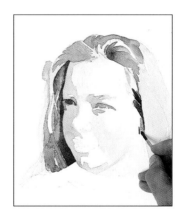

4 Darken the hair mixture with yellow ocher and raw umber and work across the hair, cutting around any highlights.

5 With a Payne's gray, raw umber, and brown madder alizarin mix paint in the dark of the right eye and the shadow down the side of the face beneath the hair. Darken the hair mix with more yellow ocher and raw umber and search out the shanks and fall of hair, working carefully around any lighter strands.

6 Darken the mid skin tone with more brown madder alizarin; add a little cobalt blue and gum arabic and paint in the dark tone on the side of the face and around the left eye. Add water and cobalt blue to show the reflected color from the blue shirt beneath the chin. Paint in the left eye with Payne's gray and burnt umber and work the dark shadows on the hair.

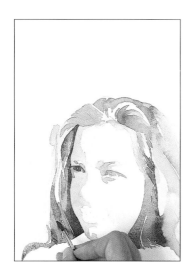

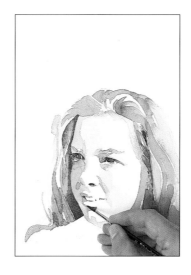

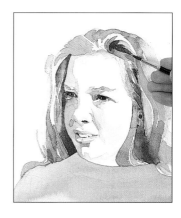

7 Add more brown madder alizarin, cobalt blue, and gum arabic into the skin color and block in the shadow cast by the hair on to the left-hand side of the face. Darken the hair mix further and add a little gum arabic. Using a range of tones rework the hair, darkening and redefining the shapes and shadows.

8 Work the subtle tones around the eyes with the skin mix, paint in the shadows at the side and below the nose. With brown madder alizarin and Payne's gray darken the eyes and paint in the nostrils and the dark area inside the mouth. Once this is dry give a little more definition to the eyelids and, using brown madder alizarin, establish the dark on the lips.

9 An ultramarine and Payne's gray wash establishes the color of the shirt. To avoid smudging the wet paint allow this to dry, then rework the lips with a range of tones and colors made from brown madder alizarin, cadmium red, and cadmium yellow. Mix in gum arabic to sharpen the color. Allow the lips to dry and paint in the shadow on the teeth with a pale mix of Payne's gray and yellow ocher. Use a dark mix of Payne's gray and burnt umber to darken the iris and pupils, then return to the hair and darken the shadows.

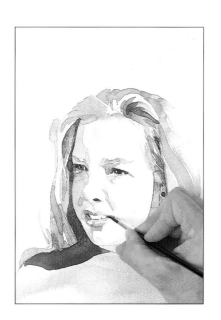

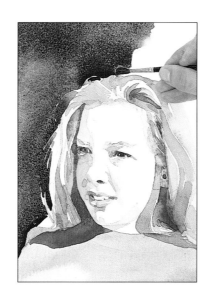

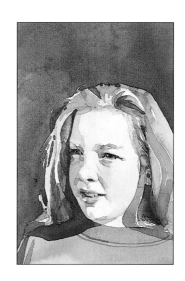

10 Payne's gray mixed with ultramarine is used to paint in the shadow on the sweatshirt. For the shadow on the subjects right lighten the mix with water. Rework the detail on the lips and around the mouth with more lip color, carefully avoiding the highlights and the teeth.

11 Mix a dark wash of burnt umber and Payne's gray and paint in the background using the no 9 round brush. Switch back to the no 5 round brush when painting in close around the hair. Pick out a few wisps of hair by simply leaving thin, curving lines of white paper showing.

12 Using the no 5 round brush, rework the painting using clean water. The paint, having been mixed with plenty of gum arabic, can be dissolved easily, allowing areas to be softened and manipulated until the result is considered satisfactory.

Alternative Approaches

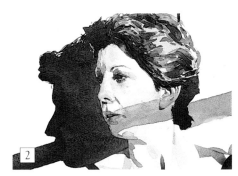

2 The shadow thrown across the sitter's face by the strong light streaming through a window makes a slightly unusual portrait.

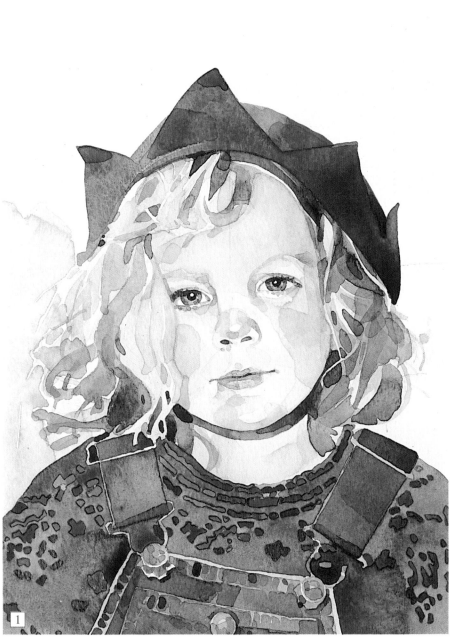

1 In this portrait delicate washes—some worked wet into wet, others wet on dry—combine to capture the confident stare of a three-year-old. Portraits painted full on from the front can sometimes look flat, but here the curve of the hat sitting on the back of the head helps give the head dimension.

MATERIALS AND EQUIPMENT

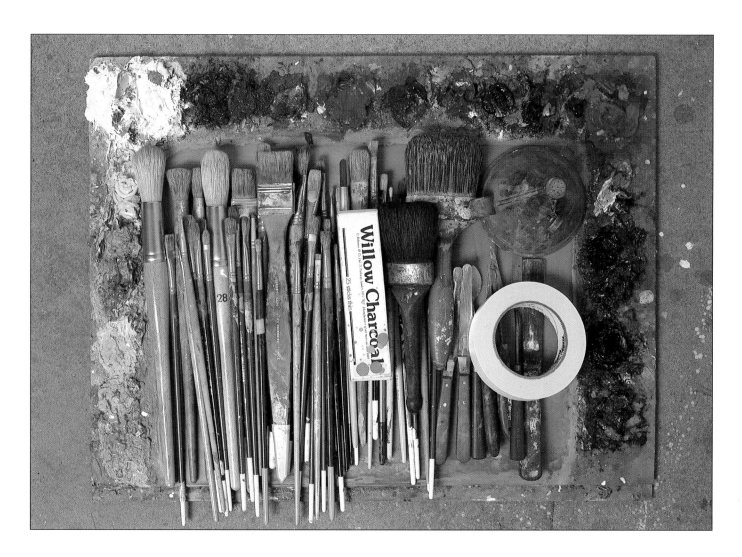

Canvas boards and other supports

The support is the surface upon which the oil paint sits or is carried. Oil paint is very obliging in that it will sit happily on almost anything that has been adequately and correctly prepared, however, certain supports have a proven record and are far more practical to use than others. Canvas is synonymous with oil painting and is the most commonly used support, if not the best.

There are several reasons why this has come about: canvas is light, making it possible to produce extremely large paintings that can easily be moved while still stretched, or if preferred removed from the stretcher and rolled up. The surface "give" of stretched canvas is very responsive to the pressure of the brush, making it pleasant and comfortable to work on and the surface tooth or texture takes the paint very easily. However, canvas is but one of many surfaces artists choose to paint on; together with paper

there are many rigid supports which can also be used and each will bring a very distinct and different quality to the finished work.

Various types and weave of canvas can be bought in a range of sizes. Already stretched and prepared with either an acrylic or an oil-based primer, these are ready for painting on, but it is far more economical and satisfying to prepare your own; it is also, as you will see later, both quick and easy. Canvas that is unprimed and preprimed is sold by the yard or meter from rolls of varying width, which can be cut to the required size. Stretching preprimed canvas can be tricky and as priming is straightforward it may be best to stick to unprimed. The thickness of the canvas is described by ounces per square yard, so the heavier the weight, the thicker the canvas. In general it is better to use heavier weight canvas for larger work but anything between 9 oz–15 oz (25 gm–425 gm) is good for all round use.

The very best canvas is linen from Belgium, the Netherlands, and Ireland. It is made from the decaying stalks of the flax plant, whose seeds also give us linseed oil. The only disadvantage with linen is that it is expensive but in recompense it is extremely strong and almost impossible to tear, with a smooth, closely woven but irregular and unobtrusive weave.

Cotton canvas—also known as cotton duck—is viewed by some as a poor substitute for linen, but it is nevertheless an extremely popular and widely used substitute. Available in a wide range of sizes and weights, cotton duck provides a more than adequate support for your work and it is relatively inexpensive, easy to stretch, and almost as tough as linen. The weave of cotton canvas tends to be more regular and mechanical but it is an easy surface to work on and takes the paint well.

Linen and cotton mixtures are also available but are not to be recommended as they both dry to different tensions making them awkward to stretch. Hessian, jute, and natural flax can also be used; they have a more open weave and offer, depending on the weight, a coarser surface that is best used for heavy impasto work so that the texture of the weave does not dominate. Synthetic polyester has been used for some time by restorers to reline canvasses, it is very stable and smooth, and unlike natural canvas it will never rot. Preprimed polyester canvas can be bought both ready stretched and unstretched and is sure to be used increasingly by artists in the future.

All canvas needs to be stretched over a wooden frame to keep it taut. These wooden stretcher pieces are usually made from kiln-dried, seasoned pine and bought in pairs that are very slightly beveled, or raised, on one side so as to keep the canvas proud of the wood. They are already mitered and slotted ready to be joined together and are available in practically any size. Always check for warping by looking along the length of the stretcher bar before buying. Each canvas requires four stretchers and larger canvasses need extra cross pieces to stop them from warping under the considerable tension that a large canvas can exert. Small, triangular wooden wedges can be tapped into the inside of the slotted corners to force them apart and increase the tension once the canvas has been stretched and primed. Stretchers are also available that are round or oval and specialist firms will make up more complex and awkward shapes to order.

Prepared oil painting paper can be bought in a range of sizes and surfaces, as individual sheets or in pads containing several sheets. While not being suitable for work that is considered important and intended for a long permanent life, it is ideal for sketching and preparatory paintings. Most papers can be used if they are substantial enough and adequately sized or primed to protect the paper fibers from the oil. The thicker watercolor papers are especially good as they are heavy enough to stay flat and not cockle when primed and they often have good surface texture. The same is true of ready prepared canvas painting boards made by mounting canvas on to a cardboard backing. These, too, come in a range of sizes and surfaces and are suitable for smaller works, as well as ideal for sketching and painting on location, but they are prone to bending and warping if they become damp.

Up until the 16th century oils were painted on gessoed wooden panels made mostly from oak, poplar and mahogany. Today with so many modern alternatives available, traditional panels such as these are rarely, if ever, used. Plywood, masonite (known as hardboard in Great Britain) and the ubiquitous medium density fiberboard (MDF) all offer excellent surfaces to work on, are reasonably priced and can be cut to the desired size. Plywood is made from a variety of woods and in a variety of thicknesses; it is prone to warping so thinner sheets that are of any size need to be reinforced with battens across the back.

The same problem applies to masonite (hardboard) which has a rough, textured surface, not unlike hessian, on one side and a smooth surface on the other. The smooth surface is usually worked on after being scuffed with a coarse sandpaper to give a little bit of tooth and then primed, but the rougher side can also be used to good effect. MDF is also readily found and is the best of the three. It is also available in a range of thickness but unlike plywood and masonite is very stable and will not warp, so it does not need battens. Both sides are smooth and can be worked on, but a little extra care should be taken with the corners as they can chip if treated roughly.

Muslin, which is a cheap thin cotton fabric, and scrim, which is also very cheap but is coarser with an open weave, cannot be stretched. However, they can be glued to any of the boards mentioned, by using an acrylic medium to provide a firm, stable and inexpensive alternative to pre-prepared boards. Canvas can also be

faced on to MDF in a similar way, with the canvas being secured at the back by staples and an acrylic or PVA adhesive.

Sizing and priming

Whatever the support it will need to be protected and prepared ready to take paint. The oils and chemicals contained in the paint can corrode and deteriorate raw canvas and paper. Most supports are too absorbent to be worked on directly, sucking the oil out of the paint and making it difficult to manipulate. This surface preparation is known as the "ground."

Traditionally the ground is prepared in one of two ways; flexible supports such as canvas are first given a coating of warm glue size which seals and protects the canvas fibers from the corrosive action of the oils and pigments, this also prevents the primer from soaking through. Then a white primer is applied which stays flexible when dry: this fills the weave of the canvas and gives a light reflective surface that takes the paint easily and gives a brilliance to the colors.

Rigid, or non-flexible supports like wood are usually prepared with gesso, which is a mixture of chalk and glue size. The gesso is applied in as many as eight or 10 thin layers; each layer is allowed to dry before the next is brushed on at right angles to the last, the surface can be sanded smooth between coats or after the last coat has been applied and is dry. Traditional gesso is best not used on a flexible canvas support as it may crack.

These traditional proven preparations can still be followed but with the advent of acrylic paint, easy to use prepared acrylic primers, and gesso based on polymer resins, all do away with the need for sizing. The acrylic coats the support making it impervious to the corrosive action of oils and driers.

These primers can be thinned with water, dry very quickly, and will take to most grease-free surfaces. If grease is a problem, panels can be degreased with methylated spirits. On some linens the first coat sometimes soaks through to the reverse but this can be alleviated by first coating the canvas with an acrylic matte medium thinned with water. Because the primer is acrylic-based it enables underpainting and colored grounds to be made using quick drying acrylic paint. This would not of course be possible if an oil ground was used, because the acrylic will not take to an oil-based primer.

Paint

Oil paint is made by mixing pigment with an extender and a binding medium, usually linseed oil. The paint is available in two basic grades usually referred to as "student's quality" and "artist's quality," the distinction between the two is not as pronounced as the difference between student and artist quality watercolor paint. Student quality oil paint from any of the reputable manufacturers is extremely good paint. The difference lies in the higher degree of permanence and durability that is found with most artist's quality colors; these are made from only the finest pigments, use less extender and are very strong and consistent in color, all of which is of course reflected in their price. So-called student's quality paints are, as stated, very good and are nevertheless used by many professionals; they are often made in a limited range of colors with modern synthetic pigments rather than the more expensive organic and metallic pigments. However, unless you are very familiar with working in oils, you will be hard pressed to detect a difference.

The range of colors available depends on the manufacturer—one Dutch firm has a list of 168. All produce the so-called standard colors with many offering grades of the same color, and all are inter-mixable so you do not have to stick to one brand. It may be the case that with time you find that you prefer a blue from one firm or a particular red from another, indeed you may begin to notice that a certain color from one manufacturer is slightly different from the same color made by another.

Some paint ranges can be bought by the can which becomes economical only if you are using considerable quantities. Paint is usually found in tubes ranging from small 3 fl.oz. (8 ml) tubes increasing in quantity up to 8 fl.oz. (225 ml) tubes. Some colors, despite rigorous testing and superior manufacturing techniques, are more impermanent and prone to fading than others. The degree of a color's permanence is indicated on its label, two of the better known manufacturers use a letter and a star system with AA**** meaning extremely permanent colors; A*** durable, considered permanent; B** moderately durable; and C* fugitive.

Pigments vary too, some of them are difficult to manufacture or obtain, and are consequently more expensive than others; so paint is sold in series numbered 1, 2, 3, 4, or, according to manufacturer, A, B, C, D, indicating the price structure, the higher

the number or letter the more expensive the paint. Certain pigments are toxic, notably the chromes, the cadmiums, and flake white, this too is indicated on the paint label. This will cause no problems whatsoever as long as sensible, straightforward precautions are followed—namely do not eat or drink when using paint and wash before handling food or putting paint-smeared hands on or into your mouth.

Media, solvents, and varnish

A medium is added to the paint to change its consistency and texture—making it thin or thick, transparent or opaque or to accelerate its drying time. There are several in both gel and liquid form that are in common use and many more that are less well known made by manufacturers around the world. Some are easily obtainable, some are less easy to find, but all have distinct characteristics and experimentation is by far the best way to find out what those features are and how they can help your style of painting.

The most common and popular medium for oil paint is linseed oil, which thins the paint increasing its transparency. It is to be found in various forms, the best or purest quality oil is cold-pressed, it is also the most expensive. Refined linseed oil is the next best and is more readily available than cold-pressed but it dries more slowly. Sun-thickened and sun-bleached linseed oil are both thicker than other linseeds, they hold brushmarks well and dry much faster. Stand oil is also a linseed derivative, it is an extremely viscous medium that dries to a smooth hard surface with little or no yellowing but it can take some time to dry. Poppy oil is also widely used, it is extracted from poppy seeds and is a pale, slow drying oil that is used with lighter colors. Also available is drying poppy oil which has similar qualities but dries more quickly.

Alkyd media are synthetic resins which have much faster drying times than the naturally extracted oils but actually retain many of their qualities. Liquin is perhaps the best known and has been around for about 40 years; it is clear when mixed with paint making the color more transparent and it is non-yellowing unlike many of the natural oils. It is excellent for glazing as it dries fast, making a very lengthy operation much shorter. Wingel is thick when first squeezed from the tube but when worked with a palette knife becomes looser and more free flowing, the medium gives body to the paint and is also suitable for building up glazes, like Liquin it also

dries quickly. Oleopasto is a translucent gel that has silica added to make it stiff. It is used specifically for heavy impasto paintwork with a painting knife because it extends the paint yet dries quickly to a strong non-cracking film.

Solvents are essential to oil painting. They dissolve and thin the paint helping it to mix and flow more easily, they then evaporate and have no binding effect whatsoever and because they are clean and clear they have no effect on color. The best known and most widely used is turpentine, distilled from the oleoresin secreted by pine trees. Turpentine that has been double-rectified to remove the residue of gum, is used for painting, it is as clear as water, but will thicken and discolor if exposed to sunlight and the air so it should be kept in a dark container with an air-tight cap.

White spirit, which is distilled from petroleum oil, is also a powerful solvent; it is cheaper than turpentine and does not yellow but it evaporates faster and more unevenly. It is not recommended for mixing with paint or media but can be used for brush and palette cleaning. For those who are allergic to, or dislike the odor of turpentine and white spirit, low odor thinners are available such as Sansodor or oil of spike lavender. The latter is made by scraping the oily residue from lavender leaves, unlike the other solvents it extends the drying time and is very expensive.

Varnish serves two purposes, it prevents dust and dirt becoming ingrained in the paint surface and it lifts and harmonizes the paint work, giving it an even finish. However, it is not absolutely necessary or obligatory and often a coat of retouching varnish is all that is needed to restore any sunken areas and perk up the color. Retouching varnish can be applied over touch dry paint and can even be used between layers of paint. A painting should never be properly varnished until the paint is completely dry, and that can take up to six months, a year, or even several years. Varnishes are made from natural resins such as damar, copal, and mastic or synthetic resins such as ketone or acrylic: they can all be bought prepared at most art stores.

Brushes

Oil painting brushes are either soft or hard. The soft brushes are made from natural hair or synthetic fiber, the synthetic fiber brushes are more resilient than the natural hair brushes and stand up to the abrasive action of painting with less wear and tear, they are also

less expensive. Soft brushes are used for detail, glazing and general finishing work, they deposit the paint flat and smooth with little or no apparent brush mark. Hard or bristle brushes are made from hog's hair and are stiffer and more hard wearing than soft brushes. Bristle brushes can deliver a lot of thick paint to the support and tend to leave their mark in the paint surface making them ideal if you are after expressive and energetic paintwork.

There are five basic brush shapes: rounds, flats, brights, filberts, and fan-shaped blenders. The round is the oldest type of painting brush, a versatile all-round brush, capable of making thin or thick lines and flicking in detail. The larger rounds can hold a lot of paint and are superb for laying in broad areas of color.

The flat is the most adaptable and versatile brush, used for laying-in broad areas of color and working thick paint in broad confident strokes; when working alla prima and wet into wet, it is also an efficient blender. Used on its edge it can deliver a thin or thick line depending on the pressure. It can also lay paint flat and smooth.

Brights are flat brushes with shorter bristles and so are a lot stiffer and can deliver controlled, precise strokes. They are good for direct impasto work and detail. A filbert is similar to a flat but it has a rounded tip. There are also short filberts that are like a bright, again with a rounded tip. Filberts are rather like well worn flats, they are good for fluid lines and short precise strokes.

The fan blender is just that, a fan-shaped brush that is used for blending together two colors. As the same effect can be achieved with a flat, unless you plan to do a lot of fine blending they are not considered a necessity. A useful addition is a range of decorators' or house painting brushes. They are readily available, are often of very good quality and are cheap and extremely hard-wearing: use them for covering large areas and any initial loose, broad blocking in.

Artists' brushes come in series, each series containing the same shape brush in different sizes. As a rule irrespective of the series, oil brushes begin at 001/size 1 the smallest, and increase in size up to 012/size 12 the largest. Decorators' brushes, those used in the home, are sold by the width measurement, ie 1 in. (25 mm), 2 in. (50 mm), and 3 in. (75 mm).

No brush, no matter what it cost, will last and give of its best if it is not looked after, following a few simple rules will keep your brushes in good shape and make them last for a long time. Never leave brushes resting on their points or ends in jars of solvent or thinners; when you have finished using a brush always wipe off excess paint with a rag or paper towel, then rinse it well in a jar of turpentine or white spirit, making sure all the paint has been dissolved from the bristles and from around the ferrule. Next, wash the brush using a washing-up liquid or by gently rubbing the bristles on to a bar of soap, use cold water, rinse the brush clean of soap, gently squeeze the bristles, hair, or fiber back to shape and store upright in a pot or jar.

Palette and painting knives

Palette knives are as necessary a piece of equipment as brushes; they are used to mix paint on the palette, to clear up unwanted paint and they can also be used to apply paint and remove unwanted paint from the canvas. Made from steel they come in a wide range of sizes either with a flat blade or a cranked blade which helps keep your knuckles from dipping into the paint. Larger more substantial knives and spatulas with squared-off blades are readily available from DIY and decorating stores.

Painting knives also have a cranked steel blade to keep the hand clear of the painting, the blade is very thin, highly flexible, and can be obtained in many different shapes and sizes, round, square, diamond-shaped, and oval. Each is capable of producing a range of marks. The technique of painting with a painting knife, oddly enough, is known as palette knife painting.

Palettes

Traditional mahogany kidney-shaped and rectangular palettes are costly, beautiful things that, in line with current thinking, are not especially practical. The problem is the color, it makes little sense trying to mix a tone or color on a rich brown surface when you are working on a support that is brilliant white.

However these traditional palettes in mahogany, or cheaper plywood, can be bought in several different sizes as can white faced wooden palettes of similar shape, and rectangular white plastic palettes. Pads of disposable paper—palettes that tear off and can be thrown away once used and dirty—are sold but they are difficult to hold as they are not that substantial and really need to be laid on a flat surface. I work from a large sheet of thick glass that rests on a trolley that can

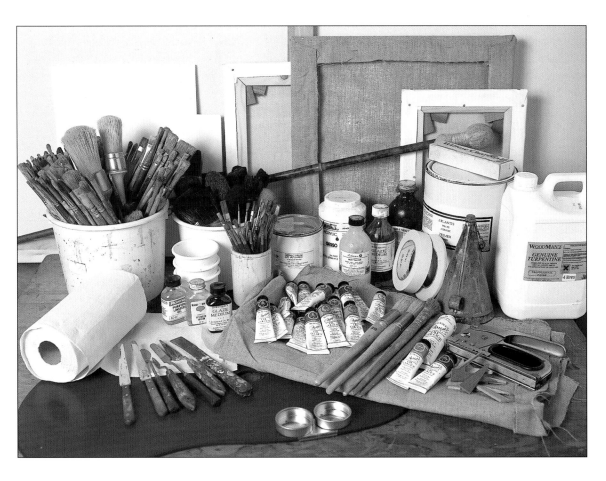

be maneuvred close to the easel. It is easy to clean and large enough to allow a lot of color to be mixed. But whatever you choose to use make sure that it is large enough for your needs and easy to clean.

Easels

You will eventually find that for serious oil painting a good easel really is a necessity. A good easel is practical, holding the canvas firm and steady and at the right height and angle, it is also a help psychologically in that it allows you to work confidently and, silly as it may seem, helps you to feel the part.

There is a large range on the market and the one you choose will depend on what and how you paint. If the space in which you work is limited or you do a lot of painting outdoors on location, then a lighter weight sketching easel would be your best choice. A particularly handy and stable support is the box easel, which consists of a materials and equipment box together with an easel that will hold a medium-sized canvas. The box has a handle for carrying and the whole thing cleverly folds up to the size of a briefcase. A

good studio easel will last you a lifetime and can hold large or small canvasses. These easels are easily tilted and go up and down by means of a ratchet device.

Sundry equipment

The Mahl stick has a long handle with a soft, usually chamois-covered pad at one end; it is used by holding the handle in one hand and resting the pad on the edge of the support or part of the easel. The hand, holding the brush, can then be rested and steadied on the long handle, while being kept clear of wet paint.

You will need any amount of jars and containers to mix paint in and hold thinners, but do be careful when using thin plastic yogurt or cream pots as the turpentine and white spirit can dissolve them. Cans are good, as are foil containers. Small containers called dippers can be bought to hold linseed oil or other painting media; they clip on to the edge of hand-held palettes. Finally keep a good supply of rags, paper towel, and newspaper to hand for cleaning your brushes and palettes, mopping up any accidental spills, and cleaning your hands.

TECHNIQUES

WHILE IT IS CERTAINLY true that a thorough working knowledge of techniques can liberate the artist to concentrate on the content of his or her work in the sure knowledge that they possess the means to make their vision or idea a two-dimensional reality, it is perhaps surprising to be told that a grasp of technique is of lesser importance when beginning work with oils than when working with any other painting medium.

Oil paint is, despite having a reputation to the contrary, a very easy and forgiving medium to use—unlike watercolor, mistakes are easily and quickly rectified. Furthermore, due to its long drying time alterations, reworking, and blending can be done more or less at leisure, unlike acrylic paint which dries so much faster. Oil paint allows the artist great latitude and perhaps the only two rules that need to be put routinely into practice if you want your hard work to last are: thorough preparation of the supports if you are preparing your own, and always work the paint fat over lean.

As you learn about and become familiar with using one technique you will find that it points the way to another and so on, the technique-learning process is cumulative—discovering and becoming familiar with one makes it easier to learn and become familiar with the next. But don't be seduced into believing the painting process will become any easier—you will find that your aspirations will move forward in tandem, tempting you to try your hand at increasingly bigger and better things.

The Techniques

Alla prima is a primary oil painting technique, often referred to as direct painting. The work is executed in one sitting, usually without any drawing or underpainting. The paint is used opaquely and mixed to a smooth buttery consistency. It is applied directly to the support in considered, confident, and usually unblended strokes. The correct tones and colors are judged carefully and mixed on the palette; once applied to the support the paintwork is seldom modified. Used correctly the technique gives an exciting fresh paint surface that retains the marks made by the brush or knife and is alive with texture and interest.

Wet into wet painting, while having similarities with alla prima, is the technique used when effects, blending, modifications, and overworking are carried out into previously applied, but still wet, paint. Oil paint dries slowly so it is not obligatory to complete the painting at one sitting—a painting can be loosely blocked in on location and the work completed later, but before the paint has dried, in the studio. Or perhaps a work painted alla prima on review needs and would benefit from, reworking and alteration. One of the beauties and strengths of oil paint is its

capacity for almost unlimited overworking, wet paint can always be scraped off the support with a palette or painting knife. Colors worked into each other in this way blend and mix beautifully but care needs to be taken: too much overworking and the wet paint will lose its fresh look and the colors will become muddy and distinctly lacking in bite.

Paint that is mixed and applied thickly so as to retain the shape of the brush stroke is known as "impasto," stiff bristle brushes are used to apply the paint in confident direct strokes. The paint is not brushed out on to the support but allowed to sit proud of the surface, giving an almost three-dimensional quality to the work. Adding a gel extender or impasto medium, such as Oleopasto, bulks out the paint and makes it go further without altering the quality or intensity of the color and without increasing the paint's drying time.

Impasto paint can also be applied with a painting knife; by using a variety of knives it is possible to produce a surprisingly varied range of surface textures.

Painting with a knife is a very tactile occupation and needs to be done well if you are not to end up with a mess. Using up such a quantity of paint, which knife painting inevitably does, requires a sure touch and a little practice. The paint can be floated on to the support, rather like icing a cake, to create a flat surface or dabbed and dotted on using the tip of the knife. By altering the angle of the blade or the direction it is pulled, lines of varying thickness can be made and the knife can further be used to scrape back into the wet paint. It should be remembered that the technique of knife painting need not be employed just by itself but can be used in tandem with other techniques using the brush, rag, or even fingers.

There are a few hard and fast rules to follow when painting, but working paint "fat over lean" is one of the most important ones, standard working practice, and should be routinely followed. Paint into which a medium such as linseed, poppy or stand oil is added is referred to as being fat, while paint which has been diluted with a thinner such as white spirit or turpentine is known as lean. Lean paint dries at a faster rate than fat paint and should be applied first. Subsequent layers of paint with oil added can then be worked over the top. If the reverse happens, the lean paint dries first, then as the fat paint beneath slowly dries it contracts and can result in the paint surface developing cracks and unsightly wrinkles.

Blending is the merging together of two adjacent colors. It serves to soften the paint edges and can create extremely subtle gradations of color and tone, allowing forms to be modeled and defined. Blending can be done in several ways and to varying degrees, the long drying time and consistency of oil paint

makes it an ideal medium for the technique. Brushes are the perfect blending tool, with the coarser hog and bristle best used for cruder blending, while using the finer synthetics can result in the imperceptible gradation from one color or tone to another. Flat rather than round brushes should be used as they enable smooth strokes of a consistent pressure to be used to move the paint around. Paint can also be blended using the finger, a rag, the edge of a piece of card, or a painting knife.

Sir Henry Tonks, who was the Professor of Painting at the Slade School of Art besides being a fine painter, has the distinction of having a painting technique named after him. "Tonking" is the deceptively easy and efficient technique of removing excess or unwanted wet paint from the support. By laying a sheet of newspaper over the area of paint to be removed, smoothing it down evenly and then peeling the paper

off, the paint sticks to the absorbent paper and comes away from the support, leaving the area to be reworked, if needed. As well as a means of correcting mistakes the technique can also be used to soften areas of color after the initial blocking in or underpainting. A variation on the technique, which is useful for smaller, more intricate areas where a thin layer of paint has been used, is the use of masking tape applied and removed in the same way.

"Imprimatura" is the term given to a thin wash or glaze of color applied to the support to create a colored ground on which to work. A stark white ground can make tones and colors very difficult to assess in relation with one another. The choice of color for the imprimatura will depend very much on your subject, any neutral color can be used but traditionally the choice is an earth color, green, or gray. The color then acts as a mid tone, making the balancing of the light and dark tones an easier task. The imprimatura will inevitably show through in places, but this is an advantage as it has the effect of harmonizing the colors of the painting as a whole.

The wash can be applied with a rag or a large brush using oil paint thinned with white spirit or, if you cannot wait for this to dry, use a thin glaze of acrylic paint mixed with water. Do not worry about getting the glaze flat and even but do make sure it is thin enough to allow the white of the support to glow through as this affects the luminosity and brightness of the colors. Toning the ground achieves pretty much the same effect as an imprimatura but the color used is opaque and is brushed out evenly over the support.

surface settling thickly in crevices and lying more thinly on any peaks of paint that are standing proud of the surface.

Glazing is a traditional oil painting technique where thin layers of transparent colors are laid one on top of the other, every layer modifying and altering the one beneath. Each layer is allowed to dry before the next is applied, so the technique can be a slow process and calls for some patience, however the results are quite different from those achieved any other way. The colors, being transparent, allow light to reflect back from the ground, or any opaque underpainting, making the colors mix optically and giving them great depth and richness. Rather than using linseed oil, or turpentine, use a preparatory glazing medium which is easily obtained and will improve the translucency of the paint and speed up the drying process. The technique is especially useful for portrait work when trying to capture those elusive skin tones.

Broken color is paint that has been applied, usually working wet into wet, or alla prima, but without any blending. The colors are applied in small, direct strokes sitting next to each other and, when viewed from a distance, appear to fuse and mix together optically. The Impressionists exploited the technique to the full and it was taken to its extreme in the work of Seurat, Signac, and the Pointillists. It can take a little practice to become confident enough to work so directly: keep your colors clean and resist the temptation to "tickle" and fuss with the paint once it has been applied, because the results give a distinct sparkle and jewel-like quality to the work.

Glazing, like most techniques, does not have to be used by itself but can be effectively combined with others, or it can be used in only one area or section of a painting. It combines especially well with impasto work, the thin transparent color finds its own way around the rough

Scumbling is the application of paint that is usually of a fairly thick and stiff consistency over a previously painted dry layer or the paint can be made thinner to resemble a glaze if you wish. It is then brushed on to the desired area roughly and freely with a stiff bristle

brush, finger, sponge, or rag in such a way as to allow patches of the underlying color to show through. Any number of paint layers can be applied in this way as long as each preceding layer is allowed to dry before working on the next; the technique combines well with glazes and is especially valuable for enlivening areas of flat, dull color.

Masking serves two purposes: firstly it protects areas from becoming covered with unwanted paint or effects and secondly the material used for the mask can introduce a different edge or line quality into the work. Masking tape comes in a wide range of widths, the thinner tapes can be used to create curves while the wider tapes can be cut into precise shapes with a sharp scalpel or torn lengthwise to give an interesting and unique edge.

For masking out larger areas use paper—either cut or torn. Newspaper will do, but depending on the consistency of the paint it may prove to be too absorbent, allowing the paint to bleed beneath it, spoiling the desired effect. Different papers tear in different ways; I find the best paper is medium-weight watercolor paper so I keep a pile of rejected and failed watercolors that can be torn or cut up just for this purpose. One word of warning, when using a mask work the paint away from the edge so as not to push paint beneath it.

Various other fabrics also make ideal masks and, like paper, they all tear or cut in a different way. Coarse hessians and canvas are especially good as the fibers along the edge tend to unravel giving an interesting, broken line, so if you stretch your own canvas remember to keep those long thin off cuts for this purpose.

Stippling builds up complex textures with thousands of tiny marks and, depending on the size of the area to be covered and the way in which the paint is applied, it can be a lengthy or a reasonably quick process. Stippling can be put to many uses—it can be used to put life into flat areas of paint or it can be built in layers, like glazing, to give a beautiful, subtle, shimmering effect. Stiff decorators' brushes, natural and synthetic sponges, scrubbing brushes, nail brushes, crumpled rags, to name but a few can all be used. Each will make marks that will give a distinct and unique quality to your work.

Because it is relatively difficult to control, spattering is usually used together with some form of masking to protect those areas of the painting where the effect is not wanted. Spattering with oil paint can be done in two ways: paint can be spattered on to a dry surface and allowed to dry undisturbed, the resulting spatters will dry with a crisp outline and can be respattered or overworked with another technique. The second way is to spatter on to a layer of wet paint and allow the spattered paint to blend and bleed together with that layer of its own accord. Varying the type and size of brush and the distance it is used from the support surface will produce a range of different effects. Whatever the desired effect it is prudent to experiment on a piece of newspaper first before committing yourself to using the technique on your painting.

Sgraffito is the technique of scratching through a layer of paint to expose whatever is beneath, which could be the support or another layer of paint. The word comes from the Italian word "graffiare" which means "to scratch.' The technique has numerous applications and can produce a wide variety of textural marks; it can be carried out with knives, bits of wood, brush handles, pieces of cardboard, and plastic, in fact any implement capable of leaving a mark, dry paint can be scratched through but a more satisfactory result is achieved when the technique is put to use into wet paint.

Paint can be used straight from the tube and dotted or smeared on to the support, a technique which can be especially useful to introduce splashes of pure color and highlights. It is also very effective when used to put in the sparkle on sunlit waters.

Ever versatile, oil paint can be mixed with a range of materials such as plaster, sand, sawdust, marble dust, and even gravel, to bulk the paint out and create some exciting and uniquely tactile surfaces. Such loaded paint is best applied with a palette knife and can be scratched and worked back into with sgraffito effects

or be worked over with other more traditional brush or palette knife techniques.

"Frottage" is the technique of rubbing and is normally associated with drawing when paper is laid over a textured surface and a drawing medium is rubbed over that surface so producing an image of the texture lying beneath. It is not possible to do this when working with oils so the technique is practiced on reverse. The textured material, be it a coarse fabric, crumpled paper or perhaps bubble wrap, is laid on to the wet paint, gently pressed down and rubbed; those parts that actually come into contact with the surface then take some of the paint away when removed leaving an impression of whatever was used.

Imprinting, when used with oils, is in many ways similar to frottage and the two techniques are interchangeable, being different in name only. Here I have painted a leaf and simply printed it by pressing it on to the surface of a sheet of oil painting paper, but any flat, natural or manmade object can be treated in much the same way. As with frottage the consistency of the paint

and the surface of the support go a long way to deciding how successful the outcome is.

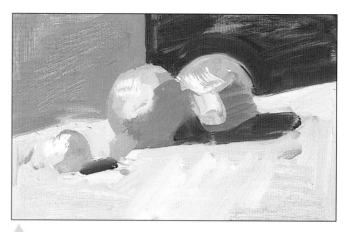

Underpainting serves the purpose of providing a firm base or foundation upon which the painting proper can be built. Certain important decisions can be made in the underpainting about the design and composition of the work and the distribution of tone and color. This preliminary painting can be done broadly and loosely using thin paint and colors that approximate those colors to be used in the final painting. A more traditional approach is to start with a tonal underpainting using only one color. This monochromatic underpainting establishes the tonal values and can be done in any color that is sympathetic to the overall color of the subject, but like the colors used when laying an imprimatura, earth colors, terra verte, or gray, are traditional and proven.

Paint can be applied in any number of ways and you should not feel restricted to using just the brush or the knife. A crumpled piece of rag can lay color down very quickly and broadly and is an excellent tool for blocking in as it forces a broader view that precludes becoming involved with details at too early a stage.

STRETCHING CANVAS

ALL CANVAS NEEDS to be stretched taut and prepared with a ground to seal and protect it before it can be painted on. Prestretched, prepared canvas can be bought in a range of popular sizes but they are expensive, stretching your own is quick and straightforward, satisfying, and very economical, stretchers can be reused time and again simply by taking off paintings that you are unhappy with and restretching them with fresh canvas.

While the procedure is the same for all canvas, be it fine linen, cotton duck, or hessian, you will find that each type of canvas stretches in a slightly different way. Medium-weight cotton duck is very easy, it just needs to be pulled flat and reasonably taut, the size or acrylic primer does all of the work. Once sized or primed the wet canvas fibers shrink as they dry, pulling themselves tight over the stretcher.

Linen dries and stretches tauter than cotton so care must be taken not to pull it too tight prior to priming, after which it will tighten like a drum. When using linen it is better to position the warp thread of the canvas across the shortest distance; the warp thread is the thread that runs the entire length of the roll of canvas.

Rather than using your fingers to pull the canvas tight you may find it easier to use straining pliers, but again, take care not to pull the canvas over-tight before it has been primed.

The Techniques

You will need four stretcher pieces of the required length and eight wooden or plastic wedges, a length of canvas, a pair of scissors, a tape measure, a staple gun with rust-proof staples, and a hammer.

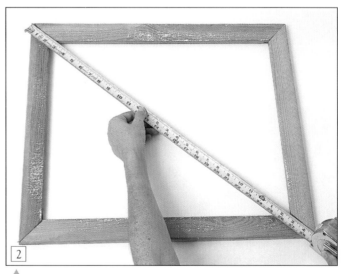

Assemble the stretcher frame by slotting the four pieces together, making sure that they all have the beveled edge on the same side. The stretchers should slide into each other easily, if not gently tap them home with a wooden mallet or hammer. If you use a hammer use a wooden block between it and the stretcher to protect the stretcher edge from becoming dented. Once assembled measure from corner to corner both ways and when the measurements are the same the stretcher will be square. If you do not have a tape measure improvise using a piece of string.

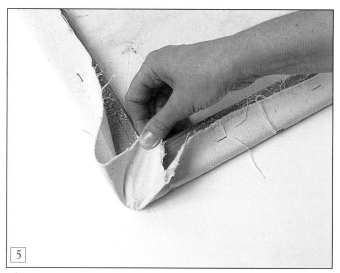

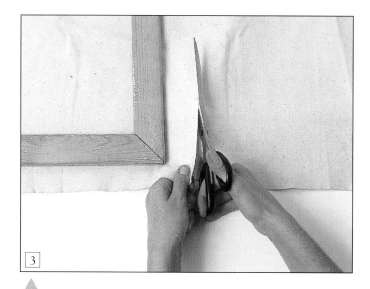

▲

Place the assembled stretcher, bevel side down, on a piece of canvas. Make sure that the weave of the canvas runs parallel with the stretcher frame and then carefully cut the canvas leaving an overlap of 2–3 in. (5–7 cm) around all the edges.

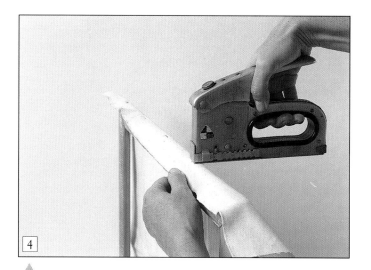

▲

Fold the canvas up and over the back of one side and secure it to the frame edge with one staple placed in the center of the stretcher. On the opposite stretcher pull the canvas taught and place another staple in the same position. Do the same in the other two sides. Now add a staple about 6 in. (15 cm) on either side of the center staple and the same on the opposite side pulling the canvas taught; do the same on the other two sides. Once a staple is in, always pull the canvas taut before securing its opposite number. The amount of staples you need along each edge depends on the size of the stretcher but as a general rule fix a staple every 4–6 in. (10–15 cm).

▲

Once you have reached the corners place the stretcher canvas side down and staple the canvas to the back of the stretcher, fixing the staples roughly half-way between those on the edge. At the corner fold the canvas corner point over the edge and back of the stretcher, so that it points toward the middle of the canvas.

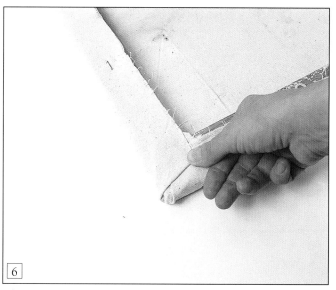

▲

Fold the two flaps in, one on top of the other and secure them with a staple.

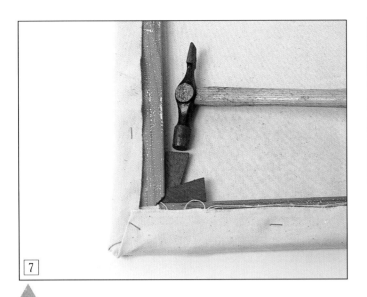

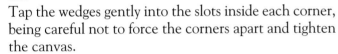

Tap the wedges gently into the slots inside each corner, being careful not to force the corners apart and tighten the canvas.

The canvas is then ready to be sized and primed traditionally or, as here, given two coats of acrylic primer. Once dry the canvas should be nice and taut but if there is any slack it can be taken up by knocking the wedges firmly into the corners—this is known as wedging out. It is useful to know that canvas tightens and stretches more when traditional size and primer is used and it stretches a little less taut when acrylic primers are used. This should be taken into serious consideration when you are pulling the canvas over the stretcher prior to stapling.

COLOR

The primary colors—red, yellow, and blue—cannot be mixed from other colors, hence their name. Red and yellow make orange; yellow and blue, green; and blue and red make purple or violet: these are known as secondaries. But as a casual glance at a paint color chart will show there are many different reds, yellows, and blues and the secondary colors obtained will depend very much on which of these primaries are used. The same is true of the tertiary colors—these are the colors that fall between the primaries and the secondaries. They are made up by mixing an equal amount of a primary color with an equal amount of the secondary next to it, to obtain a red-orange, orange-yellow, yellow-green, green-blue, blue-violet, and violet-red.

All colors are considered to be either warm or cool; the warm colors are red, orange, and yellow, the cool colors are green, blue, and violet. However, the terms "warm" and "cool" are relative as all colors have a warm and cool variant. There are warm reds, such as cadmium, which have a yellow bias, and cool reds, like alizarin crimson, which have a blue bias. To confuse the issue further, a color that is seen as warm in isolation can appear cool when seen next to a warmer variant of a similar color. This warm/cool color relationship is very important and can be put to good use, especially when you are painting the landscape, as warm colors seem to advance visually toward the viewer and cool colors appear to recede.

When mixing colors bear in mind that a more intense, brighter third color will result if mixed from two colors that have a bias toward each other. For example, cadmium red (yellow bias) and cadmium yellow (red bias) create a bright, vivid orange, whereas alizarin crimson (blue bias) and cadmium yellow (red bias) mix to create a more subdued, less intense

orange. This is because alizarin crimson is closer to yellow's complementary color, violet.

Complementary colors are those colors that fall opposite one another on the color wheel. One color will always have a warm bias, the other will have a cool bias. Hence red is the complementary of green and orange is the complementary of blue; these color opposites are known as complementary pairs and have a very special relationship. When placed next to each other complementary pairs have the effect of enhancing or intensifying each other. However, if you mix a small amount of a color into its complementary, the color will be subdued, or knocked back. Add more of a color's complementary color and you will neutralize it completely, producing a range of neutral grays and browns. It is important to be able to mix and exploit these less vivid, subdued colors as they echo many of the colors seen in nature and help bring an overall harmony to the work.

Color is a complex and intriguing subject and a basic knowledge of the theory is certainly necessary, but the very best way to understanding what is possible and why, is to spend time experimenting with your colors. But do remember to make notes, the combinations using just a few colors are countless and the chances of mixing a color and immediately forgetting how you did it is a real possibility.

Choosing colors

There are many colors to choose from, – one manufacturer offers 168 variants and it is, of course, neither economically viable or practical to work with anywhere near this many. Most professional artists use only a limited range of colors having learned from experience the mixtures these are capable of producing. I regularly use 18 different colors plus white, but seldom do I use them all together in one painting and some are used out of convenience simply to save mixing. The colors I use are listed below, those marked with an * I suggest are an ideal choice for a starter palette which, should you feel the need, can be added to and extended at a later date.

TITANIUM WHITE: * is a very bright clean white, it is very opaque so you will need only a small amount to lighten a color. It dries slowly but this can be speeded up with the addition of dryers.

PAYNE'S GRAY: * a cool gray that is useful to knock back or modify colors without destroying their brilliance. It also makes, when mixed with burnt or raw umber, a good black.

RAW UMBER: * is a versatile color that, like Payne's gray, can be used to tone down more strident colors. It is a useful color for underpainting and dries quickly.

BURNT UMBER: is a rich, warm, strong brown that mixes well with other colors, especially green, and like raw umber it dries very quickly.

RAW SIENNA: is a semitransparent color that when used thinly is a bright yellow. It mixes well with most colors and dries fairly quickly.

BURNT SIENNA: * is a powerful, bright, red brown that needs to be used with caution. It dries reasonably quickly and is a good choice when mixing flesh tones and also for glazing.

YELLOW OCHER: * a similar color to raw sienna and with some makes of paint it can be difficult to tell them apart. Yellow ocher dries more slowly than sienna but is more opaque and extremely useful for mixing flesh tones.

NAPLES YELLOW: is a useful addition to the portrait painter's palette, it dries fairly quickly and is opaque.

CADMIUM YELLOW: * is a strong, slow-drying yellow that is available in light, medium, and dark tones. It mixes well with blues and reds to make a range of bright greens and oranges.

LEMON YELLOW: * is a cool yellow that, like cadmium yellow, mixes well to make a range of oranges and greens.

CADMIUM ORANGE: can be mixed from cadmium red and cadmium yellow. I use it out of convenience.

CADMIUM RED: * a strong, warm, slow-drying red that is available in light and dark versions, it mixes well with greens to make a range of browns and is invaluable to the portrait painter.

ALIZARIN CRIMSON: * a cool, transparent and slow-drying red, again useful to the portrait painter and capable of mixing with the blues to create a range of purples and violets.

ULTRAMARINE: * is a strong, warm, transparent blue that dries slowly, it mixes will with alizarin crimson and the yellows.

COBALT BLUE: * is a cool, transparent, fast-drying blue

useful for glazes, portrait work, and subtle blue skies.

CERULEAN BLUE: a fairly weak, semitransparent blue that is useful for skies and modifying other colors.

MONESTIAL OR PTHALOCYANINE BLUE: is one of the strongest blues and needs to be used with care, it is transparent and dries slowly.

VIRIDIAN: * is possibly the only premixed green that is really needed. It is a transparent, slow-drying green that mixes well with reds, yellows and browns to create a wide range of greens.

SAP GREEN: is a bright easily-modified green useful for landscape painting.

Color Theory – The Basics

▲

This color wheel is mixed using "warm" primaries, cadmium red, cadmium yellow, and ultramarine.

▲

A color is noticeable affected by the color that is next to it. Here the red square seems to be much brighter when surrounded by its complementary green.

▲

Here the secondaries have been mixed using the "cool" primaries, alizarin crimson, lemon yellow, and cerulean blue.

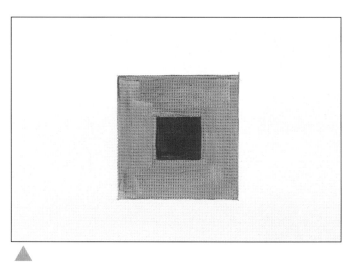

▲

Warm colors will seem to advance and cool colors recede.

All colors have an equivalent corresponding gray tone on a scale that runs from black through to white.

My palette of colors.

1 Payne's gray	7 Naples yellow	13 Ultramarine
2 Raw umber	8 Cadmium yellow	14 Cobalt blue
3 Burnt umber	9 Lemon yellow	15 Cerulean blue
4 Burnt sienna	10 Cadmium orange	16 Monestial blue
5 Raw sienna	11 Cadmium red	17 Viridian
6 Yellow ocher	12 Alizarin crimson	18 Sap green

IN THE ALCAZAR SEVILLE
Alla Prima

PROJECT ONE

ALLA PRIMA IS ONE OF the primary oil painting techniques. Translated from the Italian it means "at the first" and is used to describe paintings that are executed at a single sitting or in one "wet."

This direct method of painting is the style that found favor with the Impressionists who, with the invention of the collapsible paint tube in 1841, found it possible to work easily away from the studio en plein air. Working from nature in this way meant that the working practice of artists had to change, they needed to work faster in order to catch the ever-changing light and changes in the weather. Artists, with a few exceptions, had until then worked in the studio where it was possible to build a work slowly with layers of scumbles and glazes.

Regardless of whether you are working outside or in, it is important not to set yourself an impossible task, in other words make sure that you can finish the painting in the time that you have available. This means choosing your subject sensibly and working on a support that is not too large. Working in this way means you should only need a minimum of equipment one, two or three brushes at the most, a few tubes of carefully chosen paint, a support, an easel and turpentine and, if you wish, an oil medium such as Liquin or linseed oil.

Try to work with direct confident brush strokes laying colors and tones next to each other on the support, gradually building up something that resembles a mosaic. Mix the paint to a buttery consistency so that it leaves the brush easily, but is not so thin as to run, and try not to go over work already done, one of the attractions of alla prima work is its immediacy and spontaneity.

This view of a square, which is part of the magnificent Alcazar in Seville, was a good subject. A compositional balance is created by the row of trees, doors and windows at the top and the dark shadow of the orange tree in the foreground, which on a practical level made a relatively cool place to sit!

This painting was done on a prepared canvas board that measured 18 × 12 in. (45.5 × 30. cm). I used a stick of charcoal for the underdrawing, a no 4 flat bristle brush, and Payne's gray, raw umber, ultramarine, yellow ocher, cadmium red, viridian, lemon yellow, monestial blue, and titanium white oil paint, Liquin and turpentine.

MATERIALS AND EQUIPMENT

Stick of charcoal
No 4 flat bristle brush
Payne's gray, raw umber,
ultramarine, yellow
ocher, cadmium red,
viridian, lemon yellow,
monestial blue,
titanium white

The Painting

1 Using a piece of medium charcoal, a loose drawing quickly establishes the composition. Pay particular attention to any vertical and horizontal lines and make sure they run true. Finally draw in the orange tree at an angle and its shadow cast in the foreground.

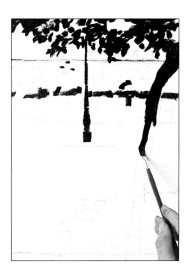

2 Dust off any excess charcoal with a large brush or by flicking over the surface with a soft, clean rag. With a no 4 flat bristle brush mix Payne's gray and raw umber and paint in the dark leaves at the top of the picture, the dark shadows in the line of trees and the trunk of the tree in the foreground. Do not make the paint too loose, keep it to a buttery consistency.

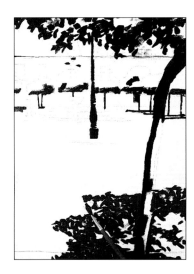

3 Into this dark mixture add some ultramarine blue and yellow ocher together with a little titanium white. Block in the dark shadows cast by the leaves in the foreground and the shadows from the line of trees seen in the distance.

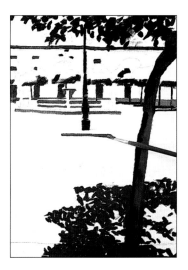

4 Using the same mix, paint in the doorways behind the row of trees and the dark line that runs across the top of the building. Add a little raw umber, yellow ocher, and white and complete blocking in the trunk of the foreground tree. Cadmium red and yellow ocher, together with a little of the previous mix and some white, give a dark brown for the stonework around the fountain and at the base of the post standing in the center of the square.

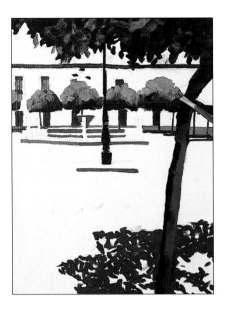

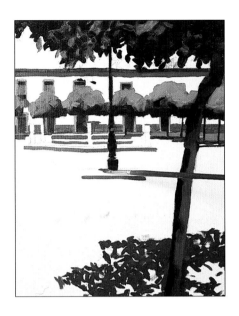

5 A mid-green is mixed with viridian, lemon yellow, and a little raw umber, some of this is lightened with white and lemon yellow and some made darker by adding raw umber and Payne's gray. The trees are then painted with these three mixtures using sure strokes to describe the shape of the foliage.

6 Yellow ocher and cadmium red together with a little raw umber make the dull orange that can be seen surrounding the doors and windows. The blue-gray band at the base of the building is painted with a mix of Payne's gray and titanium white; ultramarine is added for the shadow beneath the dark parapet and at the base of the post.

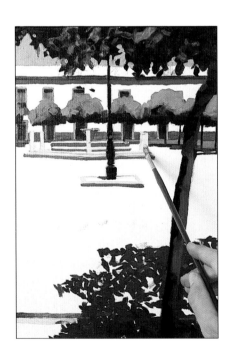

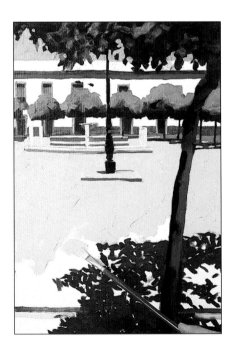

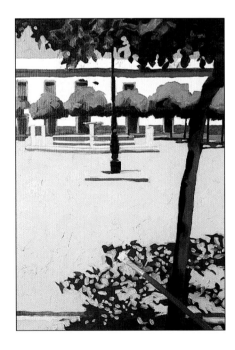

7 A light blue mixed from monestial blue and titanium white establishes the small bit of sky. Attention is now turned to the fountain where a cadmium red, yellow ocher, white, and a little gray mix gives the color for the stonework.

8 Cadmium red, yellow ocher and titanium white give the light sand color seen on the ground, with this mix work carefully down the painting cutting in and around any paintwork already done.

9 As the foreground work is approached, darken the mix a little by adding more yellow ocher and cadmium red and paint around the shadow of the tree. Keep plenty of paint on the brush and dab in the dappled light.

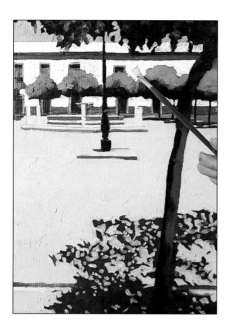

10 Pure titanium white straight from the tube is then used for the stark façade of the building, it is worked carefully around the doors, windows and trees.

11 Finally a few highlights are indicated on the lamp post and a few touches of a lighter green in the trees complete the picture.

Alternative Approaches

1 This small painting of anemones was painted in a couple of hours. A fairly precise drawing helped keep the painting on track. Only two or three tones have been used for each color, but the forms still read convincingly.

2 This early morning view in Venice looking from St Marks Square across to San Giorgio Maggiore was painted with a limited palette consisting of four colors: white, Payne's gray, cerulean blue, and raw umber.

SKULL AND POTS

Tonal Underpainting

MONOCHROME underpainting allows you to concentrate on all the tones without becoming absorbed in, and confused by, the color—think of it as a black and white snapshot rather than a color photograph.

A gray underpainting is the starting point for the traditional technique of glazing, and is known as a grisaille. Once this gray underpainting is dry the colors can be glazed over it in transparent layers. However, an underpainting can be helpful even if you intend not to work with glazes establishing, as it does, the overall composition and tonal range and giving you the opportunity to make alterations and corrections before beginning the work proper. It also serves to get rid of the intimidating stark white ground.

The underpainting can be in any color that is sympathetic to the subject, traditionally the colors chosen are neutral earth colors, or terre verte—a dull green. Here we have used raw umber mixed with a little Payne's gray. When underpainting in oils, thin the paint with turpentine to keep it lean; you may need to wait a few hours or even over night before this is dry enough to work on top of, alternatively use acrylic paint which will dry in a few minutes.

Still life painting, regardless of the actual objects used, is a marvellous way to learn about some of the primary principles of art. The objects being of a manageable size can be manipulated and moved around into different groupings, showing variations of composition, perspective and color. Anything can be used, you don't have to look far as every home is full of subjects, from kitchen utensils to childrens' toys. Here I have used a few glazed pots, a wooden box, a wooden ball and a skull, all are similar in tone making the choice of color used for the underpainting an easy one, matching, as it does, the local color or actual colors of many of the objects.

The painting was done on a primed cotton duck canvas measuring 18 × 24 in. (45.5 x 61 cm) using titanium white, Payne's gray, raw umber, raw sienna, burnt sienna, yellow ocher, cadmium orange, and cadmium red, diluted and thinned with Liquin and turpentine. The paint is applied with 1/4 in. (6 mm) and 1/2 in. (12 mm) flat synthetic brushes and a no 4 and a no 8 flat bristle. A thin stick of medium charcoal was used for the underdrawing.

MATERIALS AND EQUIPMENT

1/4 in. (6 mm) 1/2 in. (12 mm) flats, no 4 and no 8 bristle brushes
Stick of medium charcoal
Titanium white, Payne's gray, raw umber, raw sienna, burnt sienna, yellow ocher, cadmium orange, and red

The Painting

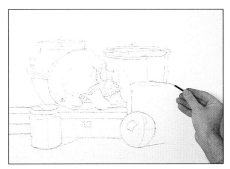

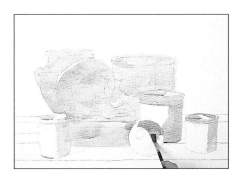

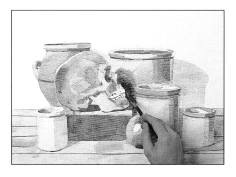

1 With a thin piece of charcoal draw in and position the objects. Work carefully and try to position things correctly in relation to each other. A few measurements may help. When drawing in the objects indicate the direction and fall of any shadows. Once the drawing is complete remove any excess charcoal by dusting over the canvas with a soft brush or a clean rag. Then give the drawing a coat of fixative.

2 The monochromatic, or tonal underpainting is done in a mix of raw umber and Payne's gray acrylic paint which dries in minutes. Oil paint thinned with turpentine would need to dry for several hours or over night before work on the overpainting could begin. The light mid tone is established first using a flat $1/2$ in. (12 mm) flat synthetic brushes synthetic brush.

3 Gradually, in careful stages, the darker tones are searched out and established and the form of the objects begins to be progressively apparent.

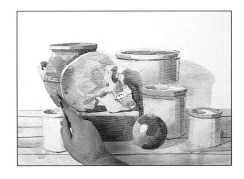

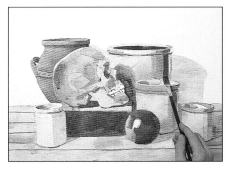

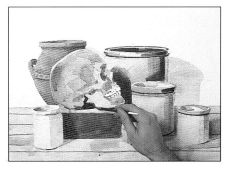

4 Once dry begin working across the painting with a $1/4$ in. (6 mm) flat brush using oils mixed with turpentine and Liquin. Starting with the Moroccan jar on the left using burnt umber, yellow ocher, and a little white, the darks are painted. The mix is lightened a little for the patches of mid tone with cadmium orange, white, and a little cadmium red; this brown is also seen on the wooden ball. The mix is lightened further with white and the jar blocked in.

5 Cadmium red is added to the mix and the red glaze inside the large pot on the right is established using a no 8 flat bristle. The same mix is brushed over the side of the wooden box, the wooden ball and the side of the large pot.

6 Raw umber darkens the mix and using the $1/4$ in. (6 mm) flat the dark beneath the rims of the jars and the shadow on the large jar thrown by the skull are painted in. Also the shadow on the front of the box and the dark wood on the ball are blocked in.

7 Yellow ocher and raw sienna together with the previous mix and some white give a range of colors and tones for the large pot. A few reflections are flicked in to help suggest the gloss of the glaze. The same yellow mix is used, thinned well with turps, for the base color seen on the tabletop. The large areas of color are blocked in with the no 4 flat and the detail and finer shapes with the 1/4 in. (6 mm) flat, brush a little of this color over the skull.

8 Raw umber deadens the yellow mix used for the jug and gives the basic mixture used on the skull. Payne's gray and raw umber are mixed for the shadows and white is added to the basic mixture for the highlights. Some of this mixture is pulled down and used to block in the small, light pot on the left. All detail and work in confined areas is done with the 1/4 in. (6 mm) soft brush and all the blocking of larger areas wit the no 4 flat.

9 The small light pot is blocked in with white, Payne's gray and a little raw umber. Burnt sienna, raw umber and cadmium red give a mix for the wooden box and the tops of the two jars on the right. Again all the details are painted with the 1/4 in. (6 mm) flat and more open blocking with the no 4 flat bristle.

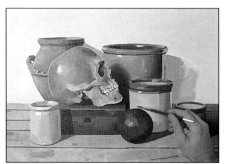

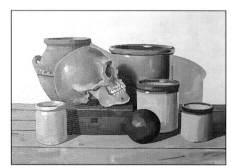

10 The bodies of the two pots are painted next with raw umber, yellow ocher, and titanium white. The shadows on the table are darkened and the background pale color is blocked in using the no 8 flat bristle brush using titanium white with a little raw umber and Payne's gray. The painting is then allowed to dry over night.

11 Once dry start to rework the painting, begin by strengthening the darks and lightening the lights in an effort to stretch the tonal range.

12 The painting is completed by reworking the tabletop and repainting the background with titanium white mixed with a little raw umber.

Alternative Approaches

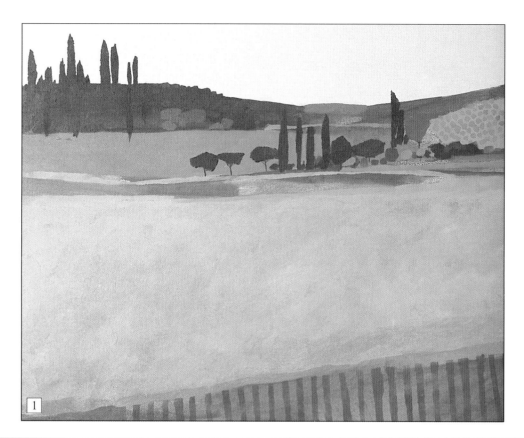

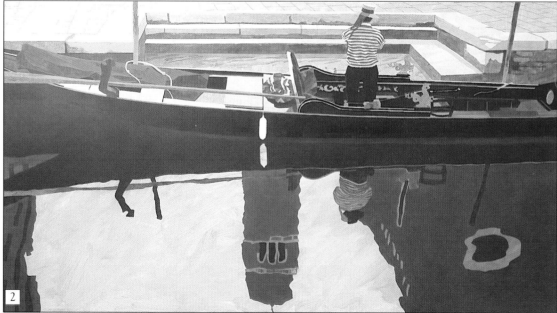

1 This painting of a hillside in Tuscany was painted in much the same way as the main project, the shape, position, and tone of the fields and trees all being established using thin washes of a dull purple.

2 The overall color of this painting of a boatman waiting for custom suggested that the underpainting should be done with a mixture of ocher and gray. The underpainting can still be seen in the light reflections on the water and around the steps and paving.

GARDENING TOOLS

Underdrawing and Underpainting

PROJECT THREE

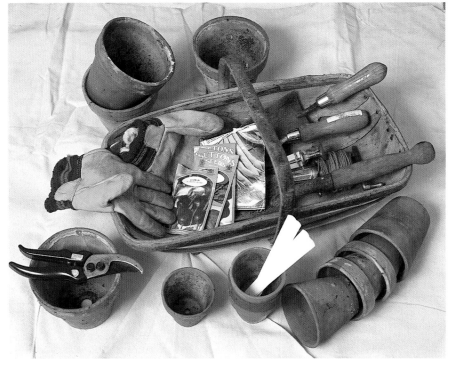

AS MENTIONED in the previous project the stark white of a support can be very intimidating, making it very difficult to make those first few marks on the canvas—covering it quickly with a drawing or underpainting commits you and helps you to relax into it, but it also provides a good solid foundation for the work to come.

An underdrawing can be made using pen and ink, colored pencils, pastel, conté crayon, indeed most drawing media except felt tip and marker pens as the ink in these tends to bleed through the subsequent layers of paint. But perhaps the medium that is most commonly used for the purpose is charcoal; this takes very easily to most surfaces, its very nature encourages a bold, fluid line that forces you to concentrate on the image as a whole rather than in detail and mistakes are easily dusted away with a cloth or a large soft brush.

Once all the drawing is in place to act as a guide, a loose underpainting will help to consolidate the composition. The idea is to work broadly and directly, establishing the overall local colors, again ignoring any detail; to this end choose either large brushes or soft rags. Remember the "fat over lean" rule and mix the paint with turpentine only. This mixture should be thin enough to allow overworking almost immediately as the turpentine evaporates from the paint quite quickly leaving a thin, tacky film of color that will take thicker paint easily.

Again a group of objects make up a still life, but this time the garden shed was the source. After playing around with the composition it was decided to look almost straight down on the group. Allowing a couple of the pots to run off the top of the picture adds tension and makes for a more interesting composition, the eye wants to travel out of the picture to see what is there, but is pulled back in by the circular grouping of the other objects.

It was painted on a 20 × 30 in. (51 × 76 cm) pre-prepared canvas board using a thick stick of charcoal for the drawing, a rag for the underpainting and a single no 4 flat bristle brush. The colors used were titanium white, Payne's gray, raw umber, burnt umber, burnt sienna, yellow ocher, cadmium yellow, lemon yellow, cadmium red, cadmium orange, alizarin crimson, viridian, and sap green. The paint was thinned and mixed with turpentine and linseed oil.

MATERIALS AND EQUIPMENT

No 4 flat bristle brush
Stick of charcoal
Titanium white, Payne's gray, raw umber, burnt sienna, yellow ocher, cadmium yellow, red and orange, lemon yellow, alizarin crimson, viridian, sap green

The Painting

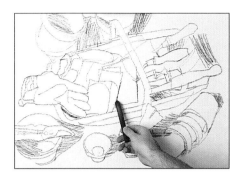

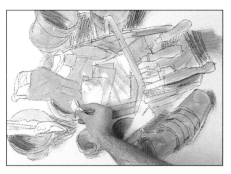

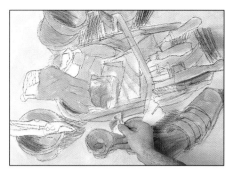

1 With a large thick piece of charcoal loosely draw in the pots, wooden basket (trug), and tools, and scribble in the darker areas of shadow. If you wish this can be dusted over or given a coat of spray fixative, either way the drawing will disappear beneath the layers of paint.

2 With burnt sienna thinned with turpentine and using a small piece of rag, paint in the overall color of the flowerpots. Using the rag lays color in quickly and makes it impossible to focus on detail. With raw umber do the same to the trug basket and with cadmium yellow and lemon yellow paint in the gloves. A little viridian and cadmium red is used for the seed packets.

3 Mix yellow ocher and titanium white and block in all of the background, work quickly and don't be afraid of smudging what has been done or straying over lines, the intention is simply to cover the area quickly.

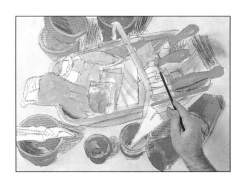

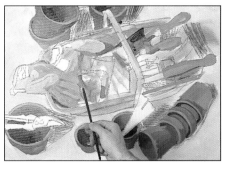

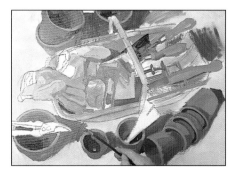

4 In the time it takes to make and drink a cup of coffee much of the turpentine will have evaporated and the thin paint will have taken on a stiffer, greasy appearance ready to be overpainted. With a no 4 flat bristle begin to block in the local (actual) color of the objects. Begin with the flowerpots using a mixture of burnt sienna, cadmium orange, yellow ocher and titanium white. Ocher, white, and raw umber mixes give the color for the handles of the tools.

5 Some of the flowerpot mixture is darkened with burnt umber and Payne's gray and the dark tones inside and between the flowerpots painted. A little sap green and white give the color for the trowel and the gloves are worked with cadmium orange, lemon yellow, burnt sienna, and white.

6 Sap green and yellow ocher with a little white give the mix for the seed packets. Then the shadows are scrubbed in using a combination of darker mixes made from the dark color used for the inside of the flowerpots with ocher and white added.

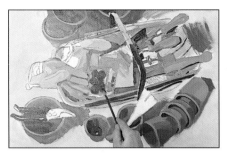

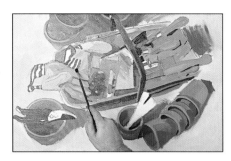

7 Payne's gray and burnt umber give a dark that is used for the shadows around the objects, the dark wood around the trug basket and the handle. Cadmium orange is used on the garden line and a dark mix of cadmium red, alizarin crimson, and the dark shadow mix gives the color for the handle of the secateurs. The dark red is lightened by the addition of more cadmium red and the radishes, illustrated on the seed packet, are blocked in.

8 Next the wooden trug is reworked using raw umber, yellow ocher, and white with a little cadmium red added. The picture on the seed packets is developed and the dark blade of the secateurs and the edge of the gloves blocked in.

9 Gradually detail is added and the secateurs and the trug basket are completed, also the colored pattern that runs around the wrist of the gloves is painted. Highlights on the edge of the pots are dabbed in and pure white is used for the plant labels and the highlights on the garden tools.

10 Neutral grays are mixed by combining red, yellow ocher, and Payne's gray together with a little raw umber and white, these are used for the shadows that run across the background cloth.

11 Finally yellow ocher and white are added to the above and the background is reworked cutting in and around the objects, giving them a crisp outline.

Alternative Approaches

1 The entire surface of this small painting of a young woman swimming was loosely washed over with various tones of blue using a large decorating brush. Once this had dried the painting was completed.

2 The underpainting of this small painting of the model boats that are for hire in the Luxembourg Gardens in Paris was done quickly on the spot using acrylic paint. The picture was then completely reworked in oil paint in the studio several weeks later.

THE CLIFFS AT ETRETAT

Thin Paint

PROJECT FOUR

THIN PAINT that is mixed with a dryer, such as Liquin, is slightly transparent and can be the ideal medium for blocking in and establishing a scene on location; the painting can then be reworked later in the studio at leisure. Often after only a few hours the painting will be dry enough to begin overpainting, again using thin paint mixed with a drier. The technique is not dissimilar to glazing, as elements of the underpainting are allowed to show through and influence the next layer of paint.

In many respects this technique is not unlike those used in traditional watercolor work. For the most part, like watercolor, the painting is worked light to dark, colors are strengthened and darkened in the reworking while the lightest areas of color and tone are left unpainted, having been established in the initial underpainting. The white of the canvas reflecting through the semitransparent layers lights the paintwork from within and even acts as the white surf and foam in the sea. The textures seen on the cliffs and in the foaming sea are represented solely by the effects of flat paint work, there is no impasto or thick paint used.

Landscape as a subject is as vast and infinitely variable as the landscape itself. The view from your kitchen window is as legitimate a subject as sunflower fields in Italy, or an Arizona desert studded with cactus. It is even possible, as so many artists have done in the past, to paint the same view over and over again, changing as it will in different weather conditions, times of day or seasons of the year. You should not need to look far for inspiration. However, whatever, or whenever you decide to paint, try to look at your subject in a fresh and original way. This is often easier said than done or certainly easier with some places than with others. Venice, for instance, must surely have been the inspiration for more paintings than any other city in the world, yet artists, including myself, still flock there to work in an effort to create something that is fresh original.

This view looking down from the cliffs at Etretat in Normandy was painted on a 19 × 22 in. (48 × 59 cm) primed cotton duck canvas using charcoal for the underdrawing, a no 4 and a no 8 flat bristle brush and a ¹/₄ in. (6 mm) flat synthetic brush. The colors used were titanium white, Payne's gray, raw umber, burnt umber, raw sienna, cadmium yellow, lemon yellow, cadmium red, ultramarine, cerulean blue, and sap green, the paint was thinned with turpentine and Liquin.

MATERIALS AND EQUIPMENT

¹/₄ in. (6mm) flat/ no 4 and no 8 bristle brushes Titanium white, Payne's gray, raw umber, burnt umber, raw sienna, admium yellow and red, lemon yellow, ultramarine, cerulean blue, sap green

The Painting

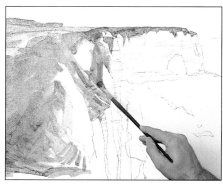

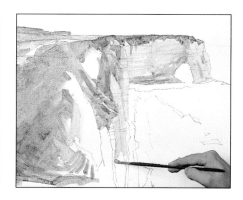

1 With a medium stick of charcoal loosely and lightly sketch in the cliffs and the beach. Fix well afterward with a spray fixative.

2 With a mix of sap green and cadmium yellow thinned with turpentine and Liquin, and using the no 4 and no 8 flat brushes, block in the light, grassy areas on the cliff top. Darken the mix with Payne's gray and burnt umber and establish the darker greens along the cliff edge.

3 Payne's gray, burnt umber and white mixes are used to establish the general color of the cliffs and the shingle beach.

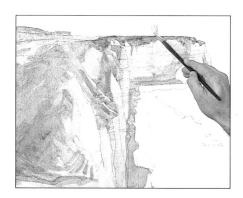

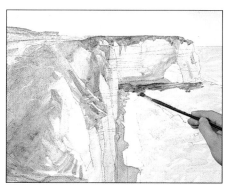

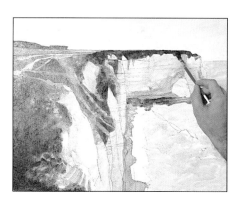

4 With cerulean blue, titanium white, and a little lemon yellow and using the no 8 flat brush block in the sky, the mixture is lightened a little at the horizon helping create the illusion of aerial perspective.

5 Darken the sky mix with ultramarine and lemon yellow and paint in the sea, darken this mix further with Payne's gray and more ultramarine for the shadow below the cliffs that crop out into the sea.

6 Once the paint has dried, (this should take just a few hours or at the most over night) work can be resumed. With a 1/4 in. (6 mm) flat synthetic brush and sap green darkened with a little raw umber, darken and consolidate the grass that is in shadow and the row of windswept trees on the horizon.

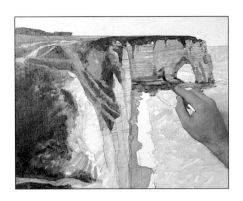

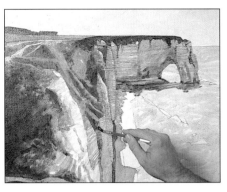

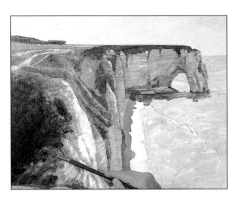

7 Still using the ¼ in. (6 mm) brush and a mix of raw umber and raw sienna, the patch of eroded earth in the center of the cliffs is darkened. Payne's gray together with a little titanium white and cerulean blue is used next to paint the strata on the rocky outcrop.

8 Add a little raw sienna to the mix and continue to suggest the rock strata on the cliffs that run parallel to the sea.

9 Burnt sienna, cadmium red, Payne's gray and white give the color for the beach. The green on the nearest cliff top is then darkened with sap green raw umber and Payne's gray using the no 8 flat brush. Also darken the shadow beneath the row of trees but using the ¼ in. (6 mm) flat.

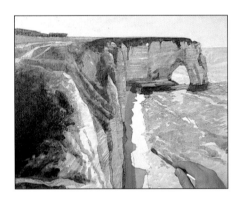

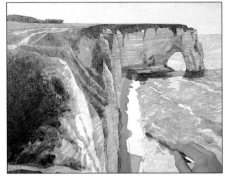

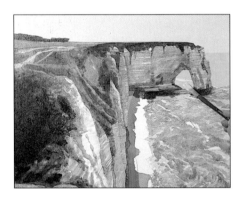

10 Payne's gray, sap green, and a little cerulean blue are mixed for the shadow on the sea below the cliffs. The mix is lightened with more cerulean blue, Payne's gray and a little titanium white and the dark patterns on the sea blocked in with the ¼ in. (6 mm) flat.

11 The sky is painted using the no 8 flat bristle brush with a light cerulean blue, lemon yellow, and titanium white mix. Darken the mix with a little more blue and yellow and paint in the wave patterns of the sea using the ¼ in. (6 mm)) soft brush.

12 Again using the no 8 flat consolidate the light sea color with a mixture made from cerulean blue, lemon yellow, and white together with a little Payne's gray.

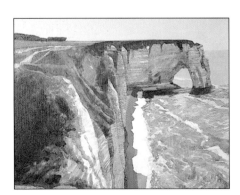

13 Finally pure white is used with the no 8 flat along the shore line to soften the edge of the surf.

Alternative Approaches

1 Very thin mixes of color diluted with turpentine were used on a smooth canvas board for this working study of the Sphinx at Giza in Egypt. The paint was scrubbed on in layers and allowed to run in places, all in an attempt to suggest the texture of corroded stone and sand.

2 Using a photograph as reference, this painting of my daughter was also done using thin paint built up in layers, each layer being allowed to dry before the next was painted. This can be seen in the reflection where the colors and tones overlap each other like glazes.

WHITE LILIES

Mixing Techniques

CERTAIN TECHNIQUES bring a very distinct quality to a work, they can be used by themselves to create a complete painting or, as is more often the case, introduced to resolve a representational problem, and in doing so they often bring a very different and interesting quality to the paint surface. One of these techniques is masking. Masking prevents certain areas of a painting from being covered in paint and in doing so can, depending on the material used, create a very distinct edge that is impossible to achieve in any other way.

Masks can be made from any material that can be laid flat on to the work and fixed to prevent paint from seeping beneath it. The most commonly used materials are masking tape, paper or card, and fabric; however masking is one of those areas that calls for experimentation and what you use will depend very much on the desired result. Masking tape is used to mask out small areas of a painting but because it needs to stick to the surface the paint needs to be dry. The tape can be torn and then applied or cut into intricate shapes with a sharp scalpel once it has been laid, care must be taken

not to press so hard that you cut through the support as well as the tape. Paper can also be cut and torn creating either a smooth or ragged edge. Paper can be used on wet paint as it only rests on the surface, the same goes for fabrics. However, the consistency of the paint is very important: if it is too thin you will find that it creeps and bleeds beneath the mask spoiling the effect, very thick paint can be used with either a brush or painting knife and if used with a thick mount, like card, makes an edge that stands proud of the surface in the same way as impasto paintwork.

Sgraffito is a traditional technique that, like masking, is usually used to bring qualities to the paint work that would be difficult, if not impossible, to achieve in any other way. Scratching through the wet paint can enliven a dead surface, adding subtle patterns and texture—especially over large flat areas of paintwork, or it can be used to add linear interest by scratching fine lines into grass, fur, hair, or fabric. Painting, while a serious pastime, should be both enjoyable and satisfying and much can be learned by experimenting and trying out things that may or may not work. Always remember that nothing you will do is irreversible—it is always possible to paint over or scrape off any mistakes.

This painting of lilies was done on a 36 × 24 in. (92 × 61 cm) primed cotton duck canvas using a no 4 flat bristle and a 1/4 in. (6 mm) flat synthetic brush, a painting knife and a graphite pencil. The colors used were titanium white, Payne's gray, raw umber, burnt umber, burnt sienna, yellow ocher, cadmium yellow, cadmium red, alizarin crimson, ultramarine, cobalt blue, sap green; they were mixed using Liquin and turpentine. You will also need a sharp knife and a roll of masking tape.

MATERIALS AND EQUIPMENT

1/4 in. (6mm) flat/no 4 bristle • Painting knife Pencil • Titanium white, Payne's gray, raw umber, burnt umber, burnt sienna, yellow ocher, cadmium yellow and red, alizarin crimson, ultramarine, cobalt blue, sap green

The Painting

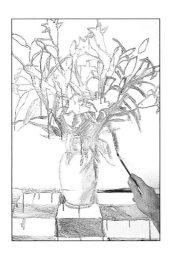

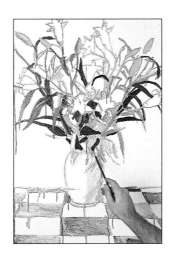

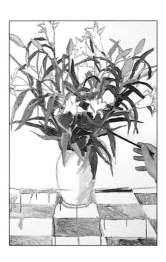

1 The basic shapes and positions of the flowers, vase, and tablecloth are established with a thin mixture of cobalt blue and Payne's gray mixed with plenty of turpentine; alternatively use acrylic paint mixed with plenty of water. Using a no 4 flat bristle brush, work loosely and freely by holding the brush at the very tip of the handle. Pay particular attention to the perspective of the tablecloth squares as these are what give the picture depth.

2 With a range of dull green mixes made using sap green, yellow ocher, burnt umber, and raw umber, cadmium yellow, titanium white, and Payne's gray, begin establishing the colors and position of the leaves and stems using the underpainting as a guide.

3 Continue the process until all of the foliage is blocked in—leave the position of any flowers clear, as much as possible, of paint. This will allow any light colors, which will be applied next, to stay clean.

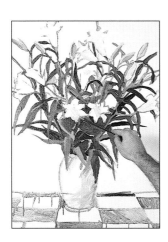

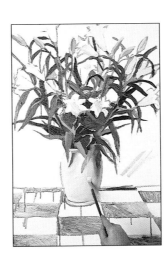

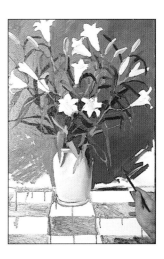

4 Titanium white is used to block in the lily flowers, and a little burnt sienna is added to give the blush of color seen on the petals.

5 A neutral gray mixed from burnt sienna, ultramarine and white is used to block in the shadows on the vase. Titanium white is then brushed into the lighter side cutting in carefully around any leaves and shadows.

6 With burnt umber, raw sienna, and white a brown mix establishes the overall background color. This has the effect of visually pushing the glowers forward. Cut in carefully around the flowers and leaves trying to use confident brushstrokes.

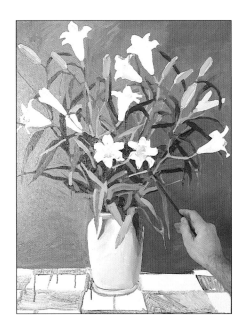

7 The paintwork on the flowers and leaves should now have stiffened sufficiently to overwork white on the flowers and shades of green on the foliage. Because the paint you are working into is still wet you will need to use light but confident strokes of the brush to float on a few layers of paint.

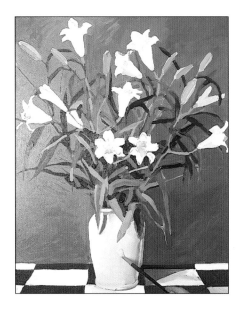

8 Cadmium red, mixed with a touch of alizarin crimson, provides the color for the squares on the tablecloth. Then pure titanium white is brushed on to the white areas, add a little yellow ocher and rebrush over the vase.

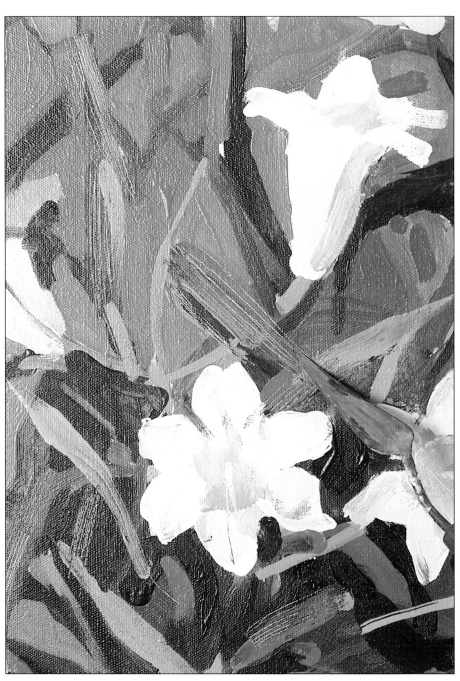

9 With a palette knife work into the wet paint drawing and describing lines on to some of the leaves and flowers. The painting is then left to dry over night.

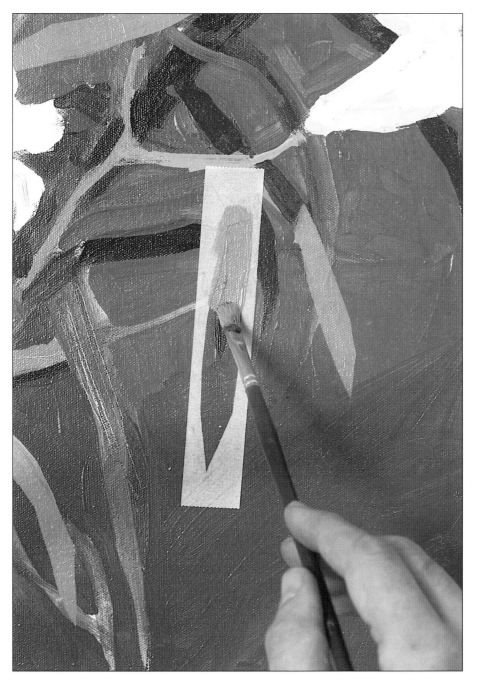

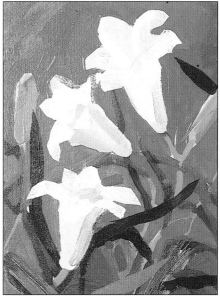

11 Work across the painting doing the same with all the flower petals, redrawing and reshaping them as you go.

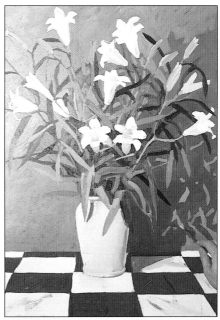

10 When the paint has thoroughly dried, masking tape is used to redefine and consolidate some of the leaves; the tape is stuck to the canvas and the shape of the leaf cut with a sharp knife, be careful not to press so hard as to cut through the support. The leaf-shaped tape is peeled off and the area loosely blocked in with thick color, the rest of the tape is then peeled off leaving a crisp leaf shape.

12 Mix a lighter background color and with a 1/4 in. (6 mm) soft flat brush, scumble paint across the left-hand side gradually tapering the color off as it reaches the shadows. Put in a suggestion of light cutting through the foliage on to the wall on the lower right. Use a mixture of masking and straight brushwork.

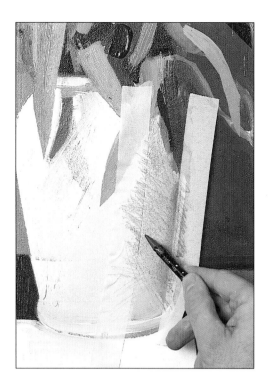

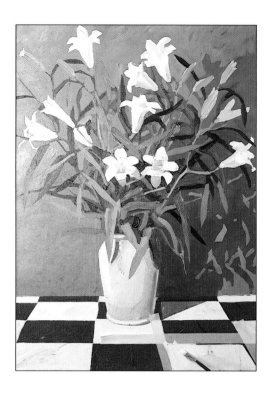

13 Mask out areas of the pot and, using a soft graphite pencil, scribble on tone to give a suggestion of shadow.

14 Mask out the highlight area on the vase and block it in with pure white. Do the same with the tablecloth redefining the edge of the squares and the shadow cast by the vase.

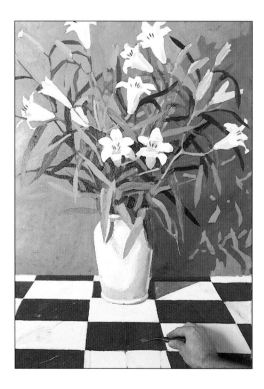

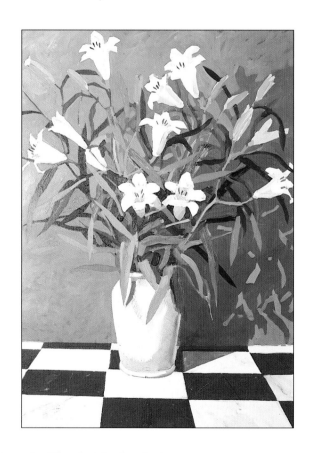

15 The flower stamens are also cut from masking tape and brushed over with burnt sienna and cadmium yellow. The painting is finished by using the palette knife to pull unmixed cadmium red across the tablecloth suggesting the rise and fall of the creases in the material.

16 The finished painting.

Alternative Approaches

1 The wall behind this portrait of a writer and collector was cunningly made from corrugated cardboard. In order to paint it I placed strips of masking tape on to a large sheet of glass and cut them into thinner strips using a sharp scalpel, these there then used to mask out the wall before painting on the dark ocher.

2 Masking tape was also used on this picture of Tuscany, the trees and rows of vines were all masked with tape that had been cut or torn. The outline of the fields were made by painting over torn pieces of heavy watercolor paper.

THE GINGER CAT

Impasto and texture

OIL PAINT CAN BE applied to the support straight from the tube with little or no turpentine added; this gives a thick, deep, and very richly textured surface that holds the marks of the brush or knife and is known as impasto. The word impasto comes from the Italian meaning dough, and like dough the thick paint can be teased and manipulated to stand u p in thick ridges that give a three-dimensional quality to the surface. This interesting technique is very expressive showing and preserving the direction and fluidity of the brush or knife strokes. This directional application of paint can be used to follow and describe the form of the subject but it does call for very sure handling and confident brush work.

Impasto is usually done alla prima or in the later and final stages of a painting that has been built and worked in thinner leaner layers. However, it is possible to paint with scumbles and glazes over the top of impasto work to develop yet more dramatic, highly effective and interesting effects, but you must allow the impasto to dry before this is done, and that can take between several months to a year!

Impasto work is best done on a surface that has at least some tooth—on smooth surfaces the paint tends to slide when it is applied—so wooden panels should be roughened with coarse sandpaper or scraped over with a saw blade. You can, if you wish, even add marble dust or sand into the primer. You can also add sand, sawdust or plaster into the paint to give it more body and texture. Impasto media are available that bulk out the paint making it go further, and you'll need them! Even a moderately sized impasto painting can eat up your paint at an alarming rate. These media happily do not alter the color of the paint but they do speed up the drying time. Take care if using these extender media with brushes as they will easily clog and spoil them.

This painting was done on a primed cotton duck canvas that measured 16 × 15 in. (41 × 38 cm), charcoal was used for the underdrawing, three brushes were used—a no 4 and a no 8 flat bristle and a 1/4 in. (6 mm) flat synthetic, you will also need a painting knife. The colors used were titanium white, Payne's gray, raw umber, raw sienna, burnt sienna, yellow ocher, cadmium yellow, cadmium red, cadmium orange, cobalt blue, and sap green; they were mixed using linseed oil and turpentine and little ordinary builder's sand.

MATERIALS AND EQUIPMENT

1/4 in. (6mm) flat/no 4 and no 8 bristle • Painting knife • Titanium white, Payne's gray, raw umber, raw sienna, burnt sienna, yellow ocher, cadmium yellow, red and orange, cobalt blue, sap green

The Painting

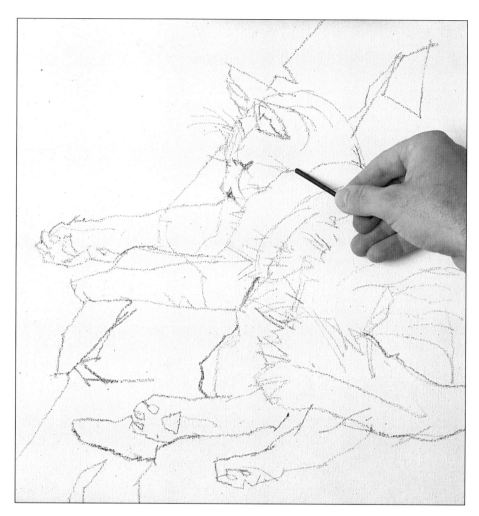

1 Sketch in the position of the cat in charcoal and fix with spray fixative. The cat almost fills the canvas and is allowed to disappear off to one side, this makes for a more interesting composition than if the cat were positioned fully on the canvas, filling it completely.

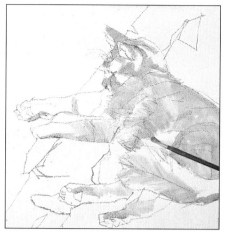

2 Mix a little cadmium orange and burnt sienna with plenty of turpentine and, using a no 4 flat bristle brush, begin to block in the ginger mid tone pattern of the cat's fur.

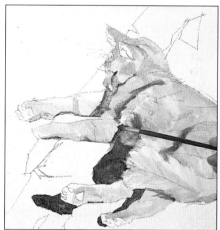

3 Lighten the mix with yellow ocher and white and complete blocking in the cat's fur. Then using cerulean blue and Payne's gray establish the shadows around the cat. These have the effect of both anchoring it to the wall while at the same time giving it some form and dimension.

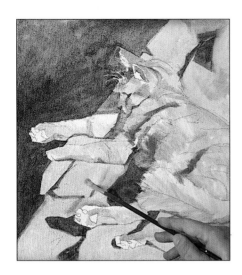

4 The dark background and shadows on the stone wall are painted using Payne's gray. Titanium white with a little Payne's gray and raw umber added are then mixed and the top of the wall established.

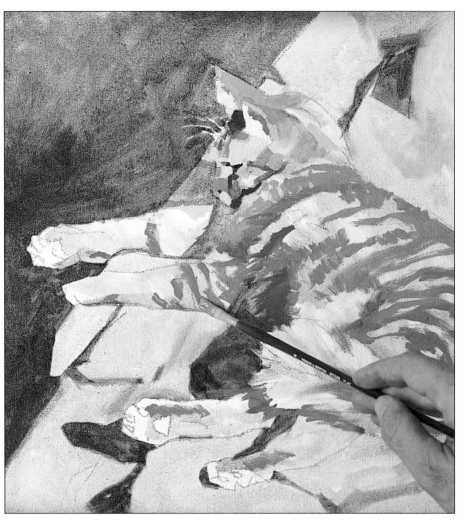

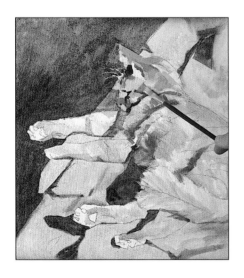

5 Using the ¹/₄ in. (6 mm) flat synthetic the mixes are thickened and the cat's eye established. Mixes of cadmium yellow, burnt sienna, raw umber, and white give a range of tones and color seen around the face and head.

6 With the no 4 flat bristle the dark pattern on the fur is painted in using cadmium orange, raw sienna and a touch of cerulean blue. Make the brush marks follow in the same direction and at the same angle as the way the fur lies.

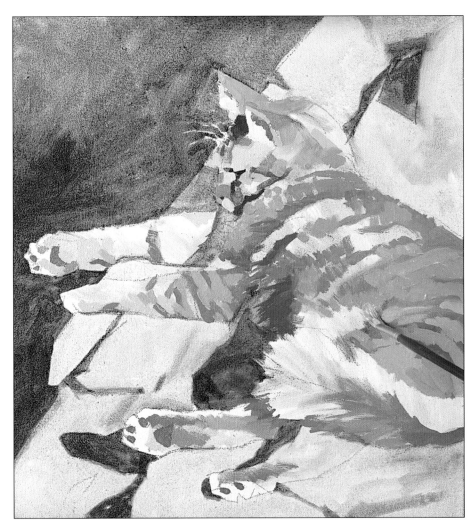

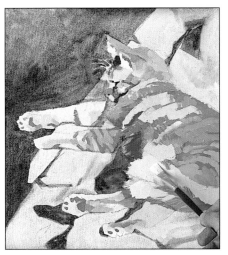

8 With a mix of titanium white, yellow ocher, and a little cadmium yellow but using the no 8 flat brush, the lightest fur is blocked in. Use short strokes with plenty of paint on the brush, adding less medium to the mix will make the paint thicker.

7 With the 1/4 in. (6 mm) brush the pads on the feet are painted next using a mixture of cadmium red, titanium white and a little dark fur color. Change to the no 4 brush and lighten the fur mix with more cadmium orange and raw sienna and continue working the pattern of the fur.

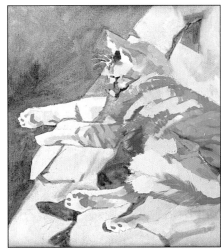

9 Fine lines to represent the cat's fur are made with a painting knife by scratching into and gently through the paint to reveal the light canvas beneath.

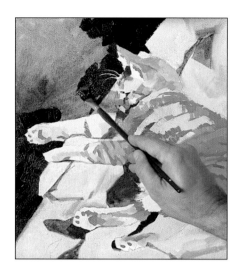

10 With a thick mixture of Payne's gray and sap green and using the no8 brush block in the dark background with short random strokes. Do not brush the paint out flat but allow it to keep its shape.

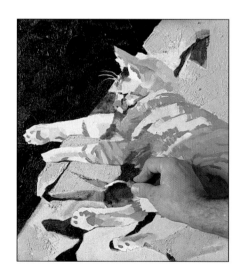

11 Mix a little builder's sand with titanium white, raw umber, and a little Payne's gray and mix well. Then apply this to the stone wall with a painting knife, working carefully around the cat.

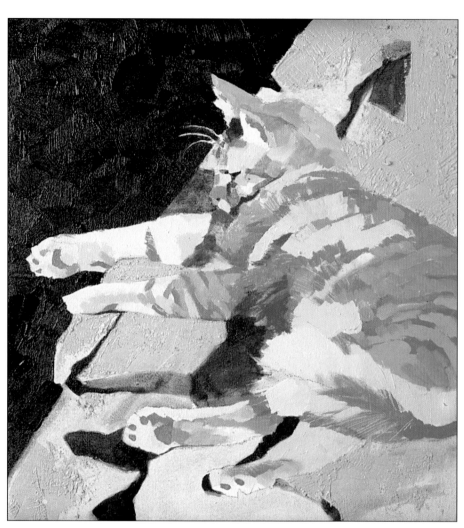

12 The finished painting.

Alternative Approaches

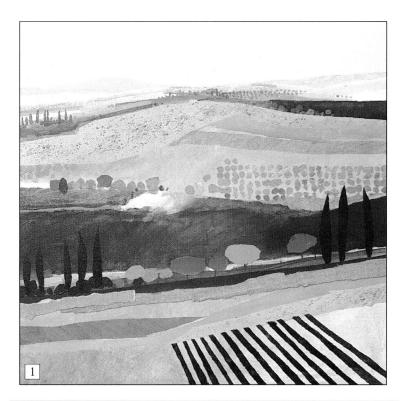

1 Here, the paint has been applied in a number of ways. Sand was incorporated into the light green paint on the distant Tuscan hillside and in the lower right field. A spattered area can be seen in the purple field and in the lower foreground sandpaper, hessian and colored paper have been collaged on.

2 Interest and movement is added to the paint surface of this Venetian view with thick and heavy impasto work in the sky and sea.

FRUIT AND VEGETABLES

Using a painting knife

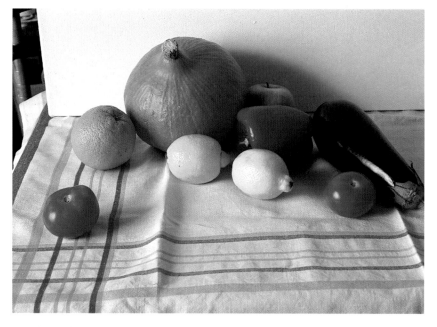

THE PAINTING knife can take some getting used to after the easy versatility of the brush. But with practice you will find that the knife is an extremely useful tool capable of a surprisingly wide range of marks. Oil paint and palette or painting knives are made for each other, the smooth buttery consistency and the long drying time means that the paint can be manipulated and worked at leisure without any fear of it drying or stiffening too quickly as would be the case with acrylics. Color is mixed on the palette and transferred to the canvas using the knife or squeezed from the tube directly on to the canvas. The color applied with a knife invariably looks brighter and denser than the same color applied with the brush, but care needs to be taken not to overwork the paint or it will lose its clarity and strength.

When painting with a knife, what you take off is almost as important as what you trowel on, only so much color can be built up and you will find that it takes much practice to float a pure color over another wet color without disturbing it. A minimum amount of color should be applied in the first instance, this can always be scraped back to the support still leaving a strong colorful image on to which thicker paint can be worked. This thin image that merely colors the canvas or board, acts as the underpainting, establishing the image and covering the white ground. A legitimate alternative is loosely to block in with thin paint using a brush. This could either be oils with plenty of turpentine added or acrylic paint could be used.

The support needs to be a fairly heavy grade canvas or textured board as quite heavy pressure is sometimes used when the paint is smeared on and scraped off. On lighter canvasses this can make dents, it also makes the work more hesitant and difficult if there is too much give in the surface. Like brushes, painting knives come in many shapes and sizes each giving a distinctive range of marks; some are easier to use and more adaptable than others and it will not take long before you will develop your own preferences. Painting with a knife uses far more paint than painting with a brush so, as mentioned in project six, the paint can be bulked out or extended with a smooth impasto medium.

The painting was done on a primed cotton duck canvas that measured 18 × 24 in. (46 × 61 cm) using titanium white, Payne's gray, cadmium yellow, lemon yellow, Naples yellow, cadmium red, cadmium orange, alizarin crimson, ultramarine, cobalt blue, and sap green, mixed and thinned with Liquin and turpentine and Oleopasto, a gel extender used in all mixes. A no 4 flat bristle brush was used for the underpainting, and a large and a small diamond-shaped painting knife for the overpainting.

MATERIALS AND EQUIPMENT

No 4 flat bristle brush
Large and small painting knives • Titanium white, Payne's gray, cadmium yellow, red and orange, lemon yellow, Naples yellow, alizarin crimson, ultramarine, cobalt blue, sap green

The Painting

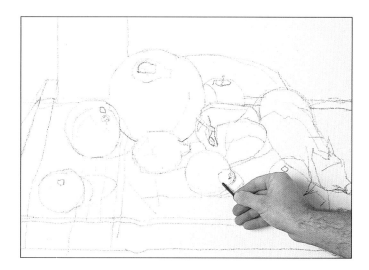

1 With a medium stick of charcoal draft out the composition on to the canvas.

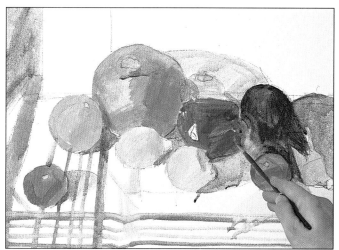

2 Paint in the approximate colors, blocking in using thinned oil or acrylic paint. Don't pay too much attention to getting them correct. It is enough to paint the orange orange and the eggplant dark blue, the intention is to cover the support with an underpainting that gives a good ground on which to work and to lose some of the stark whiteness of the support.

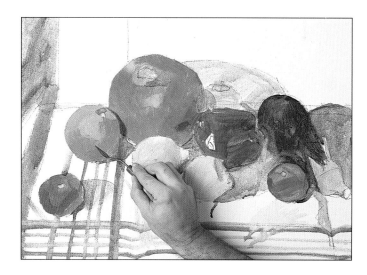

3 Cadmium orange and cadmium red are mixed and, using a small diamond-shaped palette knife, begin to establish the overall color of the squash. Lighten the mix with cadmium yellow and block in the orange—a little squash mix and cobalt blue give the dark color for the shaded side. Work the paint by turning the knife into the shape of the object following its contours.

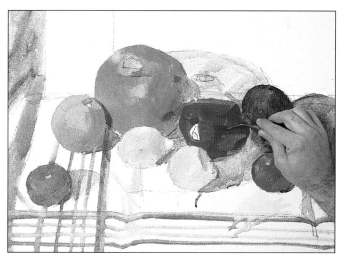

4 Turn your attention to the tomatoes. Darken the orange mix with cadmium red and use the small knife to block them in—as before move the knife around the form as if you are scraping its surface. The mix is darkened with alizarin crimson for the pepper and a little added white gives the shine on the skin.

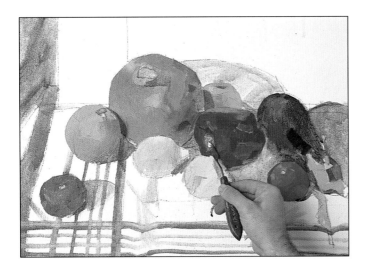

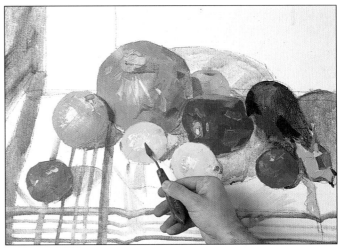

5 Mix a mid green with sap green and lemon yellow, add a little white and block in the apple and the green bell pepper stalk. Add cobalt blue for the green on the eggplant stalk and white for the highlight.

6 Cadmium yellow, lemon yellow, and titanium white give mixes for the lemons. Adding more white finds the highlight color for the orange and the squash, this is dabbed on using the very tip of the small knife. The knife is also used to scrape into the squash, suggesting the patterns on the skin.

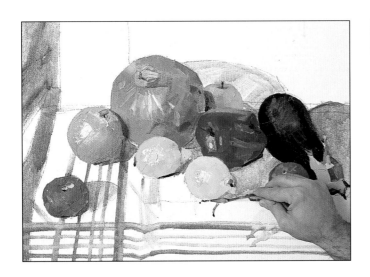

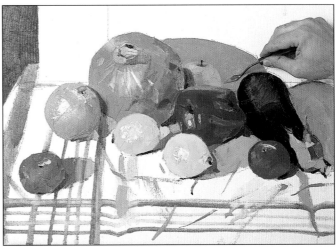

7 The dark color of the eggplant is mixed with alizarin crimson, ultramarine, and Payne's gray. The lighter reflection on the surface is made by adding white. Place a little of this dark purple color beneath the other fruit to create the dark shadows.

8 Cobalt blue, cadmium red, Payne's gray, and white mixes make up the shadows and creases on the tablecloth. Payne's gray is used for the dark patch seen in the background on the left hand side.

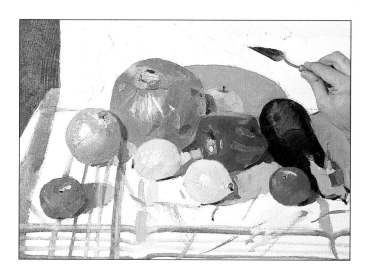

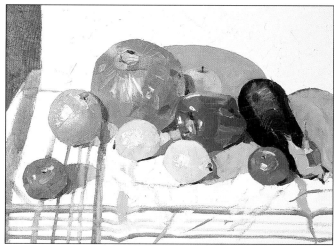

9 Naples yellow and titanium white are mixed and, using a larger diamond-shaped palette knife, the background is established.

10 For the tablecloth titanium white is applied straight from the tube. Work carefully around the shadows and the pattern, dabbing in the highlights at the end.

Alternative Approaches

1 The thick swirling paint describes perfectly the ripples of disturbed water around the swimmer. The light catching the paint surface also contributes to the illusion of wetness.

2 The thick smeared paint in this small palette knife sketch of the topiary garden at Levens Hall suits the sculptural qualities seen in the shaped yew and box trees and hedges.

PORTRAIT

Glazing

GLAZING IS THE OLDEST of all oil painting techniques; a glaze is a thin transparent layer of paint which is applied over another layer of paint. Light passing through these transparent layers is reflected back by any opaque under-painting or ground giving the work a glow or inner light that is difficult to achieve by any other means. The traditional technique of glazing was executed over a gray tonal underpainting, or grisaille, which established the form of the subject and looked like a pale black and white photograph. The underpainting needs to be as light as possible while still showing the tonal range of the subject, this is because each layer or glaze of color darkens the overall tone a little more. When two colors are glazed one on top of another in this traditional way, the resulting color can be completely different than if the colors were mixed together wet in wet.

A painting does not have to be worked using only glazes, the technique can be used in tandem with other techniques and is especially effective when used over thick impasto work. The thin transparent color settles more thickly in the troughs and crevices of the paint and less thickly on the peaks, making the intensity of the color vary across the glazed area. Many artists use a glaze in the final stages of a painting, a carefully chosen color glazed over the entire picture has a unifying and harmonizing effect on the colors as a whole. Alternatively a glaze can be applied simply to darken the tone of a color without remixing that color to make it darker.

The way I have chosen to paint this self portrait uses the glazing technique in a slightly different way to the traditional approach but the principles are the same— each layer consolidates, modifies, and qualifies the one beneath. Working on a white gessoed board the picture is painted using paint thinned with a quick drying glazing medium. Once dry the painting is completely recovered again using thin paint, the colors become darker and richer but still allow the work beneath to show through. Only two layers or paint glazes were used and the portrait will need several more before it is finished but already you will be able to detect the warm glow or light so characteristic of glazed paintings, that seems to emerge from beneath or within the paint work.

The portrait is painted on a 16 × 12 in. (41 × 30 cm) piece of MDF (medium density fiber board) that has been prepared with four coats of acrylic gesso. The paint was mixed and thinned with a glazing medium and turpentine; the colors used were titanium white, Payne's gray, raw umber, burnt sienna, yellow ocher, cadmium red, ultramarine, and cerulean blue. The drawing was done with a F pencil and three brushes were used, a $1/8$ in (3 mm) and a $1/4$ in. (6 mm) synthetic flat and a no 8 bristle flat.

MATERIALS AND EQUIPMENT

$1/8$ in. (3 mm) $1/4$ in. (6 mm) flat and no 8 bristle brushes • Grade F pencil Titanium white, Payne's gray, raw umber, burnt sienna, yellow ocher, cadmium red, ultramarine, cerulean blue

The Painting

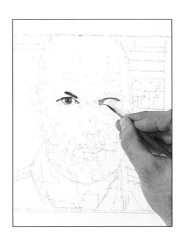

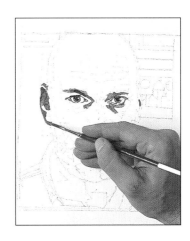

1 With a F pencil the portrait is carefully drawn on a gessoed panel made from MDF. The board is hard and smooth so the pencil line stays crisp and fine, making it possible to indicate a fair amount of detail. Fix using a spray fixative.

2 With a synthetic ⅛ in (3 mm) flat brush, burnt sienna and Payne's gray are mixed with a little glazing medium, the shapes of the eyes are carefully painted and the dark shadow beneath the brow. A little cobalt blue and yellow ocher is added which makes a dull green for the iris. Payne's gray into the mix gives the pupil color. Leave any highlights as bare gesso.

3 With cadmium red and raw umber work around the eyelids, add a raw umber and establish the eyebrows. A little yellow ocre mixed with cadmium red gives the color for the shadows beneath the eyes. The same colors are used in and around the ear.

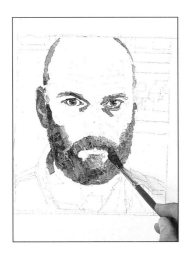

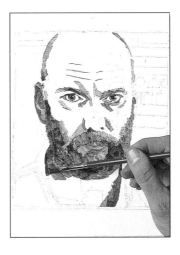

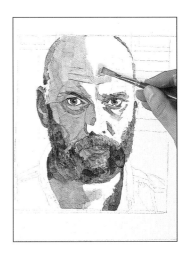

4 Thin brown mixes of raw umber, Payne's gray, and yellow ocher establishes the beard and hair, these are blocked in using the ¼ in. (6 mm) flat brush. Work carefully to suggest individual strands of hair and work around as many lighter hairs as possible.

5 Cadmium red, yellow ocher, and raw umber with a little added titanium white gives a darkish skin tone, this is used on and around the lips, nose, and eyes, the creases on the forehead and in the shadow on the neck.

6 Lighten the mix with cadmium red and a little lemon yellow, ochre and white, thin with plenty of glazing medium and block in the mid tones over the left side of the face and neck.

233

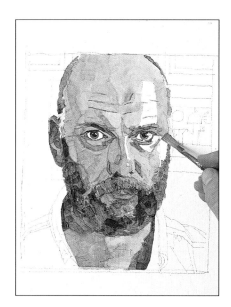

7 Lighten the mix with white, add a little more glazing medium, and block in the lighter tones on the opposite side of the face.

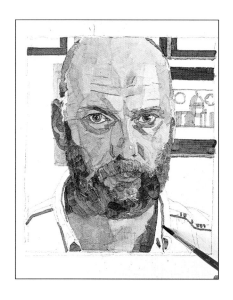

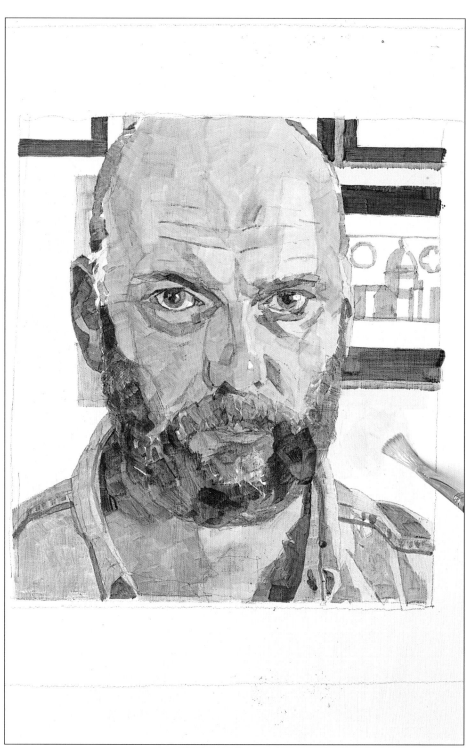

8 Lighten the mix further with a little more white and medium then paint in the highlights. Add a little gray and white into the mix and paint in the whites of the eyes. Raw umber and burnt sienna give the dark brown color for the frames seen on the wall behind the head. The dark of the shirt is painted using the small 1/8 in (3 mm) brush and Payne's gray mixed with a little cerulean blue.

9 Using the 1/4 in. (6 mm) brush mix cerulean blue, Payne's gray, and titanium white for the denim shirt. Lighten the mix with white for the highlights. White, Payne's gray, and a little ocher is then mixed and used for the background wall.

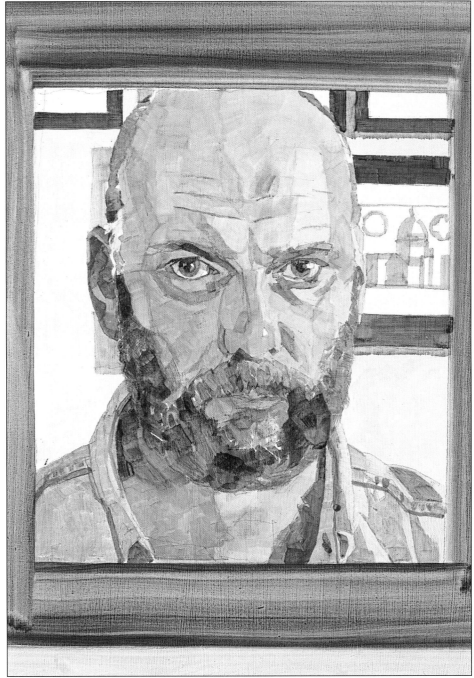

11 Once dry, which will take overnight, the painting is reworked. The flesh tones are glazed over and modified using flesh tints similar to those used on the first coat, this consolidates and deepens the color. If you come across areas of color that you are happy with simply paint round them.

10 Payne's gray and raw umber are mixed and, using a no 8 flat bristle and a ruler as a guide, paint in the mirror's wooden frame, the bristles on the brush leave lines suggesting wood grain. Then block in the background color using yellow ocher, Payne's gray, and titanium white. Once this first layer of paintwork is complete the painting is put to one side and allowed to dry thoroughly.

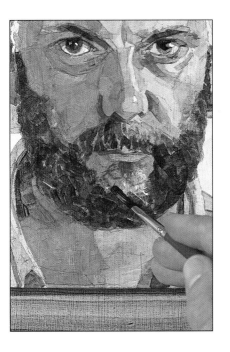

12 Details are repainted in and around the eyes cutting around the highlights which are made by the bare gessoed board showing through. The shadows are darkened and detail in the beard repainted.

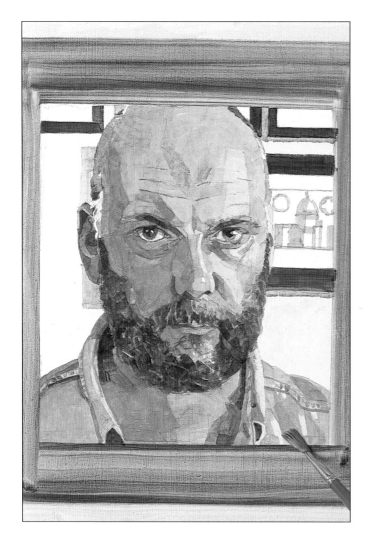 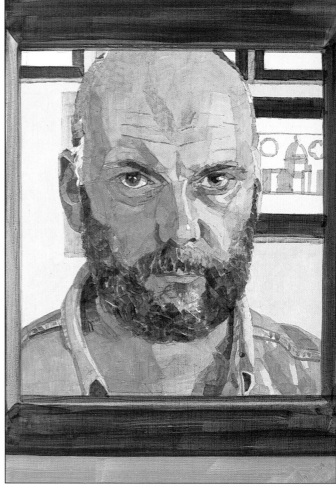

13 Cerulean blue, Payne's gray, and cobalt blue mixes are then glazed over the denim shirt, picking out the pattern of lights and darks seen along the bleached and washed out seams.

14 Finally the background is recovered and the frame glazed using a dark brown made from raw umber, burnt sienna, and a little cadmium red. The painting will now be allowed to dry overnight and the process gone through again, this can continue layer after layer until the desired and satisfactory result is achieved.

Alternative Approaches

1 In this sketch for a larger painting of my daughter at Giza, the Sphinx, and the pyramids have been built using thin layers of glazed paint. Done on gessoed masonite the painting was originally without a figure, this was added later using thicker more opaque paint.

2 Four shades of blue were used to paint the water in this painting of Venice. Working over a light blue base color the waves and ripples were glazed in layers the lightest first, the darkest last.

INDEX

238